PHOTOGRAPHING TUTANKHAMUN

PHOTOGRAPHY, HISTORY: HISTORY, PHOTOGRAPHY

Series Editors: Elizabeth Edwards, Jennifer Tucker, Patricia Hayes

ISSN: 2398–3892

This field-defining series explores the inseparable relationship between photography and history. Bringing together perspectives from a broad disciplinary base, it investigates what wider histories of, for example, wars, social movements, regionality, or nationhood look like when photography and its social and cultural force are brought into the centre of analysis.

Photography, Humanitarianism, Empire, Jane Lydon
Victorian Photography, Literature, and the Invention of Modern Memory: Already the Past, Jennifer Green-Lewis
Public Images, Ryan Linkof
Photographing Tutankhamun, Christina Riggs
Photography and the Making of Eastern Europe: Conflicting Identities, Culture Heritage (1859–1945), Ewa Manikowska
Photography and the Cultural History of the Postwar European City, Tom Allbeson
Photography and Bearing Witness in the Balkan Conflict, 1988–2015, Paul Lowe
German Vernacular Photographic Heritage of the Great War, Mike Robinson
Camera Time, Lucie Ryzova

PHOTOGRAPHING TUTANKHAMUN

Archaeology, Ancient Egypt,
and the Archive

CHRISTINA RIGGS

BLOOMSBURY VISUAL ARTS
LONDON • NEW YORK • OXFORD • NEW DELHI • SYDNEY

BLOOMSBURY VISUAL ARTS
Bloomsbury Publishing Plc
50 Bedford Square, London, WC1B 3DP, UK
1385 Broadway, New York, NY 10018, USA

BLOOMSBURY, BLOOMSBURY VISUAL ARTS and the Diana logo are trademarks of
Bloomsbury Publishing Plc

First published in Great Britain 2019

Cover design: Irene Martinez Costa
Cover image © Griffith Institute, University of Oxford

A catalogue record for this book is available from the British Library.

A catalog record for this book is available from the Library of Congress.

ISBN: HB: 978-1-3500-3852-3
 PB: 978-1-3500-3851-6
 ePDF: 978-1-3500-3854-7
 ePub: 978-1-3500-3853-0

Series: Photography History: History Photography

Typeset by RefineCatch Limited, Bungay, Suffolk
Printed and bound in India

To find out more about our authors and books visit www.bloomsbury.com. Here you will
find extracts, author interviews, details of forthcoming events and the option to sign up for
our newsletters.

To my mother, **Shirley Ellen Riggs**, who took me to the library and let me read the big books, and in memory of my father, **John Milton Riggs**, Sr., whom we all still miss. Dad was the family photographer, film maker, and slide show maestro. The man behind the camera, and thus an absence in many images – but a presence in our archive nonetheless.

CONTENTS

LIST OF ILLUSTRATIONS

A note on photographic sources

Two institutions – the Griffith Institute, Oxford University and the Metropolitan Museum of Art, New York – share between them the excavation archive of negatives and prints created by Harry Burton and Howard Carter during the course of their work on Tutankhamun's tomb. For reasons discussed in this book, the archives are similar but not identical, both in terms of the photographs they include and in terms of how they have numbered, mounted and stored the various photographic objects in their collections.

Because most of my research took place in Oxford, I have sourced the majority of the photographic images for this book through the kind cooperation of the Griffith Institute. The images they have supplied are new scans taken directly from the 1920s or 1930s negatives, digitally balanced and reversed for printing. These scans do not reflect the way Burton would have printed a paper negative: they do not include any cropping he might have done (although traces may survive as tape adhesive), nor the kinds of adjustments a photographer could make during a conventional printing process, for instance to lighten dark areas or darken overexposed ones. However, they do replicate the negative that Burton exposed at the time, often with written marks or traces of masking that are part of the history of the photographic object. Moreover, using scans from negatives makes it possible to reproduce those that he himself never printed (like Figure 7.4), where he and Carter rejected an exposure as unsuccessful or surplus to requirements.

In this list of illustrations, the figure captions in the text, and the Notes at the end of the book, I have identified by negative number all the photographs that I illustrate and discuss, using the abbreviation 'GI neg.' for those now in Oxford, which have numbers starting with the letter P, and 'MMA neg.' for those in New York, which are prefaced by the abbreviation TAA for Tut-ankh-amun. Burton worked primarily with 18 × 24 cm glass negatives, and unless otherwise indicated, all the negatives mentioned are preserved in that size and material.

ACKNOWLEDGEMENTS

Just as no one person takes a photograph, no one person writes a book. I am the one who has been tapping away at a laptop for some three years now, at desks and dining tables between Norfolk, Oxford and Turin. But my thanks here reflect the collective effort of academic endeavour – and the bonds it generates across time and space.

First and foremost, this book could not exist without the immense generosity of spirit shown to me by staff of the Griffith Institute at Oxford University, holders of the Howard Carter archive and the largest collection of negatives from the Tutankhamun excavation. Francisco Bosch-Puche, Elizabeth Fleming and Cat Warsi were tireless in accommodating my requests, answering my questions and sharing their own deep knowledge of the archive. I would also like to thank Jenni Navritil, who undertook the digital scanning of Griffith Institute negatives and documents for this book. I hope that the results presented here do justice to the dedication of current and past carers of the Tutankhamun records, for it is their work that enables me to advocate and exemplify both the benefits and the urgency of taking a critically informed approach to archives, photographs and the history of Egyptology.

In Oxford, I am also indebted to Ian Cartwright for his indispensable advice on early twentieth-century photography, including his own insights into Harry Burton's work. In the Ashmolean Museum's photographic studio, David Gowers and his colleagues helped me understand the later history of the Tutankhamun negatives in Oxford. John Baines and Helen Whitehouse likewise helped by passing on some institutional memories of the Griffith Institute, theirs being a little longer than my own.

Given the history of the Tutankhamun excavation archives, a period of research in the Metropolitan Museum of Art, New York, was also essential to this project. There I must thank Marsha Hill and Catharine Roehrig in particular for hosting my visit and dealing graciously with many follow-up requests. Their work on Harry Burton and their solicitude for his legacy in the museum has made my own encounter with him all the richer. In the Metropolitan Museum's photographic studio and collection, Nancy Rutledge and Teri Alderman welcomed me into the fold so that I could track down some of Burton's transatlantic negatives, which was invaluable.

Research of this depth and duration can only be done with exceptional financial and institutional support. I am once again indebted to the Warden, Fellows and staff of All Souls College, Oxford, where a Visiting Fellowship in Hilary Term 2015 gave me the time and energy to undertake the archival research and begin the long writing process. A British Academy Mid-Career Research Fellowship (2015) and Leverhulme Trust Research

Fellowship (2016) supported further archive visits, the purchase of images and much-needed writing time away from my normal duties at the University of East Anglia (UEA). Research funds from UEA underwrote the purchase of several image rights, while my colleague Nick Warr found small treasures in our department's photographic collection.

Many other academics, collections and individuals contributed to this project in myriad ways. At Rupert Wace Ancient Art, Claire Brown, Charlotte Reeves and Rupert Wace generously gave me full access to a collection of London *Times* newspaper photographs dating to the first two seasons of the excavation. At the Università degli Studi, Milan, I am grateful to Patrizia Piacentini and Christian Orsenigo, who helped me access the Alexandre Varille and Pierre Lacau archives, among the rich holdings of the university's Biblioteca e Archivi di Egittologia. In Florence, which was Harry Burton's long-time home, Stefano Anastasio (of the Soprintendenza Archeologia, Belle Arti e Paesaggio) introduced me to the photograph albums of Burton's friend John Spranger, now in the city's Museo Archeologico. Spyros Koulouris (of Harvard University's Villa I Tatti) and Uta Dercks and Almut Goldhahn (both, Photothek des Kunsthistorischen Instituts in Florenz/Max-Planck-Institut) shared valuable glimpses into Burton's career in Italy. Similarly, Sarah Ketchley (of the Emma B. Andrews Diary Project, University of Washington) and Barbara Midgley (in Harry Burton's hometown of Stamford, Lincolnshire) illuminated aspects of Burton's life and character long before the discovery of Tutankhamun's tomb. Elizabeth French's personal recollections of photography in the field taught me (amongst other things) how to jiggle a back-cloth, and why. Caroline Simpson shared her knowledge of the Egyptian archaeologists of Gurna and put me in touch with Mahmoud Hassaan Al Hashash, whose paternal great-grandfather Mansour Al Hashash was a *ra'is* (foreman) for Howard Carter and Lord Carnarvon in the years before the Tutankhamun discovery. The history of archaeology and its archives is closer than we think – and has more sides to it than we have yet seen or credited.

I came to study the history of photography almost by accident, having used the Tutankhamun photographs to research a previous book (*Unwrapping Ancient Egypt*, Bloomsbury 2014). A comment he may not even remember, from Christopher Morton, confirmed my suspicion that there was much more to be said about them. Jennifer Baird, Frederick N. Bohrer, Luke Gartlan, Geraldine Johnson and Gil Pasternak have also offered inspiration and encouragement in matters photographic, while William Carruthers and Tom Hardwick have been, as usual, generous with their knowledge of modern Egypt and Egyptology. Tom read part of the manuscript, as did Mirjam Brusius, who helped me take my first steps in photographic history, pushing me to run with my good ideas and abandon the rest. I am grateful for her patience, perceptiveness and camaraderie. My greatest debt remains to Elizabeth Edwards. Her belief in me and in this project has been sustaining, and a model for how one generation of scholars can inspire and enable the next. I thank her and co-editors Jennifer Tucker and Patricia Hayes for including this book in the *Photography, History: History, Photography* series.

Christina Riggs
Norfolk, March 2018

1

PHOTOGRAPHING TUTANKHAMUN: AN INTRODUCTION

The electric lamp peering over his shoulder gives the lie to our glimpse of history. Not a snapshot, but a carefully arranged stage on which to act out the moment of discovery: the archaeologist, crouched low to peer through the gilded door that swings open – only just – to reveal what we cannot yet see but which we know, thanks to thousands of other photographs that were, on this day, still to come (Figure 1.1).

This photograph is like the pivot on which the open door swivels. Push it one way and the door swings to, leaving our eyes innocent and empty on the brink of discovery. Push it the other way and let the door swing out, showing us what we think we have already taken in at spectatorly leisure. 'Everywhere the glint of gold', or so the archaeologist described the 'wonderful things' that were buried with an ancient Egyptian boy-king. We look at photographs hoping to see the wonder for ourselves.

A camera captures a split second or two of time when light through its lens exposes silver salts on the glass plate or sheet of film secreted inside its body. The split second captured here was on 3 January 1924, the crouching archaeologist was Howard Carter, and the stage set was the burial chamber of the tomb of Tutankhamun. The light that bathes Carter's face comes from the lamp above him, whose reflected 'mystic mauve' glow made the spectacle all the more 'awe-inspiring'.[1] Yet the light might just as well stream from the other side of the door he holds – the golden light of royalty and renown. The truth was more mundane: on the other side of these gilded doors were two more sets of the same, each bolted shut in a protective huddle around the stone sarcophagus, nested coffins and linen shrouds in which the mummy of Tutankhamun lay. A first set of doors had been removed with some difficulty in the preceding days, to allow the archaeologists and their tools – including the camera – better access to the confined space of the burial chamber. Carter and his colleagues had been working more than a year to reach this point, watched by the press whose attention they had courted, and 'wonderful things' was the phrase Carter had published weeks earlier, in a popular book he quickly co-authored about the tomb, amply illustrated with photographs.[2] The discovery

[1] '"Spellbound": The third great thrill at Tutankhamen's tomb', *Illustrated London News*, 26 January 1924: 144.
[2] Carter and Mace, *Tomb of Tut.Ankh.Amen,* vol. I.

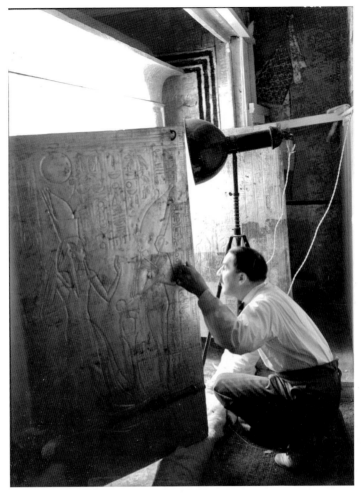

Figure 1.1 Howard Carter crouched before the open shrine doors in the burial chamber of Tutankhamun's tomb. Photograph by Harry Burton, 3 January 1924; GI neg. P0626.

of Tutankhamun proceeded through a series of piercings and dismantlings, and although there had been no camera present for that first, mythic glimpse of gilded wonder, the breach of each subsequent threshold warranted recording, each photographic exposure turning real gold into silver salts and seconds of exposure into centuries of time. As each threshold was crossed, each tomb chamber cleared, and each object numbered and repaired, king Tut and the camera seemed made for each other. Or at least, the camera helped make Tutankhamun, king Tut.

Like those gilded doors, this book hinges on both the moment of discovery and the state of knowing – with photography at the pivot. By 1922, camerawork was embedded deep within the work of archaeology, and had been for thirty years or more. The presence of a camera in the tomb of Tutankhamun was neither remarkable nor new. But many of the photographs produced – like that of Carter crouching before the shrine doors – are

among the most famous and compelling archaeological images ever made. The uniqueness of the find, the intense media coverage it generated, and the timing of its discovery in the aftermath of the First World War, coeval with the emergent Egyptian nation-state: all these factors contributed to the impact the Tutankhamun photographs had and continue to have. For all that is distinctive about the tomb and its photographs, however, there is also much that speaks to the workaday practices, assumptions and aims of archaeology and photography in 1920s Egypt. The decade marked a period of transition between the late Victorian and Edwardian formation of archaeology's core concerns and institutional apparatuses, and the trailing off of fieldwork in Egypt in the run-up to the Second World War, after which archaeology, like many of its cognate disciplines, would adapt to different modes of engagement in the emerging Cold War era.[3] Archaeological photography was changing as well during the interwar years. Film negatives vied with glass for affordability and ease of use; more portable cameras changed the nature of what could be photographed, and how; and technical novelties or refinements – the moving-picture camera, aerial photography and ever-cheaper, better quality colour photography and photographic reproductions – all opened possibilities that archaeology either embraced or, as tellingly, rejected.

Photographing Tutankhamun thus explores the interface between photography and archaeology at a crucial time for both – and it does so through close critical engagement with the archive produced during the excavation and tended, since the 1940s, in two primary locations, Oxford and New York. It is in the intricacies of the archive that this book locates the different meanings, modalities and rhetorical and evidentiary values that emerged through the interrelationship of photography and archaeology in the first decades of the twentieth century, and beyond. Those archival intricacies reveal the extent to which the creation of knowledge is a collective, and inherently unequal, endeavour, as well as the enduring impact that archives have on disciplinary identity, that is, ways of 'doing' archaeology or 'being' an Egyptologist. Rather than the top-down institutional structures or 'great man' mythologies commonly limned in histories of archaeology, I argue for the impact of bottom-up operations that were often carried out by what Steve Shapin has called 'invisible technicians'.[4] These include the secretaries, conservators and photographic assistants whose day-to-day efforts to deal with the tangible, physical presence of the Tutankhamun archive have impelled the naturalization and sublimation of the colonial knowledge structures that created such excavation archives in the first place.[5] The sheer heft of glass negatives, the bulk of multiple photo albums and the trail of paperwork that photographic objects left behind as they moved between London and Luxor, Oxford and New York, required an outlay of archival energy focused on creating a complete collection of images and making them accessible for both scholarly research and public consumption – the same goals articulated today in what is known as the digital humanities. At different points in the twentieth and now twenty-first centuries, archival practices have both facilitated and responded to wider cultural, political and disciplinary

[3] On which see Carruthers, 'Visualizing a monumental past'.
[4] Shapin, 'Invisible technicians'; Bangham and Kaplan (eds), *Invisibility and Labour in the Human Sciences*.
[5] Riggs, 'Photographing Tutankhamun'.

developments, in particular as images from the Tutankhamun excavation were reactivated for popular consumption in the blockbuster 1970s *Treasures of Tutankhamun* exhibitions and, more recently, in the spectacular arenas of TV drama and digital reconstruction. Archives are never as passive as they seem.

At the heart of the multi-sited, multi-faceted Tutankhamun archive are more than 3,400 photographic images taken by the excavation team responsible for clearing and recording the tomb of Tutankhamun between 1922 and 1933. The photographer of record for the tomb was Englishman Harry Burton, whose services were seconded to Carter by the Metropolitan Museum of Art in New York; the Museum operated the neighbouring archaeological concession on the West Bank of the Nile at Luxor, and its staff knew Carter well. Two collections of Burton's prints and negatives exist today, one in the Metropolitan Museum of Art and the other in the Griffith Institute at Oxford University, which received the bulk of its Tutankhamun-related material from the estate of Howard Carter – including his lantern slide collection based on Burton's photographs, ten albums of photographs printed and mounted by Burton, and a card catalogue of some 3,000 separate objects found in the tomb, interleaved with further Burton prints. The photographic record was thus central to the formation of ideas about the finds and to their public presentation. In addition, journalists, tourists and the team members themselves took hundreds of on-the-spot photographs, especially during the first hectic season of the dig in the winter of 1922–3. Both the New York and Oxford archives include prints and, in some cases, negatives of such photographs, which can also be traced through newspaper archives. This extensive press coverage, taken together with diaries, journals and correspondence by the excavation team, enables a near-unique reconstruction of how photography fitted into the working life of the excavation and stamped itself on the public eye – a process repeated during the 1970s tour of the finds to Europe and the US, when the Burton photographs were widely reproduced.

The calibre of Burton's photographs is renowned within Egyptology, both for the Tutankhamun material and for the extensive body of work he produced over his thirty-year career with the Metropolitan Museum's Egyptian Expedition. Although clarity and thoroughness are the characteristics for which Burton's work is often praised, many of his Tutankhamun images are highly aestheticized, valorizing the team's efforts and presenting certain objects as 'art' in canonical Western mode. Nor did Burton photograph each of the four tomb chambers, or all of the objects they yielded, as consistently or completely as often assumed, given the methodical approach the archaeologists themselves asserted. Taken as a whole, the corpus instead reflects the contingencies and compromises that fieldwork, collaboration and technology entailed in the interwar years. Burton's photographs suggest different, sometimes competing, aims and needs: on-site images to show artefacts in situ; studio shots of objects from multiple angles, including sequential photos as they were emptied or unwrapped; and views of work in the tomb, some staged for dramatic effect like the image of Carter considered here, others purporting to show more mundane operations, such as packing. Photography itself was one of the most mundane operations on an archaeological site, yet it is rarely depicted and discussed, its omnipresence counterintuitively one reason for its absence. Absent too are the indigenous workers on which photography relied, as did archaeological work in

general in Africa and the Middle East. Burton referred to his Egyptian assistants as 'the camera boys', a designation which had nothing to do with their age and everything to do with the asymmetries of collective effort and knowledge production in colonial-era archaeology.[6]

As I have argued elsewhere, Egyptology as a discipline remains markedly disinterested in the circumstances of its knowledge production, despite – or because of – their imbrication in the operations of colonialism.[7] For the study of photography, this lack of critical facility presents particular difficulty, given the twin tendency to see photographs simply as documentary sources, taking them as face-value recordings of factual data. In the visualization and interpretation of the past, however, much more is always at stake. Photography made modern archaeology possible, from day-to-day operations in the field to the study and dissemination of results. The camera shaped the very way in which digging was done, as well as how artefacts were conceptualized and how archaeologists themselves performed for the camera.[8] In a newly independent Egypt, photographic representation arguably became – like the Tutankhamun artefacts themselves – an arena for Egyptian subjectivation as well: Burton made formal photographs of visits to the tomb by Egyptian politicians, and at the unwrapping of the king's mummy in November 1925, European and Egyptian specialists, as well as Egyptian government officials, posed together for what may have been the first time. The timing was significant, for work on the tomb had ceased for a year following a breakdown in relations between Carter and the Ministry of Public Works, which oversaw the antiquities service. Ownership of the tomb's contents was the crux of the disagreement, but it had been played out through a series of manoeuvres concerning access to the tomb and the flow of information to the press – information that included Burton's photographs, exclusive use of which Carter reserved for the London *Times* and the weekly *Illustrated London News.* For many Egyptians, and especially supporters of the nationalist movement and its leader Sa'ad Zaghloul, the reawakening of an Egyptian pharaoh chimed with the reawakening of modern Egypt after forty years of British military occupation and political protectionism, not to mention centuries of Ottoman rule. That a British archaeologist, funded by a British aristocrat, should position himself as best placed to represent ancient Egypt to the modern world was no longer acceptable, especially where the evocative figure of the boy-king Tutankhamun was concerned.

This book takes an archaeological find and a body of photography that may feel familiar to many readers, and asks us to look at them in a different light – a light not of royalty and renown (though that will come into it), but of sunlight bounced off reflectors held by Egyptian hands and lamplight powered by generators specially supplied by the Egyptian government. It is a postcolonial study of a colonial phenomenon, for it would be impossible to separate either archaeology or photography from the power structures, economic

[6] Burton, 'Clearing the Luxor tomb: The work of the photographer', *The Times,* 16 February 1923: 9; Burton. 'Camera records details of tomb', *New York Times,* 15 February 1923: 2.

[7] Riggs, *Unwrapping Ancient Egypt;* Riggs, 'Knowledge in the making'.

[8] As discussed in Olsen et al., *Archaeology: The Discipline of Things,* 44–6.

relations and subject formations that colonial modernity entailed.[9] Colonialism was not incidental to the development of ways of being, doing and thinking that we associate with modernity, including technologies like photography or institutions like museums and research institutes – quite the opposite, for they were created, trialled, standardized and reformulated in the colonial 'periphery' (a misnomer) as much as the (supposed) metropole.[10] In arguing for the centrality of photography to archaeological practice and the interpretation of the ancient past in the colonial era, this book thus begins and ends in the contact zone where archaeology first found, and photographed, its objects – though it then follows those photographs on their separate journey through the archive. Because photographs and objects are material forms whose meanings, interpretations and trajectories arise through social relationships, the arguments formulated here go to the heart of what archaeology is, who does it, for whom and how. The Tutankhamun photographs exemplify archaeology's self-conscious concern with salvage, loss and preservation, as well as long-standing tensions between photography as objective record and artistic composition – tensions that Carter, Burton and the press exploited fully. But the images Burton and others made during the Tutankhamun excavation also testify to the complexities and inequities of working relationships in the field; to the uncertainties, oversights and assumptions through which archaeological knowledge emerged; and to the affective pull photographs exert in the interpretation of two pasts, the ancient one and our own. Photographs do not show archaeology or its history: they are archaeology and its history.

This opening chapter operates on two levels. On the first, it offers a chronological overview of the ten-year excavation, clearance and documentation of the tomb of Tutankhamun, introducing individuals and institutions that feature throughout the book. Situating this find within its contemporary political context is essential to sustained analysis of the excavation and its photographic archive. For readers unfamiliar with the Tutankhamun excavation or with the operation of archaeology in early twentieth-century Egypt, the historical discussion offered here counters more conventional presentations of the 1922 discovery by drawing out its messiness, confusion and contingency – characteristics in keeping with all such scientific work, which were tidied up in the process of producing and presenting the find as archaeological knowledge. For readers who consider themselves familiar with the excavation from an Egyptological perspective, the emphasis I place on knowledge production and on the colonial embeddedness of Egyptian archaeology may be unexpected, given that critical engagement with Egyptology's histories has been lacking in the discipline. Processes of knowledge production in archaeology, including Egyptology, have tended to shelter behind the notion of the archaeological record, as if the physical remnants of the past recoverable through archaeology have a fixed identity as evidence left behind for scholars to locate, document and interpret. Rather, it is scholarly effort that creates the archaeological record through the material traces encountered at times and in places primed for archaeology.

[9] On colonial modernity and Egypt, see Jacob, *Working out Egypt,* 4–6; Mitchell, *Rule of Experts;* and wider discussion in El Shakry, *The Great Social Laboratory.*
[10] A point made forcefully by Mitchell, *Rule of Experts,* esp. 1–9.

Photography was fundamental to the formation of the archaeological record, and through a sample of photographs from the Tutankhamun excavation archive, this chapter operates on a second level as well, broaching arguments about photography, archaeology and the archive that I develop throughout the text. I take the archive in its literal sense as well as the conceptual, Derridean sense through which 'the archive' has become a potent means of historical and social critique.[11] The archives of archaeology in Egypt (and elsewhere) are examples of colonial archives, but they have yet to be apprehended in this way, read 'against the grain' for what their diaries, lists, lantern slides and photograph albums may reveal about the lived experience of colonialism in the Middle East. The photograph-as-evidence, as incontrovertible record, remains the primary if not exclusive point of concern for most archaeologists and Egyptologists who make use of historical photographs in their own research or have professional responsibility for photograph collections. Yet as this introduction, and the rest of the book, will show, the creation, organization and use of photographic archives have allowed certain meanings to be fixed – or obscured – in what is considered to be the archaeological record. This raises a number of questions crucial to archaeology, perhaps the most basic of which is, how did photographic practices reinforce – or reformulate – archaeological method, interpretation and authority? Carter's dissatisfaction with his own photographs led him to seek the services of Burton, and for the most part the excavation accommodated whatever Burton's photography required, whether in terms of time, lighting, or the creation of platforms, backdrops and a darkroom. The images this yielded repaid the effort by exemplifying the 'scientific' approach of Carter and his colleagues, as their own choice of words emphasized. But what made a photograph 'scientific' invites the related question of what it is that makes a photograph 'archaeological'. The archive offers a way into this problem, by considering what kinds of photographs have been included in excavation archives, and how. Leading on from this is the wider question of how photographs associated with archaeology have created effects (and affects) suited to a range of purposes and readings, including shifts in the fashioning of both objects and selves under empire – and beyond. Why do many of the Tutankhamun photographs (Carter in the electric gleam of gold, again) retain an evocative power, their sepia elegance a shorthand for archaeological accomplishment, ancient Egypt *extraordinaire*, and, beneath the evenly toned surface, the quiet crises of colonialism and its aftermaths?

In venturing answers to such questions, this book moves beyond interpretations of photography as an instrument of disciplinary and colonial endeavours or as a totalizing technology, seeking instead to account for the entanglement of archaeology and

[11] Derrida, *Archive Fever*. There is a still-growing literature on 'the archive', some of which responds directly to Derrida, favourably (e.g. V. Harris, 'A shaft of darkness'; van Zyl, 'Psychoanalysis and the archive') or otherwise (e.g. Steedman, *Dust;* Steedman, 'After the archive'). For photography and the archive, the more Foucauldian work of Allan Sekula ('The body in the archive'; 'Reading an archive') has been influential. From the fields of archive studies, history and anthropology, I have found the following sources productive for my own thinking on the subject: Appadurai, 'Archive and aspiration'; Brothman, 'Orders of value'; Dirks, 'Annals of the archive'; A. Burton, 'Introduction' (and essays in the edited volume *Archive Stories*); Matthews, 'Is the archivist a "radical atheist" now?'; Richards, 'Archive and utopia'; Richards, *The Imperial Archive;* Stoler, 'Colonial archives'; Stoler, *Along the Archival Grain* (esp. 45–6 on Derrida); Yakel, 'Archival representation'.

photography, especially where the visualization of ancient Egypt is concerned. My approach to the history of archaeology has been shaped by strands of thought in science and technology studies, as articulated by Nadia Abu el-Haj, Mirjam Brusius, William Carruthers and others.[12] My approach is also in conversation with a significant and developing body of work in visual anthropology, art history and science studies, which takes photographs and archives as dynamic participants in our understanding of both historical practices and history itself.[13] As Gregg Mitman and Kelley Wilder observe, the 'documentary impulse' materialized in photographic archives and archival practices demands a change in our very understanding of historical epistemology: what is at stake 'is an argument not about what photographs represent but about what they do and particularly what they do in large groups, as cultural documents'.[14] Positioned in front of Burton's camera, king Tut once seemed to invite us into his gilded shrines, their doors swung open for an unobstructed view. His archival afterlife now invites us to linger longer at the threshold, examining the pivot joint itself in order to reposition the photograph as a maker of meanings, and shaper of myths, in twentieth-century archaeology.

Introducing the Tutankhamun excavation

Speaking to reporters for the London *Times* before the second season of work began, Carter estimated that another two, perhaps three, years of work lay ahead of him to clear the four chambers of the tomb, document and conserve all the objects, and write up the find for scholarly publication.[15] That was in 1923. Almost a decade would pass before Harry Burton took his last photographs for Carter, in January 1933: by his count, ten shots of the quartzite sarcophagus in place in the otherwise empty burial chamber. In a letter to Herbert Winlock – former director of the Egyptian Expedition and since 1932, director of the Metropolitan Museum – Burton wrote, 'Today I finished the "Tut" work + dashed glad I am. I began to think I never should finish it + it seems too good to be true'.[16]

The venting of such frustrations rarely figures in the creation myths and quest narratives of archaeology – of which the discovery of Tutankhamun's tomb is among the most acclaimed and oft-repeated. Creation myth, because the archaeologist conjures something – the past – that did not exist in concrete form before, and quest narrative

[12] Abu el-Haj, *Facts on the Ground;* Brusius, 'Hitting two birds with one stone', with further references; Carruthers, 'Introduction: Thinking about histories of Egyptology'; Carruthers and Van Damme, 'Disassembling Archaeology, Reassembling the Modern World'; and most recently Cox Hall, *Framing a Lost City.*
[13] E. Edwards, 'Photographs: Material form and the dynamic archive'; E. Edwards, 'Uncertain knowledge'; Klamm, 'Reverse–Cardboard–Print'; Morton, 'The anthropologist as photographer'; Morton, 'Photography and the comparative method'; and the series of Photo Archives conferences initiated by Costanza Caraffa, head of the Fotothek of the Kunsthistorisches Institut Florenz (see http://www.khi.fi.it/4831050/photo_archives for summary of research and published volumes). Though not explicitly concerned with photography, historian of science Lorraine Daston's work on the role of the archive is very relevant here as well: Daston, 'The immortal archive: Nineteenth-century science imagines the future'; Daston, 'Sciences of the archive'.
[14] Mitman and Wilder, 'Introduction', quoted passages at 1, 14.
[15] 'Back to Tutankhamun', *The Times,* 22 September 1923: 11.
[16] Letter from Burton to Winlock, 20 January 1933 (MMA/HB: 1930–5).

because the archaeologist first faces trials, even setbacks, in searching against the odds for what the past has hidden, before discovery rewards him with the raw materials he needs for the creative act. What happens next is meant to be dénouement. The career of Howard Carter and his discovery of the tomb have been recounted elsewhere, but they bear repeating here in order to introduce key personalities and places that will figure throughout this book, and to take a more critical and interrogatory stance than prevailing accounts have done.[17] Moreover, to understand the significance and changing uses of photography within the Tutankhamun excavation, it is necessary to appreciate the longer timeline – the narrative arc, as it were – of the work, which Carter himself characterized not as *fouilles* (the French term for excavation, that is, removing earth) but *déblayage,* or clearance. Only the subterranean staircase to the tomb required excavation per se. Otherwise, the tomb was crammed with objects, most of which were made of organic materials like wood, leather and textile, and thus highly susceptible to changes in humidity and temperature. The day-to-day work of the excavators required a series of conscientious decisions about recording finds *in situ,* removing them from the tomb, and repairing, cleaning and documenting them before packing them for transport to Cairo, either downriver by boat or by train. In the annals of archaeology, Tutankhamun is the excavation that wasn't an excavation, for most of the ten years of work on site.

The much-vaunted excavation team wasn't quite a team, either – or at least, they were a team by accident as much as design, their numbers dwindling as the years went by and the work became routine. At the time of the discovery, Carter relied on his Egyptian foremen, in particular a man named Ahmed Gerigar who would become chief foreman (*ra'is;* pl. *ru'asa*) on the Tutankhamun dig. Other *ru'asa* variously in Carter's employ included Gad Hassan, whom he had known for twenty years, Hussein Abu Awad and Hussein Ahmed Said, all of whom joined Gerigar in working on the tomb. Carter thanked these four men assiduously, if patronizingly, in the acknowledgements of his first two *Tut.Ankh.Amen* books (in the first volume, quoting a 'quaint' letter the men sent him in their 'zeal' over the summer break, to reassure him of security on site).[18] In keeping with well-established archaeological practice in Egypt, it was the job of these foremen to contract further manual labour required for a dig, and at times, Carter would have employed up to 100 men and boys from West Bank villages, whose occupants relied on archaeological work to complement other employment, chiefly agricultural.[19] The number varied depending on the kind of work required, with the initial excavation and subsequent backfilling and clearance, at the end of the first season and start of the second, the most labour-intensive.[20]

[17] The best secondary accounts of Carter's life and his work on the tomb – each with its own slant, and none using Arabic-language sources – are Collins and McNamara, *Discovering Tutankhamun;* Frayling, *The Face of Tutankhamun;* James, *Howard Carter;* Reeves and Taylor, *Howard Carter.* See also Reeves, *The Complete Tutankhamun.*

[18] Carter and Mace, *Tomb of Tut.Ankh.Amen,* vol. I, xv–xvi; see also Carter, *Tomb of Tut.Ankh.Amen,* vol. II, xxiv.

[19] Doyon, 'On archaeological labour'.

[20] Backfilling was done for security reasons, after the staircase was first uncovered in November 1922 and at the end of the first season, in late February 1923. At the start of the second season in October 1923, Carter employed Egyptian men and boys to clear the backfill and level the area around the tomb and adjacent workspaces, for improved access. Carter details the work in the corresponding entries of his journals (GI/HCdiaries).

When Carter realized, on 4 November 1922, that the men had uncovered a flight of sixteen stone steps ending in a seal-stamped, plastered-over door blocking, backfilling was the first task required for security's sake. Carter next cabled his own employer in England, the 5th Earl of Carnarvon, a one-time playboy who had taken to wintering in Egypt after a near-fatal automobile accident in 1901. Work waited until the Earl and his daughter, Lady Evelyn Herbert, reached Luxor on 23 November. Carter and at least one of the foremen, probably Gerigar, oversaw the careful removal of the blocking and the clearance of a short, sloping corridor beyond, which had been filled to the ceiling with limestone chips. On 26 November, they reached a second plaster-covered doorway, and Carnarvon stood by while Carter pierced the structure just enough to allow a glimpse of what lay beyond: 'the glint of gold' he later wrote, on what had been 'the day of days'.[21] The opening was widened enough to give access to the antechamber of the tomb, from which two other rooms opened, one through a small, low-level opening to the left, and another behind a large, plaster-covered and seal-stamped doorway flanked by life-size royal statues in the photograph Burton took four weeks later (Figure 1.2).

Secretly, Carter, Carnarvon and Lady Evelyn used a robber's hole at the bottom of this doorway to access the burial chamber beyond, through which they could also glimpse a fourth room; it is not known whether any of the Egyptian foremen joined them. Although

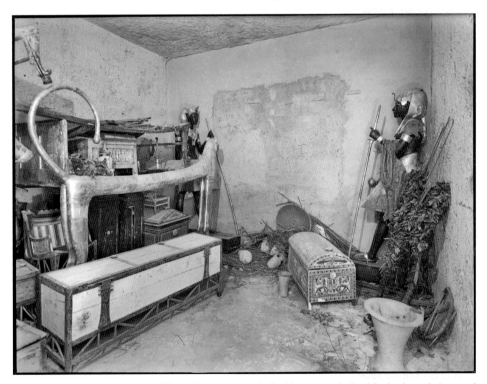

Figure 1.2 The antechamber of Tutankhamun's tomb, looking towards the blocked, seal-stamped entrance to the burial chamber. Photograph by Harry Burton, 23 December 1923; GI neg. P0007.

[21] Carter and Mace, *Tomb of Tut.Ankh.Amen,* vol. I, 94.

the layout of other royal tombs would have led Carter to expect still further chambers and a subterranean passageway, it transpired that the tomb of Tutankhamun comprised only these four rooms – dubbed the Antechamber, the Annexe, the Burial Chamber and the Treasury (originally referred to as the Storeroom in the excavation documentation).

At this point, Carter and Carnarvon began to assemble a team of British and American specialists, tapping into their existing personal and professional networks. Carnarvon contacted British Egyptologist Alan H. Gardiner, who used his personal wealth to support his scholarly interests.[22] One of the leading experts on ancient Egyptian languages, Gardiner would work on the inscriptions, and especially the papyri, that the tomb was expected to yield. He was friendly with Carnarvon and well-connected in British society, including political circles. Another expert on Egyptian language and history, who proved eager to associate himself with the find, was James Henry Breasted, founder and director of the Oriental Institute at the University of Chicago and a figure well-known to the public through his best-selling books on ancient Egypt and the ancient Near East.[23] Although Breasted and Gardiner were both fêted in the press during the first season, there proved to be little for them to do: Breasted studied the seal impressions from the plastered doorways, but no papyri were found in the tomb, and the only substantial inscriptions – those on the gilded shrines in the Burial Chamber – were not really Gardiner's specialty.

For his part, Carter had already invited his friend Arthur Callender to join him on site, in time for the first breach of the doorways. Callender was an engineer who had worked for the British-run Egyptian state railways and retired to a farm near Armant, 15 km south of Luxor. How he and Carter met is unclear (their association goes back at least to 1918), but Callender assisted loyally during the first three excavation seasons, helping devise the hoists and tackle used to dismantle the shrines and raise the heavy sarcophagus lid and coffins. Carter's next recruit came in response to a congratulatory telegram sent in early December by Albert Lythgoe, head of the Metropolitan Museum of Art's Egyptian department. Carter cabled back requesting the services of Harry Burton, who was already working in the vicinity on the Metropolitan Museum's own excavation (known as the Egyptian Expedition), and with whom Carter had recently discussed the problem of photography in the tomb. The Museum had benefitted in the past from deals brokered by Carter for the purchase of antiquities collected by Lord Carnarvon, hence a cordial relationship already existed – a relationship in which the exchange of Egyptian antiquities established reciprocal obligations. Lythgoe readily agreed to the loan of Burton's services, as well as Expedition architects Walter Hauser and Lindsley Foote Hall, both Americans. Archaeologist Arthur Mace – British, but employed as a curator by the Metropolitan Museum – offered his own services to Carter, and brought with him an excellent reputation for working with fragile objects in the field. Another British expert who volunteered to help was Alfred Lucas, a chemist employed by the Egyptian government, who had worked for the antiquities service and whose interest in ancient materials and technologies, combined with chemical expertise, would prove invaluable. On the sidelines of the excavation was

[22] See Simpson, 'Gardiner, Sir Alan Henderson (1879–1963)'.
[23] For Breasted's life and career, see Abt, *American Egyptologist*.

Percy E. Newberry, a British Egyptologist (one-time professor at the University of Liverpool) whom Carter had known since his teens. It was Newberry, then acting as an advisor to prominent collector Lord Amherst of Didlington Hall, who had met the young Carter in Norfolk, spotted his artistic talent, and recommended him for archaeological fieldwork in Egypt. Newberry and his wife Essie were genial figures with a wide circle of acquaintances in Egyptology (including Burton), and in addition to their academic contributions – Newberry specialized in ancient botany, Essie worked with ancient textiles – they were indefatigable facilitators and fixers.

For all that Carter, Carnarvon and this group of specialists – always excluding the Egyptian foremen and workforce – styled themselves as a team, and have been commemorated as such in accounts of the excavation, their working relationships were fluid and largely informal. Only Callender received a salary from Carter, which became the source of their final falling-out after the third season. Carter's abrasive personality alienated Hauser and Hall as well, who returned to the Metropolitan Museum Expedition before the end of the first season, while Mace's ill health meant that he left Egypt for good after the second season, in 1924. By this time, Captain Richard Bethell – another acquaintance of Carter, sometimes styled as his personal secretary – had also joined the work, but did not return for season three. Lord Carnarvon died of septicaemia in Cairo in April 1923, at the peak of press interest and before the first season's work was finished; his widow, Lady Almina, inherited his excavation permit but had little interest in Egyptology herself. Burton and Lucas were thus the only two on-site contributors who saw the work through with Carter to the end – apart from the *ru'asa,* of course, whose presence is almost never remarked and, after the second season, almost never depicted in photographs. Such changeability and uncertainty are characteristic of scientific endeavours like archaeology: knowledge production is a shared effort and proceeds in fits, starts and side-steps, braced and buffeted by contingencies all the while. To characterize the work of archaeology in this way contradicts the discipline's own mythology, of which the Tutankhamun find has been a prime example. But Burton's frustrations at the end of the project – 'for two pins I'd have chucked the whole business', his letter to Winlock continued – speak to the complexities of collaboration, which in this case were exacerbated by the uniqueness of the discovery, the attention it garnered, and the legal and diplomatic imbroglios that ensued. In the quest narrative Carter himself created in his publications and his personal archive, however, there is no hint of conflict or competing interests among the team, only single-minded perseverance and heroic hard work.

Finding Tutankhamun

One contingency affecting collaborations on the Tutankhamun excavation was social class and its concomitant effect on education, training and disciplinary identity. This was particularly marked among the key British contributors: Mace and Lucas were middle-class and well-educated (Mace at Oxford, Lucas at the Royal School of Science, now Imperial College), but Carter and Burton were from more modest backgrounds, both the

children of artisans.[24] Carter's father had been a respected but not well-remunerated artist based in London. Carter, who spent his childhood and youth in the small market town of Swaffham, Norfolk, was the youngest of eleven children, while Burton was also one of eleven children (the fifth), born to a cabinetmaker in the town of Stamford, Lincolnshire. Carter had little or no formal education; Burton left school at fourteen to enter service.[25] Their careers would have been almost unthinkable had either Carter or Burton been born much earlier or later than they were, in 1874 and 1879 respectively. Having grown up just sixty miles apart, that both men should first meet in Egypt on the cusp of the First World War speaks to the reach of the British empire and to its routines and institutions, which offered wide-ranging opportunities for travel and work abroad, with the prospect of social advancement. Since the British military occupation of Egypt in 1882, the country could easily be a second, or primary, home to British subjects and other foreign nationals, drawn by the textile, railway, shipping and communications industries in particular.[26]

Egyptologists tend to assume it was ancient Egypt that drew people to Egypt in the nineteenth and early twentieth centuries, its ineluctable allure (to Egyptologists, at least) feeding a boom in tourism and archaeology. But the process operated in quite the reverse: colonialism required the development of infrastructures, which required European investors and staff, which required reliable means of travel, certain standards of living, and financial and legislative practices that favoured foreign institutions and individuals.[27] The development of scientific archaeology as a discipline in the nineteenth century was inseparable from the growth of colonial and imperial interests in regions rich in architectural and artifactual remains.[28] For tourists and archaeologists alike, ancient Egypt and the Holy Land – as it was then styled – had long offered a dream of a return to Judaeo-Christianity's physical place of origin, and to the lost knowledge represented by the fabled city of Alexandria.[29] What Derek Gregory has written of nineteenth-century travel writers applies as well to other foreigners in Egypt, perhaps especially those involved in archaeology: 'By representing Egypt as an anachronistic space in which past and present existed *outside* the space of the modern, they claimed to open an imaginative (and extraordinarily presumptuous) passage into an ancient land' (emphasis original).[30] Western visitors brought 'the modern' with them, or so they assumed, to a country whose contemporary residents they perceived as 'Oriental' and thus child-like, irrational and

[24] Brief biographies of all four can be found in Bierbrier (ed.,), *Who was Who,* 4th ed. For Mace, see also Lee, . . .*The Grand Piano Came by Camel;* for Carter, see James, *Howard Carter;* for Lucas, see Gilberg, 'Alfred Lucas'; and for Burton, see Hornung and Hill, *The Tomb of Pharaoh Seti I,* 27–30 and Ridley, 'The dean of archaeological photographers'.

[25] I am indebted to the indefatigable Barbara Midgley for tracking down details of Burton's school days and adolescence.

[26] For a characterization of the British population in Egypt at this period, see Mak, *The British in Egypt.*

[27] Gregory, 'Colonial nostalgia'.

[28] Abu el-Haj, *Facts on the Ground,* esp. 6–13.

[29] Assmann, *Moses the Egyptian.* For a historical study of how Christian belief influenced interest in ancient Egypt in Victorian and Edwardian Britain, see Gange, *Dialogues with the Dead.* On Alexandria and the myth of return, see Butler, 'Egypt: Constructed exiles', and Butler, *Return to Alexandria.*

[30] Gregory, 'Scripting Egypt', 137.

untrustworthy; such were the views Breasted and Winlock expressed, for instance, and they were not atypical.[31] It was the privilege and, indeed, moral obligation of Egyptologists and their sponsors to recover, study and preserve Egyptian antiquity. Egypt had to be saved from itself.

The colonial context in which both archaeology and travel operated in late nineteenth and early twentieth century Egypt is essential to understanding the personal networks, practical constraints and transnational alliances that informed the discovery of Tutankhamun's tomb and what followed. Carter himself came to Egypt in 1891 at the age of seventeen, hired as a draughtsman by Percy Newberry after the Amherst family brought Carter to his attention; the Amhersts may already have commissioned work from Carter's artist father or brother for their Norfolk estate. In Egypt, Carter quickly gained archaeological experience, including photography, first with the eccentric but pioneering Flinders Petrie and then with the Egypt Exploration Fund, established in 1882 (just before the British bombarded Alexandria) to support survey and excavation. Archaeological excavation in Egypt required an official permit – in effect, a legally binding contract – between the sponsor and the antiquities service, which throughout the period considered here was attached to the Egyptian government's Ministry of Public Works. The Ottoman governor of Egypt, Said *Pasha*, had appointed French Egyptologist Auguste Mariette to direct the newly-established Service des Antiquités in 1858, and it remained under the direction of French scholars until 1952.[32] After the appointment of Sir Evelyn Baring (from 1901, Lord Cromer) to oversee British interests in Egypt early in 1883, the Egypt Exploration Fund and the Society for the Preservation of the Monuments of Ancient Egypt pressed him to bring the Service under British control. The compromise was for its then-director, consummate negotiator Gaston Maspero, to appoint two British archaeologists as Inspector-Generals for Lower (northern) and Upper (southern) Egypt – and Maspero chose Carter for the latter, in 1900. From an unprepossessing start, and with no formal training, Carter had made a career.

It was in his capacity as Inspector for Upper Egypt, based at Luxor, that Carter first met the American millionaire Theodore Davis, who had homes in New York City and Newport, Rhode Island, but who wintered in Egypt, travelling there via Italy the better to indulge his two expensive hobbies: excavating in Egypt and collecting Renaissance art.[33] Maspero was happy to grant Davis an excavation permit because Davis funded work on a scale the antiquities service could not afford. To the dismay of Egyptologists to whom the involvement of an amateur threatened the discipline's scientific and professionalized credentials (its own amateur past being within living memory), Davis held the license to excavate in the Valley of the Kings – and between 1902 and 1914 nearly doubled the number of tombs documented in this plum site. As Inspector for Upper Egypt, Carter

[31] See quoted passages in Reid, *Contesting Antiquity,* 61–3; Reid, 'Nationalizing the pharaonic past', 133–4. Evelyn Baring (Lord Cromer), who headed the British administration of Egypt from 1883 to 1907, elaborated similar views: Lockman, *Contending Visions,* 93–4.

[32] For the history of the Service, see Reid, *Whose Pharaohs?;* Reid, *Contesting Antiquity.* Thompson, *Wonderful Things,* vol. I, 223–37, gives a useful but less critically informed account of Mariette's career.

[33] For a biography of Davis, with an emphasis on his work in Egypt, see Adams, *The Millionaire and the Mummies.*

encouraged Davis as well, until 1904, when Carter left Luxor for Cairo, in order to switch to the role of Inspector for Lower Egypt. Within months, however, Carter was back in Luxor, under a cloud. He had offended French tourists at the site of Saqqara, taking a stand against their rude treatment of the site's Egyptian guards. The tourists complained to the British authorities, and in the diplomatic fracas that ensued, Carter had to answer for his actions to no less a person than Lord Cromer. When Carter refused to apologize, resignation was his only option – to the disappointment of Maspero and the detriment of Carter's prospects. Returning to Luxor, Carter spent several years without fixed employment, living in part off the cut he earned buying and selling antiquities. The loyal Davis also commissioned him to draw and paint objects that were reproduced in the lavish publications Davis funded for his major discoveries.

Although this stage in Carter's career may seem to foreshadow his later conflict with antiquities authorities over the tomb of Tutankhamun, the circumstances were quite different: negotiations about archaeology in Egypt involved no Egyptian or Ottoman authorities, revolving instead around informal relations between Europeans and Americans with professional or financial interests in excavation and collecting. In 1907, Maspero arranged for Carter to meet another wealthy amateur who had been granted permission to excavate on the West Bank: the Earl of Carnarvon.[34] This was the beginning of the partnership that brought the two men to Tutankhamun's door. The social gulf between them could be bridged in the field, and the sideline Carter had developed as a keen-eyed broker of antiquities also appealed to Carnarvon, for whom Carter sourced objects both for the Earl's own collection and to sell on to the British Museum and the Metropolitan Museum of Art, the proceeds going back into excavation funds.[35] Carnarvon held a permit to dig at Luxor in the valley known as the Asasif, but he and Carter kept an eye on developments in the Valley of the Kings. Davis – whom Carnarvon disliked, but to whom Carter was indebted – still held the license for the Valley and worked there each year, hiring young archaeologists to lead the work where possible. In 1910, Davis brought his own protégé to Egypt to fill this role: Harry Burton, whom he had met in Florence through mutual acquaintances interested in Renaissance Italian art. Burton had no archaeological experience whatsoever, but his own circumstances in Florence were changing, and Egypt must have seemed as good an option as any. Burton did bring his existing photographic skill to bear on Davis's work, complementing the use of artists' illustrations in the published reports. Given the small, interconnected circles in which Egyptian archaeology at Luxor operated, Burton and Carter must first have met around this time, probably through Davis.

Davis's ill health, and the impending war in Europe, led him to relinquish the Valley of the Kings concession in 1914, finally giving Carnarvon and Carter the chance to move their operations to what they hoped would be a more promising – and profitable – area, as soon as conditions permitted. Permits from the Service des Antiquités made all the costs of excavation the responsibility of the permit holder, but in keeping with the

[34] As James points out in his biography of Carter, Carter only began to excavate on Carnarvon's behalf in 1908; for their early association, see James, *Howard Carter,* 163–76.

[35] Reeves, *Complete Tutankhamun,* 47; James, *Howard Carter,* 176–80.

practice of division of finds, the permit holder could expect to receive a sizeable share of the artefacts uncovered, once the Service had made a selection to keep, usually for the antiquities museum in Cairo. Division, or *partage*, was a principle that had guided archaeological work in the Middle East throughout the nineteenth century and had been codified by pieces of legislation such as the first Ottoman Antiquities Law of 1884.[36] Specific implementations of the practice varied by country or region, and relevant antiquities laws were periodically updated, suggesting an awkward fit between the legal wording and the actual practice, or changing conceptions of what the laws should allow.[37] On Carnarvon's behalf, Carter had already cleared one royal tomb, associated with early Dynasty 18 ruler Amenhotep I; this tomb lay in part of the Carnarvon concession that bordered Davis's, and may have encouraged Carter and Carnarvon to believe that there were still royal tombs to be found in the Valley. As Carter later recollected, the Amenhotep discovery was also how he met *ra'is* Gad Hassan, who allegedly tried to sell him fragments of alabaster funerary jars inscribed with the cartouches of Amenhotep I and queen Ahmose-Nefertari.[38] Carter's recollections about Gad Hassan derive from one of several unpublished autobiographical sketches he wrote years later, after the Tutankhamun discovery had brought him a certain fame. Like the long account of his earlier work with Carnarvon presented in the first volume of *The Tomb of Tut.Ankh.Amen* – the book Carter and Mace hastily co-authored, which was in print the year after the discovery – there is a suggestion of helpful hindsight and narrative purpose in the way the excavation seasons either side of the First World War become a planned and purposeful quest for the tomb of Tutankhamun. It is true that Tutankhamun was readily identifiable as one of the few New Kingdom rulers whose tombs had not yet been securely located in the Valley – although Davis had identified a cache of embalming refuse as Tutankhamun's tomb, an error whose significance was realized only many years later when Winlock, of the Metropolitan Museum (to whom Davis gifted the find), made a close study of the large jars and their contents.[39]

Carter was well aware that he was not an Egyptologist, in the sense that he had no formal training in the ancient Egyptian language, and although he also lacked formal training in archaeology – which in any case was in its infancy as a course of university study – he had proven himself a thorough and observant field operator. The approach he took to the new Valley of the Kings concession was rigorous and logical. Having

[36] For the Ottoman context, see Bahrani et al., *Scramble for the Past;* Shaw, *Possessors and Possessed,* esp. at 106.
[37] For the 1884 act and its impact in Palestine, see Abu el-Haj, *Facts on the Ground,* 42–3. For the practice in interwar contexts in the Middle East, see general discussion by Goode, *Negotiating for the Past,* 58–9. A 1934 manual of archaeological practice addresses then-current antiquities laws, including *partage:* Du Mesnil du Buisson, *La Technique des fouilles,* 43–50. Compare the brief comments made by W.M. Flinders Petrie in 1904, calling for the governments of source countries to keep only 'such objects as are necessary to the national collection, on reimbursing whatever may have been given as bakhshish to the finder, and some proportion of the costs according to the case': Petrie, *Methods and Aims,* 187–8. For the history of antiquities legislation in Egypt, see Khater, *Le régime juridique.*
[38] Reeves and Taylor, *Howard Carter,* 122–4; James, *Howard Carter,* 194.
[39] Winlock, *Materials,* reprinted as Winlock and Arnold, *Tutankhamun's Funeral.* The initial publication of the cache – with photographs by Burton – is Davis, *The Tombs of Harmhabi.*

mapped the Valley, his plan was to clear it to the bedrock, removing the detritus of previous excavations and of ancient workings in the area. Maspero's successor as head of the Service, Pierre Lacau, approved of Carter's approach, which required considerable manpower and a light railway to shift the cleared soil and stone chips to a nearby dump.[40] Carnarvon and Carter pursued the clearance strategy in earnest from the resumption of work in autumn 1917 until the great discovery, five years later – by which time Carnarvon was planning to call a halt. In terms of objects Carnarvon could keep under the terms of the division, the yield had been slim. Two of the most striking finds were limestone flakes with draughtsman's sketches (known by scholars as ostraca), one of which the pair sold to the Metropolitan Museum, the other to the British Museum (Figure 1.3).[41]

As he organized his prints, negatives and lantern slides in the years after the Tutankhamun discovery, Carter incorporated photographs of these two ostraca as part of the quest narrative, which was composed not only through his written accounts (published and unpublished) but through his public lectures and such acts of archiving. As Elliot Colla has observed, Carter's often subjective, breathless prose sits oddly with the objective, scientific purpose he foregrounds elsewhere: there is no 'pure' science any more than there are 'pure' literary or visual forms. Ideas about ancient Egypt were created and communicated through multiple, multidirectional channels, many of which were well-

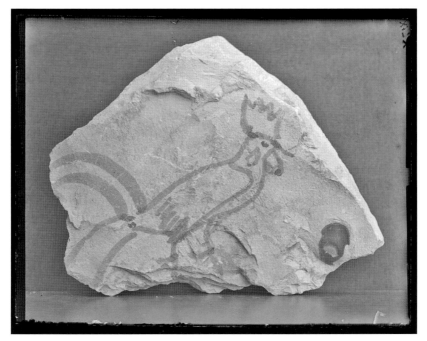

Figure 1.3 Limestone flake with a drawing of a cockerel. Photograph probably by Howard Carter, 1920 or 1921; GI neg. Pkv49 (XLIX), glass 8 × 10.5 cm.

[40] Reeves and Taylor, *Howard Carter,* 134 quotes a 1918 letter from Lacau to Carter about the excavation strategy.
[41] Reeves and Taylor, *Howard Carter,* 135.

attuned to the trope of the explorer's heroic quest and triumphant discovery.[42] Egyptologists have been happy to oblige by reiterating the unproblematic narrative of archaeological inevitability and against-the-odds stamina, for instance through the titling of books and websites: T.G.H. James' authoritative biography of Carter bears the subtitle *The Path to Tutankhamun*, while 'The Search for Tutankhamun' feature of the Griffith Institute website presents archival photographs and documentation from the pre-discovery seasons in the Valley.[43] All roads were meant to lead Carter to the stone steps, the sealed doorway and the glint of gold – and photographs like that of Carter crouching before the open shrine doors show us not only that one moment, but all the others that photography would have captured if time, like stories, could be organized with hindsight, in reverse.

Losing Tutankhamun

The winter of 1922–3 passed in a frenzy of work on site, observed constantly by the world's press, by tourists who had not expected their winter holiday to be quite so exciting as it proved, and by a parade of Egyptian and foreign dignitaries, as well as experts like Breasted and Gardiner, every Egyptologist in the vicinity, and various friends or patrons of Lord Carnarvon and the Metropolitan Museum of Art. The Ministry of Public Works, which oversaw the Service des Antiquités, also kept a close eye on developments in the Valley. The discovery of the tomb came at a challenging but exhilarating time for the fledgling government of Egypt, which had won partial independence from Britain earlier the same year. The nationalist movement, led by senior Egyptian politician Sa'ad Zaghloul *Pasha*, found in Tutankhamun the perfect symbol for Egyptian autonomy. Poets wrote odes to the ancient king, artists took pharaonic motifs as inspiration, and the Arabic and English press in Egypt covered the excavation as avidly as their Western counterparts.[44]

Hard-won Egyptian independence came in the wake of a 1919 revolution, triggered when the British had exiled Zaghloul to Malta. Months of violent clashes, strikes and protests left some 800 Egyptians dead, in an environment made more tense by the presence of hundreds of British troops not yet demobilized after the First World War. Burton, who helped head the passport office in Cairo during and just after the war, had direct experience of the revolt, writing to Lythgoe at the Metropolitan Museum that the Residency (the British High Commission) had moved his offices 'in the native quarter' of Cairo to the safer environs of the Turf Club, a preserve of the foreign elite favoured by British officials: 'I can now go to my office without the feeling that I might get bashed on the head'.[45] Although they had lived and worked in Egypt for decades, Burton, Carter and their British and American colleagues were ill-prepared for the impact that the new

[42] Colla, *Conflicted Antiquities,* 172–83.

[43] James, *Howard Carter*; Griffith Institute, 'The Search for Tutankhamun': http://www.griffith.ox.ac.uk/gri/4search. html

[44] See Colla, *Conflicted Antiquities,* 211–26.

[45] Letter from Burton to Lythgoe, 26 April 1919 (MMA/HB: 1913–19). On the Turf Club, and the even more exclusive Gezira Club, see Mak, *The British in Egypt,* 95–7.

government – and public opinion in Egypt – might have on their work. Egyptian self-government had seemed a distant, and undesirable, prospect to many British residents like Burton, whose letters to New York between 1919 and 1921 comment several times on the developing situation. To Lythgoe, again, he mused in 1920, 'I don't think anybody knows what the granting of self-government to Egypt really means. We shall just have to wait + see. In any case it will probably be years before it materializes. At least, I hope so'.[46] And in 1921, wearily, 'The Egyptian question is as far away from a solution as ever', despite the 'great fuss' over Zaghloul's recent (and temporary) return from exile.[47]

From December 1919 to March 1920, the British government sent the Secretary of State for the Colonies, Viscount Milner, to head a commission in Cairo, sounding out the potential for Egyptian self-government within the existing Protectorate. Former High Commissioner for South Africa and Secretary of War, Milner was an experienced statesman who consulted as many Egyptian representatives as possible (most Egyptians boycotted the commission) as well as numerous foreign interests in the country – including archaeologists; Burton mentions that Carter himself spoke to the commission.[48] How the considerable foreign enterprise vested in archaeology would fare under an independent Egyptian state was a matter worthy of consideration at the highest level as the British government considered the fate of its Protectorate.[49] In February 1922, after talks with Egyptian prime minister (and Zaghloul's rival) Adli Yakan *Pasha* reached a stalemate, Britain unilaterally declared Egypt to be an independent kingdom under Fuad, the then-Sultan and younger son of Khedive Ismail (r. 1863–79). Britain maintained control over the Sudan, the Suez Canal, foreign affairs and the Egyptian military in Egypt (with the British Qasr el-Nil barracks right next to the antiquities museum in Cairo), while internal affairs including archaeology became the responsibility of the new Egyptian government. Egypt began to organize independent elections and form a constitution, adopted in 1923. In January 1924, Zaghloul's nationalist Wafd party came to power in the first parliamentary elections, with Zaghloul appointed prime minister. Although the British government maintained a high commissioner at the Residency in Cairo, and advisors in each Egyptian ministry, it had to step back from any overt involvement in matters that were the purview of the Public Works department and the Service des Antiquités. From 1919 to 1925, the High Commissioner was Lord Allenby, who had commanded the British-led Egyptian expeditionary force in Palestine during the First World War (his peerage made him Viscount of Megiddo). So great was the threat of further revolt in Egypt throughout this time that Allenby would prove reluctant to intervene in the events that unfolded during the first two seasons of work on Tutankhamun's tomb.

Tensions between Carter and the Service des Antiquités had already emerged in early 1923, even before Carnarvon's death took media interest in the tomb to fever pitch. On 9 January that year, Carnarvon signed a contract with the London *Times* and reached

[46] Letter from Burton to Lythgoe, 3 October 1920 (MMA/HB: 1920–3).
[47] Letter from Burton to Lythgoe, 28 April 1921 (MMA/HB: 1920–3).
[48] Letter from Burton to Lythgoe, 26 December 1919 (MMA/HB: 1913–19). For Milner, see Newbury, 'Milner, Alfred, Viscount Milner (1854–1925)'.
[49] See also Goode, *Negotiating for the Past*, 92.

agreement with the weekly *Illustrated London News,* giving them 'exclusive' coverage. This was meant to include priority news bulletins, interviews with the British and American team members, and use of Harry Burton's photographs. Carnarvon had been negotiating with *The Times* throughout December, writing to Carter on Christmas Eve 1922 that the deal could earn them £10,000 to £20,000 towards the cost of the excavations – at least one or two season's work. The contract paid Carnarvon an initial £5,000 and promised a 75 per cent share of profits *The Times* stood to make by selling on information about the tomb and reproduction rights to the images – namely, photographs taken by Burton, Carnarvon and *Times* reporter Arthur Merton.[50] *The Times* had set a precedent for this kind of press arrangement with its coverage of the British Mount Everest reconnaissance expedition of 1921; however, *The Times* and Carnarvon both seem to have overlooked the crucial difference that Everest was as isolated a location as possible, while the tomb of Tutankhamun was centre stage at Egypt's busiest tourist resort. Moreover, granting privileged access to a British newspaper could only cause deep offence to the Egyptian press, public and politicians. Egyptologist-turned-journalist Arthur Weigall, who had himself come to Luxor to cover the discovery for the *Daily Mail,* warned his old colleague Carter (who resented the interference) that *The Times* agreement was fundamentally wrong.[51] Mace and Gardiner, too, privately expressed concerns about the agreement. Carter's own opinion about the contract is ambiguous. Reportedly, he and Carnarvon fell out over it, but after Carnarvon's death, Carter stuck to the agreement, renewing it for the second season and naming Merton as a member of the excavation team in an attempt to circumvent the access restrictions of the antiquities service.[52]

The Egyptian press understandably saw no reason why it should rely on a British newspaper for news of an Egyptian excavation. Egypt's leading Arabic-language newspaper, *Al-Ahram*, berated the London *Times* for forcing Egyptians to get 'news regarding Egyptian treasures from a non-Egyptian newspaper' and compared the situation unfavourably to that of Greece and other countries where a national government – not foreigners – was responsible for antiquities admired the world over.[53] The newspaper *Al-Liwa,* an organ of the Watani ('National') Party, was especially stringent in its criticism, accusing Carnarvon of cupidity:

Wealth lies in making propaganda about these [tomb] contents. [. . .] How many millions of pounds or pilasters will enter the pockets of Lord Carnarvon? Do not forget the prices of photographs and cinema films and all propaganda materials.[54]

For all that archaeological discourse emphasized their scientific purpose, the value of Burton's photographs was also commercial, as *The Times* contract made clear and other

[50] For the arrangements between Carnarvon and *The Times,* and a transcription of the agreement, see James, *Howard Carter,* 277–8, 480–5. The beginning and end of the contract are illustrated in Carter and Reeves, *Tut-Ankh-Amen,* xxii.
[51] Hankey, *A Passion for Egypt,* 260–9; James, *Howard Carter,* 277–8.
[52] See Reeves and Taylor, *Howard Carter,* 159–60. For the dispute over press coverage and access to the tomb, see Colla, *Conflicted Antiquities,* 202–5; Reid, *Contesting Antiquity,* 63–74.
[53] Coverage from February 1923, quoted in Reid, *Contesting Antiquity,* 64.
[54] As above.

press outlets recognized.[55] *Al-Liwa* was also well informed about the use of cinema film, since one of the trustees of the Metropolitan Museum of Art, Edward Harkness – a philanthropist whose wealth derived from Standard Oil shares – had donated a moving picture camera for Burton to use on site. What Egyptians stood to lose could be couched in financial terms (though Carnarvon saw it as recouping his expenses), but Egyptian journalists, writers and politicians readily expressed this loss in terms of national pride and international recognition, too. The 'glorious antiquities' (thus *Al-Ahram*) of Egyptian civilization validated modern Egypt, whose citizens were well aware, through lived experience, of the West's invidious characterization of 'Oriental' inadequacies. At the start of the second season, seven months after Carnarvon's death, Carter proposed a compromise whereby Egyptian journalists would receive the same press release in the morning that he had given to *The Times* the night before, at no charge. Unsurprisingly, this did little to improve matters, and the leading Egyptian newspapers joined forces to petition the government against what they argued was an illegal and immoral monopoly preventing the Egyptian press from reporting events that were taking place on Egyptian soil.[56]

Another source of friction was Carter's relationship with the Egyptian antiquities officials – a transnational alliance encompassing Lacau at the head of the Service, based in Cairo; Chief Inspector of Antiquities for Upper Egypt, Rex Engelbach (an Englishman), usually on hand in Luxor; and local antiquities inspectors for Luxor, all drawn from the *effendiya* class of aspiring, young Egyptian men with some Western-style education.[57] In the first season, Ibrahim Habib *effendi* was the inspector Engelbach deputized to deal with Carter, since standard Service procedures required an official to be present for any significant new work on site. In the second season, two other inspectors joined Ibrahim Habib, named by Carter only as Mohamed Shaban *effendi* and Abbadir *effendi.* Carter commented in his journal that the three inspectors and Engelbach were 'watching us, on behalf of the Eg. Gov. I imagine to see if we do not take anything – this is amusing especially in the case Abbadir Eff. Whose antecedents are certainly not of the best'.[58] The last comment was presumably a reference to Abbadir having relatives involved in the illicit antiquities trade – a trade from which Carter himself had profited over the years. Because the Service des Antiquités was part of the Ministry of Public Works, the ministers appointed by various Egyptian governments throughout the decade-long excavation also played key roles in the management of the work. This was the most significant change to archaeological administration in Egypt since the Service had been established, because although a British advisor remained within the Ministry, ultimate responsibility finally lay with an Egyptian national.

The Tutankhamun site encompassed not only the Tutankhamun tomb (KV62) but also the tomb of Seti II (KV15), known as the 'laboratory tomb', which the Service had given over to the team as a storeroom and conservation laboratory; a small tomb (KV55) that Burton used as an on-site darkroom; and another empty tomb (KV4) known as the 'lunch

[55] Riggs, *Tutankhamun: The Original Photographs.*
[56] Colla, *Conflicted Antiquities,* 204.
[57] On which see Jacob, *Working Out Egypt;* Ryzova, *The Age of the Effendiya;* Ryzova, 'Egyptianizing modernity'.
[58] Carter's journal entry for 1 December 1923 (GI/HCjournals).

tomb', where team members took meals, kept spare equipment, and stored their initial finds, before KV15 was ready. The site was further augmented by a low retaining wall built around the subterranean entrance to KV62, which helped keep tourists out, and by a large tent and small wooden shelter, to provide shade for the armed soldiers and antiquities guards (*ghaffirs*) who were always on duty.

The fame of the discovery meant that there were near-constant demands for access to KV62 and the 'laboratory' from a range of interested parties, and negotiating this became problematic for everyone involved, disrupting work on site and in the Cairo offices of the Service. A diplomatic tug-of-war ensued. For different reasons, the excavators were duty bound to accommodate visitors sent by the Service and the Egyptian government, as well as friends of Carnarvon and patrons of the Metropolitan Museum of Art. By February 1923, Carnarvon and the Ministry had agreed that Tuesdays – the local market day, when no work on site took place – would be visiting days for the general public as well, with up to forty permits issued each week, by application.[59] *The Times* and other papers photographed prominent visitors, even if space restrictions meant not all the images could be used. Many of the visitors reflected the colonial and military reach of Britain. For instance, the commander-in-chief of the Egyptian army and governor of the Sudan, Sir Lee Stack, visited the tomb on 22 November 1923; it was Stack's assassination in November 1924 that would lead to the downfall of Zaghloul's government.[60] Unusually, and presumably a reflection of Stack's important roles, he and his wife were accompanied by the governor (*mudir*) of Qena province ('Abd al-Aziz Yahya, who had also attended the official opening of the tomb in 1922) and two other Egyptian officials, whom Carter named only as the *mamur [markaz]* of the district (possibly still Muhammad Fahey, who held the post in 1922) and the *hakimdar,* a military commander.[61] The director of the antiquities service in India, Sir John Marshall, visited the tomb on 2 December 1923, and Carter was so impressed by Marshall that he invited him to return to lunch with the team three days later, where 'we had a long discussion regarding antiquities laws and division of proceeds, etc.', a professional interest of Marshall's as well.[62] Other well-documented visitors included Queen Elisabeth of Belgium, who repeated the experience four times, and the Sultana Malek, widow of King Fuad's elder brother (the previous Sultan), who received a personal tour from Carter. Several Egyptian ministers visited, too, or else recommended friends and family – the same tactics the excavators and their own patrons used, but resented more than the intrusions caused by Western parties. Carter's journal for the second season noted the absence of Egyptian press at the specially arranged press open days, while Mace drily commented, in December 1923, '15 native ladies to visit by request of government'.[63]

[59] Reported in 'Treasures of Luxor', *The Times,* 14 February 1923: 12.

[60] On some of the wider implications of Stack's assassination, which the British government used as leverage to intervene directly in Egyptian politics, see Gifford, 'Extracting the best deal for Britain'.

[61] Carter's journal entry for 22 November 1923 (GI/HCjournals). For the identities of the *mudir* and *ma'mur,* see Colla, *Conflicted Antiquities,* 195. I am grateful to Lucie Ryzova for identifying the *mamur markaz* title for me.

[62] Carter's journal entry for 5 December 1923 (GI/HCjournals), and Mace's diary entry for the same day (GI/AMdiaries). On Marshall, see Guha (ed.), *The Marshall Albums.*

[63] See Carter's journal entries, 17 and 31 December 1923 (GI/HCjournals); Mace diary, 13 December 1923 (GI/AMdiaries).

Although access for the press and for visitors was the issue to which the excavation team and the antiquities service returned again and again during the first two seasons of work, at the back of everyone's mind – and certainly Carter's and Lythgoe's – was anxiety about the division of finds from the tomb, at a time when the full nature and extent of what the archaeologists might find was anyone's guess. The crucial points in Carnarvon's 1915 concession to excavate in the Valley of the Kings were articles 8 through 10, concerning the division of finds from tombs. Article 8 stipulated that mummies of royalty and high priests would remain the property of the Service, together with any coffins and sarcophagi; article 9 specified that for any tomb discovered intact, everything in the tomb would remain with the Service, with no division whatsoever; and article 10 allowed that 'in the case of tombs which have already been searched', the Service would 'reserve for themselves all objects of capital importance from the point of view of history and archaeology, and shall share the remainder with the Permittee'.[64] Article 10 was the crux of the matter: it did not specify when or to what extent a tomb had to have been 'searched' in order not to count as intact. Early in the work, Carter emphasized to Engelbach, to other archaeologists and to the press that there had been at least one break-in in antiquity, evidenced by disturbances to boxes and baskets in the tomb, robbers' holes to the burial chamber and annex, and the re-sealing at either end of the entrance corridor.[65] Burton's photographs helped conjure a dramatic tale out of the physical evidence: a scarf in which eight gold rings had been wrapped, found in one of the boxes in the antechamber, became 'plunderers' loot' in the caption that accompanied a photograph of the still-twisted scarf (Figure 1.4).[66]

In the first volume of *The Tomb of Tut.Ankh.Amen,* Carter and co-author Mace elided the ancient plunderers with their contemporary descendants:

> Now, every visitor to Egypt will remember that if you give money to a *fellah* his ordinary proceeding will be to undo a portion of his head-shawl, put the coins in a fold of it, twist it round two or three times to hold the coins tight in place, and make it finally secure by looping the bag thus formed into a knot. These rings had been secured in exactly the same way – the same loose fold in the cloth, the same twisting round to form the bag, and the same loose knot. This, unquestionably, was the work of one of the thieves. It was not his head-shawl that he had used – the *fellah* of the period wore no such garment – but one of the king's scarves which he had picked up in the tomb, and he had fastened them thus for convenience in carrying.[67]

Had Burton photographed the scarf before it was fully unwrapped, as the photograph purports, or was its length re-twisted to approximate the original arrangement, the folds arranged just so to reveal the royal booty? Burton's subsequent photographs restored

[64] Carter and Reeves, *Tut-Ankh-Amen,* 5; James, *Howard Carter,* 476; and see Colla, *Conflicted Antiquities,* 206–10.

[65] Carter speculated about the date of the Tutankhamun tomb robberies in 'More Luxor treasures', *The Times* 8 February 1923: 10.

[66] Carter and Mace, *Tomb of Tut.Ankh.Amen,* vol. I, pl. xxx.

[67] Ibid., 138–9.

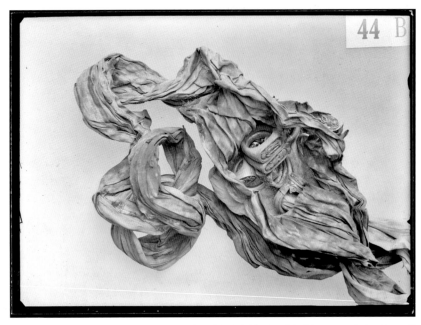

Figure 1.4 Twisted scarf with rings wrapped inside it (object 44b). Photograph by Harry Burton, early 1923; GI neg. P0220, glass 12 × 16 cm.

order to the rings, arranging them in columns on a ground-glass surface to photograph them from three perspectives (flat, side-on and bezel-side up), with their inventory numbers neatly inked at the bottom edge of the image (Figure 1.5).

Egyptologists had been concerned about the future of the division system ever since Lacau's appointment in 1914, since Lacau had made clear his intention to exert further control over archaeological finds, in particular to reduce the number of excavated objects awarded, directly or indirectly, to private collectors.[68] But as Carter and his collaborators returned for the second season of work in the autumn of 1923, explicit discussion of any division was set aside as ongoing tensions – over press access, arrangements for visitors, and relations with the Egyptian antiquities authorities – intensified. In addition to the Egyptian press, journalists from Reuters and the Hearst newspaper group had complained to the Ministry of Public Works about *The Times* agreement, and in early November, Carter met with Lacau, Lacau's colleague James Quibell (himself a respected British Egyptologist) and with the British Under-Secretary of State for the Ministry of Public Works, Paul M. Tottenham, to discuss strategy; Carter also held separate meetings with Tottenham and Lord Allenby.[69] The Egyptian minister of Public Works, Abdel Hamid Suleman *Pasha*, did not immediately concede to Carter the right to handle all publicity for the tomb, since the Ministry planned to issue its own publicity bulletins for the Egyptian press. Relations

[68] Further discussion in Goode, *Negotiating for the Past,* 69–80, 91–7.

[69] See Carter's diary entries for 4 and 15 November 1923 (GI/HCdiaries), and journal entries throughout the month (GI/HCjournals).

Figure 1.5 Rings found inside the twisted scarf seen in Figure 1.4 (objects 44c–h, 44j). Photograph by Harry Burton, early 1923; GI neg. P0222, glass 12 × 16 cm.

further deteriorated in December, when Lacau – aware of Carter's action in appointing the journalist Merton – stipulated that the Service had to approve all members of the excavation team. Carter was summoned back to confer with Tottenham (including a dinner), Allenby (over lunch) and Suleman, at the Ministry; Tottenham stressed that the Ministry was under pressure from the Egyptian press. By January, prominent associates of the excavation – Gardiner, Breasted, Newberry and the Metropolitan Museum – had themselves contacted the Ministry in support of Carter's work, at the same time that Carter was making Tottenham's efforts more difficult by refusing to tow the British government's more conciliatory line. By the end of January, the Egyptian elections that brought Zaghloul's Wafd party to power meant that Suleman was out of office. His replacement was Marqus *Bey* Hanna – for whom the British government had sought the death penalty for a charge of treason arising from Hanna's activities during the 1919 revolution.

In the meantime, Carter, Mace and Callender had focused on removing the seal-covered partition wall between the antechamber and the Burial Chamber, followed by the physically demanding task of dismantling the shrines. This involved removing the heavy wooden roofs in sections and levering apart the side walls, which for years would stay leaning against the walls of the Burial Chamber, under protective wraps. Negotiations with Lacau and the Ministry over arrangements for raising the sarcophagus lid proceeded amid the wider debates, with the date fixed for 12 February. At this significant event, the Ministry was represented by an Under-Secretary, Mohamed Zaghloul *Pasha*, and Carter was allowed to invite twelve guests, not the seventeen he had requested – although his list was reduced by one when Zaghloul and Lacau pointed

out that Alfred Lucas was in fact a government employee and hence a guest of the Ministry, not of Carter's. The gaffe reveals the divisive mindset that had developed, pitting the 'team' against officialdom. At 3 pm, the approved guests gathered in the antechamber to watch Carter, Callender and Mace in the Burial Chamber, preparing to hoist the stone lid with chains. Burton filmed the proceedings with a movie camera paid for by a Metropolitan Museum of Art patron – the use of which caused Burton endless worry, since he had no prior experience with the technology. In his diary, Mace thought it 'worthy of note that the Egyptian officials appropriated the front plank [for observers in the Antechamber], Breasted being the only outside scientist who got a place. Subsequently Lacau made one of them, the Luxor native Inspector, make room for Gardiner'.[70] Carter rolled back the linen shrouds that covered the coffin (the first of three) within the sarcophagus, eliciting a gasp from the spectators. Although the team decided at this point to stop work for the season anyway, the next day brought a final crisis: when Mohamed Zaghloul and Lacau informed Carter that Marqus Hanna had denied permission for the archaeologists' wives and family members to view the open sarcophagus, as they had long planned, Carter conferred with Mace, Breasted, Gardiner and Newberry. He typed up a statement and posted it, in English, in the Winter Palace Hotel, the centre of European social life in Luxor:

> Owing to impossible restrictions and discourtesies on the part of the Public Works Department and its Antiquity Service, all my collaborators in protest have refused to work any further upon the scientific investigations of the discovery of the tomb of Tut.ankh.amen.[71]

Recovering Tutankhamun

Throughout the excavation and its coverage in the press, the 'scientific investigations' that Carter's statement avows had been presented as the polar opposite of political or commercial interests – but politics, profit motives and prestige lay at the heart of the Tutankhamun dispute.[72] The Ministry of Public Works responded to Carter's provocation by rescinding the Carnarvon concession and changing the locks on KV62 and KV15. Egyptian newspapers critiqued the wording of the archaeological permit in their coverage of the dispute, decrying a legal framework that was now an unwelcome legacy of Ottoman rule. So too was the word 'concession' or 'capitulations' (*imtiyazat*) itself, which encompassed a range of agreements that had granted legal and financial privileges to Western powers in Ottoman lands and thus facilitated imperialist expansion.[73] Carter left

[70] Mace's diary entry, 12 February 1924 (GI/AMdiaries).
[71] James, *Howard Carter*, 337.
[72] The best-informed accounts of the dispute (though James did not use Egyptian sources) are Colla, *Conflicted Antiquities*, 199–210; Goode, *Negotiating for the Past*, 67–97; James, *Howard Carter*, 316–53; and Reid, 'Nationalizing the pharaonic past'. See also Reid, 'Remembering and forgetting'; Reid, *Contesting Antiquity*, 65–79.
[73] See Colla, *Conflicted Antiquities*, 200–1, citing coverage in *Al-Ahram*, February 1924.

Egypt to undertake an extended lecture tour in the United States and Canada, but not before filing a lawsuit against the Service des Antiquités in the Egyptian Mixed Courts, in a failed attempt to restore his access to the tomb. The lawyer who represented him, F.M. Maxwell, had been the prosecutor in the British government's previous attempt to convict Marqus Hanna of treason. In court, Maxwell accused Hanna's Ministry of behaving 'like a bandit', a phrase translated into Arabic with the loaded word *haramiyya* – thieves.[74] The Egyptian press responded angrily to this latest insult, and Prime Minister Sa'ad Zaghloul, addressing a convention of lawyers at the Semiramis Hotel in central Cairo, turned the language of science against Carter in a vigorous defence of the government's actions: 'Howard Carter does not have the right to lock tombs that are not his. In fact, the interest of science forbids this kind of behaviour'. Sa'ad Zaghloul and Marqus Hanna both made visits to the tomb of Tutankhamun in the following months, a practice – as Colla observes – that other Egyptian politicians would continue in the years to come.[75]

For his part, Carter privately printed and distributed a seventy-four-page pamphlet presenting his version of events, with copies of relevant documents and his correspondence with Lacau and the Ministry embedded in a third-person narrative that aims for 'scientific' objectivity.[76] Its defensiveness speaks for the personal qualities that had exacerbated the situation in the first place, and the pamphlet also alienated some of Carter's one-time allies, in particular Herbert Winlock of the Metropolitan Museum, who had been negotiating on the ground in Luxor, on Carter's behalf, throughout 1924. With the fall of Zaghloul's government in November 1924 – a direct result of Stack's assassination – a caretaker government led by Ahmed Ziwar *Pasha* was put in place and immediately displayed a more conciliatory attitude towards British and American interests. The Tutankhamun affair began to be resolved: Carter, who had lost his case in the Mixed Courts, relinquished any personal claim to a division of finds and agreed not to renew the contract with *The Times*. He also accepted the oversight of the new Chief Inspector of Antiquities for Upper Egypt, Tewfik Boulos *effendi,* and the ongoing contribution of local inspector Ibrahim Habib *effendi.* Carter, Callender and Lucas resumed work in the Valley in January 1925, although Carter noted bitterly in his journal where changes had been made to the facilities on site – and especially the irreversible damage done to the linen pall that had been erected over the second shrine, and which Essie Newberry had cleaned and conserved. But some peace reigned over the site at last. Prime Minister Ziwar *Pasha* paid a personal visit to the tomb on 27 February. 'He seemed very pleased with the discovery and the results of our discovery in general', was Carter's anticlimactic journal entry, his last but one before this short third season ended.[77]

After work resumed in 1925, the mood on the excavation and in the British press had changed. Even without an exclusive arrangement, *The Times* continued to cover the progress of work, and the *Illustrated London News* still published Burton's photographs,

[74] Colla, *Conflicted Antiquities,* 206, 208.
[75] Colla, *Conflicted Antiquities,* 206–8; Reid, 'Remembering and forgetting', 162.
[76] Republished as Carter and Reeves, *Tut-Ankh-Amen.*
[77] Carter's journal for January to March 1925 (GI/HCjournals).

often hand-tinted, and trailed their appearance in *The Times* ahead of publication. But coverage was less saturated than before, and less frenetic with the passage of time and the fraught history of the dispute. *The Times* opened its coverage of the fourth season by crediting its source: 'a *communiqué,* in Arabic, by the Ministry of Public Works', issued on 5 November 1925 to summarize the previous two weeks' work. There was plenty to report in the course of this season, however, since 11 November marked the start of the investigation of the royal mummy. Burton took four photographs to commemorate the occasion (Figure 1.6).

These are among the earliest formal photographs in which Egyptian officials and specialists (Dr Saleh Hamdi helped conduct the autopsy) posed alongside European officials and specialists, including Lacau, Carter, Lucas and Dr Douglas Derry, the anatomist who made the first cut into the mummy wrappings. In addition to Lacau, the antiquities service staff present were Tewfik Boulos and Mohamed Shaban, who had become one of the first Egyptian curators at the museum in Cairo. The *mudir* of Qena, Sayed Fuad *Bey* El Kholi, attended, as did the Under-Secretary of the Ministry of Public

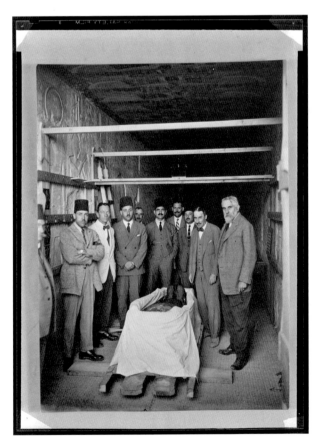

Figure 1.6 Group photograph ahead of the unwrapping of Tutankhamun's mummy. Photograph by Harry Burton, 11 November 1925; GI neg. P1559, 12 × 16 cm film copy negative, of a print of unknown date.

Works, Saleh Enan *Pasha*, and his assistant, Hamid Suleman *effendi*.[78] Callender had left the excavation after the third season, due to a falling-out with Carter over payment of his salary. Instead, Carter relied on his Egyptian foremen, Alfred Lucas for object conservation and Burton for photography, which increasingly had to be worked in around Burton's regular duties for the Metropolitan Museum's Egyptian Expedition.

In the fifth season, over the winter of 1926–7, the royal mummy was replaced in its outermost coffin and stone sarcophagus in the Burial Chamber while the clearance of the Storeroom or Treasury commenced. This season and the next, Carter had the assistance of Henri Landauer, probably supplied by the antiquities service. Prime Minister Adli Yakan *Pasha* (serving his third non-consecutive term) visited the tomb on 5 and 6 December 1926 and King Fuad, again, on New Year's Eve day. The sixth season, from October 1927 to April 1928, saw the removal and recording of the remainder of objects from the Treasury and the start of work clearing the jumbled Annex, whose floor level was almost two feet lower than that of the Antechamber. A seventh season, in the autumn of 1928 and winter of 1929, was spent working on objects already in the laboratory tomb, KV15. Burton arrived to take photographs but fell ill with dengue fever, losing two weeks of work before he recovered. Although Carter's journal for the season ends in December 1928, Burton wrote to Lythgoe on 19 March 1929 that he had only finished his work with Carter ten days previously. Burton's letter illuminates the mood among the collaborators and the concern that was preoccupying Carter:

> I am glad to have got thro' another season with him without any unpleasantness. He left last week for Cairo where he hopes to get the "Division" made. I don't envy him having to deal with Lacau, + hope he'll get a fair share of the "spoils". I was hoping this would be the last season, but there are still enough things left to keep him busy for another season. He sent 90 cases to Cairo this season so you can imagine how he has worked to get so much finished. The reason he's having the "Division" this year, is because Lady Carnarvon refuses to finance the thing after this season. This is the seventh season + one can quite understand how she feels about it.[79]

In the end, no 'division' of the 'spoils' took place, nor was any further excavation or conservation work carried out until the autumn of 1930. Instead, Carter devoted the intervening winter of 1929–30, which would have been the eighth season, to negotiations with the Egyptian government over compensation for the Carnarvon estate. As Burton's letter makes clear, Carter had still hoped to secure Lady Carnarvon a set of 'duplicates' from the tomb – in the parlance of twentieth-century archaeology, the phrase referred to objects of which there were several similar examples in the tomb, such as *shabti*-figures, jewellery or vases. Prime Minister Ziwar *Pasha* had offered such an arrangement, in recognition of the costs the Carnarvon estate had incurred, but by 1930, the government of Mustafa el-Nahhas *Pasha* – a Wafd politician who had been exiled with Sa'ad Zaghloul – was not inclined to give away objects from the tomb. Instead, Lady Carnarvon

[78] Carter's journal entry, 11 November 1925 (GI/HCjournals).
[79] Burton to Lythgoe, 19 March 1929 (MMA/HB: 1924–9).

accepted almost £36,000 in compensation, a quarter of which (after death duties and taxes were paid) she gave to Carter. The sum covered approximately everything they had spent on the excavation and clearance up to that point, although no provision was made for an estimated £8,000 of in-kind expenses incurred by the Metropolitan Museum of Art for the loan of its staff, in particular Burton. Egyptologists like Carter's biographer, T.G.H. James, have accepted the compensation scheme as if it were only the Carnarvons' due, but if Lacau's original stance held good – namely, that the tomb of Tutankhamun counted as an intact tomb and therefore was not subject to any division of finds in the first place – then there was never an obligation on the part of the Egyptian authorities to give the Carnarvon estate either objects or financial recompense for their efforts.[80] In approving the £36,000 payment, el-Nahhas's government was in effect buying what it could, by moral and legal rights, have had for free.

From 1927 onwards, Carter's journal entries became more cursory, little more than diary notes, but he was writing enough elsewhere to produce the next two volumes of *The Tomb of Tut.Ankh.Amen.* In 1927, the second volume appeared, shaped or partly ghostwritten by his friend Percy White, a former professor of English at the Egyptian University in Cairo. This volume covered the restoration of the chariots from the Antechamber, the opening of the shrines and coffins, and the examination of the mummy. In the preface, Carter defended Carnarvon's agreement with *The Times* and referred to the 'heavy expenses' the Carnarvon family had incurred; the question of receiving some objects or financial compensation remained unsettled at this time. Otherwise, Carter glossed over the details of his dispute with the Egyptian authorities, picking up instead with the 'cordial' welcome Prime Minister Ziwar extended at the end of 1924. In his final thanks, Carter referred more graciously to the Egyptian members of the team:

> Last of all come my Egyptian staff and the *Reises* who have served me throughout the heat and burden of many a long day, whose loyal services will always be remembered by me with respect and gratitude, and whose names are herewith recorded: Ahmed Gerigar, Hussein Ahmed Said, Gad Hassan and Hussein Abou Owad.[81]

The third volume appeared in 1933, after work on the tomb was complete. This volume dealt with all the objects from the Treasury and the Annex, while its preface set out in some detail Carter's version of the compensation arrangements and his 'debt of gratitude' to Lady Carnarvon, the Metropolitan Museum of Art, Alfred Lucas and Harry Burton.

Carter and Lucas devoted two final winter seasons (1930–1 and 1931–2) to the task of conserving the shrines whose walls and roofs were still stored on site. Preparing them for transport to Cairo and re-erecting them in the museum was demanding work. Carter and the antiquities service split the costs, and Burton – his patience wearing thin – dutifully turned up at the museum in November 1932 to document the re-erection of the shrines, each in position in its own vitrine before the glass walls were in place (Figure 1.7).

[80] For the compensation arrangements, see Carter's journal for 1929–30 (GI/HCjournals), and James, *Howard Carter*, 430–4.
[81] Carter, *Tomb of Tut.Ankh.Amen,* vol. II, xxiv.

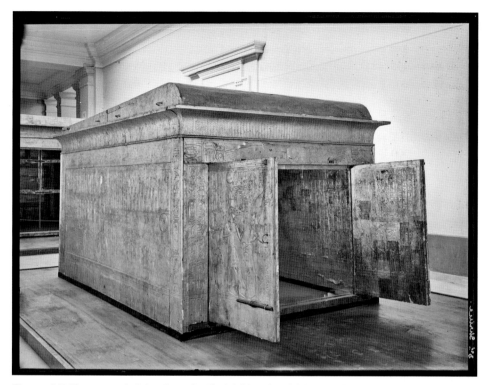

Figure 1.7 The second shrine from the Burial Chamber (object 237), re-erected in the Egyptian Antiquities Museum, Cairo. Photograph by Harry Burton, November or December 1932; GI neg. P0632A.

To Winlock, on 26 December 1932, Burton wrote that the shrines 'make a fine show, but I think it's rather a pity to display them all in a row in the upper gallery, as it is rather a squeeze + when they get the glass cases over them, it will be even more so'.[82] Carter had joined the Egyptian Expedition staff for Christmas dinner the previous day at the Metropolitan Museum dig house, and that was when Carter informed Burton that the sarcophagus still needed to be photographed in the tomb. At least, Burton noted, Carter would supply the glass negatives. Financial considerations concerned not only large expenses, but small ones as well: once he had photographed the sarcophagus, Burton promised to send Winlock a few prints – apparently using Carter's materials, or without Carter's explicit permission, since Burton explained:

> I have never given a print to anybody before, but I think I'm justified in this case as Carter hasn't been as nice to us as he might have been. It will be interesting to see whether he will write to the museum + say thank you now that I have finished.[83]

[82] Burton to Winlock, 26 December 1932 (MMA/HB: 1930–5).
[83] Burton to Winlock, 20 January 1933 (MMA/HB: 1930–5).

Carter's alienation from his one-time colleagues was the sorry coda to the Tutankhamun excavation. By the mid–1930s, he often appeared bitter or arrogant in professional encounters, and he suffered increasingly poor health. Burton and his wife dined with Carter in March 1934 and the question of a final publication of the tomb came up: Carter claimed it would cost £13,000 'to do the thing properly', and that it was out of the question at present. Carter also bragged that the third volume of *Tut.Ankh.Amen* – illustrated with 156 Burton photographs – had sold well. 'I've seen none of the proceeds', was Burton's comment to Winlock.[84]

For all that social relations between Carter and Burton had become strained, their lives ended in as curious a parallel as they had begun, with their twin small-town Victorian boyhoods. Carter died of Hodgkin's lymphoma in London on 2 March 1939, aged sixty-four. He named Burton as one of his executors and Bruce Ingram, publisher of the *Illustrated London News,* as the other. Burton spent months dealing with the sale and donation of Carter's collection of Egyptian antiquities, including objects in Carter's possession that could only have come illicitly from the tomb of Tutankhamun.[85] Back in Egypt in the spring of 1940, his work on the Carter estate nearly complete, Burton himself fell seriously ill with the diabetes that had plagued him for several years. He died at the American Mission Hospital in Asyut on 27 June 1940, aged sixty, and was buried there. Carter and Burton were linked once more in a letter Burton's widow, Minnie, wrote to curator Ambrose Lansing at the Metropolitan Museum several months later. She had heard from Phyllis Walker, Carter's niece and heir:

> She says that all his furniture, rugs, pictures which she had stored in London, had been destroyed in 2 fires. She was thankful that the best Egyptian pieces had been sold in America [as Burton had arranged]. The other things are at Spinks' [auction house] + were all right when she wrote.[86]

The Burtons' own home in Florence was destroyed during Allied bombing raids in September 1943. Carter and Burton had no truck with ancient Egyptian curses. It was simply history that buried them, as it had once buried the boy-king.

Photographing Tutankhamun

The photographs that illustrate this chapter indicate the range of styles in which Burton worked, as well as the different purposes to which photographs, and the act of taking them, were put. To this end, we must keep in mind that not all the photographs associated with the Tutankhamun archives were taken by Burton or are even contemporaneous with the excavation. This is a legacy of the archival processes carried out during the project and in the decades since, courtesy of the Griffith Institute and the Metropolitan Museum

[84] Burton to Winlock, 27 March 1934 (MMA/HB: 1930–5).
[85] See James, *Howard Carter,* 468–70.
[86] Minnie Burton to Lansing, 16 January 1941 (MMA/HB: 1936–42).

of Art. The Griffith Institute's holdings are distinctive in that they represent Carter's own ordering of the images in print, negative and lantern slide formats, although it was also Carter – not Burton – who assigned numbers to most of the Tutankhamun negatives in New York. Photographs for which Burton was not responsible include Figure 1.3, showing the ostracon from Carter and Carnarvon's early seasons in the Valley. The identity of the photographer is unknown but may have been Carter himself, or Carnarvon; both men were considered adept photographers. Carter owned a quarter-plate glass negative of the cockerel ostracon, which he sequenced in his personal collection using Roman numerals (XLIX) rather than the Arabic numbers he used for the negatives Burton made of the Tutankhamun tomb and objects. In addition, the ostracon photograph appears as a lantern slide in the collection Carter used to deliver lectures about the tomb. This is a salient reminder that photographs exist not only as images reproduced in books and newspapers (or, today, in digital databases), but as material objects – negatives, prints, slides – that were handled, mounted, exchanged, projected, filed and not infrequently lost or broken. Both as image and as object, photographs have no essential and unchanging meanings, however much archaeologists and photographers might have hoped they would. Instead, as Elizabeth Edwards and Christopher Pinney have argued (from different vantage points), the meanings that photographs and photographic practices may yield are context-dependent, created and recreated through space, time and sociation.[87]

The taking of a photograph is itself more time-consuming, space-specific and social than we now consider when flipping through the pages of a book, an album, or a website. Group photographs like that taken ahead of the mummy unwrapping, on 11 November 1925 (Figure 1.6), were only a fraction of Burton's output for the Tutankhamun excavation – fewer than a dozen – but they exemplify the multi-layered, multi-vocal nature of archaeology and photography alike. There are four group photographs from the carefully orchestrated 11 November gathering, only two of which survive as Burton negatives, made with the large-format glass plates he used to photograph the entire unwrapping over the following week.[88] For the other two photographs, including that shown in Figure 1.6, only prints exist, mostly likely made by Burton directly from his negatives, without reduction or enlargement; these have been re-photographed to create new negatives. Group photographs are significant in terms of the choices they represent about which event or delegation deserved to be photographed (though this will sometimes have depended on Burton's availability), as well as who to include and how to arrange the subjects before the camera lens. Of the images made ahead of the unwrapping, Figure 1.6 is the most formal in that everyone stands facing the camera. Nonetheless, it captures a certain awkwardness or tension in the group, and the cut-off figure of the grey-moustached Egyptian official, Mohamed Shaban, at the left disrupts Burton's usual careful framing. Standing in the entrance hall of KV15, the laboratory tomb,

[87] Edwards, *Raw Histories;* Edwards and Hart (eds), *Photographs, Objects, Histories;* Pinney, *Camera Indica;* Pinney, 'Camerawork as technical practice'.

[88] Photographs of the group at the start of the unwrapping: GI negs. P0939 (glass copy negative, *c.* 1930s, plus film copy negative, *c.* 1980s); P1559 (film copy negative, *c.* 1980s); and MMA negs. TAA 391 and TAA 1103 (both 18 × 24 cm glass plates).

all the other Egyptians confront the camera face-on, confident in their presence there. In contrast, Pierre Lacau (at far right) and the British participants turn their bodies to one side, almost ceding space, or at least wondering if they should. Lucas stands at the back, just visible over the shoulders of two Egyptian officials, while Carter hovers nervously in front, closest to the coffins and the royal mummy. Anticipation may have rushed the photography, one senses, but the time taken to set up the camera, gather the participants, and arrange and direct them (who spoke, and in which languages?) was part of the process of memorializing the occasion. Photography worked with and within the performance of the archaeological event. By the time the other three images in the sequence were taken, the men had rearranged themselves around the coffins and Burton had shifted his camera a few feet to the left, to shoot from the other side of the entrance. The unwrapping was underway, and movement – Carter leaning over the coffin, Derry making the first scalpel slice, Hamdi looking over his shoulder towards the camera – blurs the very actions Burton aimed to fix.

Only during the first two seasons, when *The Times* agreement was in force, and around the time of the momentous opening of the coffins did Burton photograph work being carried out within the tomb of Tutankhamun. Many (though not all) of the resulting images – like Carter kneeling before the opened shrine doors (Figure 1.1) – display the careful lighting effects, framing and stillness of their staging, which is most effective where the subjects, like Carter here, waited for the exposure time to do its work. Electric lamps in the tomb allowed Burton to create dramatic plays of light and shadow, in contrast to the more diffuse and even effects he aimed for elsewhere, using reflected sunlight. Back in the Burial Chamber in January 1933, after all the shrine parts had finally been removed, Burton's final exposures for the Tutankhamun enterprise probably use reflected sunlight, in addition to the tomb's electric lighting, to emphasize the sensuous contours of the quartzite sarcophagus reliefs without casting harsh shadow (Figure 1.8).[89]

The curved surfaces of the protective goddess's lips, breasts and thighs swell above the more shallow, linear carving of the wing feathers and the sunken hieroglyphic forms. Burton remembered taking ten shots in his letter to Winlock later that month. In fact, he took nine shots twice so that both Carter and the Metropolitan Museum could hold a negative, and one shot three times, experimenting with camera movements in the restricted space. The two archives, in Oxford and New York, thus yield a total of twenty-one negatives. The gentlemen's agreement Lythgoe and Carter had made in the first weeks after the discovery still held, and as we will see throughout this book, the question of duplicate and copy negatives (which were not the same thing) became a preoccupation, not only for Burton, Carter and their colleagues, but also for the Museum and Griffith Institute staff who would take responsibility for the photographic archive after Burton and Carter had died.

The bulk of the photographs Burton took for the Tutankhamun excavation – around 65 per cent of the total – are photographs of antiquities discovered and identified as 'finds' or 'objects' in the course of the work, yielding images along the lines of the twisted

[89] See Eaton-Krauss, *The Sarcophagus,* 9–11, for a discussion of stages of carving on the reliefs – based on in-person examination as well as close study of Burton's photographs, reproduced in the book.

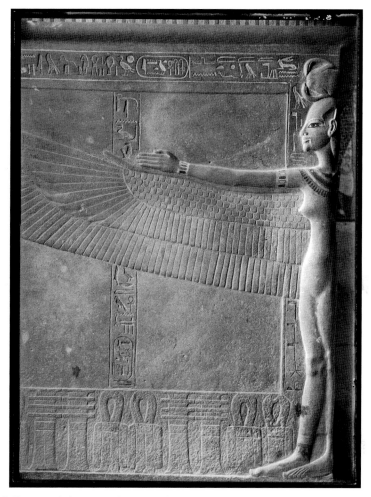

Figure 1.8 Corner of the quartzite sarcophagus in the tomb of Tutankhamun (object 240). Photograph by Harry Burton, January 1933; GI neg. P0646H.

scarf and gold rings seen here in Figures 1.4 and 1.5. Object photography, to use a contemporary umbrella term for this genre, was a standard procedure on archaeological sites or in the museums that were the destination of so many excavated objects; twentieth-century handbooks for field archaeologists often discuss the skills required under the heading 'museum photography'. Whether objects were photographed upright in front of a backdrop, with the camera level in front, or photographed from overhead with the objects on a ground-glass support, the objective was the same: to isolate the object or group of objects against a 'neutral' background. Minimizing shadows while picking up the details of inscriptions, decoration and the objects' material qualities were also priorities, which required careful lighting, lens adjustments and positioning. Photographing the object in this way was an essential stage in its becoming an archaeological object fit for study and display; photographs also became substitutes for the objects they represented,

all the more so when artefacts were destined to stay in their country of origin. Yet the visual convention of the isolated object, presented through photography as worthy scientific data, did not exclude a photograph from other uses and meanings. The heavy gold rings, precisely aligned and invisibly supported in the photograph, speak both to the riches of ancient Egyptian kingship and their rescue by archaeology, while the scarf in which they were discovered, caught (or recreated) in its not-quite-unwound state, lets the viewer step into the role of the archaeologist, poised at the moment of discovery. Photography, a medium that depended on time duration, created the illusory effect of time denial.

The archaeological aesthetic of the untouched – a virgin past, sealed until the archaeologist ruptures it – proved particularly suited to photography's apparent ability to transport the viewer not only to a different place but also to a different time. In this sense, the most overtly 'archaeological' photographs Burton took of the tomb are the interior shots of each chamber before and at stages during the clearance. Images purporting to show the tomb exactly as it was found, like the sealed doorway in Figure 1.2, seem to capture the bewildering experience of time travel that Carter described in *The Tomb of Tut.Ankh.Amen*:

> Three thousand, four thousand years maybe, have passed and gone since human feet last trod the floor on which you stand, and yet, as you note the signs of recent life around you – the half-filled bowl of mortar for the door, the blackened lamp, the finger-mark upon the freshly painted surface, the farewell garland dropped upon the threshold – you feel it might have been but yesterday. The very air you breathe, unchanged throughout the centuries, you share with those who laid the mummy to its rest. Time is annihilated by little intimate details such as these, and you feel an intruder.[90]

In the next breath of that rarefied air, Carter admitted 'the almost overmastering impulse' to break seals and open boxes in the object-stuffed Antechamber, and he drew readers' attention to the contrast between his first glimpse by torchlight, and the brightly lit effect of photographs like Figure 1.2, 'taken afterwards when the tomb had been opened and electric light installed'. The photographs themselves, though, undermine this note of caution. They conceal the electric cables and lights, and do not include the black-and-white scale rod that, by this date, archaeologists often recommended for site photography (but that Burton only rarely used, and never at the tomb of Tutankhamun). Burton also took care to take one exposure without any of the numbered cards in place that would inventory each object, and another with the cards carefully set on or against each object – a process that must itself have taken some time. When *The Times* published its first, exclusive photographs of the tomb on 30 January 1923, it used photographs without the number cards in place and a caption that identified the scene in Figure 1.2 as 'the undisturbed antechamber'.[91] If prompted, most viewers of these images would be able to deduce that some degree of interference was involved in setting-up the untouched tomb to have its picture taken. But like the photograph of the unwinding scarf yielding the

[90] Carter and Mace, *Tomb of Tut.Ankh.Amen,* vol. I, 97.
[91] 'Tutankhamen's tomb', *The Times,* 30 January 1923: 11+.

'plunderers' loot', the immediate effect of the tomb photographs relies on our suspension not of disbelief in the photograph, but of distrust. Ironically, Burton's photographs of the sealed entrance to the Burial Chamber famously hide a lie of their own, since the circular, basketwork tray propped against the lower portion of the blocked doorway conceals the ancient robber's hole that Carter and Carnarvon had secretly used to access the rooms beyond.

This chapter has traced the ten-year trajectory of the Tutankhamun excavation from its initial, confounding weeks – and photographs – to the final pictures Burton took as the shrines were pieced back together in the Cairo museum (Figure 1.7) and the sarcophagus, holding the rewrapped remains of Tutankhamun, was left standing alone in the emptied tomb (Figure 1.8). The thrill of discovery had long since given way to hard graft, and Burton's letters suggest that by the end, his contribution as photographer depended on his own good will, experienced or at least expressed as a sense of shared professional commitment both to Carter and to the Metropolitan Museum. Within the history of archaeology, and in Egyptological lore, discussions of Tutankhamun's tomb have treated it as a unified event characterized by rational progress and clarity of purpose, its discovery, recording and clearance exemplifying what we would now term best practice for the time. Like any scientific endeavour, however, work on the tomb of Tutankhamun was enmeshed in the complexities of personal relationships, claims and counter-claims to authority, and the scale and intractability of its dataset, which comprised not only the tomb and objects, but all the apparatus that went into dealing with them – scores of trays and packing crates, miles of cotton bandages and wadding, and the notes, record cards and photographs that became the excavation archives. Disorder was inevitable: in the photographic archive, negatives were damaged or went missing, parallel numbering and filing systems operated with inevitable confusion, and copyright threw up issues that echo still today.

The history of the physical negatives, slides, prints and albums is similarly complex. Those in Carter's possession survived storage in the East End of London during the Second World War (unlike his furnishings) to reach the Griffith Institute at Oxford University, donated by his niece on the advice of Percy Newberry. Carter had regularly supplied the Metropolitan Museum with a separate set of negatives, which were printed and mounted by Burton as part of his duties with the Egyptian Expedition. Carter also donated his house at Luxor and all its contents to the Museum, and Expedition staff member Charles Wilkinson brought around 500 negatives from the house back to New York to join the others, in 1948. In the post-war era, though, there was little enthusiasm for Tutankhamun, either in Egyptology as practiced in the West or in Egypt, where the 1952 revolution and the Suez crisis of 1956 continued a long-established intellectual and political trend of allying the Egyptian state more closely with its Arab neighbours and de-emphasizing nationalist associations with its pharaonic past.[92]

[92] See Gershoni, 'Rethinking the formation of Arab nationalism'; Gershoni and Jankowski, *Redefining the Egyptian Nation;* Reid, 'Nationalizing the pharaonic past'.

At mid-century, the tomb of Tutankhamun seemed like a folly from a bygone era. A handful of publications were underway – *Tutankhamun's Treasure,* published by the Griffith Institute's Penelope Fox in 1951, included around seventy Burton photographs with object information, and Russian émigré scholar Alexandre Piankoff produced a major study of the burial shrines in 1955 – but there was little academic investment in the find and nothing like the frenzied public interest of the 1920s.[93] Fox had been through every Burton photograph umpteen times, and she corresponded for years with assistant curator Nora Scott in the Metropolitan Museum, in an effort to reconcile the two institutions' sets of negatives and prints. That the photographic legacy of Tutankhamun had become 'women's work' speaks for a drop in prestige, of both the tomb of Tutankhamun and the style and content of many of Burton's photographs. Shifting disciplinary priorities and institutional practices encouraged a certain stasis in the excavation archives, but like any archive, the record cards, notes and photographs were never entirely static. Changes in photographic technologies made it ever easier to create film copies of Burton prints, for instance, and after the touring exhibitions of the 1960s and (especially) 1970s reshaped and revived interest in Tutankhamun, the archives in both Oxford and New York were subject to newly professionalized archival and conservation care. Having inaugurated the *Tutankhamun's Tomb Series* in 1963, by publishing Carter's complete list of objects from the tomb for the first time, the Griffith Institute began to produce slim monographs on the finds with greater frequency in the 1970s, all illustrated with Burton photographs. In the 1990s, the Institute's website was among the first to present digitized archaeological records online, including low-resolution scans of Burton images, made from modern prints. The following decade saw the Metropolitan Museum of Art organize an exhibition devoted to Burton's entire body of work for the Museum, as well as a separate exhibition of his Tutankhamun photographs.[94] As Tutankhamun images by Burton and from newspaper archives, like *The Times,* have circulated more widely, they have also been incorporated into picture libraries – returning to them the commercial value that Carnarvon and *The Times* had counted on back in 1922.

Because my central argument is that archival and photographic practices were inseparable in archaeology and that ongoing care of the resulting archive underpins the discipline's epistemological and professional structures, the remainder of this book is framed – bookended, as it were – by the history of the Tutankhamun photographic archive. The book takes the archive as both a research site and a research subject, to explore the formation of the Tutankhamun archive, the trajectories of photographic objects within it, and the drive for a notionally 'complete' photographic archive in Oxford and New York – a drive that has pushed the images into the digital age. The formative decades of the archive are dealt with in Chapter 2 up to the death of Alan Gardiner in 1963, which marked the end of living memory among the original excavation's key British members. Attempts by Carter and, after his death, other Egyptologists and clerical staff to organize, categorize

[93] Thus also Reid, *Contesting Antiquity,* esp. 306–8.
[94] For *The Pharaoh's Photographer* (11 September 2001–2 March 2002), see http://www.metmuseum.org/exhibitions/listings/2001/harry-burton. A later exhibition based on Burton's Tutankhamun photographs: Allen, *Tutankhamun's Tomb.*

and generally care for the photographs and excavation records are indicative of changing disciplinary priorities over the course of the twentieth century, as well as changing historical and political vectors as decolonization first gathered pace and then faltered. I return to the late twentieth century history of the archive at the end of the book.

Chapters 3, 4, 5 and 6 address the role of photography and the use of photographs during the course of the excavation. Chapter 3 turns to the practical arrangements made for different kinds of photography at the tomb, where photography was, in Carter and Mace's words, 'our first and greatest need'.[95] So integral was photography to the performance, identity and methodology of archaeology that it influenced much of the scheduling and progress of the work. However, the thoroughness that the British team asserted for their photographic programme is belied by the photographic archive itself, which instead attests the contingent nature of archaeology, collective effort and knowledge production. Chapter 4 delves into the archive to discuss Burton's object photography, which was an essential and routine aspect of his work for the tomb. As this chapter demonstrates, however, there was no single method or mode appropriate to the task. Instead, Burton adapted his approach based on judgements about the kind of object being photographed, and while his photographs of 'iconic' objects arguably helped make those objects iconic in the first place, other photographs and the objects they represent are too mundane, too numerous, or both, to have made much impact. Chapter 5 interrogates the representation of archaeological labour through photography, looking at issues of absence and presence in the representation of the Egyptian workforce as well as the way in which photography heroized the white archaeologists, in particular Carter. It also expands the notion of archaeological labour to include the Egyptian officials who oversaw the work, and in doing so considers how the tomb of Tutankhamun entered discourses of *effendiya* masculinity, nationalism and Pharaonism in interwar Egypt.

In Chapter 6, I focus on how English-language media outlets like *The Times,* the *Illustrated London News,* and Carter's own publications deployed specific photographs to tell quite specific stories about the excavation and the boy-king. What emerges in Carter's own presentation of the tomb are twin narratives, one emphasizing Western scientific rigour, the other the boyishness, domestic life and pageantry of Tutankhamun – the now-familiar 'king Tut', whose once-lauded tomb fell from academic favour by the mid-twentieth century, out of fashion and out-of-step with post-war politics. A final, concluding chapter, Chapter 7, picks up the archival history that Chapter 2 began. It opens at the moment in the 1960s when the tomb's artefacts were reconfigured as objects of diplomatic exchange, by means of the touring exhibitions, and considers the subsequent reconfiguring of the archive in a digital, online format. As the preceding chapters demonstrated, photographs had already been instrumental in creating a visual imaginary of the tomb of Tutankhamun, but the influential 1970s exhibitions of the tomb's objects would revisit, expand upon, and to some extent revise this visualization. The first 'blockbuster' museum shows coincided (not coincidentally) with closer relations between Egypt and Western powers, for whom the country was a strategic ally in the Middle East. Interest in Tutankhamun has not waned since.

[95] Carter and Mace, *The Tomb of Tut.Ankh.Amen,* vol. I, 127.

Photography was the pivot on which archaeological discovery turned, the point between seeing and not-seeing, knowing and not-knowing. But photographs had always played with time and truth, salvage and loss. That is why understanding photography requires us to go beyond the photograph alone and into the archive, to consider what photography as a practice and a technology has enabled or, conversely, discouraged and disallowed. We see, or think we see, the moment of discovery as Carter stares into the past. We know, or think we know, what it is that he is gazing at so intently – and we assume, or easily accept, that the last person who looked on the same scene was a long-dead Egyptian priest, not whoever wired the lamp, switched it on and fiddled about to get its position just right on that January day in 1924. No wonder that in archaeology, camera work proved to be anxious work, as if the doors the archaeologist eased open might reveal too much or, too easily, swing shut.

2
MIRRORED MEMORIES: EXCAVATING THE PHOTOGRAPHIC ARCHIVE

In August 1951, a crate containing twenty-four photograph albums arrived at Southampton on the S.S. *Queen Elizabeth* – at the time, the largest passenger ship in the world and, with her sister ship the *Queen Mary,* the pride of Cunard's transatlantic fleet. The long-established shipping firm of Davies Turner handled the consignment of the crate from New York via Southampton to Oxford, at a total cost of £56.12s.8d. This included the cost of packing the albums (billed by Davies Turner's American office to the Griffith Institute in Oxford for $22.43) and insuring them to the value of $1,500, roughly the price of a new Ford car. At Southampton, Davies Turner shepherded the crate through British customs. Its contents were exempt from import duty because they were considered educational materials: the albums contained prints of all the photographs the Metropolitan Museum of Art had among its records of Harry Burton's work at the tomb of Tutankhamun.[1]

Waiting to take delivery in Oxford was Penelope Fox, assistant secretary of the Griffith Institute. The arrival of the albums was the culmination of a three-year-long correspondence between the Institute and the Metropolitan Museum, as both tried to get to grips with the legacy of an excavation whose main participants were dead. Almost three decades had passed since the tomb's discovery, and the intervening world war had taken the polish off even Tutankhamun's gold. It was the end of the war, and a shifting political landscape in the Middle East, that had first set the photograph albums in motion: in 1948, the Museum sent assistant curator Charles Wilkinson to Luxor to clear the dig house that had been the base of its Egyptian Expedition since 1913. Wilkinson also cleared Howard Carter's long-empty house nearby, since Carter's will had left the property and its contents to the Museum upon his death in 1939. Both houses were handed over to the Egyptian Service des Antiquités – still headed by a French Egyptologist, Emile Drioton, but increasingly run by a new generation of Egyptian Egyptologists.[2]

Dozens of albums and thousands of glass-plate negatives from Burton's photographic studio at the dig house made their way across the Mediterranean and the Atlantic to

[1] Penelope Fox, 'Photographs of the Tutankhamun Finds', report to the management committee of the Griffith Institute, 24 January 1952, plus relevant invoices (GI/NYMMA: Acquisitions MMA photogr. TUT Corres. 1951).
[2] Reid, *Contesting Antiquity,* 263–94.

New York – together with some 500 Tutankhamun negatives (and other material) that Wilkinson retrieved from 'Castle Carter'. They were going home, as the Museum saw it, and they would have to be made at home in the Egyptian Department somehow. That was what prompted the most junior member of the Department, Nora Scott, to get in touch with the Griffith Institute in the first place, initiating the process that would see the albums cross the ocean twice more. The plan was for Penelope Fox, in Oxford, to compare the Museum's prints with the Institute's negatives. The inconvenience, expense and the hours of work involved would be worth it, they reasoned. Knowing which institution had which photographs, and coordinating to ensure that the photographic record of the famous tomb was complete, would facilitate future research on the tomb and its objects. Egyptologists were aware that Carter had failed to produce a definitive scholarly publication of the tomb, which remained an unmet goal to those few people who still had some connection to the excavation, like Alan Gardiner. Sorting out the prints and negatives was not work for an Egyptologist like Gardiner to undertake, however. It was for clerical staff like Fox and Scott (whose title at the time was research fellow, not curator) – women's work, and with a woman's deadline, since Fox was engaged to be married in a few months and would be leaving her post as a result.

Ocean liners, customs duties and wedding plans may seem far removed from ancient Egypt or the tomb of Tutankhamun. But a fine mesh caught the personal, the professional, the political and economic, and the technological – snaring together entities as seemingly diverse as the registrar of marriages; international shipping and postal services; excise offices; money transfers; and Egyptology past, present and future. It was only through this mesh that the photographic archive from the tomb could move, and in doing so, the Tutankhamun archive was transformed. And continues to be: for all that the very idea of 'archive' seems to assert or aim for fixity, in practice, archives are never fixed and never complete. Archives change over time, not only in terms of what they contain (as new material is acquired or existing material reorganized and reproduced, for example through digital proxies) but also, and as importantly, in terms of how they are stored, worked on and consulted – or even ignored and overlooked. The significance of these archival processes and histories cannot be overemphasized. Our glimpse of crated photograph albums cruising with Cunard across the Atlantic is not just another anecdote in the tangled history of Tutankhamun's tomb. Rather, it marks a fundamental stage in the making of meanings about the tomb, its photographs and the role Egyptology and archaeology have played in modern history.

This chapter follows the trajectories of the Tutankhamun photographs through the diaries, correspondence, reports and photographic objects housed today in the Griffith Institute in Oxford and the Metropolitan Museum of Art in New York. These wider, documentary archives provide the tools needed to excavate the photographic archive itself, to borrow the metaphor Jennifer Baird and Lesley McFadyen deploy in analysing the formation and use of archives within archaeology.[3] It is an apt metaphor, given that the most influential theoretical treatise on archives, Jacques Derrida's *Mal d'archive*

[3] Baird and McFadyen, 'Towards an archaeology of archaeological archives'.

(Archive Fever), engaged explicitly with Sigmund Freud's own archaeological metaphor for the stratification of history and memory.[4] In the culminating sections of *Archive Fever,* the 'Theses' and 'Postscript', Derrida reflects on Freud's dream analysis of a fictional character, the archaeologist Hanold from Wilhelm Jensen's 1902 novel *Gradiva.* Hanold suffers from archive fever, says Derrida, because he dreams of 'reliving the other' and thus reaches the limits of archaeology, a science 'committed to the production of archival evidence of the most solid, material kind'.[5] What that solid, material evidence cannot yield is the past itself – only a representation, an imprint like the plaster cast Hanold sees in a museum or, for that matter, like the traces of light transmuted into a photograph.

In the next section, I consider further some of the theoretical implications of the archive for archaeology and photography. This discussion underpins my argument that archival practices are inseparable from photographic practices and that the archive, as an ongoing process, is one of the means by which disciplinary identity is formed and sustained – and with it, the dream of reliving ancient Egypt as an almost-other of Western culture. The following sections of the chapter trace the history of the Tutankhamun archives from Carter's death to the early 1960s, when the last member of the team (as they were styled), Sir Alan Gardiner, died in Oxford. That was the point at which the excavation fell out of Egyptology's living memory, and it provides a more or less natural caesura before the development of the Tutankhamun touring exhibitions in the 1960s and 1970s, whose use of the photographs and implications for the archives are taken up at the end of the book.

Occasional ruptures in this timeline are inevitable because the archival voices themselves often make explicit reference to past actions or agreements, including the original excavation. The sequential structure adopted here helps reveal the rationales marshalled over time for the care of the Tutankhamun photographs. It also demonstrates that archaeological archives, broadly conceived, have a historical value not only as documents and images connected to a specific excavation, but also as documents and images connected to significant academic, economic and political developments over the course of the colonial and post-colonial eras. Howard Carter's records of the Tutankhamun excavation were donated on the eve of the Second World War, whose aftershocks accelerated decolonization in the global south of former colonial and imperial territories, while Penelope Fox and Nora Scott's post-war efforts to reconcile their respective collections coincided with the specific unravelling of British authority in Egypt in the early 1950s. It is only by delving through the strata that have accumulated over and around the Tutankhamun photographs, and their respective archives, that we can observe their implication in changing regimes of value, from the disciplinary and evidentiary, to the financial and legal, to the political and representational. Archives matter, but not for the reasons archaeologists usually think.

[4] Derrida, *Archive Fever.*
[5] Derrida, *Archive Fever,* 83–101, 'reliving the other' quote at p. 98. The second quotation is from van Zyl, 'Pscyhoanalysis and the archive', 57. See also Downing, *After Images,* 102–3.

In the mirror: archive, archaeology, photography

A researcher can see, and hear, a lot in an archive; more, perhaps, than she is meant to. In the course of research for this book, I spent a great deal of time in archives – primarily the Griffith Institute in Oxford and the Metropolitan Museum in New York, but several other Egyptology-related archives in continental Europe and the UK as well. As I realized that the Tutankhamun archive was itself becoming the subject of this book, I could not help but reflect on my own participation in it as a researcher, and to contemplate the way that seeing and handling photographs, and simply being in an archival space, continues to shape what we can and cannot say about the present and the past.[6]

Conversations I took part in, or overhead, in the course of this research were sometimes unexpected but, in retrospect, illuminating. One batch of files said nothing about photography, I was assured by someone who had already been through them. Yet I came away with more than 30,000 words of notes and transcriptions that seemed to me to be about photography: what, I wondered, had other archive users been conditioned to think 'photography' looked and sounded like? Another institution had recently catalogued the personal papers of an Egyptologist who had been extremely well connected in the field. His papers yielded 'nothing interesting', a staff member said, which turned out to mean that his copious correspondence and diaries did not detail ancient sites or inscriptions. At a third archive, I joined a tour of visiting Egyptologists, during which we were shown a formal photograph of Service des Antiquités staff from the late 1930s, each official sharply dressed in a Western suit and a *tarbush*, their names neatly calligraphed in Arabic script, row by row. Some of our group marvelled at these features. From their comments and reactions, they seemed to assume that the presence of so many Egyptian men, and the inclusion of Arabic, was an anomaly, perhaps a kindness granted by one of the only Europeans in the photograph: Carter's old nemesis, Pierre Lacau, head of the Service until 1936. But Lacau himself had always been well aware that he worked in a department of the Egyptian government, and an official photograph of state employees in the 1930s was bound to include *effendiya* and Arabic. The group's surprise surprised me. Perhaps it shouldn't have. Historic photographs normally appear in Egyptological publications or conference talks only to illustrate an unproblematic past, or else to characterize archaeology from that past as either 'scientific' or 'unscientific'. This distinction, which is never questioned, is based on retrospective judgements about the extent and nature of the notes, drawings and photographs archaeologists made at the time. At one Egyptology conference I attended while writing this book, a doleful sense of 'what might have been' swept over the lecture hall whenever a speaker – often using an old photograph – lamented that the archives of past work on his or her site (I use the possessive advisedly) were not thorough enough, until the next slide moved us on to more modern, more 'scientific', methodologies, with palpable relief. Now we would get to ancient Egypt – without catching Hanold's archive fever.

[6] Thus also Rose, 'Practising photography'.

If Egyptologists today see themselves reflected in excavation archives, in other words, it is often selectively and in a freshly polished mirror, all surface and no depth. But the archive is always a glass seen through darkly. Like the sheen, known as mirroring, that appears on the surface of ageing silver gelatin prints, archives draw attention to areas of decay. For this reason, even brimming or expanding archives paradoxically trigger anxieties about loss – the loss of evidence, and with it, the potential loss of history, memory and identity. Where would we see ourselves then? The archives of Egyptology help define, for its practitioners, what Egyptology is and help determine what it does, especially since these archives remain for the most part within the care of sponsoring institutions (like the Metropolitan Museum) or institutions dedicated to the subject in other ways (like the Griffith Institute). This can make it difficult for anyone, within or without a discipline, to write critically grounded and aware histories. As Brusius points out, many archive holders 'would rather not see their own disciplinary histories debated by others', or, indeed, by an insider (which, as an Oxford-trained Egyptologist, I am, or perhaps was).[7] An ethnography of the archive – as Nicholas Dirks proposed – is desirable, even necessary, if any researcher entering an archive is to avoid the pitfall of seeing archives as anything other than an accretion of documents and images shaped by actors, interests, and contingencies over time.[8] Archives are not neutral.

As knowledge formations, professionalization standards and political landscapes shifted over the course of the twentieth century, so too did the conceptualization of archives like the Tutankhamun records, and just as importantly, the day-to-day work of looking after them. I argue here that archives have not passively reflected wider changes but have actively contributed to them, thanks to the constitutive role that archives play in disciplines like archaeology (in which I include Egyptology) that were intrinsic to colonialism and imperialism in the Middle East. Egyptology today has a significant popular presence – itself in large part due to the successful marketing of king Tut over the past century – but has struggled to see the extent and implications of its colonial embeddedness.[9] This is not for the absence of the colonial in the archive, like those *tarbush*-wearing antiquities officials or the transport systems that allowed photographic supplies to be shipped with such ease between London and Luxor. Rather, it is a systemic failure to use archives critically – to see through the mirror, as it were, rather than gaze upon admiring reflections. For if archives are not examined and understood as the contingent, constructed and colonial collections that they are, then it is impossible to move beyond the positivist enterprise through which they were first formed.

Since the selection, organization and deployment of archives in colonial – and later, decolonizing – contexts is embedded in ontological and epistemological concerns, critical histories of colonial projects have much 'to gain by turning further toward a politics of knowledge that reckons with archival genres, cultures of documentation, actions of

[7] Brusius, 'Hitting two birds with one stone', 385.
[8] Dirks, 'Annals of the archive'.
[9] Riggs, *Unwrapping Ancient Egypt,* esp. 7–19, 32–5, 201–26; see also Carruthers, 'Introduction: Thinking about histories of Egyptology'; Elshakry, 'Histories of Egyptology in Egypt'; and Colla, *Conflicted Antiquities,* for its overall approach.

access, and archival conventions', as anthropologist and historian Ann Laura Stoler has argued.[10] Such a politics of knowledge has been notably, and regrettably, lacking in archaeology in general and Egyptology in particular. Yet archaeological archives, and their hundreds of thousands of photographs, must be among the most substantial – and significant – archives formed during the colonial era and thus require informed critique. In part because excavation records are taken for granted as part of archaeological method, archaeologists tend to treat archives as sources of documentation and 'stable repositories of trace', rather than constructions that are implicated in archaeology's own history and practices.[11] This approach is also a function of a persistent positivism that characterizes the study of ancient Egypt in particular, as if there is a directly accessible past, a tangible 'ancient Egypt', if only we look hard enough. In its materiality, the archive echoes the materiality that is central to archaeological methods of collecting and analysis, but disciplines that study antiquity seem able to separate ancient from more recent history, as if the two were unrelated. Like artefacts in museums, however, the daybooks and photographs in excavation archives are inscribed with interlinked histories, in layers of field and museum numbers, carbon copies and Post-it Notes produced as generations of hands have worked through archives to organize the past and shape the future.[12]

To challenge empirical (and imperial) positivism and shape an alternative engagement with Egypt past and present, the archive must be both the site and the subject of research. The trajectories of the field and photographic records from the Tutankhamun excavation demonstrate that a physical archive, its creation and curation, and its distribution and digitization serve to sustain disciplinary formations and identity – and by extension, a range of assumptions rooted in the colonial era. Research *in* the archive and *on* the archive requires attention both to the top-down effect of institutional processes on the formation and the form of an archive, as well as bottom-up decision-making about what to record, what to keep and what to do with the results. Inclusion and absence result from each. These processes are so naturalized in archival – and archaeological – practice that they appear self-evident, contributing to 'tacit narratives' of professional proficiency.[13] Unspoken expectations govern ideas about what an archaeologist should record and what an excavation archive should thus contain. Anything less or different constitutes an inadequate, hence 'unscientific', record or an archive deemed to lack interest because it does not address what a researcher thinks or hopes it will.

That is why archives, in Stoler's well-known formulation, need to be read both along and against the grain.[14] Photographic archives must also be viewed from a vantage point that encompasses inside and outside, since images circulate beyond the archives that nominally contain them – as we have already seen with *The Times*-licensed press coverage of the Tutankhamun discovery, and as we will continue to see throughout this book, which

[10] Stoler, 'Colonial archives', 88.

[11] Baird and McFadyen, 'Towards and archaeology of archaeological archives', 25.

[12] Riggs, 'The body in the box'.

[13] Ketelaar, 'Tacit narratives'; see also Cook and Schwartz, 'Archives, records, and power' and Yakel, 'Archival representation'.

[14] Stoler, 'Colonial archives'; Stoler, *Along the Archival Grain.*

follows Burton's (and others') Tutankhamun photographs into our current digital age.[15] This is one of several complications that photographic archives raise in archival theory and historical practice, together with issues of multiplicity. Conventional archival theory and practice have struggled to accommodate visual materials in general and photography in particular, as Joan Schwartz has argued.[16] With few exceptions (like the daguerreotype), photographs are not unique objects, and were not designed to be. The usefulness of the technology was its reproducibility, thus the same photographic image can exist in several archives at once, or multiple versions of it may be found in one archive.[17] Understanding the stratigraphic or familial relationships, between different positive and negative permutations of a photograph is a form of visual literacy and technical knowledge that has not been prioritized in either archaeology or in archives.

In the archaeological fieldwork of the early twentieth century, archival practices and photographic practices were built into each other: camera work may have involved some uncertainty, and trial and error, but it was undertaken with ideas in place about the use of the photographs and the immediate care of both negatives and prints. In the resulting photographic archives, research requires a certain amount of stratigraphic work to see the accretion of organizational layers, and with them, layers of meaning. The enduring myth of photographic objectivity, however, presents an obstacle to such work and helps explain the paucity of critically informed studies of photography in archaeology and Egyptology.[18] To Penelope Fox, Nora Scott and their colleagues, the subject matter of the Tutankhamun photographs – what the surface of the prints or (in reverse) the negatives showed – was ostensibly their chief value, and certainly the source of their educational value. However, the photographs had other values as well, whether expressed in blunt financial terms for insurance purposes, or implied by the extensive efforts made to bring 'home' the photographic materials left in Egypt and reconcile them with what Carter's niece had donated to Oxford in the meantime. Photography was just as central to Egyptological epistemology and authority in these later archival stages as it had been at the photographs' point of origin – and thus central to the field's very conception of itself.

Both archives and photographs are deeply implicated in memory and its counterpart, forgetting.[19] As Elizabeth Edwards has argued, drawing on historian Pierre Nora's conceptualization of *lieux de mémoire,* the archive functions in modernity as a form of

[15] Thus also Hayes, Silvester and Hartmann, '"Picturing the Past" in Namibia'; Hayes, Silvester and Hartmann, 'Photography, history and memory'; Hevia, 'The photography complex'.

[16] Schlak, 'Framing photographs, denying archives'; Schwartz, '"We make our tools and our tools make us"'; Schwartz, '"Records of simple truth and precision"'; Schwartz, 'Coming to terms with photographs'.

[17] See Edwards and Morton, 'Between art and information', who suggest the inter-generational family as a metaphor for photographic reproductions; see also Riggs, 'Photography and antiquity in the archive'.

[18] See further Bohrer, *Photography and Archaeology,* 726, 4164; Guha, 'Beyond representations'. On objectivity and photography, see Daston and Galison, *Objectivity,* 125–38, 161–72; E. Edwards, 'Tracing photography', 161–72; Tucker, *Nature Exposed;* Tucker and Campt, 'Entwined practices'.

[19] Bate, 'The memory of photography'; Cross and Peck, 'Editorial: Special issue on photography, archive and memory'; Hayes, Silvester and Hartmann, '"Picturing the Past" in Namibia'; Hayes, Silvester and Hartmann, 'Photography, history and memory'; and the influential argument in Sekula, 'Reading an archive'.

externalized communal memory – with the corollary and caveat that its exclusions, gaps and oversights are as significant as what an archive actually contains, if not more so.[20] Undoubtedly, some theorizations of the archive have overstated its totalizing effect and the structuring power of classificatory systems, in the process blurring the differences between the metaphorical Archive embraced in cultural theory and its lower-case cousin, the documents, filing systems and institutions out of which history is written.[21] But this ambiguity can be productive, not least in encouraging both the owners and users of archives to reflect on the systems and patterns that archives do perpetuate. This is no less important where that perpetuation appears to operate within disciplinary praxis, given the reach and influence a discipline like archaeology has had on everything from popular culture to Freud's psychoanalytic thought. In his 'Freudian impression', the imprint or trace that Derrida figured as inherent to the archive (and, elsewhere, the photograph) recalls Nora's own formulation of memory and archive: 'Modern memory is, above all, archival. It relies entirely on the survival of the trace, the immediacy of the recording, the visibility of the image'.[22] In other words, images are constitutive, not illustrative, of modernity, and archives repay close attention to what they contain as well as what they leave aside. The micro-history that I undertake here confirms that each archive has its own internal logic, and that amid the *realia* of correspondence files and ageing silver gelatine prints, meanings and memories have been ventured, refigured and revived, often mirroring along the way the vicissitudes of the twentieth century.

A share of the spoils

If archives take on new urgency where living memory begins to fade, then March 1939 was a crucial point in the history of the Tutankhamun excavation notes, card index and photographs. Howard Carter died a bachelor in London that month and left his estate to the only child of his sister Amy, Phyllis Walker, who had accompanied him to Egypt in 1931 and helped to nurse him through his final illness.[23] Walker faced several issues with the estate, foremost being a number of Egyptian antiquities in Carter's possession, some of which could only have come from the famous tomb and were therefore in England illegally.[24] But dealing with Carter's notes, photographic material and filed index cards from the excavation was no less a concern. In the summer of 1939, with war looming over Europe, she consulted Percy Newberry on the matter. Newberry advised her that the newly established Griffith Institute would make an ideal home, especially since another Carter acquaintance, Alan Gardiner (who lived in Oxford) was involved in the new Institute as well.

[20] E. Edwards, *The Camera as Historian,* 110–21; Nora, *Realms of Memory;* Nora, 'Between memory and history'.
[21] See Stoler, *Along the Archival Grain,* 45–6, and the different responses (in different ways) explored in Rose, 'Practising photography' and Steedman, *Dust.*
[22] Nora, 'Between memory and history', 13.
[23] James, *Howard Carter,* 452, 458.
[24] For Carter's dealing activities and the arrangements made for his estate, see Reeves and Taylor, *Howard Carter,* 170–85; James, *Howard Carter,* esp. 447–50, 460–1, 469–71.

As it turned out, war would intervene between the Griffith Institute's initial acceptance of the Carter deposit and its arrival in Oxford. In the meantime, and in the immediate post-war climate, a new concern had arisen: the Griffith Institute wondered whether it could or should own the Tutankhamun records – and specifically the photographs – at all. Protracted worries over questions of image copyright, as well as the stance the Egyptian government might take, suggest that the 1920s conflict over the tomb was well remembered in British academic circles, even though the relevant parties avoided explicit mention of it. Anxieties about what claim Egypt potentially had on the records also speaks to the shift in geopolitics in the Middle East during and after the war, and specifically the changing management of archaeology in Egypt itself. Although still headed by Drioton, the antiquities service of the 1940s was markedly different than the 1920s. The Egyptian government had made a concerted effort to train and promote indigenous scholars, appointing Selim Hassan as assistant director in 1936.[25] It was a moment of transition, and the choices that the Griffith Institute and, separately, the Metropolitan Museum made concerning their respective share of the Tutankhamun records arguably helped shape the direction of mid-century ideas about the position of 'ancient Egypt' in Europe and America.

In this section, I explore this transition through correspondence in the Griffith Institute concerning Phyllis Walker's donation and the Institute's efforts in the 1940s to establish its legal – not to mention moral, intellectual and financial – position with respect to the Tutankhamun records. Important as the Tutankhamun material was recognized to be, its exact purpose was by no means a certainty in the minds of the academics who found themselves in possession of it. Through the archival correspondence, we see institutional positions, disciplinary values and collective memories taking shape – positions, values and memories which reverberate in the curation and use of the Tutankhamun archives and photographs down to the present day.

The history, management and staff structure of the Griffith Institute are an important part of this story. The Institute had been set up through a bequest of Francis Llewellyn Griffith, the university's first professor of Egyptology, with the aim of promoting the subject at Oxford.[26] Griffith left his own excavation records and correspondence to the Institute, along with investments to fund it. The Institute also became the home of an encyclopaedic (and ongoing) project known as the *Topographical Bibliography of Ancient Egyptian Texts, Reliefs, and Paintings,* which Griffith initiated in the 1920s and a later professor described as the 'Scotland Yard of Egyptology'.[27] Although the 'Top Bib', as it is known in Egyptology, did not commission photographs specifically for its bibliographic work, it made use of them, alongside drawings and other site documentation. Thus, the Institute from its origins was attuned to images as tools from which to extract information – in its case, primarily ancient inscriptions. From 1939 until 1999, the Griffith Institute shared space

[25] Reid, *Contesting Antiquity,* 279–91; Goode, *Negotiating for the Past,* 119–26.

[26] There is no published history of the Griffith Institute, but see Simpson, 'Griffith, Francis Llewellyn', as well as James, 'Moss, Rosalind' for biographies of two pivotal personalities involved in its founding and operation.

[27] History, downloadable files, and online presentation at http://topbib.griffith.ox.ac.uk//project.html. 'Statues' were added to the title, and remit, of the project for the publication of Volume 8: http://www.griffith.ox.ac.uk/gri/3statues.html.

with the Ashmolean Museum library in an extension to the back of the museum; both were rehoused in 2001 in the Sackler Library constructed on the same site. From its founding, the Institute has been governed by a Management Committee comprising selected staff of the Ashmolean Museum, Oxford University academics, and other UK academics or museum curators active in Egyptology or the study of the ancient Near East. Since the late 1990s, leadership of the Griffith Institute has taken the form of a Directorship that rotates between Ashmolean curators and academic staff in the Faculty of Oriental Studies. Previously, the museum's Keeper of Antiquities held this role *ex officio* with the title of Secretary, answering (like today's Director) to the Management Committee. The Institute was set up at a time when university museums and academic teaching and office space were less rigidly separated from each other in physical and administrative terms, although these were always in flux. The Secretary was expected to fit his (the appropriate pronoun) oversight of the Institute into the duties of his primary, salaried post. In this, he had the support of a full-time Assistant Secretary at the Institute, a clerical post always held by a woman.

On 29 August 1939, it thus fell to the first Secretary of the Griffith Institute, Anglo-Saxon specialist Edward Thurlow Leeds, to acknowledge the receipt – on loan – from Phyllis Walker of '[t]wo green painted steel filing-cabinets containing card-indices, photographic records and other manuscript material, referring to the excavations of the Tomb of Tut-ankh-amen, and compiled by the late Mr. Howard Carter'.[28] In May 1945, Walker moved to make this loan a formal gift, and to add to it the glass negatives and lantern slides still in storage in London's East End, where they had escaped bomb damage. She wrote to Alan Gardiner, who sat on the Institute's Management Committee, expressing her wish that all of Carter's Tutankhamun records be 'presented to the Ashmolean Museum as a memorial to him and his work'.[29] An archive could function as a repository of memory in many ways.

However, the visitors who comprised the Ashmolean's governing body had reservations about accepting the donation, as did Leeds himself. Their concerns were articulated around the issue of copyright in the photographs that were being added to the existing loan, with everything reconfigured as a gift. As early as 1941, Leeds asked Percy Newberry to clarify who owned the copyright and could therefore give permission to reproduce the Burton images; Newberry replied that the copyright was Walker's, as Carter's heir. In 1943, Newberry and Gardiner discussed the matter over lunch in London, at which point Gardiner offered to buy the copyright for £200 and donate it to the Ashmolean. Newberry passed this offer on to Walker, who declined on the grounds that the museum already held the copyright – apparently unaware that they thought the copyright was hers.[30] In June 1945, Leeds wrote to the director of the British Museum, Sir John Forsdyke ('Dear Forsdyke', was Leeds' opening to his old acquaintance). Being head of a national museum

[28] Typed receipt, 29 August 1939 (GI/Carter 1945–6).

[29] Letter from Walker to Gardiner, 10 May 1945 (GI/Carter 1945–6).

[30] In 1944, Percy Newberry detailed these earlier exchanges in a memorandum for Gardiner, which Gardiner then gave to Battiscombe Gunn, the Professor of Egyptology at Oxford University. The memo, with Gunn's pencilled annotations, is in GI/Carter 1945–6, together with other correspondence referred to here.

gave Forsdyke considerable authority in the hierarchy of British museums, hence Leeds asked him for advice about copyright – specifically whether the Egyptian government might have a claim:

> The Egyptian Government, as I understand, purchased the whole of the collections including Lord Carnarvon's share of the spoils, but they do not appear to have made any attempt to secure the records, and at the initial stages of the offer of the gift I was given to understand that the copyright would pass to the Museum, since the records were entirely the property of Howard Carter. The question really is, has the Egyptian Government any right over the records for the purposes of the Service des Antiquités?[31]

Forsdyke replied swiftly and confidently ('Dear Leeds'), though not correctly, that copyright in photographs and manuscripts belonged 'to the person who paid for them to be made', which would be the Carnarvon family. He thought it unlikely that they were part of Carter's settlement with the Egyptian government and advised that the university should assert its own copyright. In any case, he added in handwriting, a penalty for breach of copyright would only be relevant if the images were used commercially: 'Nobody is likely to make money by publishing this material – more likely to lose it'.[32]

A month after receiving Forsdyke's reply, Leeds contacted Gardiner, saying that the Visitors of the Ashmolean were still 'hung up' about copyright questions should they accept the gift.[33] To Leeds and the Egyptologists involved in managing the Griffith Institute, the question of image copyright bled into the question of whether and how to publish the Tutankhamun material, which seems to have presented both an anxiety and an obligation. Consensus among Egyptologists, especially in Britain, was that Carter had failed to produce an adequate publication of the tomb, along the lines he himself had often hinted was in the works. Leeds had heard second-hand reports that Drioton considered it an *'obligation d'honneur'* for someone, somewhere to produce a definitive study of the tomb of Tutankhamun. But if the Griffith Institute, now that it had the Carter records, were to do this, 'might [it] give the Service a definite lien' on them, as Leeds voiced his concern to Gardiner: 'I have never been clear in my mind as to the position in which the Egyptian Government stood, or may stand, in relation to the documentary material covering the excavation of the tomb'.[34] It was not only past agreements or expectations that were at issue here, but a sense of instability in present-day relations with the Egyptian authorities, who were, in the mid-to-late 1940s, exercising ever more autonomy.

The copyright question also indicates the extent to which the Tutankhamun photographs, and other records of the excavation, were seen by scholars in the post-war years as equivalent to, or inseparable from, the tomb artefacts. What had not occurred to Carter or the Service des Antiquités in the 1920s now occurred to Leeds, Newberry and Gardiner: did the Egyptian government and its antiquities arm have a moral or legal claim

[31] Letter from Leeds to Forsdyke, 8 June 1945 (GI/Carter 1945–6).
[32] Letter from Forsdyke to Leeds, 15 June 1945 (GI/Carter 1945–6).
[33] Letter from Leeds to Gardiner, 19 July 1945 (GI/Carter 1945–6).
[34] Letter from Leeds to Gardiner, 19 July 1945 (GI/Carter 1945–6).

on the images and index cards as well? And if not (or if such a claim was not forthcoming), was there anyone else who might? The obvious answer to the last question was yes: the Metropolitan Museum of Art in New York, with whom the Griffith Institute seems not to have been in touch about the Tutankhamun material until 1946, sparked – as many things were – by a tip-off from the well-networked Newberry. In October 1945, Leeds heard from retired Oxford professor of ancient history John Myres, who had heard from Newberry, that Belgian Egyptologist Jean Capart was preparing a second edition of his 1923 book (in French) on the tomb of Tutankhamun. The first edition had been illustrated with Burton photographs copied and adapted from the *Illustrated London News* and Carter's *Tut. Ankh.Amen* books.[35] For the new edition, Capart first approached the Metropolitan Museum, Newberry explained, who had said they could not give permission to publish the photographs since copyright was held by Carter's heir. This satisfied Leeds, who recounted the entire exchange in a handwritten memorandum for the Griffith Institute, as if he could not let his worries over copyright and publication rest.[36]

Leeds retired in 1945 and was succeeded as Keeper of Antiquities (and thus Secretary of the Griffith Institute) by Donald B. Harden, a Roman glass specialist and able, amiable administrator.[37] Harden took up the copyright matter directly with Capart, and the Belgian scholar supplied copies of his own exchanges with Ambrose Lansing, curator of the Metropolitan Museum's Egyptian department. Lansing had explained to Capart that the Metropolitan had a 'duplicate set of negatives' for its own use and that it could only permit publication of prints with the permission of Carter's heir, Phyllis Walker. With the Metropolitan correspondence in hand, Harden wrote to reassure Capart about the Ashmolean Museum's own intention: it had long been the practice of the antiquities department to levy a small charge for supplying a print and to request an acknowledgement 'by courtesy of the Ashmolean Museum'. 'It was no more and no less than this that we wished to reserve for ourselves in the matter of the Howard Carter copyright', Harden explained, concluding, 'I do hope this will clear up the matter and make you believe that we are not grasping or monopolistic'.[38] Charging for photographs was a matter of professional and academic honour, evident in Harden's soothing tone and emphasis on the museum's financial disinterest in the images.

But photographic objects did have a financial value, as Harden himself had to concede when he arranged the long-anticipated transfer first of Carter's glass negatives and later the lantern slides. This took place in the spring of 1946 – almost seven years after Walker had first offered her uncle's Tutankhamun records to the Institute. Harden instructed a firm in Oxford's Turl Street to collect three large and ten small cases from the Mincing Lane depository in the East End and deliver them to the Ashmolean. As if organizing the insurance had reminded him of what could go wrong, Harden described the case contents to the transport firm in words that rely on the aura of Tutankhamun and assert the specific value of photographs as evidence:

[35] Capart, *Tout-ankh-amon*.
[36] Dated 10 October 1945 (GI/Carter 1945–6).
[37] See Hurst, 'Donald Benjamin Harden 1901–1994'.
[38] Letter from Harden to Capart, 14 December 1945 (GI/Carter 1945–6).

You will, however, I know, take every precaution with these negatives as they are irreplaceable should they get damaged or lost. For your information, they are the original photographs taken during the excavations on the tomb of Tut-ankh-amen in Egypt, and therefore a priceless record of the original condition of the objects found therein.[39]

The arrival of some 990 glass negatives and more than 500 slides in Oxford coincided with the first communications between the Griffith Institute and the Metropolitan Museum regarding the Tutankhamun material. Thanks to the Capart quandary, Harden began to correspond directly with Ambrose Lansing about their shared interest in Burton's photographs, since these, unlike the notebooks and index cards in Oxford's possession, were believed to be held as two 'duplicate' sets. Lansing explained that the Metropolitan Museum used Burton's photographs in lantern slide lectures and 'educational publications', as agreed with Carter and confirmed by Walker; only if an image were to be used 'purely to promote the sale of a book' did they bother Miss Walker for further permissions. Lansing thought copyright in the Burton photographs was likely to become less of an issue because the Egyptian Museum in Cairo now sold its own prints of the objects and allowed visitors to photograph them in the galleries without charge. In other words, Lansing assumed that the interest lay in the subject of the photograph, not in whether the photograph was one of Burton's or dated to the time of the discovery.[40] Harden replied to explain, as he had done to Capart, that the Griffith Institute charged only the cost of a print if its use was educational, but would levy a copyright fee for commercial use. If the Griffith and the Metropolitan Museum adopted the same approach, each should then keep whatever fees they earned in this way from the photographs.[41]

This was, Lansing replied, 'a logical solution', adding that 'both objects *and records* should be considered as for the information of the public *and if the popularization of ancient Egypt is one of the results so much the better*' [emphasis added].[42] From the American's perspective, more than a copyright fee was at stake: encouraging the public to take an interest in ancient Egypt could only benefit Egyptology and its institutions. Lansing seems to have hit on the specific appeal photographs could play in this, whether through illustrated books and lectures, or through postcard sales and tourist snapshots. The point was not inconsequential, given that the decade following the Second World War saw Egyptology sidelined in many museums, for different reasons. In the United States, civic museums established to bring 'art' to the urban masses – the Metropolitan in New York, the Boston Museum of Fine Arts and the Art Institute of Chicago, for instance – were questioning whether ancient Egypt fitted comfortably into 'fine' arts, and sought to reduce the size of their collections by sale or transfer. In the UK, where many collections, including the Ashmolean's, had been stored off-site for safety, factors including

[39] Harden to Charles Scott's Road Service, Oxford, 25 April 1946 (GI/Carter 1945–6).
[40] Letter from Lansing to Harden, 23 January 1946 (GI/Carter 1945–6).
[41] Letter from Harden to Lansing, 31 May 1946 (GI/Carter 1945–6).
[42] Letter from Lansing to Harden, 7 June 1946 (GI/Carter 1945–6).

post-war austerity, the delayed arrival of a modernist display aesthetic, and a turn, in regional museums, towards local archaeology similarly cast doubt on whether, where and how ancient Egypt belonged in the public eye.[43] And in continental Europe, German Egyptology, which had long dominated study and publishing in the field, was shattered by the war, the exile of Jewish and resistance scholars, and the taint of Nazism among several scholars who remained in, or were restored to, their posts.[44] Wherever they were based (including Egypt), Western Egyptologists trained in the interwar years must have wondered, like Lansing, what might help secure the future of their field in these uncertain times.

Was Tutankhamun a possible solution? It was worth a try: in 1947, the Ashmolean displayed a selection of Burton's photographs on the bare interior walls of the sandstone Shrine of Taharqa, which dominated one of the museum's ground-floor galleries.[45] This was one of several photography exhibitions the Ashmolean's antiquities department ventured in the late 1940s, some of which proved extremely popular – although whether the Tutankhamun exhibition was one of these, is not mentioned in museum reports. No academic institution wished to seem 'monopolistic' or money-driven, as Harden had been at pains to make clear to Capart, but the potential of photographs to play an explicit role in promoting an institution or a subject (and generating income) was becoming clear. Questions of copyright, insurance value and competition from other image sources, like the antiquities museum in Cairo, meant that directly or indirectly, finance was now linked to these photographic objects in a different way than it had been in the 1920s, when *The Times* contract and the cost of Burton's time and supplies were the primary concern. With the arrival of the negatives and lantern slides in Oxford, and fruitful lines of communication opened between the Metropolitan and the Griffith, the idea began to take shape that – if properly organized – the two photograph collections might help Egyptology meet its scholarly aims as well as its populist ambitions, two aspects of the discipline that have always been intertwined.

Lansing and Harden thought it would be straightforward to coordinate research and publication strategies on either side of the Atlantic, a collegial undertaking to the benefit of both. Their institutions each had a duplicate set of the Tutankhamun photographs, or at least that was what each understood based on a collective memory, and received wisdom about how Burton had carried out photography at the tomb. Memory was fallible, however, and photography was a technology characterized by replication and multiplication, which was not at all the neatly contained, 'duplicate' set of records that Lansing and Harden had in mind. As the next section will show, any excavation of the archive means seeing several strata of time at once – and taking seriously the numberings, search tools and systems by which caretakers have tried to give shape to the archive which, in turn, shapes them.

[43] See Stevenson et al., 'Introduction – object habits'; Stevenson, *Scattered Finds*.
[44] Schneider and Raulwing (eds), *Egyptology from the First World War to the Third Reich*.
[45] Ashmolean Report (1947), 5.

Doubling up

In the press and in academic publications, those directly involved in the Tutankhamun excavation had always emphasized the collegiality of the team members and their single-minded dedication to science. But by 1945, only a handful of the British participants were still alive (Gardiner, Newberry and Alfred Lucas, who died that December), while those most closely involved from the Metropolitan Museum (Burton, Albert Lythgoe and Herbert Winlock) had died. To understand why Lansing and Harden assumed they had identical sets of photographs, and why Lansing fully expected this to be the case, I present three glimpses into the archives of both the Griffith Institute and the Metropolitan Museum. These snapshots, as it were, criss-cross time and space from the 1920s to the 1940s and between Egypt, Oxford and New York. In doing so, they show how even 'facts' are lost in archives, and how archival practices strive for a fixity that belies the fluid arrangements through which the Tutankhamun photography took place – not to mention the contingencies that inevitably characterize the archival processes of numbering, ordering and accumulation. In this way we will return, with the third glimpse, to the photographic objects themselves.

The first glimpse is a black-bordered memorial service card from The Queen's College, Oxford, dated 1945 and paper-clipped to an (apparently) unrelated letter in the Griffith Institute archives.[46] On the back of the card, Percy Newberry pencilled a note about Herbert Winlock's reaction to the settlement Carter had negotiated on Lady Carnarvon's behalf in 1930, which saw the Egyptian government pay her almost £36,000 in compensation for the excavation costs. According to Newberry's information, Winlock was bitter that Carter had not secured or offered any compensation to the Metropolitan for its substantial contribution to the dig, which included not only Burton's ten years of photographic work but also Arthur Mace's full-time dedication in Seasons 1 and 2, and Lindsley Hall and Walter Hauser's drawings in Season 1. The note alleges that Winlock sought reimbursement directly from the Egyptian government himself, without success. It is a surprising claim, since Winlock never publicly expressed dissatisfaction with the outcome of Carter's negotiations; however, the accuracy of the account is in many ways less important than what it reveals about old resentments, score-keeping and bill-tallying in the 'disinterested' science of Egyptology. Newberry subsequently typed up the note, naming Lucas as his source, and kept it in his copy of Carter's privately printed *Statement* of 1924.[47]

The second glimpse comes from Ambrose Lansing's correspondence with Capart and Harden about the question of copyright in Burton's Tutankhamun photographs. Faced with two sets of photographs that were presumed to be identical or equivalent, how could Oxford and New York respect each other's ownership and not overstep the rights of

[46] *In memoriam* Hermann Georg Fiedler, Taylor Professor Emeritus of German Language and Literature, for a service to be held in The Queen's College, 28 April 1945 (GI/Carter 1945–6). I thank Francisco Bosch-Puche for checking this information for me in the archive file.

[47] Blue sheet of paper with typewritten notes, 2 July 1939, emended in pencil by an unknown hand on 10 October 1945 to say that it was in Newberry's *Statement* (GI/Carter 1945–6).

Carter's heir, Phyllis Walker? Lansing outlined his understanding of the situation in almost identical words, first to Capart in August 1945:

> When the services of Harry Burton were lent to Lord Carnarvon and Howard Carter, the agreement included the specification that the Museum should obtain a duplicate set of negatives for its own use.[48]

And then to Harden at the Griffith Institute over a year later, in November 1946:

> My understanding of the arrangement which Mr. Lythgoe made with Howard Carter is that Burton should do the photography, making duplicate negatives of all subjects, and that these duplicates should come to us.[49]

Neither Lythgoe nor Carter were alive to shed light on their 'arrangement', which was never more (or less) than a gentleman's agreement in any case. Read in light of Winlock's alleged unhappiness at being excluded from the Carnarvon settlement, and keen awareness of how photographs could generate both income and publicity, Lansing's formulation stakes a subtle claim on the Metropolitan's behalf. The Metropolitan had received its own bequest from Carter's estate – several antiquities, plus his Luxor house and all its contents, including further Burton negatives. But in the absence of explicit compensation from Carter, much less any settlement from the Egyptian government, the Museum seems to have retrospectively configured the Tutankhamun photographs it possessed as payment-in-kind for its contribution. In the Museum's institutional memory, the informal and *ad hoc* arrangements between Carter and Lythgoe had taken a definite shape, and Burton's photographic practice as well.

The third glimpse takes us back in time and gives us Burton's own input into the fate of his Tutankhamun photographs. In 1931, when Nora Scott joined the Metropolitan's Department of Egyptian Art as 'Assistant', one of her tasks was looking after the growing number of negatives and photographic prints.[50] When a shipment of large-format glass negatives arrived from Carter, in 'badly dented' tin boxes, Scott drew up a list of queries to be passed on to Burton, in particular to ask his advice about replacing the thirteen negatives that had arrived broken. Burton responded to Scott's queries, via assistant curator Charlotte Clark, three months later: he annotated Scott's list in red ink and enclosed a print 'of Carter's neg. no. 412', so that a replacement negative could be made in New York by photographing the photograph – creating a copy negative.[51] Burton's annotations to Scott's list reveal the different fates his Tutankhamun negatives had met with over the years, at Carter's disposition. Some were in London, at Carter's apartment, while others were with Carter at his house at Gurna, opposite Luxor. Of the latter, Carter gave four negatives to Burton to pass on to New York in due course: three from the 1925

[48] Carbon copy of a letter from Lansing to Capart, 22 August 1945 (GI/Carter 1945–6).
[49] Letter from Lansing to Harden, 13 November 1946 (GI/Carter 1945–6).
[50] Scott's hiring: MMA Report no. 62 (1931), 5.
[51] Letter from Burton to Clark, with enclosures, 6 January 1933 (MMA/HB).

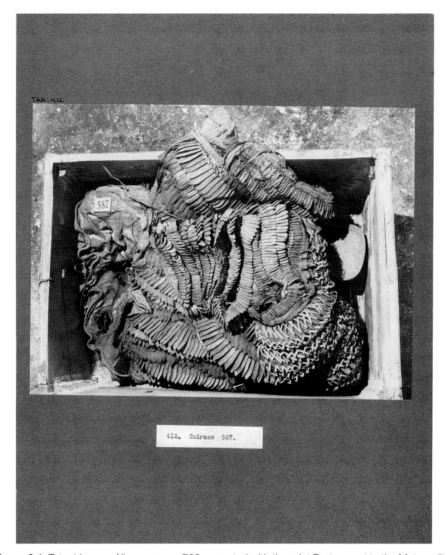

Figure 2.1 Tutankhamun Albums, page 702, mounted with the print Burton sent to the Metropolitan Museum of Art in 1933 as a replacement for lost negative TAA 412.

mummy unwrapping and one with a striking view of the jackal shrine in the Treasury doorway.[52] Burton seems to have followed through, since corresponding original (not copy) negatives are in the Metropolitan collection. The Museum did not, however, take his advice to make a copy negative of no. 412: only the print exists in New York, mounted on an album page like the others and labelled '412' with the prefix 'TAA' the Museum used for its Tutankhamun photographs (Figure 2.1). Carter's own 18 × 24 cm negative, from which this print was made, is now in Oxford and bears the number P1304 instead.

[52] It is difficult to identify these three negatives from the mummy unwrapping amongst the several now in New York. The view of the Treasury may be MMA neg. TAA 54, TAA 54A or TAA 55; the suffix 'A' may indicate that that particular negative is the later addition.

These three glimpses – today in two different archives, and each from a different source – point in their own ways to the centrality of photography not only during the clearance of Tutankhamun's tomb, but in the afterlives of the excavation records, with all the confusion, hassle, potential and responsibility they brought to their respective institutions. Much depended on the idea that each had a duplicate set, as Lansing asserted in his 1945 and 1946 correspondence, and the fact that Burton could substitute for broken negative 412 a print made from a second negative numbered 1304, still with Carter, appears to suggest that this was the case. Two negatives, two numbers – but one subject, one 'record' for archaeological posterity. The photographic objects, and the Metropolitan and Griffith Institute files, tell a different story, however, and in doing so, they highlight how deeply ingrained the idea of the photograph-as-record has been (and remains) in the identity and practice of archaeology – alongside the idea of the 'duplicate', which refers either to images or to objects so similar to each other that no qualitative difference between them exists. Or for that matter, no quantitative difference: the figure of either 1400 or 1850 usually given as the number of photographs Burton took for the Tutankhamun excavation is around half the number of negatives that he in fact exposed.[53] By my own count in the course of this research, Burton took well over 3,000 photographs during the ten-year project; the two archives together contain evidence of some 3,400, including photographs taken by Carter or other, unknown photographers.

Burton himself had explained the problem of the 'duplicate' set in a second letter he wrote to Nora Scott, in January 1934. By the mid–1940s, however, Burton's letter lay overlooked in the museum files. Scott herself may have forgotten his explanation, given everything that had transpired between the early 1930s and the mid–1940s, when she returned to the problem of cataloguing the Egyptian department's photographs. I quote Burton's 1934 comments about the Tutankhamun photographs in full, for it is the most complete statement he ever made about his 'duplicate' negatives and the numbering of the negatives – which had fallen not to him (as it did in his usual work for the Egyptian Expedition) but to Carter:

I saw Mr Carter a few days ago and went into the matter of the Tutankhamen negatives. He said that you have all the red number negatives. The red nos. were put on especially for N. Y. He also said that you have all the duplicate negatives that exist. In some cases the negatives although called duplicates *were not actually so* [emphasis added]. Sometimes a particular object was taken from different positions and the best position was chosen for the regular negative and the other was called a duplicate, although in the strict sense it wasn't so. It wasn't possible for the Museum to have a complete set; the idea was for the Museum to have all the duplicates, and these you have with the exception of the broken ones and these Mr Carter will have made in London, but should there be a delay perhaps you would send him a reminder.[54]

[53] Allen, *Tutankhamun's Tomb,* 12 states 1400; Collins and McNamara, *Discovering Tutankhamun,* 10 gives 1850.
[54] Letter from Burton to Scott, 6 February 1934 (MMA/HB: 1930–5).

Perhaps Burton's succinct explanation meant little to someone less familiar with photographic methods, or perhaps the idea of a duplicate that was equivalent, but not exactly identical, to a similar object was so fundamental to archaeological and museum practice that it was not seen as important. What constituted a 'duplicate' in an excavation archive underscores the primacy of the photographic surface – its subject matter – in archaeological research. At the same time, however, if photography was meant to provide a unique record of the destructive practice of excavation, the idea of the 'duplicate' photograph, like the 'duplicate' artefact, sits uncomfortably alongside the discipline's rhetoric of a unique and fragile material past.[55] The expediency of having duplicates won out: Carter passing on 'second best' negatives to his New York supporters was not so different from how Flinders Petrie divided pottery, scarabs and every other type of find among subscribers to his work, or sold them at public exhibitions to raise funds.[56] The entire *partage* or division system that operated in the colonial-era Middle East worked on similar lines. Artefacts that were ascribed inalienable and supposedly universal values, by virtue of being turned into archaeological objects (in most cases, destined for museums), had also to be conceptualized as interchangeable and exchangeable in order for archaeology to do its work.

Negative numbers

That there were two parallel systems of Arabic numbers was a quirk of Carter's separation of the 'best' (black-number) and 'duplicate' negatives. The red numbers that Burton describes to Scott may survive in red ink on three or four negatives in Oxford and the Metropolitan Museum, while a typed list of the red numbers – its first page well-worn, repaired with sellotape and headed, in an unknown hand, 'Burton's List' – survives in a binder at the Griffith Institute in which other information on the photographs has been gathered over the years.[57] The Metropolitan Museum also has in its archives a partial list on notebook sheets, written in Burton's hand and with the notation, 'H. Carter Photo. Cat. – Keep!' at the top, which the museum has done.[58] The negatives Carter gave to the Metropolitan during the clearance of the tomb, numbered from 1 to 835, are organized with a logic that could only be applied once the clearance was complete, since they are numbered first in order by room (Antechamber, Burial Chamber, Treasury, Annexe), and

[55] Riggs, 'Photography and antiquity in the archive'.

[56] See Stevenson, 'Artefacts of excavation'.

[57] Plates preserving red ink numbers: GI neg. P0113 (13 × 18 cm); MMA negs. TAA 414 and 523 (both 18 × 24 cm). The typed list is in a ring binder, GI/Black, 66–89, giving red numbers up to 835; these correspond to the first 835 TAA numbers in the Metropolitan Museum archive. A follow-on list (GI/Black, 90–109), probably typed by Nora Scott, gives the continuation of the sequence from 836 to 1352; these are the TAA numbers she assigned in New York, as discussed in the rest of this paragraph.

[58] Harry Burton's handwritten list of Carter numbers is housed with the Museum's register of Tutankhamun photographs. It correlates 'C[arter]' numbers and 'TAA' numbers, presumably meaning the black and red numbers, respectively. However, I have not been able to reconcile these handwritten lists with each other in full; perhaps Burton was referring to another list or register.

then by object type, from A to W in English alphabetical order. The 'A' sequence, for instance, includes Adzes, Amulets, Anubis Emblems, Anubis, Aqal and Arrows – an 'aqal', the band that held a Bedouin man's headscarf in place, being used for the twisted textile wreath around the head of the royal mummy. The series ended with Wine Jars and Writing Implements, by way of Vessels (although one had to see 'F' for Faience Vessel and 'S' for 'Stone Vessel'). To this sequence, the museum subsequently assigned numbers 836 to 874 to its share of the large-format glass negatives Burton made in 1932 and January 1933, depicting the shrines re-erected in Cairo and the sarcophagus in the tomb. After the war, when Charles Wilkinson shipped some 500 negatives to New York from Castle Carter, Nora Scott was responsible for numbering them, starting from TAA 875 (up to 1375) and grouping them by subject matter as much as possible. Among these, which were Carter's 'best', there were inevitably black-number negatives as well, some 250 by Scott's reckoning.[59]

The photographic material that had been in Carter's London home reached the Griffith Institute with numbers he had already assigned, unifying his negatives, lantern slides, some loose prints, and – once they followed in 1959 – a set of prints Burton had mounted for Carter in ten albums. These are not necessarily the numbers by which the Griffith Institute has since catalogued the Burton negatives, however, thanks to another quirk of Carter's numbering system. In the first one or two seasons, where a negative showed two or more objects, he assigned black-ink negative numbers to each *object* on the plate, rather than a single number to the plate itself. The black-ink numbers, in his neat script, sometimes survive on the negative, but not always; thus only one number is now used for each negative plate, giving the impression that several numbers in the sequence are missing.[60] To complicate matters further, Carter (or Burton) may also have assigned separate numbers to individual prints, at least on the loose prints that Oxford received from the estate.[61] The multiple numbering of the glass plates carried through to Carter's albums, which isolate each artefact by physically cutting a print down to the individual object itself. Designed as a consultation set, Carter's albums do not contain photographs of objects from the Treasury or the Annex, suggesting that they were compiled before the clearance of the Treasury began in 1926. But the albums do reveal something of the logic behind his sequencing of Arabic numbers, similar to that later applied to the negatives he gave to the Metropolitan. Although there is some chronological structure – photographs taken before the 1924 cessation of the work form one 'lot', with photographs taken when work resumed having higher numbers – the negatives were not numbered by the order in which Burton

[59] A typed note from Scott, enclosed with a letter from Lansing to Harden dated 13 November 1946, describes what sense she had been able to make of the numbers, and gives the 250 figure (GI/Carter 1945–6).

[60] For example, GI neg. P0185, a glass half-plate showing six small stone vessels from box 32, originally had six negative numbers, one for each vessel: negative 185 (for object 32j), 186 (for object 32k), 187 (for object 32l), 471 (for object 32f), 480 (for object 32h) and 481 (for object 32i). In the Griffith Institute's online database, a scanned print made from this plate is catalogued again as GI neg. P0481, preserving one of the 'phantom' numbers – but in the physical archive, the single plate is housed as P0185.

[61] A letter from Harden to Lansing, 22 October 1946 (Carter 1945–6 file) makes this observation, and a handwritten note in an unknown hand notes that loose prints were numbered up to 620, but there were no negatives for photos 337 to 620.

Figure 2.2 A page from one of the photograph albums Burton made for Howard Carter, around 1924: Carter Album 4, page 39, in a section headed 'Vases – alabaster'.

had taken them. Instead, they are grouped by room (clearing the Antechamber), by subject matter (the mummy unwrapping), and, across four of the albums, by object type, using an alphabetical order slightly different than that in the Metropolitan Museum photograph collection – 'Vases', rather than 'Vessels', for instance. In Burton's hand, each print in the object albums has its unique negative number at the top and object number at the bottom (Figure 2.2).[62]

In this sea of numbers and negatives, we may seem far adrift from the tomb of Tutankhamun and the empirical research prioritized by Egyptology. Many people (including myself) have tried to correlate the competing systems of numbers assigned to the negatives at different times, or to determine a more precise logic than the general observations I have been able to make here. Having a complete list of every photograph Burton took, and every negative that survives, is a temptation the archive holds out – then withholds. Perhaps just as well, since striving for a 'total archive' overlooks the larger issues these near-doubled collections raise. As we saw in the three archival glimpses that opened this section, the idea that two duplicate, separate-but-equal sets of photographs existed was a necessary fiction in the relationship between the Metropolitan Museum and the Griffith Institute thanks to earlier, unspoken tensions between the museum and Howard Carter. Notions of pure scholarship and disciplinary unity took precedence over

[62] For more detail on the Carter albums, including a similar set of five albums now in the Universitäts Bibliothek, Heidelberg, see Riggs, 'Photography and antiquity in the archive'.

personal or institutional resentments, with the care of the Tutankhamun photographs helping to foster a sense of shared values and efforts. The moment when the Carter negatives and slides reached Oxford, and Lansing and Harden began to correspond about the Tutankhamun archives, was also (and not coincidentally) a moment when Egyptology sought to reposition itself after the disruption of the war. Facing uncertain prospects for fieldwork in Egypt, and questions about the legitimacy of owning both objects and excavation records from the discovery, the Metropolitan Museum and the Griffith Institute could not help but wonder how best to serve the academic and popular interests of Egyptology. These two aspects of the discipline may have been more interconnected than scholars cared to admit, but the 'priceless' photographs – as Harden had characterized them – now had two secure homes, and would soon have two homemakers to look after them.

Transatlantic Tutankhamun

Like the crate of photo albums that crossed the Atlantic on the S.S. *Queen Elizabeth,* we have arrived now in Oxford in 1951. Ambrose Lansing and Donald Harden's initial discussions about their 'duplicate' sets of Tutankhamun photographs broke off late in 1946. They had established that there was no 'complete catalogue' of Burton's negatives (as Harden had hoped), nor did the Metropolitan have a 'full set of duplicate negatives', or even prints from all the negatives it did own (which was Lansing's hope).[63] But in 1948, Nora Scott resumed the correspondence from New York, where she had been cataloguing the Burton negatives that had recently arrived from Carter's home in Egypt and checking them against the museum's existing holdings. She had identified 425 negatives already represented in the museum – 'duplicates' of the same subject – and the Metropolitan offered to send these negatives to Oxford if the Griffith Institute could pay for shipping and insurance.[64] It fell to the new Assistant Secretary of the Griffith Institute, Penelope Fox, to arrange the practicalities, and the negatives arrived 'safe and sound' in Oxford in January 1949. They included 136 images of the Annex and its objects, which were especially welcome in the Griffith Institute.[65] Until then its collection had not included any photographs from the Annex, the last room cleared in 1927, suggesting that Carter had kept those negatives with him in Egypt.

Over the course of 1949, other occasions would arise for Scott and Fox to communicate about their respective collections of Tutankhamun photographs – a matter which they took directly in hand as part of their normal responsibilities. Although Scott was educated to MA level (Fox's qualifications are not known), both women occupied professional

[63] Quotes, respectively: letter from Harden to Lansing, 25 October 1946; letter from Lansing to Harden, 13 November 1946 (both, GI/Carter 1945–6).

[64] Carbon copy of letter from Wilkinson to Moss, 12 August 1948 (GI/NYMMA Acquisitions – gifts accepted. MMA: Tutankhamun material, 1948–9).

[65] Letter from Harden to Wilkinson, 1 February 1949 (GI/NYMMA Acquisitions – gifts accepted. MMA: Tutankhamun material, 1948–9).

posts, and salary grades, well below university lectureships or museum curatorships. Scott's title at the time was 'research fellow' (she appeared at the bottom of the staff list in the museum's annual report for 1946), while Fox began her secretarial post at Oxford by sorting and classifying material in the 'Record Room'.[66] Dealing with photographs and other records was a clerical duty, and in museums and academia in the twentieth century, such work was largely done by junior female staff.

The correspondence between Scott and Fox developed a warm and informal tone, especially after they were able to meet in person on the occasion of Scott's visit to England in November 1949. Between them, they organized additional exchanges of negatives and prints, not only of the Tutankhamun photographs but also of photographs Burton had taken inside Theban tombs, which helped Rosalind Moss, editor of the *Topographical Bibliography,* continue to collect and compile data on behalf of the Griffith Institute. Scott sent another eleven glass negatives to Oxford, which arrived in January 1950, while Fox could help Scott with queries about specific objects in New York's Tutankhamun photographs, since Carter's notes and index cards in the Institute had information not otherwise available to researchers. One example of such an exchange is a query from Scott concerning a photograph of beads, which were tagged in Carter's hand (in the photos) as 256o and 256bb: did Fox know, she asked, where on the mummy the beads had been found?[67] Fox replied by enclosing her own hand copy of Carter's notes about the beads – plus prints she had had the Ashmolean Museum's photographic studio make by photographing Howard Carter's drawings of the mummy unwrapping. She emphasized that the photographers had made the prints the same size as the drawings, to preserve Carter's scale.[68]

Photographic technologies thus complemented the archival technologies the two women were using in their day-to-day work on the Tutankhamun records, which was construed not as research, but as facilitating research. The multiplication inherent in photography was integral to their ambitious plan to collate the two collections by using the Metropolitan's more sizeable range of album-mounted prints, many made by Burton at the time of the excavation. By establishing – they hoped – the 'complete catalogue' of Tutankhamun photographs that had not existed to that point, Scott and Fox then aimed to convince their institutions to use photography to make two truly equivalent sets, first by printing from existing negatives where one or the other collection had gaps, and then by making copy negatives of the many prints for which negatives had been lost or damaged. Hence the precious cargo aboard the *Queen Elizabeth* in 1951.

That autumn, Fox undertook the work for which the Tutankhamun albums had made their journey, comparing as best she could the prints in the albums with the loose prints and glass negatives in the Griffith Institute's own collection. Fox also conferred with Alan Gardiner over photographs of the shrines, since he seemed to own the only set of prints

[66] MMA Report 75 (1946), x (as 'junior research fellow'); Ashmolean Report (1948), 58.
[67] Letter from Scott to Fox, 23 November 1949 (GI/NYMMA Acquisitions – gifts accepted. MMA: Tutankhamun material, 1949–50).
[68] Letter from Fox to Scott, 13 December 1949 (GI/NYMMA Acquisitions – gifts accepted. MMA: Tutankhamun material, 1949–50).

of the innermost shrine; neither the Institute nor New York had the corresponding negatives.[69] To Nora Scott, Fox wrote of her frustrations at having to work mainly from negatives, since the Institute did not have prints of every negative it owned. Furthermore, she remarked, it was almost impossible to be certain of comparisons between the museum albums and the Oxford material, 'with often so many similar views of the same object'.[70]

As 1951 gave way to 1952, the exchanges between the two women reveal the deadline by which Fox needed to complete her collation of the photographs: she was soon to be married and would be moving to Liverpool with her husband. The women corresponded on at least a monthly, sometimes weekly, basis throughout this period, trying to reach a cost-effective solution. Fox knew that it would be 'costly and unsatisfactory' to make copies of prints that had no corresponding negatives, 'for the copies are never as good as the originals'.[71] Instead, she devised a scheme that combined new printing and an exchange of existing multiple prints, which would calibrate the two sets of photographs in Oxford and New York. To this end, and to secure the necessary funds, she submitted a report to the Management Committee of the Griffith Institute and circulated a selection of Burton photographs for inspection by committee members, most of whom would never have seen them except as reproductions in Carter's books or in the press.[72] The timing of the meeting – 24 January 1952 – would prove in retrospect to be a watershed for British authority in Egypt, falling two days before anti-British riots that presaged the revolution of July 1952.

Fox's sixty-five-page tabular guide to the Tutankhamun photographs, presented at that 24 January meeting, would remain a consultation document in the Griffith Institute until the creation of an online database in the late 1990s (Figure 2.3). It is in some ways still a helpful working guide, since neither institution has fully digitized its negative and print collections. Because Fox noted whether a print or a negative, or both, existed in the Oxford archive at the time, it potentially would allow further reconstruction of the exchange process – and identification of older prints among the many generations of prints stored in the Griffith Institute. The Egyptian department in New York kept a copy of Fox's guide as well, but has tended to rely on its own set of albums and a typed register prepared by the dig-house secretaries and updated in New York.

To create her schema, Fox had broken the two photograph collections down into groups: negatives owned by one but not the other (124 in the Metropolitan, 201 in the Institute), and single (91) or duplicate (93) prints with no corresponding negatives in the Institute, which were missing from the Metropolitan's collection (a total of 184 prints). The Institute also owned 476 negatives for which it held no prints at all, but which the Metropolitan Museum did – these were probably the 'best set' negatives found at

[69] Letter from Fox to Gardiner, 6 January 1952 (GI/NYMMA Acquisitions MMA photogr. Tut Corres. 1952–).

[70] Letter from Fox to Scott, 15 March 1952 (GI/NYMMA Acquisitions MMA photogr. Tut Corres. 1952–).

[71] Letter from Fox to Scott, 6 February 1952 (GI/NYMMA Loans).

[72] The circulation of the photographs appears in a pencilled note on a copy of Fox's report to the Management Committee, 24 January 1952 (GI/NYMMA Acquisitions MMA photogr. Tut Corres. 1951).

Figure 2.3 First page of Penelope Fox's guide to the Tutankhamun photographic archive, comparing prints and negatives in the Griffith Institute and the Metropolitan Museum of Art; dated 6 February 1952.

Carter's house at Luxor after the war. By taking into account this last group, Fox calculated that the two institutions could fill the gaps in their collections on a 'print for print exchange basis', making new prints for each other from their own negatives and gifting duplicate prints as well. This avoided the cost and time of making copy negatives of the ninety-one single prints in the Griffith Institute for which no negatives existed. It would cost the Griffith

just over £25 to prepare and ship its share of new and existing prints for the Metropolitan, with a further £50 or so required to print all of its own negatives – work that would be carried out by the Ashmolean Museum's photographic service, established just five years before.[73] At that January 1952 meeting, the Committee voted to approve these expenses, which were in addition to the cost of transporting and insuring the Metropolitan albums to and from Oxford.

With the funding secured, Fox wrote to Scott in early February with the good news, enclosing the guide she had compiled to correlate the two sets. She explained the abbreviations (she hoped not 'too trying') that she had used to indicate where a photograph was represented by only a print, only a negative, or both. In the course of the collation, Fox had found another fifteen 'duplicate' negatives, which she would pack for return with the albums. There were a number of queries, too, which Scott would only be able to answer once she had the albums back. Finally, Fox apologized for the extra work: 'I am afraid it is rather complex; I have tried to simplify it as much as possible, but it remains nevertheless somewhat involved'.[74]

This is an example of British understatement: what Fox had undertaken, and produced, was extraordinarily complex, and Scott recognized the effort when she received the guide: 'You <u>have</u> had a job about this', she wrote to Fox in March, confirming that Lansing had approved the print exchange and offering a number of corrections and clarifications to the list. Scott also asked for more details about Fox's fiancé and advised her, 'You'd better just forget Egyptology and become a housewife'.[75] But her tongue seems to have been firmly in her cheek, since in the next paragraph she praised Fox for her recently published book, *Tutankhamun's Treasure* – featuring photographs by Harry Burton, many reproduced for the first time and all from the Griffith Institute's collection.[76] Although only a 'picture-book', in the words of the Institute's annual report for 1951, *Tutankhamun's Treasure* was intended as a 'partial substitute' for Carter and Mace's three-volume *The Tomb of Tut. Ankh.Amen,* which had been out of print for many years.[77] It was hoped that sales of the book would generate income for the Griffith Institute, perhaps even replicating the success of Carter's books a generation earlier. Fox's steady and in-depth work on the Tutankhamun photographs may not have been recognized as scholarship, but both her book and her collated guide were the most tangible accomplishments of the Griffith Institute's post-war years. Moreover, the transatlantic exchange of albums, prints and negatives that she and Nora Scott undertook helped create an equitable, reciprocal partnership between the Griffith Institute and the Metropolitan Museum.

One of the last things that Fox did before marrying and leaving her post that spring was organize the return of the Metropolitan albums to New York. They were packed in a wooden case 63 inches (1.6 m) long, 23 inches (0.58 m) high and weighing 412 lbs. (186.9 kg), and Davies and Turner once again handled the shipment. For their return

[73] See Dudley, 'Chief photographers', and Ashmolean Report (1947), 4.
[74] Letter from Fox to Scott, 6 February 1952 (GI/NYMMA Loans).
[75] Letter from Scott to Fox, 6 March 1952 (GI/NYMMA Loans).
[76] Penelope Fox, *Tutankhamun's Treasure*.
[77] Respectively: Ashmolean Report (1951), 71 and (1950), 63, both during Harden's tenure as Secretary.

journey, the albums still had an insurance value of $1,500, but their sojourn in Oxford had created a different kind of value for the Tutankhamun photographs – by cementing their future promise, as records whose potential for producing knowledge about the tomb could at last be realized.

Reciprocity and aspirations for the future: both these outcomes of the photographic exchange were part of a larger reconfiguration of knowledge economies about the ancient Middle East, at a point when the modern Middle East seemed to be slipping further from Western influence. Writing to Ambrose Lansing before she left her post, Fox had conveyed the Griffith Institute's gratitude to him for enabling the collation:

> for if the definitive publication becomes possible, it will be invaluable to whoever carries out the work. Whatever happens – and in spite of the political situation we continually receive encouraging reports from Egypt which give us every reason to be hopeful – we believe that this work has carried the plans a stage further.[78]

This is a near-unique reference to overtly political matters in the correspondence, but the topic could scarcely be avoided in early 1952. During the same months Fox was working away on the collation, a series of anti-British demonstrations and guerrilla attacks on British interests in the Suez Canal Zone had destabilized King Farouk's government. The force of British military reprisals, in particular a deadly attack on Egyptian police barracks in Ismailia, saw riots erupt in Cairo: on 26 January 1952, the city went up in flames as buildings linked to foreign interests were hit by arson. The Opera, Shepheard's Hotel and Barclays Bank were among the hundreds of buildings destroyed before the Egyptian Army restored order – two days after Fox circulated sample photographs to the Griffith Institute's Management Committee.[79]

In the climate-controlled archive room of the Griffith Institute today, a wooden system of 'lateral filing' made by Ashmolean technicians in the 1950s still holds hundreds of prints of the Tutankhamun photographs – several likely made by Burton in the 1920s as well as those dating to Nora Scott and Penelope Fox's exchange, and many more besides. Staff refer to these long, low shelves as 'the coffins', and the prints are rarely consulted now, in favour of a set made in the 1980s after the glass negatives had been cleaned by the Ashmolean's photographic studio – and yet another set made in the 1990s and early 2000s, in conjunction with the digitization project. Archives are places that accrue not only time, but ways of thinking, being and doing. Something as seemingly simple as English alphabetical order persisted as a way of trying to order multiple prints and the many artefacts and events they represented: Carter had one alphabetical system in his albums, Burton another in the dig house albums, and the Griffith Institute yet a third, when its administrator for almost thirty years (from 1964 to 1992), Fiona Strachan, relied on her

[78] Letter from Fox to Lansing, 5 February 1952 (GI/NYMMA Acquisitions MMA photogr. Tut Corres. 1952–). The same file contains paperwork for the March 1952 return shipment.
[79] Kerbouef, 'The Cairo fire'.

own alphabetical ordering of the 'coffin' prints and other sets.[80] It was the only way she could locate the photographs she needed, Strachan explained when introducing new staff members to the system – besides which, people who requested Tutankhamun photographs did so by subject matter, not by numbers. Only in the 2000s did the Institute create a consultation set of modern prints in order by negative number, which is how the online database arranges the scans available there. Millennial technology encouraged the use of a running numerical order of the kind that no one, even Carter himself, had consistently applied to the Tutankhamun photographs before.

Numerical or alphabetical order may seem minor points, but they reveal how persistently the archival choices of the past influence archival practices, disciplinary frameworks and knowledge creation in the present.[81] From their creation and initial ordering in the 1920s, through the effects of duplication in the post-war era, to the digital presence they occupy today, the Tutankhamun photographs exemplify how archaeology has used and viewed photographic objects – as surface and subject matter, rather than material forms whose own histories draw into question the histories of archaeology and antiquity alike. In their institutional transformation from 'records' to 'archives', the Tutankhamun photographs reflect a wider search for preservation and totality in twentieth- (and now twenty-first-) century archival undertakings. The documents of history, with their irreplaceable evidentiary value, were increasingly seen as fragile, susceptible to damage or decay: it was a lesson the Second World War had taught well. During the post-war era and its decolonizing decades, institutions such as record offices and research institutes became more conscious of their own role in preserving a past that was slipping out of living memory. Museums, too, took seriously this archival impulse, even if, like the Metropolitan Museum of Art, they were thinning out their collections of antiquities at the same time. The excavation records, personal archives and library holdings that resided with Western institutions allowed these institutions to reconfigure – and reconfirm – their influence in Egyptology, even as the Egyptian state asserted its nominally independent control of archaeological concessions and museums within the country. Maps, plans and, especially, photographs could give Egyptologists access to at least some of 'ancient Egypt', even if the instabilities of modern Egypt threatened to disrupt fieldwork and recording in the present day. Archives were insurance, in a sense. They were also a source of power, not in the top-down direction that Foucauldian interpretations of the archive might imply, but in the bottom-up of institutional behaviour, from how academic research was conducted (and by whom) to how much time and money went into classification and conservation efforts. When we excavate the archive, these mundane processes become significant within larger schemes of value.

The Burton photographs, the Carter archive, the Tutankhamun records: these are just a few of the names by which this material has been known over the past century, and what exactly each name encompassed was, and to some extent remains, in flux. From

[80] Strachan started work at the Griffith Institute in 1964 and retired in 1992. See Ashmolean Reports (1964), 1, 85; (1993), 60. I thank Elisabeth Fleming for explaining the alphabetical system to me.
[81] Thus also Stefanie Klamm, 'Reverse–cardboard–print', complemented by the more wide-ranging discussion of nineteenth-century visualization and archival practices in her book *Bilder des Vergangenen*.

the start of Burton's work on the excavation, distinctions between original, copy and 'duplicate' photographs complicated the content and the character of what I refer to – in full recognition of its fuzzy boundaries – as the photographic archive of the tomb. Rather than seeing the multiplicity of photographic objects as a problem to be solved, however, or 'duplicates' to be weeded out, such multiplicity must be understood as inherent to photographic technology and the archives it produces. That is one reason why photographic practices are inseparable from considerations of archival practice, all the more so in a field like archaeology that was self-consciously creating a photographic record alongside the artefact record it located and recovered from the earth. Persistent and protracted efforts made in the post-war era to try to square the two collections in Oxford and New York thus arose out of earlier practices – and have informed current ones, replicating disciplinary praxes and priorities in the process. The notion that a complete photographic archive of the tomb exists still shapes the digital presentation of the Tutankhamun photographs online, for instance, but as this chapter has argued, without a critical approach to the history and operation of the archive itself, such efforts only serve to reinforce the empirical positivism that underpinned the colonial project in which archives, and knowledge, were originally produced. Rationales for the ownership and care of the Tutankhamun photographs have changed over time, following the twists and turns of modern history. But with its stratigraphy cut cleanly through, the archive will allow us now to look more closely at the Tutankhamun images to see how Carter, Burton and their colleagues used photography in the course of the excavation – already keenly aware that history was watching.

3

'THE FIRST AND MOST PRESSING NEED': PHOTOGRAPHIC PRACTICE AT THE TOMB OF TUTANKHAMUN

In the autumn of 1923, as the second season at the tomb was about to get underway, the Metropolitan Museum's *Bulletin* published a report by Arthur Mace of the Egyptian Expedition, whose steady hand – and brain – made such a significant contribution to the removal, recording and repair of the Tutankhamun objects in the first two years of work. Mace offered readers of the *Bulletin* a look back at the momentous events of the first season, and the Museum's key role in them – especially for the photography that was so fundamental to the undertaking. As Mace explained,

> Photography was the first and most pressing need at the outset, for it was absolutely essential that a complete photographic record of the objects in the tomb should be made before anything was touched. This part of the work was undertaken by Burton, and the wonderful results he achieved are known to every one, his photographs having appeared in most of the illustrated papers throughout the world. They were all taken by electric light, wires having been laid to connect the tomb with the main lighting system of the Valley, and for a darkroom, appropriately enough, he had the unfinished tomb which Tutankhamun had used as a cache for the funerary remains of the Tell el Amarna royalties.[1]

How straightforward the role of photography seems in Mace's explanation, which appeared almost verbatim in the first volume of *The Tomb of Tut.Ankh.Amen* that he and Carter co-authored ('Obviously, our first and greatest need was photography').[2] The idea

[1] Mace, 'Work at the tomb of Tutankhamun', 7–8.
[2] Carter and Mace, *The Tomb of Tut.Ankh.Amen*, vol. 1, 127.

of a photographic record had long been gospel in archaeology.[3] As with many other disciplines and field sciences, it is difficult to imagine that archaeology would have taken the form it did in the late nineteenth century without the existence of photography, and it is no coincidence that archaeological projects, publications and university appointments markedly increased from the 1890s onwards, when both photography and the reproduction of photographs in print became easier and cheaper. Photography also encouraged – and endorsed – a way of seeing and being an archaeologist that had become the field's scientific standard by the 1920s, and that remains largely unchallenged in its methods and epistemology. Expert, trained eyes were needed first to recognize what an archaeological feature or object was, then to photograph it appropriately, and later to use the photograph as external reinforcement of an internal, visual memory.[4]

The technical details of Mace's *Bulletin* report, elaborated further in his and Carter's book, validate the work of photography and the excavation alike. The two are inextricable down to the repurposing of tomb KV55 – the 'unfinished tomb' – as Burton's on-site darkroom, a reuse that resonates across millennia to link ever more closely the historical personage of Tutankhamun and the contemporary archaeologists. The Valley of the Kings was a space for serious undertakings, whether in the ancient Egyptian New Kingdom or the 1920s. As a core part of their undertaking, photography was uppermost in the excavators' minds, but the photographic record that Burton produced attests that its creation remained a work-in-progress. Those 'wonderful results' were achieved through experimentation, adjustment, and a degree of serendipity, while the planned destination – or destinations – of the 'record' negatives and prints shifted with the progress of the work as well. There were many more, and more kinds, of photographs taken during the excavation than the *in situ* photographs that Mace emphasized after the first season, with their seeming glimpse of the tomb frozen in Tutankhamun's time. Practical considerations also went far beyond the supply of electricity and the availability of a darkroom for quick development and test printing. Photography influenced the entire schedule of the work, depending not only on Burton's availability (an issue in later years, in particular) and lighting conditions, but also on the progress of unpacking, stabilizing, cataloguing, cleaning and crating the thousands of objects discovered. If objects were going to be photographed (not all of them were), only once this was done were they readied for transport to Cairo, an end-of-season deadline that determined the point by which Burton's photographic work had to be finished. Not surprisingly, questions surrounding the supply, shipment, and aftercare of the negatives and prints preoccupied everyone involved, and although Mace, Carter and Burton all emphasized the thoroughness of the photographic

[3] See Baird, 'Photographing Dura-Europos'; Banta and Hinsley, *From Site to Sight,* 72–99; Bateman, 'Wearing Juninho's shirt'; Guha, 'The visual in archaeology'; Klamm, *Bilder des Vergangenen,* 221–33; Lucas, *Critical Approaches to Fieldwork,* 206–11; Riggs, 'Objects in the photographic archive'. On the problematic development of the relationship between archaeology and photography, see also Brusius, 'From photographic science to scientific photograph'; Brusius, 'Beyond representations'; Brusius, *Fotografie und museales Wissen,* esp. 95–108, 144–81; and Kett, 'Monuments in Print and Photography'.

[4] As discussed in Bohrer, *Photography and Archaeology*, 50, with reference to American Egyptologist George Reisner's essay on photography (Der Manuelian and Reisner, 'George Andrew Reisner on archaeological photography').

programme, the photographic archive presents numerous gaps and oversights, with as many missed chances as there are iconic images of iconic objects, tomb views and Egyptologists. Negatives were lost or damaged, tempers flared, and Burton at times struggled to satisfy both Carter and the Museum, not to mention himself.

This chapter surveys the role of photography throughout the ten-year project of clearing and documenting the tomb of Tutankhamun. Arrangements for Burton's work were paramount, as Mace acknowledged, but they were also contingent on other factors. Closer scrutiny of how different photographic practices were embedded in different spheres of activity counters the narrative of discovery, neutrality and scientific rigour that dominated the official presentation of the find – as well as the focus on the first two seasons that has dominated most previous discussions of the excavations. The first section of the chapter looks at how implicit ideas about the visual qualities and purposes of photographs contributed to Harry Burton being brought on board in 1922. The chapter then turns to the initial arrangements made for documenting and photographing the tomb and its objects, which intersects with the archival history discussed in Chapter 2. Finally, the chapter considers changes in photography at the tomb from the time work resumed in 1925 until Burton took his last shots in the Burial Chamber in January 1933. From technical issues, such as lighting and the use of colour plates or moving-picture cameras, to questions of patronage, press obligations and time pressure, the practice of photography on site manifested many concerns that may seem distinctive to the tomb of Tutankhamun. But the excavation in fact was similar to contemporaneous archaeological projects in terms of the empirical aims and archaeological authority that photography helped articulate and, indeed, create. In Egypt and elsewhere, cameras gave archaeology a methodological framework and an aesthetic identity in two ways: first through the performance of photography, that is, how one 'did' or took the photograph, and second through the performance of the archive, that is, what one did with the photographic negatives and positives. It was this double indemnity that made photography 'obviously' a requirement in the field, as Mace and Carter wrote – and obviously worth getting right.

In search of success

Faced with the first sealed doorway at the bottom of the now-famous steps, Carter knew that the seals themselves, bearing the name of a little-known king, were important even if nothing else survived. The mere existence of a tomb (if that is what it proved to be) would count as a major Egyptological discovery. At that point, Carter had no idea what exactly lay behind: what size or layout the structure would have, what it would contain, or what condition any contents would be in. It is from this moment of uncertainty we begin, for the camera enters the Tutankhamun story as a foray, a test of whether the archaeologist and the lens could be made to see the same thing.

They could not. Having waited for Carnarvon and his daughter Evelyn to arrive, on 24 November 1922, Carter and his friend Callender oversaw the re-clearance of the staircase to reveal the sealed doorway in its entirety. Rex Engelbach, the chief inspector of antiquities for Upper Egypt, came to observe in his official capacity, together with other

colleagues including fellow Briton, the archaeologist Guy Brunton. Carter's journal and his pocket diary diverge here, as the more descriptive prose of the journal slips between recording the day's events and projecting into the future.[5] The journal entry for 24 November elides the clearance of the stairwell, which yielded a mix of potsherds, broken boxes and a scarab naming several 18th Dynasty rulers, with a backwards glance at the hypothesis Carter first formed: this 'conflicting data led us for a time to believe that we were about to open a royal cache', rather than a single tomb.[6] Worried about security, Carter spent the night camping near the tomb. The next day, he continued to make handwritten notes of the seal impressions and perhaps executed the sketches of impressed cartouches and their placement, now filed with the record cards for object number 4 in the catalogue of tomb objects.[7] Supplementing these manual forms of recording, Carter also trained his own quarter-plate camera on the sealed doorway either that day or (if one prefers the pocket diary) the day before: 'Made photographic records, which were not, as they afterwards proved, very successful', as his journal tersely puts it.[8]

What makes a photograph a failure? Figure 3.1 gives us some idea of why Carter was dissatisfied with the results of his photographic efforts. Shadows at the top of the image, and a streak perhaps from a flaw in the chemical coating, obscure the rough plaster or bedrock – which one, is even difficult to tell. Over the surface of the doorway, a mottled pattern of light and shade overlays the impressions, a visual echo of the undulating texture of the plaster and the gritty rubble still remaining at the bottom of the doorway. The photograph almost resembles a stratigraphic section, with its horizontal bands of different heights (shadowy surface at top, wide band of impressions, gritty rubble below), but this was not the image Carter wanted or needed. To capture the impressed seals in sharp outline and be able to read the hieroglyphic signs within them – that was the goal. One appeal of photography for scientific purposes was that it allowed different viewers, in different places, to make a study of what the photograph represented, something that Carter, who had a rather basic command of ancient Egyptian, would have valued in interpreting the seals.[9] But the sealed doorway presented several photographic challenges. Its subterranean position made it difficult to light consistently, and the plaster surface was rough, with impressions applied at different angles and depths, not to mention overlapping each other. The photograph Carter produced is a failure for the purpose of reading the seal impressions from it. That it succeeds as a photograph of the rather messy, daunting doorway the excavators faced, and as a testament to trial and error in the field, and flaws and fingerprints on negatives, matters only in retrospect. It did not matter to Carter in late

[5] Carter seems to have written many of his journal entries some time after the fact, and their texts do not always correlate with the pocket diaries he kept, which briefly note a day's events, and which survive only for the first three seasons at the tomb (http://www.griffith.ox.ac.uk/discoveringTut/journals-and-diaries/). Diary entries could also be entered retrospectively, of course – or prospectively, setting out plans that might not have been realized on a given day. Either way, the different formats of journals and diaries Carter kept over the years appear to accommodate different registers of expression and, perhaps, differences in perceived function and audience.
[6] GI/HCjournals, 24 November 1922.
[7] See records for object 4: http://www.griffith.ox.ac.uk/gri/carter/004.html.
[8] GI/HCjournals, 25 November 1922; contrast GI/HCdiaries, 24 November 1922.
[9] Wilder, *Photography and Science*, 56–65, 94–101, highlights the importance photography acquired for science, in terms of allowing practitioners in different places to observe and evaluate photographic data.

Figure 3.1 Seal impressions covering the first doorway of the tomb. Photograph by Howard Carter, 25 November 1922; GI neg. P0274, glass 8 × 10.5 cm.

November 1922, with the world's press and his colleagues already attuned to the potential discovery of a royal tomb.

Without knowing whether his exposures were 'successful', Carter, Callender and the unnamed (indeed, unmentioned) Egyptian workmen set to work removing the seal-stamped plaster, breaking it into moveable chunks that preserved as much as possible of the seals. They proceeded through the rubble-filled passageway, 9 metres long, to the second blocked doorway – the one famously pierced for one person at a time to peer through by candlelight, causing Carter to gasp, 'Yes, it is wonderful' (as the journal has it), or 'Yes, wonderful things' (as it became in his book with Mace). No one bothered to try to photograph the second doorway in the darkness of the passageway, and even the notes taken of the impressions on its surface were – by Carter's own admission – 'not sufficiently complete to give a detailed enumeration of the seals employed', which he blamed on 'the heat of excitement at the moment of the discovery'.[10]

[10] See records for object 13: http://www.griffith.ox.ac.uk/gri/carter/013-c013–2.html.

In the flurry of the next week's activity, the Antiquities Service enabled Callender to rig the Antechamber with electric lighting, to facilitate the initial inspection of the tomb by Service officials as well as Carter, Callender and the Carnarvons. Even this was not enough for photography, however, and attempts to take pictures using flash – perhaps by Carnarvon himself – also proved unsatisfactory, as Carnarvon explained to *The Times* when he was back in England. It was, he said, 'impossible to distinguish between the ebony statues of king Tutankhamun and the dark shadows that were cast on the wall. The plates were useless'.[11] There were plenty of other things to organize, however. An 'opening' ceremony took place on 29 November, attended by Lady Allenby (wife of the British high commissioner), the London *Times* correspondent Arthur Merton and his wife (a sign of the paper's early advantage), and a number of Egyptian officials including the *mudir* of Qena province, the *mamur markaz* of Luxor, the head of police and the provincial irrigation inspector. Pierre Lacau and Paul Tottenham, from the Ministry of Public Works, came the next day. After these formalities were out of the way, and having consulted Lacau and Tottenham to make plans for the work, Carter had the tomb backfilled until a better security gate could be installed. To order the gate and other equipment (stationery, cardboard boxes and packing materials), Carter travelled to Cairo in early December with the Carnarvons.[12] There, with preparations for the work foremost in his mind, he received a congratulatory telegram from Albert Lythgoe of the Metropolitan Museum, who was then in London on business. Carter replied with thanks, adding 'discovery colossal and need every assistance, could you consider loan of Burton in recording in time being, costs to us, immediate reply would oblige'. Lythgoe did oblige, replying 'only too delighted to assist in every possible way, please call upon Burton and any other members of our staff, am cabling Burton to that effect'.[13]

The exchange of telegrams between Lythgoe and Carter is the source of the gentleman's agreement that would be remembered and revisited at various junctures not only over the course of the ten-year excavation, but over the following decades, as we have seen. Burton was not a passive participant in the transaction that linked him to Tutankhamun: in Cairo that December, Carter and Carnarvon had already sounded him out about his willingness to help with photography, before cabling the request to Lythgoe – wisely letting the decision appear to be up to the Metropolitan Museum.[14] Lythgoe's readiness to lend the Museum's Egypt-based staff (including Mace, Hauser and Hall) was the result of long professional acquaintance, but it was also an offer made with the Museum's own benefit in mind, for all that Egyptologists have preferred to emphasize Lythgoe's scientific 'disinterestedness'.[15] The Museum stood to gain on several counts: publicity, fund-raising revenue, and, under the *partage* system, a potential share of the unparalleled finds, if

[11] 'Lord Carnarvon's discovery', *The Times,* 18 December 1922: 13.
[12] GI/HCdiaries, 7 December 1922.
[13] The telegrams are quoted in Cone (ed.), *Wonderful Things,* xiv–xv; Reeves and Taylor, *Howard Carter,* 149.
[14] Burton, 'Clearing the Luxor tomb: The work of the photographer', *The Times,* 16 February 1923: 9; Burton, 'Camera records details of tomb', *New York Times,* 15 February 1923: 2.
[15] James, *Howard Carter,* 269; likewise the prologue written by an elderly Charles K. Wilkinson in a book accompanying the 1979 Metropolitan Museum of Art venue of the 'Treasures of Tutankhamun' exhibition: Cone (ed.), *Wonderful Things,* xi–xviii, describing Lythgoe as 'self-abnegating' (p. xiv).

descriptions (not yet photographs) of the Antechamber were anything to judge by. Assertions of scientific neutrality have nonetheless held fast in standard histories of the Tutankhamun excavation – with that supposed neutrality permeating every aspect of the archive, including Burton's photography.

Although I touched briefly on Burton's biography in Chapter 1, it is worth saying a bit more here about the skills and reputation he brought to the Tutankhamun 'team' in 1922 – and about the ways in which his role and his work have latterly been understood in Egyptological literature. Writers have been keen to analyze Burton's photographic methods and emphasize his technical accomplishments, creating the impression that Burton's was the decisive vision in terms of what to photograph, when, and how – the photographer as artist-auteur.[16] This was not the case, whether in his work for the Metropolitan Museum, for the Tutankhamun excavation or in Italy, where he had been photographing Renaissance art and architecture since moving to Florence as secretary-companion of the English art historian Robert Cust in the 1890s. In addition to photographs he took for Cust in the early 1900s, Burton may also have accepted commissions to photograph artworks, especially paintings, for other expats; he seems to have maintained an interest in Renaissance art throughout his life.[17] From the time he began travelling with, then working for, Theodore Davis in Egypt, however, archaeology was the focus of Burton's activity: he was employed as an archaeologist, not as a photographer, however much photography became his remit once he began working for the Metropolitan's Egyptian Expedition in 1914. Especially in the early years of his Museum employ, decisions about what to photograph emerged through networked dialogue, and Burton took photographs as favours and for exchange. That December in 1922, for instance, he had been in Cairo for a month, in part to take pictures of a statue in the antiquities museum as a courtesy – at Lythgoe's request – for Museum trustee Charles W. Gould. Burton managed the task, but reported to Lythgoe that it had been a hassle, because Museum staff had to remove the case that covered the statue. Nonetheless, Burton took six negatives and posted two prints of each to Lansing – one for the Egyptian department, one for Gould.[18]

In other words, Burton's evident skill with a camera might have been discussed and admired by his colleagues as a recording device, but it served other purposes as well, cementing professional and patronage relationships through photographic exchange. From his years with Cust, then Davis, Burton was accustomed to relying on social superiors for

[16] In particular, Ridley, 'The Dean of archaeological photographers'; G.B. Johnson, 'Painting with light'. The most balanced source remains Marsha Hill's biography, in Hornung and Hill, *Tomb of Seti I*, 27–30.

[17] Prints of Burton negatives are in the collections of the Villa I Tatti (former home of collector Bernard Berenson) and the Fototeca of the Kunsthistorisches Institut in Florence. I thank Spyros Koulouris, Ute Dercks and Almut Goldhahn for this information, and Stefano Anastasio for further information about Burton's connections in Florence (see Anastasio and Arbeid, 'Archeologia e fotografia'). In 1926, Burton wrote to Winlock that he was 'getting rid of all my negatives' in Florence; some he seems to have sold to the photographic firm of Jacquier, whose collection is now part of the city photographic archive (letter from Burton to Winlock, 4 July 1926; MMA/HB: 1924–9; for information on the Jacquier photographic archive in Florence, see http://www.sbas.fi.it/servizi/fotografico.asp).

[18] Letters from Lythgoe to Burton, 31 January 1922, Burton to Lythgoe 6 October and 7 November 1922, and Lythgoe to Burton 12 December 1922, acknowledging receipt and describing the photographs as 'most pleasing in spite of the difficulty you must have had with the light' (MMA/HB: 1920–3). As on other occasions, Burton borrowed the Cairo Museum's camera and darkroom for the purpose.

opportunities of advancement. But the subordinate tone he adopted in his correspondence with Lythgoe, especially early on in his employment, also reflects Burton's awareness that he was a novice where Egyptology was concerned, unable to read hieroglyphs like his new colleagues did and uncertain what to prioritize when faced with requests to photograph a certain object, tomb, or site. For instance, tasked with photographing Egyptian collections in Florence and Turin in 1914, when the outbreak of war meant he could not get to Egypt, Burton sought advice from both Lythgoe and Mace about exactly what he should photograph, and with what size plate. Mace specified inscribed material as most important, and Lythgoe's reply similarly revealed a set of disciplinary and museological priorities:

> We wouldn't need photographs of ushabtis, scarabs, amulets or similar small objects, but would like all kinds of sculpture (in the round or in relief), stelae and all the more important classes of material. The Turin collection, of course, contains the most important Egyptian material.[19]

Once Burton set out for Egypt to commence his work for the Expedition in 1915, Lythgoe was again specific, sending Burton a list of requirements that took into account site documentation as well as photographs needed for the Museum's active publication programme.[20] Not only what subject matter to photograph but how to photograph it were a normal part of the conversations Burton had with his colleagues, judging by his correspondence. Burton was the specialist when it came to photography, but all the archaeologists involved – just like Carter – were familiar with the technical considerations photography required: lighting conditions, the effect of temperature on negatives and developing solution, the use of filters and f-stops on a lens, not to mention the use of different lenses in different contexts. Like archaeology itself, photography was a joint enterprise – including the Egyptian assistants who worked with Burton, whom he referred to collectively as 'camera boys' in the derogatory language of the day.[21]

By 1922, after seven years of work with the Expedition, Burton's colleagues fully recognized his distinctive skill with a camera, to the extent that he received publication credit when his photographs appeared in Museum publications or the illustrated press.[22] The tributes paid to him years later, after his death in Egypt in 1940 from complications of diabetes, described his 'expert knowledge of photography' as 'invaluable' to the work of the Egyptian Expedition. In an obituary in the Metropolitan Museum *Bulletin,* Ambrose Lansing singled out another talent that stood Burton in good stead: 'his cheerful disposition

[19] Lythgoe to Burton, 28 October 1914 (MMA/HB: 1913–19).

[20] Lythgoe to Burton, 16 January 1915 (MMA/HB: 1913–19).

[21] As in Burton, 'Clearing the Luxor tomb: The work of the photographer', *The Times,* 16 February 1923: 9; Burton, 'Camera records details of tomb', *New York Times,* 15 February 1923: 2; and in letters written to Lythgoe dated 24 November 1925 ('The remainder of the camera boys arrived here on Friday'), and to Winlock, 9 January 1934 ('My boys are not particularly bright during the [Ramadan] Fast'). The American archaeologist George Reisner, director of the Harvard–Museum of Fine Arts Boston excavations at the Giza pyramids, used the same expression for the Egyptian photographers on his staff. One example among many is a diary entry for 13 December 1909: 'I arrived from Constantinople. The force at work was ninety-three including four photographic boys and the guards'. See *The Giza Archives* project at www.gizapyramids.org, using the search term 'boys'.

[22] E.g. 'In 2000 B.C.: A slaughter-house, brewery, and bakery in Egypt', *Illustrated London News,* 2 April 1921: 449.

even under the most trying of circumstances endeared him to all with whom he came in contact'.[23] Burton would need all his skill and good cheer to make a success of the photography of Tutankhamun's tomb.

What such photographic success might look like began to emerge later in December 1922, when the team assembled in the Valley of the Kings to size up the work. On 18 December, the leading American Egyptologist James Breasted – then on a Nile journey with his family – arrived to view the tomb and offered his initial opinion on the still-sealed doorway to the Burial Chamber as well as the impressions on the chunks of plasterwork Carter had already removed from the first and second doorways.[24] It may have been around this time that Burton ventured his own photographs of the fragmented sealings, before they were removed for storage; their whereabouts since his photographs were taken is unknown (Figure 3.2).

Even the setting of the photograph is uncertain: in the first weeks, nearby tomb KV4 offered storage space, but this is more likely the area just inside or outside the laboratory, tomb KV15, at the far end of the valley. If so, it supports a December 1922 date for the photographs, since the chunks of mud plaster needed to be out of the way before more attractive and delicate objects began to be removed from the tomb in the new year. Since their dismantling, these doorway fragments had been transformed from an

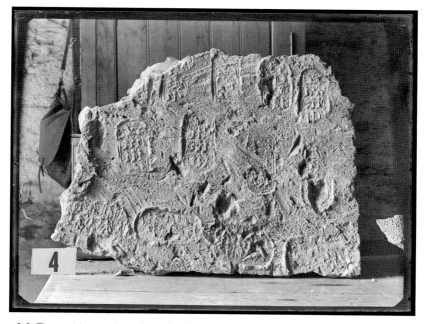

Figure 3.2 The seal impressions from the first doorway of the tomb, now catalogued as object 4. Photograph by Harry Burton, on or around 18 December 1922; GI neg. P0277, glass 12 × 16 cm.

[23] Lansing, 'In memoriam: Harry Burton'.
[24] See Abt, *American Egyptologist,* 303–9, esp. 306–8.

in situ, sealed-up doorway, smoothed and stamped by many hands, into discrete, if unwieldy, objects that could be numbered and manipulated. The individual pieces of the first doorway were now collectively known as object 4, and as such could be turned into a photographic record. In Figure 3.2, we see one of the largest pieces of object 4 positioned on a table. It sits level and upright, a number card – presumably part of Carter's stationery order in Cairo – positioned to the left and a wooden cabinet behind providing a neutral-enough background that no separate backdrop was deemed necessary. Light comes from the viewer's left, and at least one of Burton's Egyptian assistants will have been holding a reflector to concentrate and direct sunlight across the surface of the plaster. This raking light was what had been missing from Carter's own attempt at photographing the seals in place: it was the only way to isolate the impressions and individual signs from the textured plaster surface. Directed light meant that object 4 could be 'read' from the photograph, its seals and their layering deciphered, or at least made to support a decipherment that would in fact require close in-person scrutiny, sketching and note-taking. The competing stamps and smears needed to make linguistic and logical sense – but they also needed to make photographic sense, producing a legible record that the trained eyes of Egyptologists could read or, failing that, take on trust.

The visual epistemology of archaeology valued clarity of detail, especially where inscriptions were concerned: Breasted himself was in the process of establishing an Epigraphic Survey of the great temples at Luxor, using photography as an intermediate stage in producing exacting scale drawings of inscriptions and relief on the temple walls.[25] A photograph was one step in a process that extended before and beyond the exposure of a negative or the making of a print. After all, for readers of Arabic numerals the card printed with a bold number 4 is the most legible text in Burton's photograph, and any eventual publication of the seals would likely have transformed the hieroglyphs into a facsimile drawing and typeset transcription.

From the moment Carter admitted the failure of his own attempts, the process of photography was thus built into every aspect of the Tutankhamun excavation, from the choice of camera and negative (Burton's photographs of the seals are, less usually for him, on glass half-plates), to the timing of the clearance and recording work, to the arrangements for printing, distributing and filing the results. Photography would help bring the apparent jumble of Tutankhamun's tomb into manageable order, creating usable data out of the abundant detritus of ancient ritual – or at least, as the next section demonstrates, that was the plan.

The organized archaeologist

Since the 1970s, accounts of the excavation of the tomb of Tutankhamun have reiterated the methodical organization of the removal and recording work, emphasizing its meticulous

[25] Abt, *American Egyptologist,* 249–301. For a complementary history of the method, together with discussion of its contemporary use, see W.R. Johnson, 'The Epigraphic Survey and the "Chicago Method"'.

detail and objective accuracy in echoes of Carter's own words. Several point out that Carter removed the first doorway only after it had been photographed, without mentioning that he considered the photographs a failure and did not photograph the second doorway, at the entrance to the Antechamber.[26] With his team assembled, and probably in consultation with them, Carter developed a scheme of organization – an ideal, which worked in some respects but not in others; scale drawings were only ever made of the Antechamber, for example. To conflate the scheme's intentions with its execution is to overlook the contexts and contingencies through which scientific knowledge is generated: that is the point here, not whether the excavation was as 'methodical' as Egyptology has asserted.[27] Historians of science have moved away from, and critiqued, the hagiographic approach of earlier historians, but the history of archaeology and Egyptology continues to be dominated by biographies and surveys with little or no analysis, nor awareness of such historiographic considerations.[28] Even work that purports to critique the history of Egyptology from within (such as recent publications identifying the Nazi party affiliations of German and Austrian Egyptologists) implies, as William Carruthers observes,

> that these practices can, after appropriate historical reflection, be separated from pernicious political "ideology". In this way, influences inappropriate to the conduct of scholarly inquiry can be placed outside the Egyptological sphere and the discipline progress to better, implicitly more correct, work. In this sense, then, constituting disciplinary history is akin to a practice of purification: a means of claiming future Egyptological work as authoritative by suggesting that it can be removed from negative influences and instead take on an ideal form.[29]

Instead, 'the act of constructing a pure discipline, no matter how unintentionally, allows practitioners attached to that discipline to assert their place within the world: by purging order, order is also produced' – an order, I would add, that often looks to excavation archives and photographic 'records' to make ahistorical judgements about accuracy, objectivity, and veracity.[30]

In this section, I use Burton's photography during the first two seasons at the tomb to consider the practical considerations of his work as well as the visual and verbal emphasis placed on it in contemporary publications. Those first two seasons, before Carter's conflict with the Antiquities Service became public knowledge in February 1924, have been taken

[26] E.g. I.E.S. Edwards, *Treasures of Tutankhamun,* 34.

[27] E.g. Reeves, *The Complete Tutankhamun,* 58; Collins and McNamara, *Discovering Tutankhamun,* 37.

[28] Most recently Thompson, *Wonderful Things,* in three volumes. For a contrasting, science studies approach to histories of archaeology and photography, see Abu el-Haj, *Facts on the Ground;* Brusius, 'Hitting two birds with one stone'; and Cox Hall, *Framing a Lost City.* In history of science, a more balanced, bottom-up, and problematized approach to the production of knowledge is classically exemplified by Shapin and Schaffer, *Leviathan and the Air-Pump,* and Shapin, *Never Pure.* On the purification of science, see also Latour, *We Have Never Been Modern.*

[29] Carruthers, 'Introduction: Thinking about Histories of Egyptology', 4.

[30] Ibid., 7.

as representative of the entire excavation project, but using the rhythm and rhetoric of photography at the site helps bring that into perspective. I look first at Burton's overall output for the tomb of Tutankhamun, building on the archival histories discussed in the preceding chapter. I then consider how Carter, Mace and Burton discussed photography in the press and in the first book on the tomb, a bestseller when it was published in 1923. The photographic archive and surviving tomb registers intersect with their statements in variously competing or complementary ways. The section concludes by considering how Burton brought different photographic techniques to bear on his work in ways that speak to aims beyond those that the archaeologists articulated – and in ways that would gradually be reconfigured when work resumed in 1925, as the final section of the chapter will discuss.

Stock taking

The half-plate photograph of object 4 is one of five extant negatives depicting that object number: three show other parts of the demolished doorway, propped on the same table (often with cigarette boxes and Fortnum and Mason packing cases as support), and two show the same section as in Figure 3.2, 'duplicates' now divided between Oxford and New York.[31] We saw in Chapter 2 that confusions arising from different practices of duplication and copying led both the Griffith Institute and the Metropolitan Museum of Art to think of themselves as having a complete and essentially identical set of photographic negatives and positives. At the same time, the priority archaeology has given to a photograph's subject matter – the looking through, not at, the photograph – has meant there was little motivation for tallying the total number of photographs taken at the tomb, at different phases of the work and in different formats.[32]

Such information would normally have been part of a photographer's log book or register, like the register the Metropolitan Museum dig-house kept of its share of the Tutankhamun photographs and of Burton's normal output for the Egyptian Expedition. Other excavations kept even more detailed logs, such as those George Reisner described for his work at Giza: the 40 × 44 cm photo registers (similar to the site's object registers) had columns for recording the negative serial number, brief description, place taken, photographer, date, plate size and other remarks.[33] Individual methods of tracking photographs on site were diverse, but also widespread; photography was too important, and its products so numerous, that some means of keeping track was required. No wonder that when Lansing and Harden began to compare their respective Tutankhamun

[31] GI neg. P0277 (used here as Figure 3.2) shares its subject matter with MMA neg. TAA 613; the other Burton negatives showing object 4 are GI negs. P0276, P0278 and P0279.

[32] For looking 'through' the photograph, see Bohrer, *Photography and Archaeology*, 50.

[33] Der Manuelian and Reisner, 'George Andrew Reisner and archaeological photography', 27–9. Reisner logged photographs only once he was satisfied with the result, but from the mid-twentieth century, advice manuals for archaeology emphasized the importance of logging every shot taken, with observations such as weather conditions that might affect the outcome: Atkinson, *Field Archaeology*, 159–61; Cookson, *Photography for Archaeologists*, 98–102.

holdings in the late 1940s, the men assumed that a catalogue of the Tutankhamun photographs existed. It did not. The parallel 'red' and 'black' lists that Carter made of the developed negatives seem to have done no more than equate negative and object numbers (or other subjects), while Burton himself apparently kept no separate log – and in any case, no complete list of the black numbers, a correlation between the two sets, or a photographer's log survives.

What does survive in the Griffith Institute – overlooked in other studies of the excavation – is a slim, twenty-five-page bookkeeping notebook pressed into service as a working log in the first season, the winter of 1922–3, and converted to a list of running object numbers after that (Figure 3.3). The handwriting throughout is Carter's, but a system of crosses used in the first ten page-spreads devoted to 1922–3 might have been done by others; they were certainly done at different times, judging by the mix of writing media. These page-spreads have columns for Brought to No. 15, Treated, Recorded, Photographed, Packed and finally Box No. [number], to indicate the boxes bound for Cairo. However, even the first page shows that the system was inconsistently applied: object 4 seems to have been 'brought to no. 15', but the other columns are blank until the thick pencil strokes under 'packed' and 'box no.', which imply that neither occurred. Other objects were ticked, by someone, as photographs were made or (perhaps) negatives catalogued, but not all objects seem to have required separate photography, or perhaps they missed their chance: object 19, eventually catalogued on index cards as five pieces of basketry or floral material, has the word 'nil' in the photography column (correctly: there are no photographs that isolate these objects, and the catalogue cards indicate that

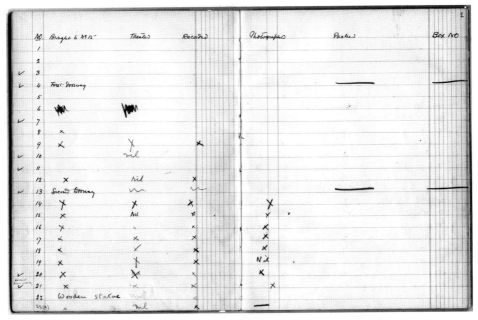

Figure 3.3 First page of the working register of objects for the tomb, showing numbers 1 to 22. Carter archive, Notebook 13.

four of the five pieces were not kept once recorded).[34] The frantic pace and pressure of the first two seasons is evident as the notebook becomes a pencilled list of object numbers and brief descriptions, punctuated by tick marks of uncertain meaning. Carter continued to use the notebook until the final object number – 620 – was assigned in 1928, but without trying to track the progress of recording and photography. Only an inserted slip of paper cross-refers to the unlocated register of negatives: 'Note for Burton. A set of prints required for register nos. 1135 to 1150'.[35]

The only way to reconstruct how many photographs Burton made, on what date, and in what format is to weave the photographic archive together with the rest of the excavation archive, in particular the diaries and journals kept by Carter and, for the first two seasons, Mace. Carter's journals and diaries sometimes mention when Burton started and ended his work or, during the November 1925 mummy unwrapping, the specific times of day given over to photography. Which object was removed on which day, or repaired at a certain time, can suggest a date before or after which certain photographs were taken. Dated notes about phases of work within the tomb likewise indicate specific days or weeks when corresponding photographs must have been taken on site. Other sources of evidence offer clues as well: Burton's correspondence with his Metropolitan Museum colleagues, the diary of his wife Minnie, and to some extent the dates when his photographs appeared in the press, which involved at least a two-week delay thanks to the time it took to post prints to London.[36] Internal cues nonetheless leave question marks about when, even where, some of the photographs in the Tutankhamun archive were taken, or by whom. Some of these uncertainties originate in the first phase of the archive's formation, while the excavation was in progress; others have been introduced during the subsequent archival orderings and re-orderings.

A bit of number-crunching from my own research in both collections offers a rough guide to the contents of the entire photographic archive and the season-by-season character of the work. Although it was impossible to see every negative (the large-format glass plates being especially restricted for handling), I was able to scan the shelves and drawers in both archives in order to check negative numbers, sizes and materials. My working database of the archive, which incorporates these observations, estimates that there are around 3,400 negatives, or prints from lost negatives, in both Oxford and New York – more in Oxford than in New York, since Carter retained his own small-format glass negatives and a number of negatives from handheld cameras, as well as almost all the Burton negatives that depicted himself, Mace, Callender or the Egyptian foremen at work. Of these 3,400, around 700 are copy negatives made since the 1950s, by photographing prints for which no negative survives or for which only one negative was ever made, both

[34] See http://www.griffith.ox.ac.uk/gri/carter/019b(1)-c019b.html.

[35] GI/Carter Notebook 13: 22A. If these are 'black' negative numbers and if they correspond to current Griffith Institute negative numbers (neither is certain), these negatives would be those showing jewellery and amulets from the Anubis shrine (object 261), an ebony and ivory chest (object 267), and the cartouche-shaped storage box (object 269), as well as the canopic shrine and its gilded wooden statuettes of protective goddesses.

[36] The Griffith Institute acquired the diary of Minnie Burton during the research and writing of this book, and it has been scanned and transcribed online: http://www.griffith.ox.ac.uk/minnieburton-project/.

during and since the Scott and Fox collation. However, this has not led to all the original glass plates being printed, because where Burton did take two (or more) similar exposures, he and Carter only chose one negative to print. Hence the creation of copy negatives from existing prints has replicated the earlier printing choices, rather than reflecting the full range of negatives in either institution. Of the prints for which no negatives exist, the largest group comprises about seventy photographs that show parts of the outermost burial shrine (object 207) before it was re-erected at the Cairo Museum. The approximate total of 3,400 also includes more than a hundred known in the Griffith Institute as the 'Valley of the Kings' negatives, most taken by Burton, some by Carter. To these, Carter assigned Roman rather than Arabic numerals, to distinguish them from photographs taken of the tomb and tomb objects.[37]

Correlating the photo archive to events mentioned in diaries and correspondence allows some reconstruction of the schedule of the work, and in particular, a better understanding of how many photographs (that is, negative exposures) Burton took each season and how the intensity of photograph work across different seasons compares (Table 3.1). It is immediately obvious that in the first season, many more photographs were taken than in any subsequent year – some 750, nearly double the range of 400 to 450 in Seasons 2, 4, 5 and 6, and nearly a third more than the next most numerous season, Season 7, when Burton photographed objects from the Annexe, the last part of the tomb cleared. Season 1 also saw Burton use considerably more half-plate negatives than he did in other seasons: more than half of the approximately 750 for which he was responsible. In contrast, in every other season, nearly all the photographs Burton took were in his preferred 18 × 24 cm format. It may be that in Season 1 only smaller plates were available in the numbers needed for the unexpected discovery, either from existing stock that Carter or the Metropolitan Museum had to hand, or based on what could be bought locally in Luxor or ordered from Cairo.

The higher number of half-plates also reflects Burton's use that season of a stand that held a camera upside-down over a sheet of ground glass, for photographing small objects.[38] This camera had a fixed front (rather than swing-and-tilt) and took or could be adapted to take the half-plate size, judging by the resultant negatives in the archives. In later seasons, he used a different ground-glass stand, which accommodated his preferred full-plate camera for object photography.[39] Overall, large-format plates outnumber half-plates in the archive by a ratio of 2:1, with more than 2,000 negatives (lost or extant) measuring 18 × 24 cm compared to around 1,100 half-plates. For the remaining 230 or so images in my working database, either no original negative (or indication of negative size) exists, or else they comprise a mix of film and glass negatives in smaller formats, ranging from quarter-plates (9 × 12 cm, 8.5 × 10.5 cm) to roll or sheet film from handheld cameras.

[37] Discussed in Riggs, 'Photography and Antiquity in the Archive'.

[38] See Riggs, *Tutankhamun: The Original Photographs,* 12 (fig. 5), for a *Times* newspaper photograph of Burton using this camera stand. I am indebted to Ian Cartwright for pointing out to me that the camera in the photo has a fixed front, and explaining the difference this would make.

[39] Of the approximately 800 exposures in both archives, across all seasons, that show objects arranged on ground-glass, the ratio of full- to half-plate negatives is around 60:40, respectively.

Table 3.1 More than ten years of photography at the tomb of Tutankhamun, with estimates of how many photographic exposures Harry Burton took each season.

Season and dates	Activities	Exposures
Season 1, October 1922 to May 1923	Clearing the Antechamber, dismantling wall adjoining Burial Chamber, initial investigation (and photography) of Burial Chamber and Storeroom (or Store-Chamber, which Carter renamed the Treasury in late 1920s)	ca. 750
Season 2, October 1923 to 9 February 1924 (Carter's 'strike')	Clearing the Burial Chamber, disassembling the burial shrines, lifting the sarcophagus lid	ca. 400
Season 3, January to March 1925	Working on objects from Burial Chamber and Treasury, including vases 210 and 211, and fans 242 and 245; initial investigation and cleaning of outermost coffin	ca. 150
Season 4, September 1925 to May 1926	Opening the coffins and unwrapping the mummy; photography of mask and inner coffin (December 1925); spring spent working on objects removed from mummy	ca. 450
Season 5, September 1926 to May 1927	Re-photographing and clearing the Treasury; re-photographing Box 21; photography of objects such as the small shrines containing wrapped statuettes	ca. 450
Season 6, October 1927 to April 1928	Opening the canopic chest; photography of canopic jars and contents, foetal remains, boat models, and *shabti*-figures; clearing the Annex	ca. 400
Season 7, September to December 1928 (according to Carter's journal), continuing into spring 1929 (Burton's correspondence)	Photography of objects from Annex, including calcite (alabaster) and ceramic vases, and Box 370 containing weapons. Burton suffered an attack of dengue fever in November, delaying his work.	ca. 600
Season 8, winter of 1929–30	Carter negotiating with Ministry of Public Works, to arrange financial settlement for Carnarvon family	No photography
Season 9, September to November 1930	Work on the burial shrines and chair 351; opening of magical brick niches in Burial Chamber	ca. 50
Seasons 10 and 11 (no Carter journal), during the winters of 1930–31 and 1931–1932	Further work on the burial shrines, which were readied for shipment to the Cairo museum in 1932	ca. 100
Winter of 1932–33	Photography of burial shrines in the Cairo museum, November or December 1932, and of the sarcophagus in place in the tomb's Burial Chamber, January 1933	ca. 50

Uncertainties over the date of certain photographs, and the existence of similar negatives with identical numbers, make it difficult to give an exact quantity of exposures, hence the estimates given here. These yield a total of 3,400 photographic exposures, not far off the 3,427 photographs I have documented in the New York and Oxford archives.

Burton did, briefly, try large-format film sheets (eight of these survive in the Oxford archive), but he seems to have rejected them as unsuitable, whether because of the results they gave or other concerns.[40] Similarly, Burton experimented with Autochrome colour plates both in his work for the Metropolitan Museum and at Tutankhamun's tomb, as discussed below. The glitter of gold and stones, and shades of ebony and ivory, were a fundamental part of the marvel the Tutankhamun objects inspired, but photography could still do its work in black-and-white, yielding results as crisp and clear as the archaeologist's self-avowed priorities where the scientific record of the tomb was deemed at stake.

'Work in the laboratory'

This phrase was the title of the penultimate chapter in Carter and Mace's *The Tomb of Tut. Ankh.Amen,* written and published at speed in 1923.[41] The chapter elucidates the methods used to record and repair the tomb objects, which, the authors emphasized, was an essential task of the archaeologist. Using a language of obligation and responsibility, and writing in Carter's authorial voice, they present the systematic approach taken at the tomb – in which photography was essential:

> Then there is photography. Every object of any archaeological value must be photographed before it is moved, and in many cases a series of exposures must be made to mark the various stages in the clearing. Many of these photographs will never be used, but you can never tell but that some question may arise, whereby a seemingly useless negative may become a record of the utmost value. Photography is absolutely essential on every side, and it is perhaps the most exacting of all the duties that an excavator has to face. On a particular piece of work I have taken and developed as many as fifty negatives in a single day.[42]

It was in fact Burton, not Carter, who took fifty negatives a day at the busiest times, as the season-by-season breakdown of his photographic output helps demonstrate (see Table 3.1). How that output fitted into – and shaped – the larger scheme of work on site is what concerns us here. No matter how specialist it became, photography could not be isolated from other activities in the tomb and in the so-called laboratory of KV15. Specialization required more, not less, coordination, and Carter and Mace described a 'very definite order of procedure' to keep the work flowing smoothly.[43] Each 'primary'

[40] GI negs. LXXIV, LXXV, LXXVIa, LXXVIa-dup, LXXVIa2, LXXVII-dup (there are two negatives with this designation) and LXXVIII. Burton wrote to Lythgoe from London on 28 July 1922, shortly after placing an order at Watson's photographic supplies with Mace: 'I see that Kodak are making Panchromatic cut films. Would it be possible for you to have sent out a doz. 18x24. I don't know how they will do in Egypt but I think it is worth trying them. If they do as well as glass plates it would be a tremendous saving in freight + there is no risk of breakage.' (MMA/HB: 1920–3).
[41] Carter and Mace, *Tomb of Tut.Ankh.Amen,* vol. I, 151–77.
[42] Ibid., 155.
[43] Ibid., 163.

object was assigned a registration number while still in the tomb, but in many cases – notably the ancient boxes full of other material – letters of the English alphabet were used for associated objects, doubled, tripled, or (at the mummy unwrapping) quadrupled as required. Hence the painted box, object 21, eventually required sub-numbers from 21a to 21yy in order to separate and catalogue the various material it contained. 'Constant care' was required to keep the objects and their number and letter tickets together all the way through the process, since Burton needed these cards for his photographs as well.[44]

The recording system that Carter envisioned, and more or less maintained throughout the project, was based on the use of 6 × 8-inch (15 × 20 cm) index cards. The cataloguing was, by design, an endeavour of multiple hands and multiple media, and photography contributed to the hybrid forms the task required. The main card was to include basic data (object number, material, measurement) and a description, another card would include Lucas's notes on any cleaning and repair undertaken, and inscribed material would have a separate card with Gardiner's notes and translation. There should then be at least two photographs for each object: one showing its position in the tomb, followed by one or more 'scale photographs' (as Carter termed them) showing the object on its own.[45] In the card catalogue, preserved in the Griffith Institute, several prints are often filed behind the written cards; prints from full-plate negatives had to be folded in half or cut down in order to fit. The prints interrelate with the catalogue cards and with drawings Carter made, either on squared paper or on the cards themselves; he also occasionally made a notation directly onto a print. The set of cards for object 4, the sealings of the first doorway, is one example of how drawings and an annotated photograph supplemented the main card, which in this case gives only the number and identification of the 'object'. A fuller description was typed onto two pieces of foolscap paper, folded in half, and then filed with a trimmed and part-folded piece of squared paper on which Carter made rough sketches of the impressions. These pages are followed by four prints, one from each half-plate negative that showed a distinct section of the object – and each print has been inked with a letter corresponding to the typed description and indicating which seal impression is visible (Figure 3.4).

Other prints in the card catalogue bear traces of pencil lines, applied along a straight edge to mark where they were trimmed down; some have scale ratios (e.g. 1:4) pencilled on the back. Photographs may also have been a reference for Carter when he executed detailed drawings on the record cards of some objects, like the 'throne' (object 91), complementing in-person observation. The drawings and photographs of an object usually share the same orientation.

In this process, numbering was a significant act of transformation, and one which Burton's photographs perpetuated so successfully that the Carter object numbers are still used (as I do here) in preference to the registration numbers eventually given to the objects in the Cairo Museum. Assigning numbers changed them from the material traces of

[44] Ibid., 164.
[45] Carter and Mace, *Tomb of Tut.Ankh.Amen,* vol. I, 163.

Figure 3.4 Print from GI neg. P0278 marked-up in Carter's hand, from the card catalogue record for object 4 – the sealings from the first blocked doorway of the tomb.

ancient acts of manufacture and deposition, to objects for archaeological study, with the new acts of manipulation this status required. Carter must already have formed a plan to associate numbers with the *in situ* objects, since the printed number cards appear in Burton's first photographs inside the tomb (see Figure 1.2); presumably the cards were among the stationery items ordered in Cairo in early December 1922. The idea of numbering the objects while they were in place, rather than after they had been removed, was an efficient solution to the distinctive situation the Antechamber presented, with its closely stacked objects and 'crime scene' disturbances. Numbering features on a site, and sequentially cataloguing objects, were both well-established in archaeological practice, although this is the first instance I know of where they were brought together in this way. Likewise, archaeologists had used different methods of incorporating the numbers of both site features and objects into the photographic record, either within the staging of the photograph (chalking a grave number on a slate, for instance) or by marking the negative after the fact. The number-card system was a solution to the distinct set of problems the archaeologists faced, especially in the Antechamber, but it was not a system others chose to adopt. At Giza, in contrast, George Reisner did not pre-number the jumbled funerary material of queen Hetepheres he found in 1926 inside a single chamber.[46] His Egyptian staff photographer, Mohammedani Ibrahim, took copious

photographs of the material in place, but numbers were assigned after, not before, removal.[47]

At the tomb of Tutankhamun, the large type face on most of the number cards – which are around 2 inches (5 cm) tall, judging them against object measurements – made them clearly legible in the photographs, another indication of how photography was designed into other archaeological acts. The inclusion of the cards helped draw attention to items in the photographs that might not immediately have appeared to be separate or significant 'objects', except to the observers who were on the spot. For example, in one of the photographs Burton took mid-clearance in the south corner of the Antechamber, where dismantled chariots had been stacked, just-seen number cards single out parts of the chariots and the grid-like structure of a portable canopy frame that might otherwise have been unintelligible (Figure 3.5).

The absence of number cards meanwhile helps indicate the objects that are not objects, namely, the two wooden batons used to prop up a chariot frame to the viewer's left, after the objects on which it once rested had been removed. Yet the cards were recognized as intrusive as well, too visible to allow the impression that viewers were seeing with the eyes of the last ancient witnesses. Thus, Burton sometimes took one set of exposures with the number cards in place and one without.

The objects *in situ* were the only 'before' shots taken of objects before the cataloguing process. With the exception of a handful of photographs taken in advance of restoration, mainly of jewellery, all other photography was reserved until after objects had been recorded, cleaned and repaired in the laboratory tomb.[48] These are what Carter and Mace meant by 'scale photographs' – though only a few include a scale in the form of a foot-long ruler, a folding yard- or metre-stick, or an unreeled tape measure. Scale would have been adduced for some objects according to a ratio between their actual size and their size on the glass plate. Otherwise, it seems that the number cards may have offered a rough visual guide to size, even though Burton regularly cropped them out when making prints for album mounting. On the whole, and despite the nomenclature of 'scale photographs', object size does not seem to have been a priority in Burton's object photographs. The photographs were only one part of a whole record system, in which dimensions featured prominently on the main cards for each catalogued object.

[46] For the find, see Reisner, 'Hetep-Heres, Mother of Cheops', and the posthumous publication Reisner and Smith, *History of the Giza Necropolis, Vol. 2, The Tomb of Hetep-Heres*. Like other archaeologists, especially in the wake of the Tutankhamun discovery, Reisner made sure the tomb was covered in *The Times* (2, 3, 4, 5 March 1927; 7 June 1927) and the *Illustrated London News* (12 and 26 March 1927). For an important reconsideration of the nature of this deposit, see Münch, 'Categorizing archaeological finds'.

[47] Reisner trained Egyptians as photographers at Giza, a move that may have been motivated in part by the lower cost of their labour. Generations of the same family were responsible for Reisner's photographic work. I thank Lawrence Berman of the Museum of Fine Arts, Boston for discussing his forthcoming work on Reisner's photography with me.

[48] 'Before' photographs as follows: MMA negs. TAA 965 (object 269m, bracelet); TAA 1112 (objects 269a1 and a2, earrings); TAA 1113 (objects 269a3, earrings); TAA 1042 (object 270b, casket); TAA 1159 (object 269i, necklace with pectoral); TAA 1160 (object 269k, necklace); TAA 1176 (object 492, shield). The jewellery items, but not the casket and shield, were all photographed again after repairs were complete.

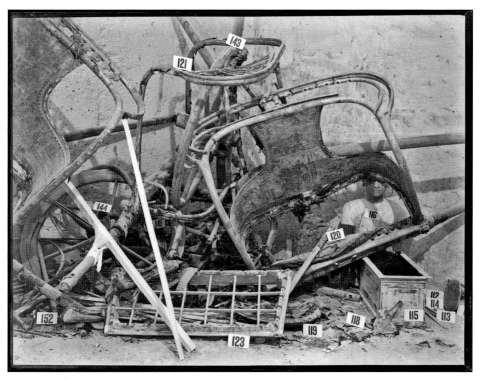

Figure 3.5 Dismantled chariots and other objects in the Antechamber, with number cards in place. Photograph by Harry Burton, January 1923; GI neg. P0035.

It is unclear whether the laboratory tomb ever included facilities for developing negatives. If not, the nearest facility was in tomb KV55, situated close by the tomb of Tutankhamun, around the midpoint of the valley (KV15 is at its farthest end). The antiquities service had given KV55 over to Carter's team, and Burton described in interviews for the London *Times* and *New York Times* how they converted the space into an effective, if awkward, darkroom:

> It is approached by a flight of twenty-five steps, down a passage 30 feet long, at the end of which four more steps lead down into a chamber 30 feet square. At the foot of the first flight of steps we hung a heavy black curtain, with another at the end of the passage, and when these are drawn I have a very efficient dark room.[49]

When developing plates, Burton explained, he posted 'one of my camera boys' outside the first curtain with his (Burton's) watch, to call out the minutes as the developer was poured over the negative. In this way, Burton could tell by hearing when the time had passed to take the plate out of the developer and place it in the fixing bath. Checking that

[49] Burton, 'Clearing the Luxor tomb: The work of the photographer', *The Times,* 16 February 1923: 9.

he had the shot he wanted would have been vital at stages in the clearance work, before anything was moved, hence the advantage of having a darkroom close at hand. It also made the photographic process at the tomb more visible to observers. Carter and Mace commented that the sight of Burton dashing between the tomb of Tutankhamun and KV55 'must have been a godsend' to the gathered tourists and journalists, since there was little else to see some days.[50] But apart from visitors who had privileged access, or readers who saw a handful of sanctioned photographs that appeared in the press, activities in the laboratory took place out of sight.

For the purpose of determining whether he had the shot he wanted in the tomb, Burton only needed to develop a negative, not print it; any prints he did make in the dusty environment of the KV55 darkroom would only suffice as test prints, in any case. More likely, he did much of his printing during the first two seasons at Carter's house, since the developed negatives were presumably transported there for cataloguing and safekeeping. Beginning with Season 3, the catch-up season after work resumed in 1925, Carter gave Burton permission to take the negatives to Metropolitan House, as Burton reported with evident relief to Lythgoe:

> He has consented to my bringing the negatives over here to print, which will be much more convenient and will take much less time. We got a little annoyed with one another one day last week, but I think + hope I shall get away without any trouble.[51]

If there were no developing facilities in the laboratory tomb KV15, then when photographing objects there, Burton must have trusted his own experience in getting the desired image, even where multiple views were needed to show stages of emptying the ancient boxes or opening one of the miniature shrines. At the laboratory, Burton had recourse to several staging methods for photographing different kinds of objects, in different ways, during the first two seasons: a wooden platform from which he could angle his camera directly over long objects on the ground below; the stand that held a camera over a ground-glass shelf; folded cloths that could be fixed, draped, or held behind objects to isolate them; and a portable roll-down backdrop. In later seasons, he refined these staging methods (for instance, having assistants put the backcloth in motion for a blurred effect in the image background) and developed new ones too, as I discuss below and return to, in more detail, in the next chapter.

Although KV15 was meant to function as a scientific laboratory, that function did not extend to scientific experimentation – or at least, experimentation was never mentioned in the public statements Carter, Mace and Burton made. To admit to experimenting in the context would have been admitting uncertainty, and thus undermining their authority as the only experts who could be trusted with the work. Burton's photography did involve a degree of experimentation, however, primarily directed towards his main work for the Egyptian Expedition. For the Expedition, he had ventured some new methods at Lythgoe's

[50] Carter and Mace, *The Tomb of Tut.Ankh.Amen,* vol. I, 127.
[51] Burton to Lythgoe, 17 March 1925 (MMA/HB: 1924–9).

urging, in particular the use of colour plates (which Burton had tried before the war, unsatisfactorily) and of a moving-picture camera.[52] For most of his work, however, Burton relied on panchromatic plates. These yielded adequate tonal balance and differentiation, which were especially important, but difficult to achieve, among the copious gold and gilding of the Tutankhamun objects.[53] Encouraged by Lythgoe, Burton had begun to trial Lumière colour plates, known as Autochromes, in 1921.[54] Susceptible to heat and dust, and unstable even when developed (they faded in sunlight), Autochromes became a small but consistent portion of his work for the Metropolitan, and Burton kept them on hand throughout the 1920s, for instance ordering six dozen large-format colour plates from Watson's photographic supplies in London in the summer of 1922.[55] He used this stock to take 'some colour photos' for Carter at some point in 1923 or 1924, for which Carter later gave Burton a separate payment of £62.[56] While the gold, stones, painted objects and different woods in the tomb might have seemed obvious subjects for further colour photography, it appears not to have been a priority; Carter's neatly annotated sketches served the function of recording colour well enough. In the nineteenth and early twentieth centuries, monochrome photography was standard for documentary purposes, and would remain so for decades. The absence of colour did not make black-and-white photography less real, but more so. As Peter Geimer has recently argued: 'It is obviously true that colour – at least as humans experienced it in the visible spectrum – was *absent* in photography for almost one hundred years. But this absence does not necessarily mean that it *lacked*'.[57] Colour became desirable where images needed spectacular visual impact, rather than a scientific record value. The impact of colour appealed for more popular forms of publication, for advertising or for projecting lantern slides, and in these instances, colour effects could more easily be obtained by hand-tinting reproductions, than by using colour photography. This may have been one factor working against more concerted efforts to take colour photographs at the tomb, likewise the expense and difficulty of printing Autochromes to the standard of book, rather than periodical,

[52] In a letter he wrote to Lythgoe from his home in Florence, before travelling to Egypt for the season, Burton explained: ''As regard[s] colour photography I have ordered a couple of dozen of Lumière plates to try how they will work at Luxor. Winlock + I thought it would be a good plan to get coloured photos of last season's sarcophagus, so the two dozen were ordered for that. If they are successful, then we might try them on the tombs. It is a long time since I tried them + then I found them very difficult to work if the water was at all warm as they fill so easily. Then again the film is so soft that the least bit of dust scratches them + makes nasty marks which it is next to impossible to retouch. As I said before, it is some years since I tried them, so they may have improved since then' (MMA/HB: 1920–3, letter dated 30 September 1921).

[53] See G.B. Johnson, 'Painting with light', 64–6 for Burton's plate and lens preferences in the 1920s.

[54] Lythgoe first suggested using colour plates to record Theban tombs, in a letter to Burton dated 13 September 1921 (MMA/HB: 1920–3). By February 1922, three dozen plates had arrived at the Metropolitan Museum dig house, almost all used over the following month (letter from Burton to Lythgoe, 25 March 1922; MMA/HB: 1920–3). For more on Burton's use of Autochromes, and surviving examples in the Metropolitan Museum of Art, see G.B. Johnson, 'Painting with light', 66–7, 69.

[55] Lythgoe advised Burton to order this quantity for the following season (letter dated 29 June 1922), and Burton replied from London, confirming that he and Mace had done so (letter dated 28 July 1922; MMA/HB: 1920–3).

[56] Burton to Lythgoe, 28 October 1925, page added to letter dated the previous day (MMA/HB: 1924–9). Burton sought, and gained, Lythgoe's approval before accepting the payment from Carter.

[57] Geimer, 'The colors of evidence', quoted passage at 49.

publication. Such printing, or the printing of photographic plates more generally, might have been one of the costs Carter had in mind when he claimed that a full publication of the tomb was too expensive to pursue – £13,000, he told Burton over dinner at Luxor years later, in 1934.[58]

There was another experimental aspect to Burton's work at the tomb, again an extension of what he was already doing for the Metropolitan Museum: moving-camera footage. The movie camera was a gift to the Egyptian Expedition from trustee Edward Harkness, and its use and issues with maintenance dominated Burton's correspondence with Lythgoe throughout the early 1920s. Lythgoe's idea was to film not only the work of the Expedition at Luxor, but also scenes that would convey the flavour of life in Egypt to the Museum's public in New York. The Egyptian life that Lythgoe had in mind was invariably 'traditional', not modern: Burton filmed in the old city of Cairo, around the ruined temples of Luxor, and Egyptian women getting water at a well.[59] Filming work at the tomb of Tutankhamun seemed only natural, for use in newsreels or even a feature-length film, as Carnarvon had imagined. The first camera Burton used – and which the London *Times* photographed him using outside the tomb in 1923 – was an American-made Akeley.[60] When this jammed that spring, and had to be shipped to New York for repair, it prevented Burton from filming the transport of the crated objects to the river.[61] Such was the interest in filming the tomb, however, that Carter helped arrange for a new cine-camera, a model made by James Sinclair, the London photographic supplier and manufacturer.[62] The films had to be developed in New York or London, meaning that of the film he took in the first season, Burton only saw the results in August 1923, when he was in England to visit family and attend his father's funeral. He explained to Lythgoe that seeing the films had helped him understand how the camera needed to be used, since some of them were failures – either out of focus because of the lens setting or because he had panned too quickly:

> The views of the tomb <u>can</u> be done again, but not the couches coming out of the tomb. My only regrets are that I didn't insist on putting the 'movie' on to the removal from the beginning.[63]

[58] Burton to Winlock, 27 March 1924 (MMA/HB: 1924–9).

[59] Lythgoe first raised the subject of the movie camera in a letter to Burton dated 21 June 1920, suggesting that Harkness would like films of 'excavation or native life or Cairo street-scenes'. Burton wrote to Lythgoe on 18 October 1923, to report that he had been filming in the bazaar and old city in Cairo; on 10 August 1925, he reported that Winlock had suggested filming around the Giza pyramids to illustrate 'irrigation' techniques and complete an array of agricultural scenes. Lythgoe clearly thought along similar lines, writing to Burton: 'Get all you can of other sides of native life this season, won't you? We ought to have more of the native quarters and bazaars of Cairo and also smaller towns like Kena. Also weaving, pottery making and the like.' (Letter dated 26 October 1925; for all of these, MMA/HB: 1920–3 and 1924–9).

[60] See Riggs, *Tutankhamun: The Original Photographs*, 60 (fig. 75).

[61] Letters from Burton to Lythgoe, 1 May 1923 for the jamming, and 18 August 1923 for the Akeley having been repaired and when it would be sent back (MMA/HB: 1920–3).

[62] Letters from Burton to Lythgoe, 17 July 1923 for the new Sinclair, and 2 September 1923 to report that he prefers the Sinclair camera and has had training from the firm in London (MMA/HB: 1920–3).

[63] Burton to Lythgoe, 2 September 1923 (MMA/HB: 1920–3).

Filming inside the tomb was even more of a problem, because the electric light that was adequate for still photography was inadequate for filming. He tried to film inside the Burial Chamber, but when the films were developed in London, Sinclair sent word that they were a 'complete failure', as Burton recounted to Lythgoe:

> I am terribly mortified at this failure although I am not wholly to blame. I kept telling Carter that unless he concentrated the light it was a waste of good material + time. His only reply was that I must do the best I could. By the end of the season I felt completely done up by constantly trying to make Carter see reason.[64]

That failure, though, meant that Harkness arranged to send Burton to Hollywood, to see at firsthand how the movie studios achieved their effects. Burton and his wife had an enjoyable trip across the United States, but Hollywood proved disappointing: the studios were reluctant to reveal their trade secrets, and Burton in any case realized that the kinds of generators and electric lights they used would never work in Egypt. The generators were 'colossal' (Burton didn't think they would make it across the Nile), and the quantity of lights and wattage needed far beyond what the tomb could hold or the antiquities service supply.[65]

Hollywood glamour may seem a strange fit for the discourse of scientific probity in which Carter and the Museum archaeologists engaged. The excitement and attention of the Tutankhamun discovery did not initiate the use of the latest photographic techniques or promotional activities: Burton was already using Autochromes and a movie camera, and the Expedition's work, with Burton prominently credited, had featured in the *Illustrated London News* in 1921, using the same wording that would always appear with his Tutankhamun photographs. In a sense, the first two years of the Tutankhamun excavation confirmed the value archaeology had placed on photography, and confirmed the range of modes in which different kinds of photographic techniques could operate. The 'record' photograph, and its archival framework, was part of a coordinated array of visual practices through which archaeology saw its subject matter and encouraged others to see itself. What is just as telling is which of those practices the team would keep, and which abandon, over the course of the Tutankhamun project.

Job done

In the more restrained mood that prevailed when work on the tomb resumed in 1925, some aspects of Burton's photography for the tomb became more restrained, too. Carter himself kept no further diaries (or else they do not survive), and his journal entries became more cursory, apart from an extended description, added to daily, of the mummy unwrapping.[66] For the period after Carter's falling-out with the Service, Burton's correspondence with his Metropolitan Museum colleagues helps fill gaps in knowing what work was happening at

[64] Burton to Lythgoe, 30 April 1924 (MMA/HB: 1924–9).
[65] Burton to Lythgoe, 1 July 1924 (MMA/HB: 1924–9).
[66] See GI/HCjournals for the relevant years.

the site, and when, as well as giving voice to Burton's own views and those of his Metropolitan Museum colleagues. The relationship between Burton and Carter (and Winlock and Carter) was not always easy, nor was Burton's continued involvement in the Tutankhamun work a given. Writing to Lythgoe in August 1924, after he had seen Carter in London, Burton described Carter as being 'in a peculiar mood' and 'cryptic' about plans to go on working in the tomb. Negotiations on Carter's behalf were still taking place, but Burton was left with the impression that work would resume in the new year. Although he told Lythgoe he had no idea whether Carter would 'allow' him to continue, Burton ordered adequate plates just in case, together with the requirements for his usual work with Winlock.[67]

The short third season of early 1925 saw Burton photograph the outermost coffin lying in the basin of the stone sarcophagus, surrounded by the draped and dismantled walls of the burial shrines. Carter spent the season working on objects still left in KV15, such as one of the pair of guardian statues, a series of walking sticks, and the objects found inside and in between the burial shrines. One of these, object 210, was an Egyptian alabaster perfume vase found just inside the doors of the first burial shrine in early December 1923, and stored in KV15 during the cessation of work on site. During that winter before the 'strike', Burton seems to have taken a photograph of this virtuoso example of carving, using a piece of hanging (or held-up) fabric, the creases of its fold lines visible (Figure 3.6).[68]

Returning to the laboratory tomb early in 1925 gave him an opportunity to revisit this arrangement, using a new backdrop he had devised: a paper-lined board of some kind, thin enough to curve around one edge of a round table (Figure 3.7). This set-up was fundamental to his object photography in subsequent seasons, featuring in around 650 negatives. As mentioned above, this was also the point at which Burton reported to Lythgoe that Carter had agreed to let him take the Tutankhamun negatives to Metropolitan House to print at his own convenience.[69]

Preparations for Season 4 focused on opening the king's coffins in time for the mummy unwrapping to take place in November 1925, and Carter had asked Burton to be ready for work at the tomb by mid-October.[70] Burton complained to Lythgoe that Carter had not given the Museum credit for photographs he used in lectures in London that summer, but Lythgoe could respond by assuring Burton that his photographs had plenty of interest in New York, where prints forwarded by Carter were being framed to make a second public display, after the success of a previous exhibition in 1923.[71] Still, frustrations were evident:

[67] Burton to Lythgoe, 25 August 1924 (MMA/HB: 1924–9).

[68] Two 18 × 24 cm glass plates exists, MMA neg. TAA 1054 and GI neg. P0671A.

[69] Burton to Lythgoe, 17 March 1925 (MMA/HB: 1924–9).

[70] Burton to Lythgoe, 7 July 1925, in which Burton also reports that he would stay at Carter's house for the initial part of the season, since Metropolitan House would not yet be open (MMA/HB: 1924–9).

[71] Lythgoe's letter to Burton, dated 26 October 1925, included this postscript: 'Please give my best greetings to Carter and tell him I greatly appreciated his letter. The prints which he sent us from your negatives of last year arrived safely and please give him our best thanks for them. We are just putting them on exhibition in the frames with the photographs of the previous years in the tomb. A steady stream of people are greatly interested in them, day after day, week in and week out. There is no loss of interest in the tomb, I can assure you.' The previous exhibition of Burton's photographs was reported in the *New York Times* ('Tut-ankh-amen views in museum: Photographs of tomb and its wonderful treasures shown in Egyptian Room', 5 May 1923: 14), and in *The Metropolitan Museum of Art Bulletin* 18.5 (May 1923), 132, under 'Notes'.

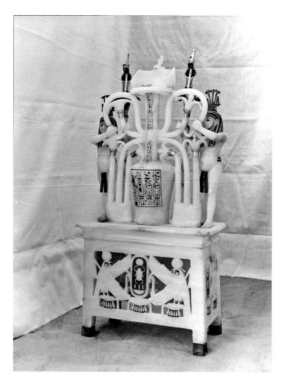

Figure 3.6 Perfume vase (object 210). Photograph by Harry Burton, December 1923 or January 1924; MMA neg. TAA 1054.

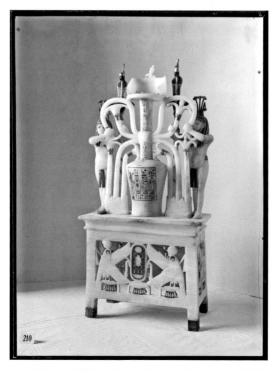

Figure 3.7 Perfume vase (object 210) photographed again in early 1925, using a new, curved backdrop. Photograph by Harry Burton, February or March 1925; GI neg. P0524.

citing the need for secrecy, Carter would not allow Burton to use the movie camera as he'd hoped to do, to film the coffins being removed from the tomb – but Burton did manage at that point to get Carter to agree that the Museum could have the 'duplicate' Tutankhamun negatives. 'We have a claim on them', Burton wrote.[72]

This season saw the last of the staged 'work-in-progress' photographs that Burton had taken during the first and especially the second seasons, with publicity purposes in mind. As Carter finally opened the royal coffins in October 1925, Burton photographed him lifting back the linen shrouds that covered them (see Figure 5.1), brushing away unseen dust, and, with one of the Egyptian foremen, hammering resin off the innermost, solid gold coffin (see Figure 7.1).[73] Each shot was studiously lit and posed, with no blurring from human movement. In November, on the day the mummy unwrapping commenced, Burton marked the occasion with the sequence of formal group shots of 'the Committee' discussed in Chapter 1 (see Figure 1.6). During the week-long unwrapping, which took place just inside KV15, work could only be done during the hours of around 8 am and 3 pm, so that Burton had adequate light for photography. His 'camera boys', he noted, had arrived just in time to help with the work, though it is unclear from where, and Burton was not happy with what light he did have, although he did make sure to take duplicate photographs. In the end, he reported to Lythgoe that not being able to use the movie camera didn't really matter: the mummy, which was stuck fast with resin in its coffin and wrapped in brittle, carbonized bandages, was a disappointment compared to mummies the Egyptian Expedition had found and Burton photographed.[74]

For the rest of that autumn and winter, Burton combined his work for Carter with his work for the Egyptian Expedition: from 8 am to 1 pm, he was either at the tomb or in KV15 with Carter, followed by lunch at Carter's house; Burton returned to the Metropolitan dig house after 2 pm and worked there into the evening. The work for Carter entailed photographing some of the most splendid objects from the tomb, although Burton felt rushed when it came to photographing the mummy mask and especially the innermost, solid gold coffin, both of which had to be sent to Cairo – accompanied by Carter, Lucas and an Egyptian military escort – at the end of December 1925.[75] In April of the new year, Burton returned to photograph the jewellery, having been put off by Carter for a month, for no good reason that Burton could discern. It had been 'a nightmare' trying to serve 'two masters', since the delay competed with work that Winlock needed him to do for the

[72] Burton to Lythgoe, 27 October 1925 (MMA/HB: 1924–9).

[73] The relevant negatives showing preparations for the unwrapping, all 18 × 24 cm glass plates, are GI negs. P0720, P0721, plus a print with no extant negative, copy-photographed in film after 1980 and catalogued as P1853; and MMA negs. TAA 371 and TAA 1354. For the latter of these, a c. mid-twentieth century copy negative exists in the Griffith Institute as P0770, made using a glass half-plate negative.

[74] Burton to Lythgoe, 24 November 1925 (MMA/HB: 1924–9), and for the hours of work during the mummy unwrapping, see GI/HCjournals for 12, 13 and 15 November 1925 (http://www.griffith.ox.ac.uk/discoveringTut/journals-and-diaries/season–4/journal.html).

[75] For the schedule, see GI/HCjournals, entries for 16 and 31 December 1925. Burton's disappointment over the rushed timing is mentioned in a letter to Lythgoe, 21 January 1926 – in which he also reports that his photographs would appear in the press, following arrangements Carter made with the Egyptian government (MMA/HB: 1924–9).

Expedition. However, Burton's correspondence makes it clear that he felt unable to confront Carter about this directly, presumably because of sensitivities concerning the Museum's relationship with Carter and what the Museum still hoped to gain in terms of an eventual division. Instead, he asked Lythgoe to intervene by making Carter aware that Burton's Tutankhamun work must not interfere with his principal duties to the Museum.[76]

Perhaps this concern was successfully conveyed to Carter, since from the next season, in the winter of 1926–7, Burton seems to have done his work for Carter in shorter, concentrated periods, during which he kept to the pattern of spending mornings with Carter and afternoons with Winlock.[77] There was another advantage that season, from Burton's point of view: eighty of 160 negatives Carter had packed for shipment to New York had broken when a box slipped from the net as it was being loaded onto a ship at Port Said.[78] The loss made Carter grateful for the 'duplicates' at his Luxor house, and by the time Burton arrived on site in mid-October, Carter readily agreed to let Burton take all photographs in duplicate – that is, exposing two plates under near-identical conditions – from that point on.[79] From Burton's point of view, this was a victory for the Metropolitan, but Carter continued to reject any use of moving-picture cameras on site.[80] Carter was, at least, in a good mood and much easier to get along with, compared to previous seasons.[81] Burton's work that season included a set of photographs of the painted chest found in the first season (box 21), which Carter brought back to Luxor from the Cairo Museum for that purpose. He also photographed a series of gilded wooden statuettes from the two-dozen miniature shrines found in the Treasury. It was exciting to open them, he reported to New York, and he was happy with the photographs he achieved, angling the divine figures against the curved backdrop (Figure 3.8).[82]

For the shrine statuettes and other sculpture in the round, like the four goddess statues that protected the canopic chest, Burton did not take 'true' duplicates, but he did take two different views, by adjusting the angle at which each object stood to the camera.

[76] Letters from Burton to Lythgoe, 9 March and 25 May 1926 (MMA/HB: 1924–9).

[77] Burton to Lythgoe, 11 January 1927 (MMA/HB: 1924–9).

[78] Burton to Winlock, 26 August 1926 (MMA/HB: 1924–9).

[79] Letter from Burton to Lythgoe, 19 October 1926 (MMA/HB: 1924–9). This did not entirely put the matter to rest, however. In a further letter dated 11 November 1926, Burton wrote, 'Carter growls a bit at my taking so long, but since he lost so many negatives last season there's no question about duplicates!'

[80] In Burton's letter to Lythgoe, dated 11 November 1926, as follows: 'The work with Carter is going very well, so far, + he is quite reasonable. I spoke to him about doing some more "movies" but he said he was sorry he couldn't consent, as he had promised the Govt that no more should be taken in the tomb. He said he couldn't object to my doing things coming out of the tomb, but he would rather I didn't, as he didn't wish to give anybody cause for complaint. After that I felt it wouldn't be fair to take the camera over. As a matter of fact, there is really nothing worth while doing as the boxes as they come out of the tomb are covered over + are therefore nothing like as interesting as the bed etc that we got the first year' (MMA/HB: 1924–29).

[81] As above, plus a letter from Burton to Lythgoe, dated 11 January 1927: 'The work on the tomb is going very well + Carter has been much easier to get on with this season + my one hope is that he will keep it up until the end' (MMA/HB: 1924–9).

[82] In the letter of 11 November 1926 (see n. 78): 'The black boxes contain gilt wooden statuettes + are really very fine. There are two that are particularly attractive, where the king is standing on a reed boat throwing a spear. They are both the same + are full of movement, which is rather unusual in Egyptian sculpture. It is very exciting opening these boxes + as my photographs, so far, have come out well, I am much happier than I was last year' (MMA/HB: 1924–9).

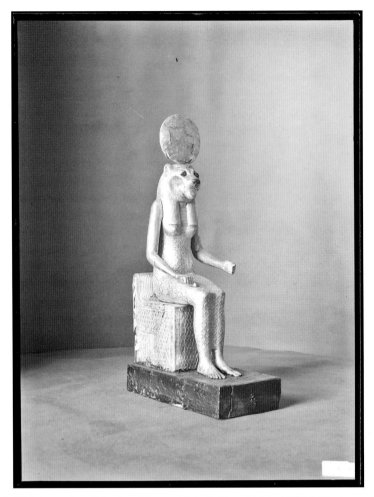

Figure 3.8 Gilded wooden statuette of the goddess Sekhmet (object 300a). Photograph by Harry Burton, March 1927; GI neg. P1040.

Some of these were subsequently divided by Carter between himself and the Museum, rather generously because there were so many of the statuettes to deal with. The Sekhmet statuette (object 300a) in Figure 3.8 is Carter's negative, now in Oxford, while a negative showing the object angled in the other direction (facing left instead of right) is now in New York, as are negatives showing the statue when it was still wrapped and depicting the smoothed-out, ink-inscribed linen wrapping itself.[83]

By Season 6, over the winter of 1927–8, all that remained to be done in the tomb was removing the last few objects – in particular, the canopic shrine and its inner chest – from the Treasury, and then clearing the Annex, which was done fairly rapidly in the new year. Burton

[83] The negative used in Figure 3.8 is GI neg. P1040. MMA negs. as follows: TAA 711 shows the statuette facing left; TAA 880 shows it still wrapped (with three others); TAA 881 shows the linen. All 18 × 24 cm glass plates.

started his work in mid-October again, tackling a backlog of objects awaiting photography. These needed to be finished to make space in KV15, before the canopic chest and a fragile ship model with rigged sails (object 276) could be brought out of the tomb.[84] Burton was pleased that Carter never now questioned the need for duplicates. He described to Lythgoe a 'marvellous' bow case (object 335) Carter was working on, of which Burton planned to take ten photographs; in the end he took eleven 'duplicates', with one failed negative, for a total of twenty-three exposures.[85] Burton finished his work for Carter after photographing the Annex in stages, in early January 1928, but he did another ten days' work on Carter's behalf in April, printing Tutankhamun negatives.[86] Carter was not oblivious to what he owed the Museum: on this occasion, he made a point of asking Burton to send a set of prints to New York, by the more expensive letter post if Burton thought that was the safest route. Perhaps the recent death of Arthur Mace, which Burton mentions in his own letters, had reminded Carter of the extent of his personal and professional relationship with the Museum.[87]

With the tomb clear as of early 1928, apart from the dismantled shrines, the next phase of Burton's Tutankhamun work focused on photographing the objects in KV15 as Carter and chemist Alfred Lucas worked through them; Lucas had retired from government service in spring 1923 in order to devote himself to work on archaeological objects, including the Tutankhamun excavation.[88] In Season 7, Burton was set to start work with Carter in late October 1928, but shortly after he arrived, Burton collapsed with dengue fever and needed weeks to recover.[89] His planned photography was put off until the new year, finishing only in early March 1929 – by which time Carter had gone to Cairo to commence his negotiations with the Egyptian authorities for 'the spoils', as Burton put it.[90] These negotiations continued for a year, and although Carter had hoped to work on site in the winter of 1929–30 (he asked Winlock well ahead of time whether Burton would be available), he in fact stayed in Cairo.[91] The pause, coupled with the outcome of the

[84] Burton to Lythgoe, 25 November 1927: 'I am still working with Carter + I am glad to say most of the objects from the inner chamber have been photographed + Carter hopes to commence moving the objects form the last chamber this next week. He wants, if possible, to move all the objects out of the tomb this season + put them into No 15 + work on them at his leisure. He is in good form + so far we have got along very well' (MMA/HB: 1924–9).

[85] Burton to Lythgoe, 21 October 1927 (MMA/HB: 1924–9). In the end, Burton took 23 exposures showing the complete case and details of both intricately worked sides: GI negs. P1120, P1121, P1122 (there are two negatives with this number; one is out of focus), P1123, P1124, P1125, P1126 and MMA negs. TAA 161 to 167 inclusive and TAA 1219 to 1225 inclusive. I thank Ian Cartwright for examining the two negatives numbered P1122 with me in Oxford and sharing his observations.

[86] Letters from Burton to Lythgoe, 10 January and 10 April 1928 (MMA/HB: 1924–8).

[87] Burton to Lythgoe, 21 May 1928 (MMA/HB: 1924–8).

[88] See Gilberg, 'Alfred Lucas: Egypt's Sherlock Holmes'.

[89] Letters from Burton to Lythgoe, 3 July 1928, mentioning that Carter did not need him before the end of October, and another on 21 November 1928, describing his illness and Carter's kindness (MMA/HB: 1924–9). See also Carter's journal entries for 9, 15 and 24 November (http://www.griffith.ox.ac.uk/discoveringTut/journals-and-diaries/season–7/journal.html).

[90] Although Carter's journal for the season ends on 4 December 1928 (see http://www.griffith.ox.ac.uk/discoveringTut/journals-and-diaries/season–7/journal.html), Burton wrote to Lythgoe on 19 March 1929, reporting that he had had a long season with Carter, finishing about ten days previously (MMA/HB: 1924–9).

[91] In a letter of 10 June 1929, Winlock informed Burton that Carter had asked whether Burton could help out next season (i.e. 1929–30). Winlock felt it was up to Lythgoe, and Lythgoe had expressed a wish that Burton see out the work (MMA/HB: 1924–9).

negotiations, seems to have given the Metropolitan Museum staff a reason to reconsider their position. With neither a share of the antiquities nor cash compensation forthcoming, would Burton continue to contribute? Lythgoe thought he should, for reasons of continuity: it would be a 'misfortune to the science' not to see the work through to completion, if Burton could face it.[92]

Face it he did. When Carter resumed work in late 1930 (Season 9), Burton was on hand to photograph an impressive chair from the Annex (object 351) that had required extensive repairs, as well as the tomb's last act of opening and unveiling, when four plastered-over niches in the Burial Chamber were opened, revealing the magic bricks and wrapped figures inside them.[93] Through that winter and the next, Carter and Lucas focused on cleaning, repairing and stabilizing for transport the four burial shrines, which had been dismantled in the winter of 1923–4 and spent years, in protective wraps, inside the tomb. They were finally sent to Cairo in 1932 and erected that December in new vitrines on the upper floor of the antiquities museum, where Burton was able to photograph the largest shrine while it was still in pieces in the museum galleries, and all four of the shrines before the glass was put in place (see Figure 1.7).[94] Burton took the negatives with him to Luxor to print at leisure in the dig house, together with the final negatives he would take of the sarcophagus in the new year. It was amidst this work that Burton turned his attention to the first set of queries Nora Scott had sent, as she attempted to sort out the Tutankhamun prints and negatives in New York.[95] By September, she was still straightening out the 'Tutankhamun negative mess' and sent another set of questions, via assistant curator Charlotte Clark (who added that they were still awaiting a batch of negatives Carter had promised to send months before).[96] Finally, in February 1934, Burton sat down at the dig house typewriter to deal with Scott's questions and explain the red and the black numbers, and the real and the not-quite duplicates.[97] Just over eleven years had passed since Burton had set up his camera in the Antechamber of Tutankhamun's tomb. His photography was finished, but the archive was not.

Photography may have been the 'first and most pressing need' at the tomb of Tutankhamun, but it was necessary for more reasons than those admitted by the discourse of disinterested science. Built into the daily and seasonal working rhythms of archaeology,

[92] Winlock to Burton, 10 June 1929.

[93] Negatives as follows, all 18 × 24 cm glass plates: GI negs. P0879, P0879A, P0879B, P0879C (there are two negatives with this number), P0884, P0884A, P0884B, P0884C; MMA negs. TAA 493 to 496, inclusive. The niches had been identified and numbered in the appropriate sequence within the Burial Chamber, but there was inadequate space to open them. Hence, they were left intact while the burial shrines were dismantled in Season 2, and during subsequent seasons when wrapped-up walls of the shrines were left leaning against the chamber walls.

[94] Burton to Winlock, 26 December 1932 (MMA/HB: 1930–5).

[95] Burton to Clark, 6 January 1933, in which he apologizes for the late reply to her own letter of 10 October 1932, caused by the work he had to do in the meantime – including photographing the shrines in Cairo. He continues: 'After I got back there was Carter's printing to be done, all my last year's photos to be mounted, so that literally I've only just got to Miss Scott's queries. I am enclosing them in this letter with the answers in red ink + hope they are sufficiently clear' (MMA/HB: 1930–5).

[96] Clark to Burton, 18 September 1933 (MMA/HB: 1930–5).

[97] Burton to Scott, 6 February 1934: see Riggs, 'Photographing Tutankhamun', fig. 7.

photography had an impact far beyond the physical space of the field and the intellectual space of the accurate 'record'. It required coordination and connections between Luxor and Cairo, and London and New York, by way of several other places in between – the docks of Port Said, the railway station at Naples, or Lythgoe's summer home in Connecticut, to name just three of the places mentioned in Burton's correspondence. It also offered opportunities to commemorate the archaeologists at what were deemed crucial points in the work, as well as oiling the wheels of a sometimes difficult collaboration between Carter and the Metropolitan Museum.

Most discussions of Burton's photography for Tutankhamun's tomb have focused on what he photographed, and sometimes how, but never at the epistemological, practical and archival issues that informed his work and its subsequent trajectories. Such discussions have tended to assume a single aesthetic for Burton's photographs, without distinguishing between different aims and settings, or for changes in his approach over time. In the absence of any register of negatives that Carter kept, much less any dated log, the quantity of photographs Burton took, and when he took them, has only been established during my own research for this project, and then only with tentative results, due to the later history of the archive and its current 'state of play', in particular the online database created by the Griffith Institute from its holdings in the late 1990s. There is an irony in the mismatch between such a famous body of archaeological photographs and the lack of firm technical or chronological information about them. The dogma of the 'complete' photographic record, as a hallmark of 'scientific' archaeology, produced a tautology whereby any photographic record characterized as 'scientific' was presumed to be 'complete'. Inadequate photography was always some other, less competent, excavator's problem. As this chapter has demonstrated, the reality was inevitably more complex, and all the more interesting for its gaps, flaws and foiled attempts.

The chapter also shows how time-consuming and often repetitive a task photography was, one reason why, over the course of the interwar period, it was increasingly devolved to specialists like Burton, or George Reisner's Egyptian photographic staff. Amid the tensions around how archaeology would operate in semi-independent Egypt, Burton's photographs during the first two seasons in particular spoke to a more recent past as well as the ancient one – a past in which British discoveries and derring-do still held sway. Even hampered by time pressure, political wrangling, and supplies, Burton produced the kinds of photographs that suited and supported the narrative the team were creating about their own work, and about Tutankhamun. What they recorded was not simply the 'evidence' the archaeologists emphasized as their goal, but the unique skill of the archaeologists themselves. To this purpose, Burton's work went beyond photographs of the tomb interior and the prepared objects, to include photographs – and film footage – of the work in progress, legitimizing the team's efforts while also creating opportunities for publicity and fund-raising. After the Service des Antiquités allowed Carter to resume the excavation in 1925, subtle adjustments were made in his working relationships, the schedule of the photography, and the press circulation of the photographs. Not only the authority of the Service but also the technical requirements of Burton's photography had been better established. As he saw the job through to its 'bitter' end, the range of photographic techniques that Burton brought to bear on his work continued to speak to

motivations beyond the 'scientific' aims that the archaeologists articulated – aims that the next three chapters explore by focusing in turn on object photography, the representation of labour at the site, and the use of Burton's photographs in the press.[98] This last had often been a delight to Burton, who was pleased with the quality of the printing in weekly illustrated newspapers and in Carter's *Tut.Ankh.Amen* books. Nonetheless, a sorry note hangs over the end of the long partnership: 'I wonder very much whether we shall ever get anything out of it', Burton complained in a letter to Herbert Winlock in 1932.[99] Negatives and prints were a poor substitute for the treasures they represented in such rich silver gelatine tones.

[98] The phrase 'the "bitter" end' (which Burton expressed in inverted commas, thus) appears in his letter to Winlock, 20 January 1933 (MMA/HB: 1930–5).
[99] Burton to Winlock, 26 December 1932 (MMA/HB: 1930–5).

4
TUTANKHAMUN'S TREASURES: OBJECTS, ARTWORKS, BODIES

The quantity, variety and deposition of the artefacts in Tutankhamun's tomb required a system to make sense of them – a system Carter and his colleagues created at the outset of the excavation and adapted over time, as the previous chapter discussed. It was a system that relied on several processes (such as numbering, measuring and restoring) both to produce the object-as-artefact and to yield an archival record that aimed to capture the object itself. This was a task for which photography seemed to offer a clear advantage, but decisions about how to number objects, what to keep and what to restore, what to photograph, and how to photograph it, reflected and reinforced ideas about the artefacts. What were they, other than the 'wonderful things' of Carter's famous phrase? And was it photography's job to convey that wonder, or help create it?

This chapter considers the process of transformation that artefacts from the tomb of Tutankhamun underwent to become (some of them, at least) the treasures of the newly famous king – and the role photography played in that process. Thanks to the thousands of objects discovered in the tomb, including the king's mummy, photographing objects was part of Burton's routine, and object photographs comprise around two-thirds of the archive. But there was no single way to photograph the variety of objects that comprised 'ancient Egypt' or that related, in different ways, to the boy-king. It was not even clear what word to apply to them: 'treasures', sometimes 'art', but also 'antiquities' or 'artefacts', a more general categorization similar to my own use of the word 'object' here. Burton adapted his photographic approach based on judgements about the kind of object being photographed, which might reflect its material qualities, its aesthetic appeal, or, in the case of the unwrapped and dissected mummy, visual paradigms derived from physical anthropology and racial science. Although some of Burton's photographs of iconic objects, like the mummy mask, arguably made those objects iconic in the first place, other photographs and the objects they depict are too mundane, too numerous, or both, to have made much impact. Photography thus brings into question the status of the object in archaeology and the function of the archive as a mnemonic and amnesiac device. Many object photographs taken in archaeology can look similar – in some cases, numbingly repetitive – when they are seen together in an album, as published plates in a book, or now in a database, but one object was not necessarily just like another. Nor was

one photograph just like another, when we observe the details of each image and consider the different actions, settings, timescales and projected end uses that went into making it. The archive was already being formed through photographic practice. Each depended on the other for its existence.

Photography has been characterized by its quality of 'excess' (as Deborah Poole has termed it) or 'abundance' (in Elizabeth Edward's phrase), which operates in two interrelated ways.[1] First, photographs often capture unintended details, a blur caused by movement, for example, or a feature that looks visually distracting in the image in a way that had not been obvious at the point of exposure. Second, as the nature of the photographic archive makes clear, photographs are abundant in their quantity. They allow many similar exposures to be taken, as well as permitting multiple generations of a single image to be made. In the photographs Burton took for the tomb of Tutankhamun, both forms of abundance appear, sometimes in photographs with only one ostensible subject. The elaborate perfume vase (object 210) that he re-photographed against the curved backdrop is a case in point. Burton's initial photographs consisted of two large-format plates exposed shortly after its discovery in December 1923 (see Figure 3.6). Ripples and fold lines on the backdrops, and the right angle at which they meet in one version, compete with the object that is meant to be the focus of our attention: there is an excess of visual detail, of the wrong kind.[2] We can surmise that Burton was unhappy with the effect; he often expressed dissatisfaction or anxiety about his work in letters to Lythgoe, and given the opportunity would re-take photographs or try different staging or lighting. Hence in early 1925, the paper-lined backdrop that followed the curve of a round table solved one kind of abundance and led to another – namely the nine negatives he made at that point, positioning the vase at different angles from front and back (previously, he photographed it only from the front) while reflected light from the left picked out material characteristics like the bands of the stone (see Figure 3.7).[3] There was no visual distraction behind the object now, only the graduated greys of light and shadow.

The chapter opens in the archive by first considering how objects became objects, and how photography – intentionally or otherwise – helped archaeologists distinguish between the different kinds of objects the discipline valued, or devalued, in its work. The process of transforming antiquities into archaeological objects began in the tomb, with the act of discovery, but continued through their conservation and documentation, including the photographs taken of them and incorporated into the excavation records. Conventions for object photography had been developed over several decades in the field and the museum, with archaeologists like Flinders Petrie and J.P. Droop detailing specific advice

[1] E. Edwards, 'Anthropology and photography'; Poole, 'An excess of description'; Poole, *Vision, Race, and Modernity.*
[2] GI neg. P0671A (which has 'dup' written on one long edge of the negative in Carter's hand) and MMA neg. TAA 1054.
[3] GI negs. P0667–P0672 inclusive, MMA negs. TAA 773–775 inclusive. Carter seems to have assigned sub-numbers to the negatives to sequence them, hence of those in the Griffith Institute, P0668 has a '6' on one short edge, P0670 a '3' and P0671 a '5'.

in handbooks of archaeological practice.[4] By the 1920s, these conventions included drab, usually pale, backgrounds; a light source from the left or upper left; and no overlap between any antiquities or other objects (like a scale) that might legitimately be included in the shot. Inevitably, such conventions lent a certain sameness to the resulting images once the negatives were printed, filed and pasted into albums, one reason object photographs have been so easily overlooked both as a genre of photographic practice and as photographic objects in their own right.[5] Photographic similarity in turn tended to reinforce the banality of plain or serial objects, and to reduce the distinctiveness of more aesthetically appealing or rare antiquities. There were advantages in this, to the extent that similarity and conventionality evoked scientific distance, neutrality and the orderly compiling of evidence. But there were constraints as well, in terms of what meanings or narratives a photograph like this could generate. This may account for some of the more dramatic photographs Burton took of certain objects from the tomb of Tutankhamun, which the second section of the chapter considers by analyzing a series of photographs he took of one of the chariots painstakingly restored by Mace.

Although Egyptologists did, and still do, praise Burton's photographs for their evenness and clarity, qualities that made them 'good' archaeological photographs, his object photography operated in what I characterize as multiple registers or visual modes. In addition to the more conventional record photographs that I consider in the next section, Burton also took sequential images that followed the act of archaeological discovery through time, arresting the object at stages of its becoming *an* object – and representing the skill of the archaeologist in the process. Depending on the object, it might then merit an artistic or aestheticizing mode of photography, which emphasized the sculptural features of certain antiquities and hence placed them closer to a Western canon of art. This is certainly true of the most-photographed single object from the tomb: the gold mummy mask. Finally, as discussed in the last part of the chapter, Burton deployed an anthropometric mode to photograph human remains from the tomb, in particular the head of the king's mummy. It is entirely to be expected that his photographs of the unwrapped corpse would reflect long-established methods for photographing bodies for research, whether the bodies belonged to the living or the dead. Yet Burton's photographs of Tutankhamun's body are revealing for how they operate between the aestheticizing and anthropometric registers of photographic rhetoric – and because they seem to have been taken with an idea already in mind of what could and could not be published, at least in the initial media coverage of the mummy unwrapping. In fact, only two photographs of the head of the royal mummy were published until the early 1960s and 1970s, when interest in Tutankhamun – and in questions of race – had been

[4] As discussed in Riggs, 'Objects in the photographic archive', with further reference in particular to Droop, *Archaeological Excavation,* 46–50 and Petrie, *Methods and Aims,* 73–83; see also Baird, 'Photographing Dura-Europos'. For the photography of sculpture in the field of art history, around the same time, see G.A. Johnson, '"(Un)Richtige Aufnahme"'.

[5] See E. Edwards, *Raw Histories,* 51–79; Edwards and Lien, 'Museums and the work of photographs'; Edwards and Morton, 'Between art and information'.

rekindled.[6] Dispassionate analysis, scientific progress, or aesthetic wonder are still easily legible on the surface of the Tutankhamun photographs, so consistent are both the conventions of representation in archaeology and the discourse of 'ancient Egypt' in which these images have been enmeshed.

The object in the archive

As we have seen, Carter and his colleagues consistently used press interviews and published accounts to emphasize the thoroughness of their work at the tomb of Tutankhamun. According to these accounts, which subsequent presentations of the tomb have taken at face value, every object was recorded in full, with index cards, treatment notes (plus translation notes, for inscribed material) and Burton's all-important photographs. In reality, and inevitably, although nearly every object seems to have been catalogued, some were recorded in more detail than others – and plenty of objects were never photographed. Depending on how the number of objects in the tomb are counted, somewhere between 15 and 20 per cent of the total are not represented in the archive of Burton images. In the *Handlist* that inaugurated the Griffith Institute's Tutankhamun publication series in 1963, a dagger (†) marks each object from Carter's catalogue for which no photograph existed. Based on this, at least 560 of more than 3,000 numbered items went without photography, including groups such as 620.115 from the floor of the Annex, '238 miniature agricultural implements belong to *shawabti* [*shabti*] figures'.[7] The missed-out objects are predominantly fragmentary pieces, textiles and baskets, as well as items of pottery; sticks, clubs or bows; objects from multiple series (faïence rings, *shabti*-figures, model boats); a bedstead (object 497); and one 'plain wooden footstool' (object 613). They are the small, the serial, the things made from dull materials or craft techniques – or the simply overlooked.

One of those overlooked objects was 'kiosk' 319, one of ten resin-coated wooden shrines found in the Treasury, in the shape of a portable cloth or reed portico (hence the 'kiosk' designation); a white-washed box in the same room also contained *shabtis*, while one more resin-coated 'kiosk' was found in the Annex.[8] In fact, only three of the kiosks or *shabti*-shrines were photographed, arranged side-by-side on a table in KV15 (Figure 4.1), and none were photographed as they were unpacked, unlike the storage boxes of previous seasons or some of the shrines containing textile-wrapped gilded statues.[9]

[6] Desroches-Noblecourt, *Tutankhamen,* 164 (fig. 101, edited to remove the support), 165 (fig. 104); Leek, *Human Remains,* esp. pls. v, vii–x, xiii–xx, xxiv (only the photographs on pl. vi had been published before). For the 1960s turn to medical investigations of mummies, see Riggs, *Unwrapping Ancient Egypt,* 194–213.

[7] Murray and Nuttall, *Handlist,* 19.

[8] Objects 330 and 337, respectively: see the list online at http://www.griffith.ox.ac.uk/gri/carter/300–349.html. The ten kiosks from the Treasury are objects 318, 319 and 322–9 inclusive.

[9] GI neg. P1046, showing kiosks 318, 322 and 325. Only one of the ten quartzite *shabti*-figures in shrine 337, found in the Annex, was photographed; this took place at a later date when Burton shot other objects from the Annex.

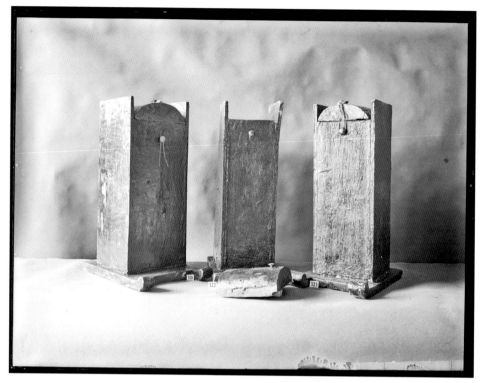

Figure 4.1 Three *shabti* kiosks from the Treasury (objects 318, 322 and 325). Photograph by Harry Burton, October or November 1927; GI neg. P1046.

Instead, we rely on the descriptions Carter recorded on object cards for indications of the *shabti*-shrine contents, which included the figures as well as the loose implements (miniature sceptres, hoes) associated with them; the white-washed box (object 330) also contained long-pile cloth used as packing material.[10] Each of the twelve containers held between three and twenty *shabti*-figures of the king, some carved from stone, others from wood and a few mould-made from faïence, a glazed composite of ground quartz that was kiln-fired like ceramic wares. The *shabti* was a magical figure that had come into increased use, and in increased numbers, during the 18th Dynasty (*c.* 1550–1320 BC); it was a well-established burial deposit by the time of Tutankhamun's reign. A *shabti* represented the deceased in transfigured form, body shrouded and head topped with one of several coverings, crowns or headdresses that signalled divinity. The *shabti* was usually inscribed with the opening words of a recitation calling on it to dig canals and shift sand in the afterlife – hard physical labour, which may have reflected social anxieties about such labour but presumably also had symbolic associations concerning the transformative power of labour and the control of water resources. In all, the Treasury and the Annex yielded 413 *shabtis,* the number that came to represent an ideal in the Egyptian New

[10] See http://www.griffith.ox.ac.uk/gri/carter/330.html.

Kingdom, with one *shabti* for each day of the year, and another three dozen or so to head the 'gangs' of labourers.[11] The choice of words Egyptologists used to describe *shabtis* derived from its own labour practices in the colonial era: Carter referred to the 'overseer' figures (as Egyptologists still call them) as 'reises' (i.e., *ru'asa*).

In October 1927, Burton faced the task of photographing more than a hundred *shabti*-figures found in the Treasury – around half the amount that this room's *shabti* containers had yielded. He wrote to Lythgoe that the different sizes and materials presented a challenge in photographic terms – and in terms of space to sort and store them, which he was fortunate to have in KV15.[12] To achieve consistent light effects on surfaces with different reflective qualities, Burton photographed the *shabtis* in groups by material. Size seems to have been a secondary consideration, since similar sizes would fit more easily into the image field of the glass plate when the figures were lined up in a single row. These qualities – material and size – took priority over the number of the shrine in which they were found, especially where *shabti*-figures from different shrines were taken to represent one 'type' of *shabti*. The 'type' was an identification that Carter, perhaps together with Burton, would have determined through an initial visual evaluation of the figures, sorting them by small differences in headdress or hand-held attributes. And since the 'type' was just that – an object that could stand in for others that it closely resembled – identifying the *shabti* types among the Treasury shrines was crucial to the photographic process. In the autumn of 1927, Burton took at least nine photographs showing groups of four to six *shabti*-figures, exposing two negatives for each assemblage.[13] Since these objects easily lie flat, he used one of the most common techniques of record photography, lining them up on the ground-glass surface of a camera stand – a larger stand than that he used in the first two seasons, and with metric scales marked along its sides.

Burton's photograph of six *shabtis* from shrine 319 exemplifies how photographic and archival practices worked in tandem with each other and with archaeological judgements (Figure 4.2). This shrine had contained fifteen figures in total, all of painted wood; their sizes are not recorded. On the catalogue card for object 319, Carter wrote that the *shabtis* found inside were 'illustrated by photos – see A, B, C, H, K, J and H'.[14] One of the photographs to which Carter referred is Figure 4.2. A small card bearing the shrine number, 319, appears at the bottom left corner of the photograph, along one edge of the ground-glass frame, while individual letter cards identify each *shabti* in not-quite-alphabetical order from left to right: h, a, b, i, j and l. It is unclear why *shabti* 319h was placed on the far left, before letters a and b – perhaps because its inscription, like theirs, was the best preserved. The *shabtis* are spaced equidistant from each other and with ample space between their level feet and the equally level cards below. This meant that the negative could be masked to isolate one or more figures if necessary, or that a print could be cut into smaller images – which is exactly

[11] Carter, *The Tomb of Tut.Ankh.Amen,* vol. III, 81–4, 104, 106. See also Reeves, *Complete Tutankhamun,* 136–9.
[12] Burton to Lythgoe, 21 October 1927 (MMA/HB: 1924–9).
[13] GI negs. P1031, 1032, 1034, 1038, 1039, 1041, 1042, 1044, 1045. Later, from the Annex, Burton took photographs of *shabti*-groups that exist today only as prints and the GI copy negs. P1458, P1537 and P1662.
[14] See the scanned and transcribed card for 'kiosk' 319, at http://www.griffith.ox.ac.uk/gri/carter/319.html.

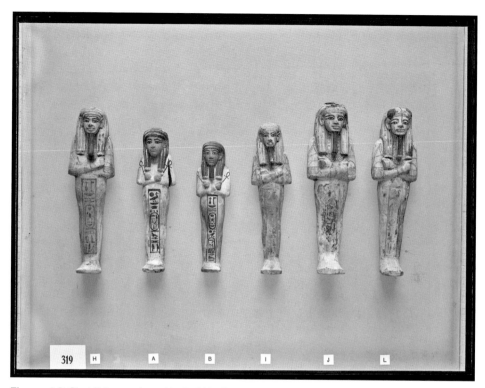

Figure 4.2 *Shabti*-figures from kiosk 319. Photograph by Harry Burton, October or November 1927; GI neg. P1042.

what Carter did to make the record cards for these objects, pasting cut-down selections from photographic prints directly onto the card and adding his own notes and sketches in pencil. Assembling the cards brought the processes of photography and Egypto-logical interpretation ever closer together via the hybrid materiality of the archive, and the cards hint at the planning that informed the taking of the photographs as well as the contingencies or changes of mind that required some photographs to be adapted at a later stage. A seventh *shabti*, 319c, was photographed with *shabtis* from shrine 323 on a different negative entirely.[15] Carter subsequently restored it to the 319 record cards as part of group '319a to g' (Figure 4.3) – cutting a strip from the photo-graphic print to be able to close the gap between the letter cards and *shabtis* a and b; 'c' was simply written in ink at the corresponding location on the trimmed second print.

To Carter, this group of *shabti*-figures represented a distinct 'type' because of the *ankh*-signs painted in each figure's hands, regardless of all other differences in their size, workmanship and inscriptions.[16] *Shabtis* 319h to o were a different 'type' because the

[15] See the record card (http://www.griffith.ox.ac.uk/gri/carter/319c.html) and GI neg. P1045.
[16] See record card at http://www.griffith.ox.ac.uk/gri/carter/319a-c319ag.html.

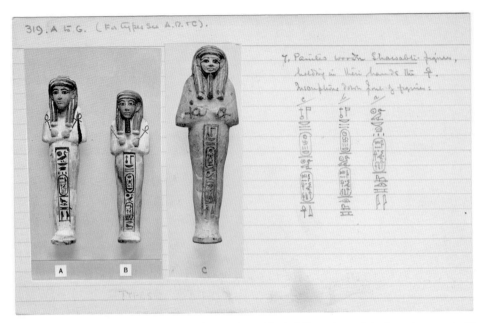

Figure 4.3 Catalogue card for *shabti*-figures from kiosk 319, using prints from two separate negatives (GI negs. 1042 and 1045) and with notes in Howard Carter's hand.

artists had painted baskets and hoes in their hands instead, as their own record card demonstrated by cutting and pasting figure 319h back in line with i, j and l.[17]

Practical considerations guided every aspect of archaeological recording, from the way objects were grouped by material and placed on blank backgrounds, to the reduced note-taking required where one 'type' could do duty for several artefacts. Yet these choices reveal the working assumptions and motivations of the archaeologists, and they determine what could be done and said about different objects, both at the time and in the future. This was especially true under the division or *partage* system used throughout the Middle East: photographs became the proxy for objects that would remain in the country of origin, whether in museums or site storerooms.[18] In the event of a division – which Carter still hoped for, in autumn 1927 – it is unclear whether the *shabtis* selected and defined, through photography, as 'types' would have been earmarked for the Service des Antiquités to retain. Multiple objects like *shabti*-figures were useful to excavators and the Service precisely because there were so many of them, allowing 'duplicates' to be shared out unless there was an overriding reason for keeping them together – something significant about the group as a group, for instance. When Carter spoke of duplicates among the Tutankhamun finds, some of the objects he had in mind were exactly such serial, repetitive examples, whose serial, repetitive character photography tended to

[17] See record card at http://www.griffith.ox.ac.uk/gri/carter/319h-c319ho.html.
[18] In the 1920s–1930s University of Michigan excavations at Karanis, in the Fayum region, the photograph albums that excavators kept became known as 'division albums', with object photographs sometimes marked to indicate which had remained in Egypt: see Wilfong and Ferrara, *Karanis Revealed,* 18–20.

reinforce – even if practical constraints or the force of the 'type' meant that only a portion found themselves grouped in front of the camera. On the one hand, Carter and Burton may not have considered the *shabtis* worth photographing one-by-one, or worth expending additional glass plates on, just as it was not deemed worthwhile, for whatever reason, to photograph their backs, side, top or bottom views, nor to take any close-up details. On the other hand, photographing them in groups may have been a positive choice, since it created a visual rhetoric that enabled and encouraged comparisons among these similar-but-different objects.

Jennifer Baird has observed that photographing archaeological objects by typologies or materials, rather than find spot or assemblage, afforded them a visual treatment akin to *objets d'art* rather than archaeological artefacts.[19] There is a certain tension, however, between the different effects that object photographs achieve, depending on such factors as whether the antiquities were staged singly or in groups, were lying down or standing up, and whether scales or some kind of labelling was included. (Burton rarely included a scale, a trait Baird likewise identifies in photographic practices at Dura-Europos in the 1930s.) Isolated objects, positioned against 'neutral' backdrops, are decontextualized in archaeological terms – though recontextualized for other purposes. The overall effect of object photographs, especially when viewed in quantity, encourages a sense of sameness. If object photographs seem to level hand-made, three-dimensional objects along the smooth, monotone surface of the photographic print or projection, there are nonetheless differences to be observed on those surfaces, and especially in the practices that surround the creation and use of object photographs. It was not only the conventions of object photography or an image's subject matter that helped determine the banality, ubiquity or 'superficial coherence' that characterizes such photographs in archaeology and other fields: it was the entirety of the 'photographic performance', as Elizabeth Edwards has argued.[20] For all that clarity and neutrality were the purported aims of the record photograph in archaeology, camerawork offered a certain latitude in terms of how archaeology made photography work on the object – and how the object itself worked on photography.

From the serial to the singular

The larger *shabti*-figures from the tomb of Tutankhamun help illustrate the shift in visual register that different photographic performances encouraged or even, arguably, required. Although discovered in the same shrines, the larger *shabtis* occurred in smaller numbers, and their size – around half a metre in length (or height, a revealing distinction in itself) – meant that fewer could fit into each shrine, even when they were mixed with smaller figures. Shrine 318 held just three *shabti*-figures, including one of the largest and most finely carved wooden examples, object 318a (Figure 4.4).

[19] Baird, 'Photographing Dura-Europos', 441.
[20] E. Edwards, *Raw Histories,* 52, and see Baird, 'Photographing Dura-Europos', 440–2.

Figure 4.4 *Shabti*-figure 318a photographed on frosted glass. Photograph by Harry Burton, October or November 1927; GI neg. P1056.

The figure was distinctive for its size (some 48.0 cm long) and for representing the king, or his otherworldly double, wearing the so-called blue crown, the only one of the *shabtis* to do so. The crown was carved separately from ebony, with a gilded band that matched the gilded collar on the figure; only the facial features were picked out in paint, lending the whole object a spare elegance. Another distinctive feature of *shabti* 318a was an inscription on the bottom of its feet, naming a royal scribe and military leader named Nakhtmin – and indicating that he had donated this figure to the burial.[21] Five other large *shabtis,* distributed among the shrines in the Treasury, were discovered to have similar inscriptions naming the same man (Carter read the name in reverse, as Minnakht) or a man named Maya, who

[21] Gilbert (ed.), *Treasures of Tutankhamun,* 152–3 (cat. 42). A different *shabti*-figure donated by Minnakht featured in the British Museum exhibition in 1972: I.E.S. Edwards, *Treasures of Tutankhamun,* cat. 11.

headed the treasury and oversaw royal building works. Carter speculated that Maya might have been responsible for preparing the tomb; having their names incorporated among Tutankhamun's burial goods would have been a great honour for these men.[22]

In his letter to Lythgoe that October of 1927, when he was faced with a 'laboratory' full of *shabtis* to photograph, Burton referred to some of them as 'statuettes of the king', and there is no doubt that 318a and some of the other, larger *shabtis* are what he had in mind.[23] The word 'statuette', rather than *shabti* (which is how they were catalogued) places these figures higher up a scale of value, closer to being considered works of art and certainly more singular than the smaller *shabti* series. Carter expressed a similar sentiment in the third *Tut.Ankh.Amen* volume, observing 'in the finer examples, the attempt at likeness to Tut-ankh-amen' – 'likeness' implying portraiture, and portraiture being a category of Western art and a form of fine art.[24] To illustrate the point, Carter referred readers to plate 23, with two of Burton's photographs of object 318a, one in right-facing profile and one cropped to show the upper half of the figure angled three-quarters to the camera, turned to the viewer's right. Burton had achieved each of these photographs in different ways: the front and profile views using the ground-glass camera stand, and the cropped image chosen from a series (including Figure 4.5) made using the curved, paper-lined backdrop that he had first devised in 1925 to photograph the alabaster vase.

It is worth comparing the photographs Burton took of object 318a to explore the different effects of each. First, Burton adapted the ground-glass method to bring out the sculptural qualities and singularity of 318a and other larger *shabtis*. He photographed these figures either alone on the ground glass or, at most, in pairs. Internal, formal features – notably the headdress – determined which were placed together. From shrine 318, *shabtis* b and c were each paired with two *shabtis* from shrine 330, on the basis of the royal figures' hair or head-coverings.[25] In total, shrine 330 contained 15 *shabti*-figures, for some of which Carter organized his descriptions on the record cards using the biological terms 'genus' and 'species'.[26] 'Genus' encompassed materials and paint colours, 'species' the insignia and head-gear that distinguished each type.

Unlike the smaller *shabtis,* spread out along the length of the ground-glass frame, the larger examples were centred on the glass and allowed to fill the negative, excluding the wooden sides of the frame, and its millimetre markings, from each shot (see Figure 4.4). Appropriate number and letter cards still appeared at the bottom of each figure on the glass, allowing enough distance for them to be cropped out of prints if needed. For *shabti* 318a, Burton took the profile view Carter selected for the book publication, with the figure lying on

[22] Carter, *The Tomb of Tut.Ankh.Amen,* vol. 3, 83–6. The figures dedicated by Nakhtmin are objects 318a, 318c and 330i–k; by Maya, object 318b.

[23] Burton to Lythgoe, 21 October 1927 (MMA/HB: 1924–9).

[24] Carter, *The Tomb of Tut.Ankh.Amen,* vol. 3, 82. On portraiture as a concept in the history of art, see Brilliant, *Portraiture.* For more incisive discussion of how a focus on mimesis in nineteenth-century art history excluded non-Western art, see Bahrani, *The Graven Image,* 75–90; Bahrani, *The Infinite Image,* 39–43. Work considering 'portraiture' in ancient Egyptian art is uneven, but see Assmann, 'Preservation and presentation of self'; Spanel, *Through Ancient Eyes.*

[25] *Shabtis* 318b and 330i, with the *nemes*-headscarf: GI neg. P1036; MMA neg. TAA 637. *Shabtis* 318c and 330k, with ebony 'wigs' of tightly curled hair: GI neg. P1037; MMA neg. TAA 638.

[26] See the relevant cards for objects 330a–k inclusive: http://www.griffith.ox.ac.uk/gri/carter/300–349.html#330m.

Figure 4.5 *Shabti*-figure 318a photographed upright in front of the curved backdrop. Photograph by Harry Burton, October or November 1927; GI neg. P1057.

the glass, facing right; no left profile was made, perhaps because the fly-whisk in the figure's hand was an impediment to turning it. Burton also experimented by tilting the figure to create a three-quarter angle, using an unseen support underneath it on the glass surface – a total of three poses on the ground-glass, two of which he photographed in duplicate to yield five negatives.[27] In addition, he stood *shabti* 318a upright before the curved backdrop for another five negatives – using twice the number of negatives than photographing on one or the other set-up would have required.[28] Taken together with the actions and extra time

[27] Figure lying on back: GI neg. P1056; MMA neg. TAA 632. Figure in right-facing profile: GI neg. P1057A; MMA neg. TAA 633. Figure angled three-quarters to right: MMA neg. TAA 634.

[28] Figure angled three-quarters to right: MMA neg. TAA 1049. Figure angled three-quarters to left: MMA neg. TAA 635. Half-figure angled three-quarters to right: MMA neg. TAA 1050. Half-figure angled slightly to left: GI neg. P1057; MMA neg. TAA 636.

involved in shifting the object between the two set-ups, it indicates the greater significance associated with a 'statuette' than a run-of-the-mill *shabti* – and the fact that this greater significance arose primarily or exclusively from its visual and tactile qualities.

The photographs Burton took with object 318a standing upright seem to animate the figure and bring out those selfsame qualities (see Figure 4.5). Posed with a slight turn to each side, giving a three-quarter view to the camera (no front, back or profile views were taken upright), figure 318a was illuminated by sunlight bounced from the viewer's left, using reflectors at the mouth of KV15 – the same direction of light Burton always used when photographing there. Where the vertical stand tended to flatten three-dimensional objects, here the object's material form feels graspable, even to the texture of the wood grain. Burton took four views, over five more negatives, only one of which represented a duplicate. Two of the views captured the figure from above knee level (as in Figure 4.5). This framing device emphasized the graceful contours of the face, the gilding of the crown, collar and fly-whisk, and the sharply incised details in the wood, such as the thumbnail and knuckle, or the hieroglyphs cast into legible relief by shadow. It is comparable in some ways to art historian Charles Kennedy's long-exposure photographs of classical sculpture in the 1920s, which used light effects and close-up framings to bring out the details he thought a scholar would observe in person through the close visual observation of formal analysis.[29] There is no direct link between the work of Burton and Kennedy; rather, it speaks to a shared, contemporaneous interest in attaining dramatic or textural visual effects in the photography of sculpture. Kennedy's images were admired by photographers working in self-consciously 'artistic' modes, like Ansel Adams, and the pioneering historian of photography Beaumont Newhall declared that Kennedy 'paints with light' – the same expression used in posthumous descriptions of Burton's work.[30]

The appeal of Burton's half-length photographs of *shabti* 318a at the time is evident in their publication record: the *Illustrated London News* used both in 1928, while Carter chose one of them for the third and final volume of *The Tomb of Tut.Ankh.Amen,* published in 1933.[31] The *Illustrated London News* text alluded to the dedicatory inscription on the bottom of this (and other) figures, but could not illustrate it, since Burton did not photograph the underside of the feet. The inscriptions were recorded only by Carter's hand sketch on the relevant record cards, and they are the sole features Carter discussed in the third *Tut.Ankh.Amen* book, other than making passing reference to these *shabtis* as the 'finer examples' of the kind.[32] The photographic archive thus speaks to aesthetic

[29] Kennedy and Newhall 1967; Swenson, *The Experience of Sculptural Form.*

[30] Kennedy and Newhall 1967, 11; the book opens with a portrait of Kennedy taken by Adams. For Burton as a 'painter of light', see G.B. Johnson, 'Painting with light'.

[31] Carter, *The Tomb of Tut.Ankh.Amen,* vol. III, pl. lxviii, showing the full-length right profile shot on the ground-glass (GI neg. 1057A; MMA neg. TAA 633) and a cropped version of the upright, half-length close-up to the right (MMA neg. TAA 1050). The *Illustrated London News,* 17 November 1928, 904–5, devoted a double-page spread to the theme of *shabti*-figures, mentioning the *corvée* or forced labour system and illustrating MMA neg. TAA 1050 as well, along with the ground-glass frontal and right profile views (see n. 27 above).

[32] For the dedicatory inscriptions, see relevant cards for objects 318a, b and c, at http://www.griffith.ox.ac.uk/gri/carter/300–349.html. There is a brief discussion in Reeves, *The Complete Tutankhamun,* 139 and Eaton-Krauss, *The Unknown Tutankhamun,* 109–10.

concerns that run parallel, and sometimes counter to, the more academic concerns made explicit in Carter's text, for all that the books were aimed at a wider audience. What marked certain *shabtis* out for more attention in their interlinked visual and archival presentation were factors such as size, material and calibre of workmanship – the very factors that the conventions of object photography tended to downplay. Hence the desirability of alternative stagings of the photographic act, to better distinguish the more mundane 'type' object from objects with the potential to qualify as works of art, despite their essential Egyptian-ness. There was beauty to be found among the eerie gods and crumbling textiles of ancient Egypt – if one let the camera demonstrate how to look for it.

From artefact to art

Objects like the *shabti*-figures – even the singular, outsize examples – were familiar from other excavations in Egypt, and thus fell easily into well-established categories not only for Carter and Mace, but for Burton, who had photographed such artefacts many times before. Other objects in Tutankhamun's tomb were extraordinarily rare or elaborate examples of their kind, such as the intricately carved alabaster lamps and vases (like object 210), or the dagger and sheath found on the mummy, with a rock-crystal knob and virtuoso gold work on its handle (object 256k). Still other objects were entirely unprecedented, notably the burial shrines and many examples of wooden sculpture found in the tomb, including the gilded figures of deities, photographed after they were divested of their wrappings (see Figure 3.8) or the so-called 'mannequin' of the king's head and torso (object 116), which found a measure of fame for the striking impression it made being carried past press cameras to KV15 (see Figure 5.8). Rare or unprecedented objects presented the archaeologists with novel forms to characterize, document and interpret – and, of course, to photograph.

Apprehending both familiar and unfamiliar objects began with visual assessment and led, almost inevitably, to a photographic act. But it would be wrong to imply that these were separate or sequential acts: seeing and photographing went together, since, as George Reisner cautioned in his 1920s guidance on photography, the archaeologist can only photograph what he has first observed.[33] Moreover, photographs created new opportunities for visual observations and comparisons. Photography created its own truths, especially as it mediated between decisions taken about what and how to photograph an artefact in the laboratory tomb, and the discourse into which the resulting photographs then entered. When the London *Times* first began reporting on objects in the Antechamber, for instance, it spoke of them as examples of ancient craftsmanship or decorative art.[34] By the time the second season was about to get underway, they had acquired the higher status label of 'art' in the paper. Hence a page of Burton's photographs published in September

[33] Der Manuelian and Reisner, 'George Andrew Reisner on archaeological photography', 4, and see Bohrer, *Photography and Archaeology,* 50.

[34] E.g. 'Decorative art in the pharaoh's tomb', *The Times,* 2 February 1923: 14.

1923, to build interest ahead of the second season of work, bore the headline 'Ancient Egyptian Art: New Luxor Pictures'.[35] Building on the discussion above of the different stagings for *shabti* 318a, this section considers how Burton's photographs emphasized the aesthetic characteristics of key objects and, at the same time, developed their own photographic aesthetic, both of which had the effect of making Egyptian antiquities more convincing – and more culturally and commercially valuable – as works of art.

The images under *The Times'* 'Ancient Egyptian Art' headline included two views of the 'coronation throne' (object 91), some of the rings tied up in a scarf (see Figure 1.5), a restored beaded shirt collar (object 21o), and the painted lid of box 21, in a photograph that dominates the bottom of the page. The caption for the box lid directs readers to note the 'sense of movement and vivid expression' in its hunting scene, while other captions on the page emphasize the splendour of the materials (gold, alabaster, ebony, ivory) or, for the shirt collar, the skill of the restoration. The richness and rarity of the materials – especially in their restored state – was one feature that set the Tutankhamun objects apart, befitting the royal find, and these would be emphasized throughout *The Times* and *Illustrated London News* coverage. Materials, workmanship and the extraordinary detail that Burton's photographs captured helped elevate artefacts whose functionality was so obvious, like pieces of furniture or clothing, that it tended to exclude them from the 'fine arts' of painting and sculpture, as understood in the art historical canon of the time – and as referenced in the language of 'movement' and 'expression' *The Times* used to describe the painted scenes of box 21.

The canon also allowed for 'decorative arts', however, and phrases like 'glittering splendour', 'exquisite design' and 'beauty' or 'beautiful', all used to describe the reassembled and restored chariots, support the visual rhetoric of the colour and monochrome photographs that accompanied them.[36] Since the discovery and restoration of the chariots bridged the first two seasons of the excavation, they also provided a narrative thread for Merton to develop in his *Times* reports. Prominent in photographs of the Antechamber before and during its clearance (see Figure 3.5), the chariots required weeks of repair and conservation by Arthur Mace before they were ready for photography in December 1923.[37] Burton took at least fifty black-and-white negatives of chariot 120, as well as a series of Autochromes which were published in colour in the *Illustrated London News* in January 1924.[38] The large number of negatives, and the use of colour, indicate the

[35] 'Ancient Egyptian Art: New Luxor Pictures', *The Times,* 21 September 1923: 14. On distinctions between the arts and crafts, see Shiner, *The Invention of Art.*
[36] 'A pharaoh's "state coach": one of Tutankhamen's chariots', *Illustrated London News*, 12 January 1924: 60.
[37] According to Mace's diary (GI/AMdiaries), he commenced work on chariot 120 on 25 November 1923 and continued for nearly three weeks, finally starting to wax the surface on 15 December, the day before he left for Cairo with Carter, for meetings with the Ministry of Public Works. Returning to Luxor on 19 December, Mace continued to wax chariot parts until the morning of Christmas Eve, when work stopped for the holiday. Between 26 and 31 December, he packed chariots 120 and 122, which means that Burton's photographs must have been taken at some point in the latter half of the month, depending on when specific parts of each chariot were ready for photography.
[38] 'Tutankhamen art in colour: An exclusive reproduction', *Illustrated London News,* 12 January 1924: 59; 'Tutankhamen's regal splendour: Panels of his golden chariot', ibid.: 63. These followed on from the weekly paper's first colour reproduction of Burton's Autochromes a few weeks earlier: 'The colour of Tutankhamun's treasures: Exclusive reproductions in this paper – the first examples', *Illustrated London News,* 10 November 1923: 846–7.

importance of this chariot as well as its physical complexity. Burton photographed its constituent parts (body, axles, harness fittings) separately, in part because both chariots were only set up as whole vehicles in the museum in Cairo, not on site. Given that the different parts had varied physical forms, Burton had to use all the stagings available to him: the ground-glass stand for small parts of the harness; the tall wooden platform to fit in the long axles (Figure 4.6), and the roll-down backdrop with a cloth-covered table, to photograph the body (Figure 4.7), afterwards masking the negative to conceal the cords of the roller mechanism and the bare stone surface outside KV15.

For such a complex object, and one with a clear function, the art was in the details of its workmanship – and in how Burton photographed them. Three views, shot in duplicate (hence, six negatives) sufficed to show the whole body of the chariot, but Burton used a further fifteen negatives, plus several Autochromes, to show the chariot's low-relief decoration – in particular, an interior frieze that depicted the king as a striding sphinx trampling bound, kneeling captives (Figure 4.8).

When publishing the monochrome photographs, the *Illustrated London News* praised the 'wonderful lifelike embossed work' of the frieze and highlighted the racial characteristics of the foreign captives: 'the typical Semitic cast of countenance of the Asiatic and the characteristically negroid features of the Africans are remarkable'.[39] A week later, the same paper printed the colour versions, taken directly from Burton's Autochromes, noting that only in colour could one 'adequately appreciate the full beauty of these [chariots] and all the other treasures from the tomb, representing the perfection of ancient Egyptian art and craftsmanship'.[40] While racial types dominated discussion of the monochrome images of the chariot frieze, in trumpeting its 'exclusive colour reproductions', the paper emphasized both art and craft instead – another way of signalling the shifting border between fine and decorative arts.

The question of colour versus black-and-white was not the only photographic effect that helped guide aesthetic reception either of the photograph itself or its subject matter, and in any case, monochrome dominated both Burton's output and the illustrated press, if for different reasons (documentary purposes and production costs, respectively). More significantly, the way in which detailed views of two-dimensional imagery, whether painting or relief, filled the negative plate allowed 'artistry' to be abstracted from the function of the object. Boxes or chariots could be 'read' through the rectangular format of photographs almost like panel paintings in the Western tradition: so important was this, that Carter brought box 21 back to Luxor from Cairo in 1926 to permit Burton to take more controlled photographs that isolated the scenes on each side and on its lid.[41] Such photographs created a sense of aesthetic awe and visual pleasure at the wonder of the work depicted – and perhaps the wonder of photography as well. They added value to

[39] 'A pharaoh's golden chariot: How Tutankhamun dazzled Thebes', *Illustrated London News*, 5 January 1924: 27.
[40] 'Tutankhamen's regal splendour: panels of his golden chariot', *Illustrated London News*, 12 January 1924: 62.
[41] Letter from Burton t–o Lythgoe, 19 October 1926: 'I started work in the valley on the 17th + I am working on the painted chest that Carter has brought back from Cairo. I am doing large details + I am happy to say that Carter has quite come over to our way of thinking that all photos should be done in duplicate' (MMA/HB: 1924–9). These detail views are: MMA negs. TAA 176; TAA 177; TAA 178; TAA 180; TAA 181 (now GI neg. P0078A; it was sent to Oxford in 1949); TAA 182; TAA 184; TAA 185; TAA 186; TAA 188; TAA 189; TAA 190; and TAA 961.

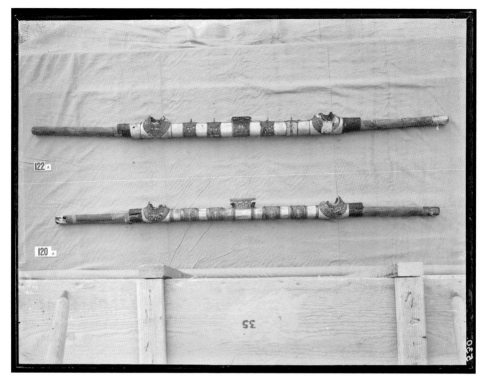

Figure 4.6 The axles from two chariots, objects 120a and 122a. Photograph by Harry Burton, December 1923; GI neg. P0530.

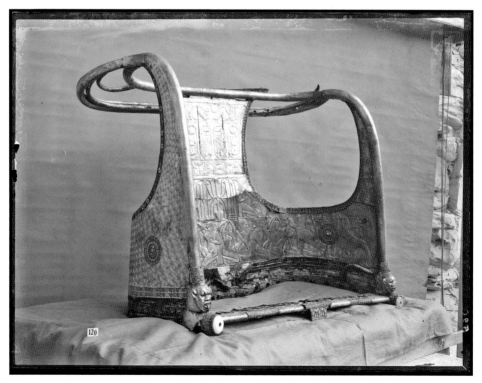

Figure 4.7 The body of object 120, a gilded wooden chariot. Photograph by Harry Burton, December 1923; GI neg. P0520.

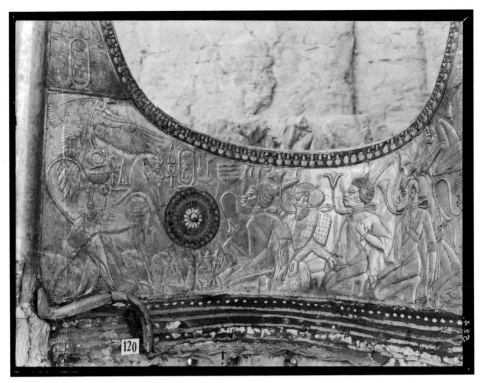

Figure 4.8 Detail of the relief frieze on chariot 120. Photograph by Harry Burton, December 1923; GI neg. P0524.

the objects emerging from the tomb, not only in the scientific, knowledge-producing terms that were made explicit at the time, but in terms of the cultural and commercial value of the objects and the photographs alike. The ancient Middle or Near East, including Egypt, had long occupied a lower rank than ancient Greece and Rome in an imagined hierarchy of ancient art, 'othered' and Orientalized by virtue of the age, geographic location and (contested) racial and linguistic identities of Near Eastern civilizations as well as the nature of their cultural products, like art.

Burton and Carter were no modernists, although they were no doubt at least somewhat aware of the appeal 'primitive' art, including some ancient art, held for avant-garde artists and writers in the early twentieth century.[42] The visual and written emphases that Burton and Carter respectively placed on the artistic qualities of Tutankhamun's burial goods engage instead with the established discourse of progress that positivist scholarship had been developing for more than a century. Often explicitly couched as a question of West and Orient, this discourse traced a line of development leading to the admired, mimetic

[42] On which see, for example, Ades and Baker, *Undercover Surrealism*; Braddock, *Collecting as Modernist Practice;* Evans, *The Lives of Sumerian Sculpture,* 61–9; Price, *Primitive Art;* Roberts and Allmer (eds), *'Wonderful Things': Surrealism and Egypt;* Wiese (ed.), *Ägypten, Orient und die Schweizer Moderne.*

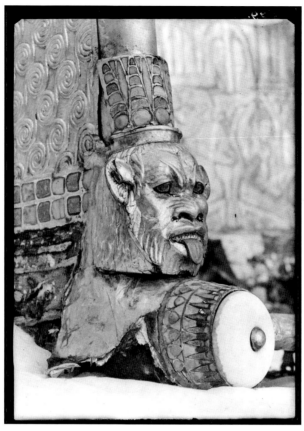

Figure 4.9 The head of the protective god Bes at the bottom edge of chariot 120. Photograph by Harry Burton, December 1923; GI neg. P0529.

accomplishments that art attained in the Classical world and the Renaissance of southern and northern Europe. A selection of non-European art was integral to this narrative of art history, and non-Western cultures that were not formulated as 'primitive', in anthropological thought, could be incorporated – albeit in a circumscribed way – into art historical discourse; these included the arts of East Asia, the Islamic world, and the ancient Near East and Egypt.[43]

In another of Burton's photographs of chariot 120 (Figure 4.9), the grimacing, gilded face of the god Bes captures this last quandary: where exactly did Egyptian antiquities fit in the progressive scheme of art, and which were potential or worthy precursors to Western art? With all its strange gods and files of pharaohs, there was something too stiff, functional or magical about ancient Egyptian art to incorporate it fully in a narrative based around 'art', hence the faultlines between art and craft, or the fine and decorative arts. Photographing the head of Bes as he did, in a close-up that isolated it from its physical context, Burton was able to achieve for the gilded, sculpted wood an effect similar to that

[43] Bahrani, *The Graven Image,* 40–1; Evans, *The Lives of Sumerian Sculpture,* esp. 46–75.

in his detail shots of low relief work or paintings. The grotesque head, the bound captives, the king on a hunt, all looked in his photographs like objects in their own right, and objects with the potential to be taken seriously as art.

Burton achieved his arresting photograph by centring the Bes head on the plate, lowering his camera to put the lens almost level with the support on which the chariot rested (see Figure 4.7). The focus is on the sculptured grotesquerie, further brought out by an angle that puts the god's head into a three-quarter view. The interior of the chariot, where the 'African' and 'Asiatic' captives occur, becomes a blur in the background, although there is a visual echo of the inner frieze's racialized theme in the broad nose and thick mouth of Bes, whose physical 'otherness' was essential to his apotropaic role in antiquity. Two heads of Bes adorned chariot 120, one on each side of the body so that the fearsome face, with leonine ears and mane, the tongue protruding between bared teeth of ivory, would ward off any dangers behind the driver. The angle at which the photograph was taken brings out that ferocity, lingering on the lines of the contorted face. There are two layers of aestheticization at work, that of the ancient sculptors and goldsmiths and that of Burton's camera. The photograph had an immediate appeal: *The Times* published it on 28 December 1923, as did the next day's *Illustrated London News,* devoting a full page to it. Burton also made an Autochrome, taken from a vantage point further to the front of the Bes image, and with the head lower down on the plate rather than centred. This featured in the *Illustrated London News'* colour spreads of 12 January 1924, again taking up an entire page.[44]

Isolating a hybrid or animal head in a tight, three-quarter view was a composition that Burton used for other objects in his early work at the tomb, and with similar success in terms of publication and publicity. He photographed the hippo-headed funerary couch (object 137) while it was still in place in the Antechamber, the near-profile or three-quarter angle of the animal head in part necessitated by the confines of the space – but so effective in the final result that the *Illustrated London News* made it their cover image towards the end of the first season.[45] He then photographed one of the lions on the seat edge of the 'throne' (object 91) in a similar way, producing one of the images that featured in *The Times'* 'Ancient Egyptian Art' spread in September 1923.[46] Another lion, also from the end of one of the couches (object 35), received the same photographic treatment once the couch had been disassembled. An Autochrome of this lion head appeared full page, in colour, in the *Illustrated London News,* its 'startling realism' singled out from the description in Carter and Mace's book on the discovery.[47]

[44] 'Tutankhamen art in colour: An exclusive reproduction', *Illustrated London News,* 12 January 1924: 59.

[45] *Illustrated London News,* 3 March 1923; the corresponding negative is either GI neg. P0166 or MMA neg. TAA 409.

[46] 'Ancient Egyptian Art: New Luxor Pictures', *The Times,* 21 September 1923: 14. The corresponding negative is GI neg. P0164.

[47] 'The king of beasts in Tutankhamen art: A golden lion', *Illustrated London News*, 9 February 1924: 227. Burton also made several shots using half-plate, panchromatic negatives: GI negs. P0512 and P0512A, MMA negs. TAA 404 and TAA 1367. In addition, Burton also photographed the couch with cow heads at one end (object 73, associated with the goddess Hathor), while its two long sides were dismantled and could be set against his roll-down photographers backdrop. An Autochrome appeared in the *Illustrated London News* on 22 March 1924, captioned with details about the dispute Carter had with the Service des Antiquités ('The colour of Tutankhamen's treasures: The Hathor couch', at p. 499). His panchromatic negatives of the same object, in the same staging, are GI negs. P0513, P0514 and P0515; MMA negs. TAA 405, TAA 406 and TAA 407.

Thus, in the first two seasons, with press interest at its peak, Burton had created a successful formula for conveying the more monstrous aspects of Egyptian art in a glowing light, in every sense. Other objects photographed at an angle to the camera during those two seasons benefitted from the sense of depth this created: the alabaster lamps and vases, wooden shrines, and especially the boxes, chairs, beds and footstools that were so prominent in the Antechamber. When it came to individual pieces of sculpture in human form – in those first seasons, only the so-called mannequin of the king (object 116; see Figure 5.8) and a *shabti*-figure (object 110) – Burton invariably included at least one three-quarter angle as well. By the end of the second season, and the rupture with the Service des Antiquités, Burton would have suspected that if and when his Tutankhamun work resumed, there would be even more works in-the-round to photograph: the access the team then had to the Treasury made that clear, with its myriad boxes, the sculpted cow's head (object 264), and the gilded wooden goddess figures that stood around the canopic shrine (object 266). This knowledge, combined with dissatisfaction with the existing cloth backdrops, may have encouraged Burton to develop the curved backdrop that proved so crucial in his subsequent object photography, in particular for angled views of human or divine subjects. Photographs of the large *shabti* (Figure 4.5), the shrine statuettes of gods and goddesses (Figure 3.8) and the carved stone lids of the royal embalming jars, all depended on the smooth, shadow-less background, soft light and well-chosen angles for their own effectiveness. Any image that could be taken as an image of Tutankhamun himself, like the *shabti,* the jar lids, or – of course – the mummy mask (see cover and Figure 4.16), benefitted from lighting and angles that made these objects legible as portraits, and thus indisputably works of art in Western mode. Burton's photographs opened the potential for viewers to see Tutankhamun himself in these works of art, whether of wood, stone, or gold – and in the flesh and bone of his own body.

Royalty and race

If Burton's photographic staging of objects from the tomb depended in part on their physical and material properties, and in part on judgements about their seriality or uniqueness, his photography of the mummy and its unwrapping was in some sense more straightforward, because the subject matter was quite firmly established in the visual repertoire of Egyptology. Staged unwrappings of mummies had been the subject of aestheticized representations for decades, often positioning the ancient, wrapped body as an object of anatomical investigation by surgeons.[48] In the 1880s, Emil Brugsch began to photograph significant mummies, including royal mummies, in the Cairo museum in a way that removed human operatives altogether. By aiming the camera over the mummy, he isolated it against a plain background, a setting further echoed in published versions of

[48] See Moshenska, 'Thomas "Mummy" Pettigrew'; Riggs, 'An autopsic art'; Riggs, 'Colonial Visions'; Riggs, *Unwrapping Ancient Egypt,* 49–76.

his photographs which, following the standards of scientific drawings and atlases, created the effect of floating the objectified mummy on the printed page. Burton used a similar technique to photograph mummies for the Egyptian Expedition over the years, with the added feature of capturing distinct stages in the removal of the unwrappings; these were almost always taken to show the body at full length. For the mummy of Tutankhamun, which presented its own challenges in terms of the unwrapping and the photography, Burton's photographs of the procedure included more close-up shots. Some hundred objects were interleaved in the wrappings of the body, and as in the clearing of the tomb, they were identified within the photograph by cards (in this case, alphabetic English letters, added to the number 256 applied to the intact mummy itself). As the mummy ceased to exist in any meaningful form, the artefacts extricated from it, from 256a (the mask) to 256vvvv (a head-rest amulet of meteoric iron), began the process of transformation and objectification that would be completed when Burton photographed them again months later, in splendid isolation on the ground-glass stand.

This section will first discuss how photography was incorporated into the unwrapping of Tutankhamun's mummy, and then examine how Burton photographed the head of the mummy – and how those photographs were subsequently used. Photographing the face and skull shape was crucial, even though getting to the face of Tutankhamun proved more challenging than Carter and the medical team expected. Once a desiccated body had been revealed and photographed at full length, it was commonplace in Egyptology to photograph the head in some form of close-up, in particular showing it directly from the front and at least one profile. These were the well-established norms of anthropometric photography, developed in the nineteenth century to complement methods of measuring skulls and body proportions.[49] By the First World War, anthropometric photographs of both the living and the long-dead in Egypt were standard products of camera work on archaeological sites in Egypt, whether taken by archaeologists themselves or by anthropologists: Francis Griffith, founder of the Griffith Institute, photographed adolescent boys during his 1912–13 excavations in the Anglo-Egyptian Sudan, while the Italian archaeological mission led by Ernesto Schiaparelli included an anthropologist, Giovanni Marro, who photographed and measured both ancient skeletal remains and men and children from villages near the Valley of the Kings.[50] The resulting 'type' photographs were one of the most powerful visual tropes of race science, but as Amos Morris-Reich has demonstrated, such photographs were put to work in different ways in the published presentation of racialist arguments.[51] In Egyptology, many type photographs either were not published or were published with little or no comment, for instance using words that did the work of race science without using explicitly racial terms. I argue here that

[49] See E. Edwards, 'Photographic "types"'; Morris-Reich, *Race and Photography;* Poole, 'An excess of description'; Poole, *Vision, Race, and Modernity.*

[50] Boana et al., 'Giovanni Marro'; for sample photographs, see Schiaparelli, *La tomba intatta,* pls. 11, 12.

[51] Addressed in Morris-Reich, *Race and Photography,* throughout the volume and encapsulated here: 'As we shift our focus from the methodological definitions of photography as scientific evidence to the actual use of photography in scientific and scholarly study and writing on race (in this chapter and the chapters that follow), it becomes even more important to pay close attention to the respective places of these various uses of photography in economies or processes of demonstration' (p. 85).

Burton's carefully devised photographs of the head – only two of which were published before the 1960s – made their own contribution to this discourse by creating a visual link between the royal body, works of art and race. They also underscore the centrality of anthropometric practice to archaeological performance in the interwar era, both in the taking of photographs and the making of anatomical measurements.

Planning for Season 4, which commenced in October 1925, centred on opening the nest of coffins and unwrapping the mummy, events that had been anticipated from the moment Carter opened the sealed burial shrines. As an event in itself, the unwrapping required coordination with officials in the antiquities service and the Ministry of Public Works, as well as the two medical practitioners who would conduct the autopsy-like procedure: Dr Douglas Derry of Cairo's Kasr al-Aini medical school, who regularly consulted on human remains for archaeologists, and Dr Saleh *Bey* Hamdi, professor and former director of the medical school in Alexandria.[52] The inclusion of Hamdi seems to reflect the more balanced and diplomatic approach required after Carter was allowed to resume work at the tomb. Similarly, the event was timed to include Pierre Lacau as well as several Egyptian members of Ministry staff and the Service. Since the nineteenth century, mummy unwrappings of any kind – but especially of royal mummies – had shifted from being displays of an individual Egyptologist's or medical practitioner's virtuosity to being arenas for displaying the interlinked status of research institutes and governing powers: in the 1880s, Gaston Maspero unwrapped the mummy of Ramses II in the presence of Khedive Tewfik, and in the early 1900s, unwrapped other royal mummies before Lord Cromer.[53] In 1925, there was no question of King Fuad being present. Instead, the opening of Tutankhamun's mummy brought together the civil servants of an elected Egyptian government – including Pierre Lacau – to bear witness to the event.

With the unwrapping set for 11 to 18 November, to accommodate Lacau's schedule, Carter and Alfred Lucas spent several weeks ahead of time opening the nest of three coffins in the burial chamber, which Burton managed to photograph from above, despite the restricted head space necessitating that he could get only half the length of a coffin in frame at one time.[54] The tomb's electric light helped Burton capture the linen shrouds that covered the two inner coffins and the wreathes of strung leaves and flowers on each lid, whose fragility offered a counterpoint to the immense age, and intactness, of the royal burial. In addition, Burton used lamp light to take several shots of a shirt-sleeved Carter tending to the second of the three coffins, first lifting away the shroud (apparently afterwards discarded), then posing with a brush to the face of the lid (see Figure 5.1). Because the bases of the inner two coffins were stuck fast to each other with resin, and the wrapped mummy likewise embedded in resin within the innermost shell, the whole ensemble had to be carried out of the tomb by eight men and transferred to KV15. Using

[52] In the event, as Donald Reid points out (*Contesting Antiquity,* 57–8), Hamdi's name was excluded from the report Carter published in *The Tomb of Tut.Ankh.Amen,* vol. II, 143–61, and it was Derry, not Hamdi, given the privilege of making the first cut into Tutankhamun's fragile textile wrappings (on which see also Riggs, *Unwrapping Ancient Egypt,* 28–9).

[53] See Riggs, 'Colonial visions'; Riggs, *Unwrapping Ancient Egypt.*

[54] Carter's journal entries for autumn 1925 detail this period of the work and some of its rationale: http://www.griffith.ox.ac.uk/discoveringTut/journals-and-diaries/season–4/journal.html.

the heat of paraffin lamps to melt the resin, Carter managed to free the second coffin from the inner coffin, which proved to be of solid gold. However, since there was no way to extricate the mummy itself, a conventional unwrapping – with the shrouded body laid out on a table, autopsy-style – was impossible. Instead, the base of the gold coffin, with the mummy inside, was set up just inside KV15 for the examination.

Burton had hoped to use a movie camera to film the removal of the coffins and mummy from the tomb, but Carter 'wouldn't hear' of it.[55] The film would not have had visual interest anyway, Burton thought:

> [A]s it turned out, it couldn't possibly have been done. The wrappings were all carbonized + were just like so much soot + the whole thing was embedded in about 2 to 3 inches of pitch + the poor little man was dug out in pieces. I had imagined he would have been in as good a condition as the mummies Winlock unwrapped last year + in that case, it would have made a wonderful film.[56]

Due to the poor condition of the textiles and quantity of solidified resin ('pitch') that Burton describes, the vaunted unwrapping was not so much an unwrapping as a chiselling away. Little of the cloth could be salvaged (none was catalogued), nor could much be determined about the pattern of the wrapping.

Instead of filming the event, Burton used his large-format camera to document the opening act of the unwrapping on 11 November, taking group shots of the so-called 'Committee' as they gathered, somewhat nervously, around the prepared coffin (see Chapter 1). The stage had been set for photography: white cloths draped the edges of the gold coffin both to protect it and to help make a clean backdrop for the photographs Burton took from overhead. These cloths, and the woven floor covering inside KV15, neutralized the space surrounding the coffin and helped focus attention on the process of the examination inside (Figure 4.10). The height of the ceiling in KV15 allowed Burton to stand his camera tripod on a 'wooden paraphernalia' constructed for the purpose on 8 November, by a 'carpenter and boy' who had arrived on site the previous day.[57] From this vantage point, Burton could tilt the camera at right angles, to bring its lens board parallel to the mummy below.

What had potentially been a tense affair, given the reframing of Carter's relationship with the Antiquities Service, in fact 'passed off quite peaceably' – or so Burton reported to Lythgoe with clear relief:

> The unwrapping took seven days, working form 7 to 4 each day. Enan (?) Pasha, Under Sec[retary Ministry of] P[ublic] W[orks], Lacau, Dr Derry + Dr Saleh Bey Hamdi were present. The Under Sec. thought the whole thing would be over in one morning.

[55] Burton to Lythgoe, 24 November 1925 (MMA/HB: 1924–9).

[56] As above. The mummies in question include those from Roman burials the Egyptian Expedition had found at Deir el-Bahri: Riggs, *The Beautiful Burial*, 232–43.

[57] Carter's journal entries for 7 November ('Carpenter and boy came') and 8 November ('Constructed a wooden paraphernalia for Burton to photograph upon'): http://www.griffith.ox.ac.uk/discoveringTut/journals-and-diaries/season-4/journal.html.

Figure 4.10 The camera tripod stood on a wooden structure specially created to allow Burton to photograph directly over the mummy during the unwrapping. Photograph by Harry Burton, 11 November 1925; GI neg. P0780A. Two negatives with this number are preserved in the Griffith Institute, taken with slightly different adjustments in the angle of the camera lens.

He stayed two days only + the others saw the thing through. Carter + Lacau got on admirably + I breathed a prayer when the whole thing was finished without any unpleasantness. I did a great number of photos, nearly all in duplicate. The unwrapping took place in the entrance of no. 15, not a very good light, but the photos came out fairly well considering.[58]

[58] Burton to Lythgoe, 24 November 1925 (MMA/HB: 1924–9). The name Burton queried in the letter is correct: Carter's journal entry for 11 November lists Saleh Enan *Pasha* first among those present, followed in order by Lacau, Derry, Hamdi, Sayed Fuad *Bey* El Kholi (the *mudir* of Qena province), Lucas, Burton, Tewfik Boulos *effendi* (the chief inspector of antiquities for Upper Egypt), Mohammed Shaban *effendi* (assistant curator at the Cairo antiquities museum), Hamed Suliman *effendi* (Enan *Pasha*'s 'tech[nical] sec[retary]') and 'the Egyptian Staff attached to our expedition'. See preceding note for URL of the relevant journal.

As Burton's letter makes clear, available light was a factor even for still photography. On the second day, presumably after Burton had developed and checked his negatives overnight, the team turned the coffin around to change the angle of the light. That same day, the investigation had to stop when conditions became too dark after 3 pm.[59] His evident sense of disdain for Enan's early departure echoes the tone of Carter's observation, on the second day of the unwrapping, that 'the Chief Inspector of the district' was absent 'for reasons best known to himself' – but whether Carter and Burton are referring to the same man is unclear; the chief inspector of antiquities was in fact Tewfik Boulos.[60] Perhaps Burton confused the identities of the two Egyptian men; in any case, it indicates the generally suspect attitude the British archaeologists had concerning the motivation or level of interest on the part of Egyptian officials.

The other factor that determined the pace of the work as the week progressed was the number of objects discovered at different places on the body. The examination proceeded by working up the body from the foot end, halting whenever objects like the stunning dagger (object 256k; see Figure 6.11) were located so that Burton could photograph them with an identifying letter card in place. The mummy was documented and cleared in much the same way as the tomb chambers, but it was also, identifiably, a body once the limbs were exposed. Perhaps in conjunction with the physical measurements Derry and Hamdi would make of the human remains, Burton included a tape measure in photographs of the lower limbs while they were still in place in the coffin, stretched up towards the still-masked head to convey something of the king's physical stature (Figure 4.11).

Since he also included a tape measure when photographing other objects from a height, like the chariot axles, this may have been as much to do with a lack of proportional scale (that is, object size to negative size) as with the expectations for photographing a human body. When two mummified human foetuses found in the Treasury were unwrapped, possibly at a later date, their small size meant that Burton could photograph the remains resting on cloth or cotton wool in shallow cardboard boxes – each with a standard 12-inch ruler alongside it, extending beyond the length of the tiny, supine bodies.[61] A notch cut out of the side of one of the boxes allowed the ruler to pass

[59] Carter's 12 November entry also alludes to Burton's duplicate photography – although here, the 'duplicates' are the same views taken on two days and with the coffin in a different orientation: 'The proceedings recommenced 8.15am by Mr Burton taking further records – duplicating yesterday afternoon's photographs – as we had decided to reverse the position of the coffin on account of the light'. Later, the same entry reports that work stopped mid-afternoon '[as] the light was insufficient for the necessary photographic records to be taken'.

[60] Journal entry for 12 November: http://www.griffith.ox.ac.uk/discoveringTut/journals-and-diaries/season–4/journal.html.

[61] Body 317a2 (with notch cut into cardboard box): GI neg. P1063, MMA neg. TAA 382. Body 317b2: GI neg. P1063, MMA neg. 385. When he printed the negatives, Burton cropped to the white background of the cloth or cotton wool, but left the ruler in shot: MMA Tutankhamun albums, pp. 684 and 689. The date of the unwrapping is uncertain: the box containing their coffins was photographed *in situ* in late October 1926 (e.g. GI neg. P1170, MMA neg. TAA 70). According to Carter's journal, Burton was photographing Treasury ('Storeroom') objects throughout Season 5 (1927–8), after he finished photographing the bulk of the *shabti*-figures: see entries for 27 October and 27–9 November 1927 and 23–8 March 1928, at http://www.griffith.ox.ac.uk/discoveringTut/journals-and-diaries/season–5/journal.html. For the foetal remains, see Carter, *The Tomb of Tut.Ankh.Amen,* vol. III, 167–9 (report by Douglas Derry), pl. li; Leek, *Human Remains,* 21–3, pl. xxiv; and Reeves, *The Complete Tutankhamun,* 123–5.

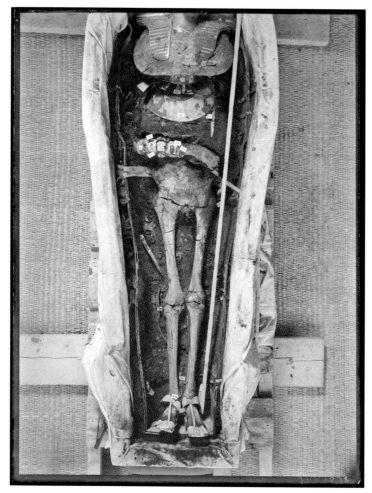

Figure 4.11 An extended tape measure runs alongside the revealed legs of the royal mummy. Photograph by Harry Burton, 13 November 1925; GI neg. P0783A.

beyond its edge while lying perfectly flat inside, so as not to distort the visualization of the measure.

Expectations certainly did shape the photographs of the mummified head, however. Reaching the head of the mummy was the pinnacle of the unwrapping, 'which we were obliged to leave until the last due to its being completely covered by its golden mask fast adhering to the coffin', Carter wrote.[62] Mask and head together were removed from the body by detaching the head at the base of the neck, and Carter and his colleagues used heated knives to prise out the wrapped head and a thick wad of padding inserted between

[62] Journal entry for 15 November: http://www.griffith.ox.ac.uk/discoveringTut/journals-and-diaries/season–4/journal.html.

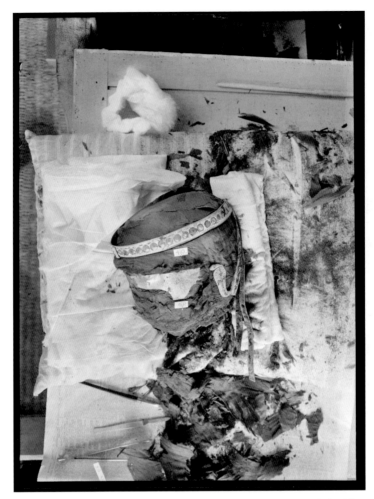

Figure 4.12 A stage in unwrapping the head of the mummy. Photograph by Harry Burton, 16 November 1925; GI neg. P0805.

its crown and the top of the mask.[63] With the head freed, it was placed on pillows covered in ticking-fabric, on top of a table in KV15 (Figure 4.12).

The pillows helped cradle it on its side, with Burton's camera still positioned above it, as work continued to remove as much of the wrappings from the face as possible, leaving in place a beaded covering on the cranium. Burton took at least eight views (five in duplicate) as this work progressed, gradually revealing the contours of the face.[64] Fragments and powdery remnants litter the pillows and table in these shots, where the

[63] Journal entry for 16 November: http://www.griffith.ox.ac.uk/discoveringTut/journals-and-diaries/season–4/journal.html. Burton photographed the padding (object 256–4u, i.e. uuuu) against the circular backdrop: MMA neg. TAA 1240.

[64] GI negs. P0805, P0806, P0807, P0808 and P0809, of which there are two plates taken under different lighting conditions. MMA negs. TAA 527, TAA 528, TAA 535, TAA 1153, TAA 1246, TAA 1247 and TAA 1248.

tools of the scientific trade are also in evidence: scalpels, tweezers and fine brushes – of sable, as the *Illustrated London News* specified in its 3 July 1926 edition, a follow-up to its more extensive February coverage of the unwrapping earlier the same year.[65] The *News* published only one of Burton's photographs from the unwrapping of the head. In his second book on the tomb, Carter made space for one more – and both are images Burton must have taken with their published destination in mind, for in each, a piece of white cloth has been arranged under and around the head on the same tool-strewn table (Figure 4.13).[66] Nothing else was changed. Like the cloths that draped the gold coffins

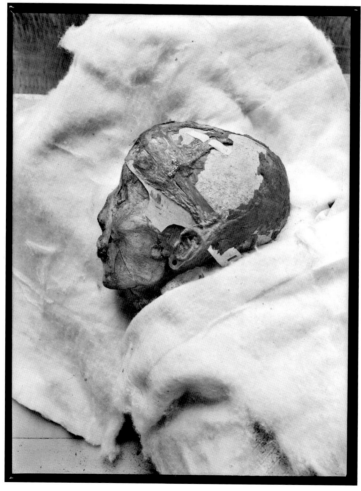

Figure 4.13 The head of Tutankhamun's mummy, with cloth wrapped around it to conceal the decapitation. Photograph by Harry Burton, 16 or 18 November 1925; GI neg. P0809.

[65] 'The magnet that is drawing many thousands to Egypt: Tutankhamen's mummy in its mask of solid gold', *Illustrated London News*, 3 July 1926: 14–20. The earlier coverage: 'Mr Howard Carter's triumph: the superb coffins of Tutankhamen', *Illustrated London News*, 6 February 1926: 227–33.
[66] Carter, *The Tomb of Tut.Ankh.Amen*, vol. II, pl. xxxi.

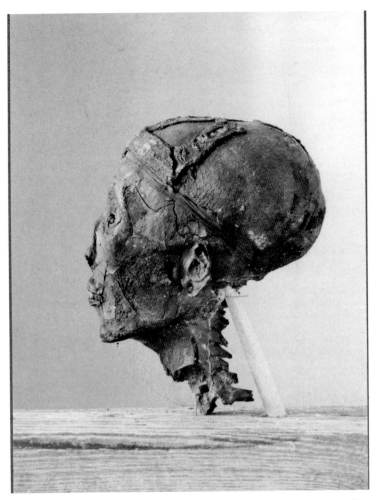

Figure 4.14 The head of Tutankhamun's mummy, propped on a wooden plinth. Photograph by Harry Burton, 19 November 1925; MMA neg. TAA 534.

during work on the king's body, this cloth creates a neutral backdrop against which to isolate the king's head. But they also cover up the messiness of the work table and conceal the fact that the head had been severed from the body.

The head of Tutankhamun's mummy was such a significant and complex object that further work on it was carried out later in the same season, for example to remove the sheet gold band around the temples and consolidate the beadwork head covering with paraffin wax. At that point, Burton photographed the head again, using the curved paper backdrop (Figure 4.14). The backdrop's even tone and the soft, redirected light contrast with the supports used to hold the head upright: a brush handle at the base of the cranium, jammed into a sawn-off wooden beam whose deep graining and fissures dominate the bottom of the photograph. With the head thus supported, Burton took eleven exposures: eight shots showing the front, back, left and right profiles of the head, and three that are

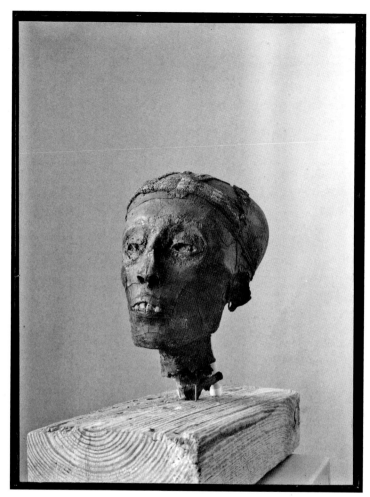

Figure 4.15 The head of Tutankhamun's mummy, in three-quarter view. Photograph by Harry Burton, 19 November 1925; GI neg. P0815.

at slightly different three-quarter angles, two with the head turned to the right, and one to the left (Figure 4.15).[67]

Like those taken on the ticking-cloth pillow, the front-facing and profile views of the upright head are clear examples of the type photograph, in use for racial (and criminal) classification since the 1880s. Yet three-quarter or near-profile views could also serve a type function, as Morris-Reich has discussed. The legibility of the photograph in racial, or other, discourses depended on other factors, not only the position of the human subject

[67] Front: GI neg. P0814. Back: GI neg. P0812, MMA neg. TAA 531. Right profile: GI neg. P0810, MMA neg. TAA 532. Left profile: MMA negs. TAA 533, 534, 1244. Three-quarters to right: GI film copy neg. P1594, MMA neg. TAA 530. Three-quarters to left: GI neg. P0815. Photographs of the crown of the head show the detailed beadwork of the textile head cap: GI negs. P0812A (there are two negatives with this number), P0813; MAA neg. TAA 529.

or the aesthetic of the photographic staging. Race in ancient Egypt was an anxious subject for Egyptology, however, and one it both returned to and, as tellingly, avoided. An earlier generation, represented by Carter's one-time employer Flinders Petrie, had taken racial typology seriously and photography with it: Petrie compiled and offered for sale a set of *Racial Photographs* (as it was titled), using photographs of works of two-dimensional art to characterize 'northern' and 'southern' races.[68]

Burton's photographs of the chariot-frieze captives (see Figure 4.8) would have fit right into Petrie's visual methodology, but more than thirty years on, neither 'type' photographs of human remains nor of humans represented in art necessarily served the same purpose or had the same epistemological value. Race was made explicit in the description of the chariot frieze, likewise in press coverage of walking sticks from the tomb that showed 'African' and 'Asiatic' victims of the king.[69] When the two photographs of Tutankhamun's draped head were published, in contrast, they were accompanied by language that made his racial identity implicit: his face, the *Illustrated London News* reported, was 'refined and cultured', aligning his physiognomy with the north African, Levantine or Caucasian norms already associated with the kings of the period, and with the dominant view of ancient Egypt in general. In the face – quite literally – of such royalty and 'refinement', the photographs of the head render race with subtlety: it needs no label or name, because the two published photographs make it visible.

Yet race was invisible, too, in that the other photographs, staged in front of the paper backdrop, were not published until the 1960s and, most obviously, the 1970s. Presumably, they were not meant to be, given the treatment of the head that they reveal, and in the first publications of these images, the supporting paintbrush handle was edited out of some of prints.[70] The question of why they were taken brings the type photograph into the ambit of artefact and art considered throughout this chapter, and demonstrates that such photographs could serve several purposes or visual modes at once. As an object, and an important one at that, the head required photography as the culmination of its cataloguing; the number of exposures Burton took was in keeping with his approach to other key items, like *shabti* 318A. As a human head, this 'object' required a certain kind of photography and commensurate measurements, which were taken by Derry and (presumably) Hamdi in a performance that was *de rigeur* for the treatment of ancient bodies. But as the head of a king who was also the subject of sculptural artworks and intense biographical interest, the photographs that posed the head at a three-quarter operated like a portrait, eerily aestheticizing the empty eyes, crumpled nose and stretched lips. Here, as we have seen for works of three-dimensional sculpture, the paper backdrop played an important role by helping erase visual disturbances around the photographed object and equate objects of different materials, from stone to gold to human flesh.

[68] Petrie, *Racial Photographs*. See Challis, *The Archaeology of Race,* for further discussion.
[69] This is how the *Illustrated London News* described the chariot freeze, for instance: 'The wonderful lifelike embossed work is now more striking than ever; the typical Semitic cast of countenance of the Asiatics and the characteristically negroid features of the Africans are remarkable'. ('A pharaoh's golden chariot: How Tutankhamen dazzled Thebes', 5 January 1924: 27).
[70] Desroches-Noblecourt, 164 (fig. 101) completely removed the paintbrush handle and cropped the photo close to the head. Leek, *Human Remains,* pls. vii–x, with tape applied to the righthand negative on pl. ix.

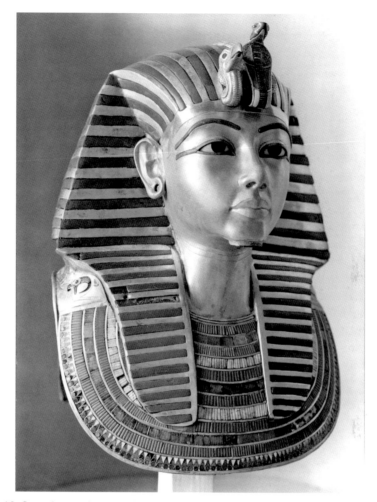

Figure 4.16 One of around twenty views of the mummy mask. Photograph by Harry Burton, late December 1925; MMA neg. TAA 504.

Printed at the time but not circulated beyond the 'team', the three-quarter images of the mummified head allowed it to operate as object and human, artefact and art. They invited contemplation not only of race, but also of how it compared to all the sculptural representations of Tutankhamun that Burton photographed from similar angles. Chief among these – and the last object this chapter considers – was the gold mummy mask (Figure 4.16 and cover photo). Made of hammered gold with glass and stone inlays, the mask was a treasure among treasures – a masterpiece, in the eyes of the excavators and the press. Together with the innermost coffin, of solid gold, it was also of considerable financial value, and Carter faced time pressure to clean and wax these items for shipment to the Cairo museum for safekeeping, just after Christmas 1925. Applied as a protective coating, as was standard practice in early conservation work, the wax likely had the added effect of reducing glare on the metal surface when Burton photographed this and

other objects.[71] Burton wrote to Lythgoe in New York that he felt rushed with his photography of both objects and wished he had had more time to photograph the coffin in particular.[72] He took some nineteen exposures of the mask, each at a subtly different angle, by rotating it from one profile to another across the front of the mask, in addition to two views of the back.[73] He photographed its long-detached beard and beaded choker separately on the ground-glass stand. The heavy beard was only reattached in the late 1930s or 1940s, and the necklace – for which there are attachment holes either side of the neck – has never been put back in place.[74]

For all Burton's own worries about them, his photographs of both the gold coffin and in particular the mummy mask were without doubt a success: this was the face of Tutankhamun most people would remember, not the mummified head. By levelling the camera lens with the long, bare neck of the mask, Burton centred the entire object on the negative plate and let its wide eyes gaze over and beyond the viewer. Although near-frontal and profile views also appeared in print (the latter showed how the blue glass stripes of the royal head-scarf continued around the back), three-quarter views were the most popular: one based on a negative now in the Metropolitan Museum of Art appeared on the cover of the *Illustrated London News* in February 1926.[75] In a bold, uppercase font directly under the image, the cover identified it as 'the finest and most perfect work of Egyptian sculpture ever found' and a 'life-like portrait', leaving absolutely no doubt – for its middle-brow, middle-class readership – about how the object should be understood and appreciated. The caption text quoted Carter valuing the quantity of gold at £5,000, but its value was more than financial. Having handled both the head of Tutankhamun and the mummy mask, he could also assure the paper's readers that the mask was 'a superb example of Egyptian art. Not only is it life-size, but, on comparison with the mummy, a life-like portrait'. And seeing the light fall across the contours of the mask's face in Burton's photograph, who could argue otherwise.

Objects, artworks and bodies complemented each other in the photographic archive, and as the Tutankhamun objects were crated and sent to Cairo or – in the case of the mummy – rewrapped for deposit in the tomb, photographs invariably came to stand in for the artefacts themselves. That was (and remains) one aspect of photographic technology's

[71] An observation made by G.B. Johnson, 'Painting with light', 74.
[72] Burton to Lythgoe, 21 January 1926 (MMA/HB: 1924–9).
[73] Front: GI negs. P0754 (there are three plates with this number), MMA neg. TAA 502. Back: GI negs. P0759, P0760. Angles, GI set: negs. P0746 (half-plate glass, possibly a mid-century copy negative), P0750-P0753 inclusive, P0755, P0757, P0758, and a film copy negative, P1700, made from a print in the Metropolitan Museum albums labelled, after the Scott-Fox collation, 'Griff[ith] no neg.'; perhaps it represents the missing number in the sequence (*P0756), for which no negative appears to survive. Angles, MMA set: negs. TAA 503, TAA 504, TAA 505 and TAA 1360.
[74] GI neg. P0762, MMA neg. TAA 506.
[75] 'The finest and most perfect example of Egyptian sculpture ever found: The massive gold mask of Tutankhamen – a life-like portrait – placed over the head of the mummy', *Illustrated London News,* 2 February 1926, cover. The photograph corresponds to MMA neg. TAA 504. It also appeared in *The Times,* 8 February 1926: 16 (captioned 'A portrait of the pharaoh'), and was tinted for colour as a double-page spread, *Illustrated London News,* 13 February 1926: 274–5 ('The gold portrait-mask of the boy-king Tutankhamen').

hold over archaeology, and one reason for the development of visual framings that would draw attention to what archaeologists needed and wanted to see. Beyond certain practicalities, such as what could stand upright, or what size an object was in relation to the negative plate, decisions about how to photograph different objects both reflect and reinforce decisions about what kind of object a thing was and what value or values it spoke to. These decisions were rarely articulated as such, since they involve the same 'tacit knowledge' that Eric Ketelaar identified among archive professionals: experts do not explain what their training or acculturation in a field has taught them to take for granted. Hence the persistence in archaeology and Egyptology of an epistemology as old as photography itself, which does not see the image-ness of the image.

One function of photographic archives in the early twentieth-century was that one photograph could stand for many. That is, each photograph chosen for publication or display implied the existence of many photographs that could have demonstrated the same thing, so well-established by this point was the multiplicity of the photograph and the habit of putting the camera to archive-making use.[76] Hence photographic abundance was part of the creation and perpetuation of scientific authority, no matter how selective the choice of photographs to publish. Abundance, as we have seen, was built into the Tutankhamun archive from Burton's own duplicates ('in the strict sense', as he described it, and otherwise) to efforts to collate the New York and Oxford collections later on. Publication choices gesture to the archive behind them, as did Carter's division of the negatives: there were enough of them to divide in two, and their eventual institutional homes obliged by abnegating ownership of specific negatives in favour of what they imagined to be an archival whole.

Looking across the photographic archive, where photographs of the tomb objects constituted nearly two-thirds of Burton's output, it becomes possible to follow continuities and discontinuities in the choices he made, from negative formats and lighting, to angles and staging. The numbers of negatives devoted to different objects, the varying treatment of serial versus singular objects, and the absence of photographs of other objects, all help limn the process of knowledge-making around the discovery, and the priorities that photography negotiated within that process. Apart from Burton's occasional comments, such as wishing he had had more time with the mask and coffin, there is little to help us reconstruct the discussions that must have gone into his photographic work, not only between Burton, Carter, other British colleagues (including the journalist Merton, early on), but also between Burton and his Egyptian assistants. Like all the work on an archaeological site, photography was a collaborative process, undertaken with certain end goals in mind that were not necessarily Burton's own or immediate priorities – what photographs would work in a newspaper, for instance, what objects or themes Carter wanted to elaborate in print, or how the photographs would be incorporated into the excavation archives and put to potential future use.

Some of these priorities did not necessarily sit easily together, hence the range of modes that Burton employed – and the tensions that sometimes creep through, for

[76] Morris-Reich, *Race and Photography,* 100–1, drawing on the work of Andreas Mayer, 'Museale Inszenierungen von anthropologischen Fiktionen'.

instance in the photographs of the mummified head treated almost as a work of sculpture, yet mounted on rough wood. Already in the first season of work, Burton used close-up views or animal or hybrid faces to animate artefacts that might otherwise have seemed odd or even threatening, rather than alluring, and throughout his ten years of work on the tomb, he produced images that evoked the norms of portrait photography or journalism, rather than those of strictly scientific or record photography. From the time work resumed in 1925, yielding now-iconic objects like the coffin lids, mummy mask and canopic chest goddesses, Burton took fewer close-ups like the grimacing Bes head (Figure 4.9) and fewer unpacking shots of shrines and boxes than he had in the first two seasons. Nonetheless, he found other ways to bring a sense of dramatic tension and aesthetic wonder to his photographs, for works of sculpture in particular. Working against the levelling effect of archaeological conventions, Burton's photographs of objects like the gold mask operate in a different register to bring out the qualities of artistic calibre and material splendour – qualities that would elevate these objects to 'treasures' and make them convincing as works of art in a Western mode. Photography transformed Tutankhamun from an obscure name into a potent visual and material archive, one that operated far beyond the different physical spaces – tomb, laboratory, museum – through which his body and his burial passed on their way to a different kind of immortality.

5

MEN AT WORK: THE RESURRECTION OF THE BOY-KING

Not a goddess's arms but Howard Carter's reach around the second coffin of Tutankhamun to pull away from the gilded face the shattered red shroud that had covered it (Figure 5.1). Carter's own face is in shadow, his back to the electric lamp out of shot to the viewer's left, but the royal coffins are illuminated. Like Carter, they stand on wooden planks across the top of the quartzite sarcophagus. We are back in the Burial Chamber of the tomb, but the doors of the shrines can no longer swing shut: they were dismantled almost two years before this photograph was taken, and the shrines here lean in shrouded pieces against the chamber walls. The space is criss-crossed by the wooden beams erected first to help take the shrines apart, and then to raise the coffins and their lids, unboxing them like Russian dolls. Somewhere inside lies Tutankhamun, waiting for his own photographic moment.

Archaeologists like Carter often emphasized the dull, careful nature of their work, in the process validating its scientific character. Yet when it came to having himself photographed at this dull, careful work, Carter made it look rather interesting, even exciting. That was in part due to the moments he chose for photography, perhaps in consultation with Burton or *The Times* reporter, Arthur Merton – moments such as opening the shrine doors (see Figure 1.1), breaking through into the Burial Chamber, or here, bending over the pharaoh's emerging form. The interest was also due to Burton's photographic choices, which staged the work-in-progress scenes as carefully as his object photography. Inside the tomb, electric lamps made for sharp contrasts between light and dark, while his usual 18 × 24 cm negatives maximized detail and required human subjects to hold still on command, since any movement would blur the shot. Where he thought a composition could be improved, Burton took additional exposures, too: the photograph in Figure 5.1 is one of four he made in close succession on 17 October 1925, two with Carter's back to the camera, as here, and two with him standing on the other side of the coffin, taking a brush to its face as both of them shared the lamp light.[1] One of those last shots was deemed the best, and published in the February edition of the *Illustrated London News* dedicated to the mummy unwrapping. Carter also included it in the second volume of *The Tomb of Tut.Ankh.Amen,* published in

[1] Back to camera: GI negs. P0720, P0721. Facing camera: MMA neg. TAA 371, plus GI neg. P1853 (a film copy negative, *c.* 1980s, for a print whose original negative is lost).

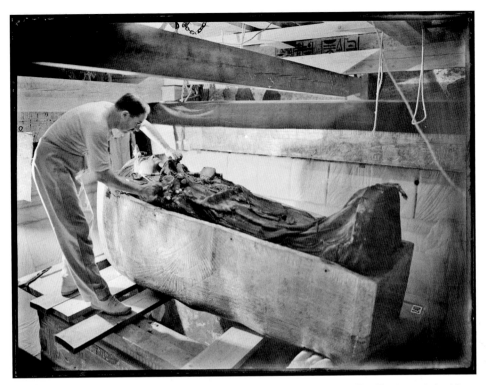

Figure 5.1 Howard Carter rolling the shroud back from the second coffin. Photograph by Harry Burton, 17 October 1925; GI neg. P0720.

1927.[2] Such imagery has arguably influenced how archaeologists – in particular, male Euro-American archaeologists – have been photographed going about work in the field ever since, merging as it does an aesthetic of discovery and the trope of solitary masculine endeavour.

This chapter asks why and how the work of archaeology was photographed during the Tutankhamun excavation, and considers how such photographs were incorporated into – or excluded from – the archives formed by Carter and the Metropolitan Museum. The subject matter requires looking beyond the institutional archives of the excavation to a wider archive of press and personal photography, since work outside the tomb, in the open air, was beyond the control of *The Times'* monopoly. Some of these press or tourist photographs have subsequently been collected by the Griffith Institute in Oxford, as its archival reach and remit expanded in the late twentieth century. Others can be found in a range of libraries, archives and personal collections, as well as commercial picture libraries and in circulation online. Still others belong to what I have come to think of as a shadow archive: the photographs I have not seen, but which I assume must exist, taken by Egyptian visitors to the site in both personal and official capacities.[3] It remains, for now,

[2] 'The great golden coffins of Tutankhamen: a triple "nest" of wonderful sculptured effigies', *Illustrated London News,* 6 February 1926: 228–9; Carter, *The Tomb of Tut.Ankh.Amen,* vol. II, pl. xxiiia.

[3] E.g. Riggs, *Tutankhamun: The Original Photographs,* 63 (fig. 77), for a *Times* newspaper photograph in which an *effendi* pictured in the Valley of the Kings carries a collapsible camera.

impossible to say whether photographs taken by Egyptians captured different scenes or different ways of engaging with the Tutankhamun discovery. But of the photographs taken by Burton, by other colleagues, or by Euro-American journalists and members of the public, those that showed both British and Egyptian men engaged in physical labour at the site were defining images of the excavation. Despite or because of this, they have frequently been reproduced without further interrogation, and often without reference to the members of the Egyptian workforce they depict.

The expanded photographic archive considered in this chapter allows us to interrogate the representation of archaeological labour through photography. In particular, I am interested in how photography represented various working processes in archaeology, and how photography itself formed part of the collective effort in the field. Without the evidential value of photographs, much of the labour that went into colonial-era archaeology would remain invisible, even unknown, in particular the roles played by indigenous workmen, as Nick Shepherd has discussed for South African archaeology and Zeynep Çelik for the Ottoman Empire.[4] The affective value of photographs, however, is just as significant for the historiography of archaeology, because photographs make visible an embodied experience of labour that sometimes distinguishes foreign archaeologists from indigenous workers, according to who undertakes different kinds of labour – but that also brings them into close proximity due to the various physical demands of fieldwork. As Çelik observes, the relationships engendered by fieldwork were 'indispensable and intimate', making their absence from histories of archaeology all the more conspicuous.[5] Like Shepherd, Egyptologist Stephen Quirke has noted the invisibility of the indigenous workforce where it is most present, referring to the 'hidden hands' that made Flinders Petrie's long career in Egyptian archaeology possible.[6] But it is an absence only in terms of scholars' persistent failure to see what is in Petrie's photograph albums (for instance) or give credit to his workers by name, which Quirke was able to do by cross-referencing excavation records, pay lists and Petrie's diaries.

In the records of the Tutankhamun excavation, no similar evidence survives: only four members of the Egyptian field staff, and one from the photography staff (identified here for the first time) are known by name, and none is ever identified in a photograph. Nor was this convention of anonymity – on both Burton's and Carter's parts – exclusive to Egyptians of the labouring class. Where photographs included antiquities or Ministry of Public Works officials, or visiting Egyptian politicians, names were not explicitly recorded in photo registers or albums either, nor have they been of much interest to Egyptologists in the decades since. Yet the existence of such photographs, whether of foremen, porters, camera assistants, or site security guards, argues for a more encompassing idea of who did the work of archaeology – an idea that upends conventional narratives of 'discovery' at their source. Moreover, a more encompassing notion of how Egyptians contributed to archaeology in the semi-colonial, interwar era must take into account the staff of the Antiquities Service and

[4] Çelik, *About Antiquities,* 135–73; Shepherd, '"When the hand that holds the trowel is black"'; Shepherd, *Mirror in the Ground.*
[5] Çelik, *About Antiquities,* 135.
[6] Quirke, *Hidden Hands,* with discussions of Petrie's recruitment practices and named workforce at 37–85, 155–270, instances of anonymity at 86–109, and photography at 271–93.

Ministry officials who held relevant administrative roles. These men belonged to Egypt's *effendiya* class, and many (like Mohamed Shaban, who was near retirement when he attended Tutankhamun's mummy unwrapping) had been sidelined for decades by the exclusionary tactics of European archaeologists and politicians.[7] Correspondence and diaries by men like Burton, Carter and Mace often betray their sense of condescension – or perhaps incomprehension – towards the Egyptian men they worked alongside or, in fact, under, such as the Undersecretary of Public Works whose early departure from the unwrapping Burton took enough issue with to report to Lythgoe. Photographs bring out the texture of these relationships, unwittingly and often in ways that speak to the very fact that they were relationships, not one-directional stereotypes or binary oppositions.

Both archaeology and photography were collective efforts, and as Bruno Latour has cautioned, collectivity is characterized by asymmetry, inequality and anonymity.[8] The persuasive discourse of disinterested science seeks to erase considerations of capital or class, but money and the manpower of 'invisible technicians' (and overlooked administrators) were what made archaeology possible on many levels.[9] This chapter continues as it began, by first analyzing Burton's valorizing photographs of Carter and other team members – both British and Egyptian – for what they suggest about working relationships at the tomb, including relationships between different workers and Burton's camera. I then turn to the less formal, journalistic snapshots that documented the more menial work of porterage outside the tomb and between the tomb and the riverbank. Few if any of these were taken by Burton, but their ubiquity in the expanded archive speaks to the significance not only of their subject matter but of the photographic act they represented. Finally, the chapter concludes by considering photography itself as a collective action in which Egyptians participated both before and behind the camera, and from opposite ends of the social ladder. Returning to Burton's work yields two glimpses of Egyptians in the Tutankhamun archive: one a group photograph of politicians and officials, the other an encounter with one of the 'camera boys', a man named only as Hussein. Carter may have believed he was resurrecting a boy-king from centuries of obscurity, but many Egyptians considered it a resurrection of Egypt itself. In the photographic archive, competing visions of what it was to work on and at the tomb of Tutankhamun rupture Egyptian archaeology's benign self-mythology and reveal the frictions, insecurities and miscommunications that lie beneath.

Archaeological acts and photographic affects

We now take for granted the immense media interest in the discovery of Tutankhamun's tomb, an interest which naturalized the act of photographing work on site. Consider,

[7] Reid, 'Indigenous archaeology'; Reid, *Whose Pharaohs?* esp. 172–236; Reid, *Contesting Antiquity,* 109–33. On the *effendiya*, in particular its changing composition in the interwar period, see Ryzova, *The Age of the Effendiya;* Ryzova, 'Egyptianizing modernity'.

[8] Latour, *Reassembling the Social,* 74–5.

[9] Shapin, 'Invisible technicians'; see also Shapin, *Never Pure.*

though, that from the early twentieth-century onwards, practical handbooks of how to 'do' archaeology offered minute instructions about photographing a site and its objects, recommending tidy trenches, raking light and ground-glass set-ups like the one Burton used.[10] None of them mentioned photographing the work as it was being carried out, either by Western or indigenous team members. Their emphasis instead was on how best to light a ruined wall, how to prep a burial for the camera, suggestions for lens types, or the merits of film versus glass negatives. Only George Reisner, in the manuscript of photographic advice he penned in the 1920s, mentioned photographing living human subjects: his expedition at Giza kept a handheld, snap-shot camera to hand 'exclusively for taking pictures of the men at work, of people and scenes encountered on our travels, and among the local inhabitants where we have worked.'[11] Photographing archaeologists at work – whether the foreign expedition leaders or the indigenous labourers – either was not (or not supposed to be) a priority, or was so commonplace and straightforward that it did not require further elaboration or better tools.

In the 1970s and 1980s, critiques of colonial photography, often influenced by a Foucauldian interpretation of power relations, saw the objectification of colonial subjects in photographs as inherent to the medium, in part due to the way a photograph gives power to the viewer, whose gaze may travel where it wants.[12] However, as Elizabeth Edwards and Deborah Poole, among others, have pointed out, such critiques were overly determined in the way they instrumentalized photography and denied agency to the very people whose subjectivity they sought to restore.[13] Instead, taking into account the entire photographic encounter, as well as the resulting image itself, offers a way to consider the multiple human interactions – and perspectives – that photography involved, as well as how the resulting photographs were used and what they show, or purport to show. One of the purposes photography served was the authentication and valorization of archaeologists' work, but one of the uses to which such photographs can now be put is a reevaluation of how, and by whom, different tasks in archaeology were done.

Archaeologists had been photographing each other for as long as they had been photographing anything, and the archives of many archaeologists contain photos not only of family members and colleagues, but also of indigenous employees, other locals (men and children, more than women), and events such as *fantasia* performances or – a frequent subject – the workers' payday. In the 1920s and 1930s, when archaeologists experimented with moving-picture cameras, they tended to film similar themes, suggesting a certain repertoire was thought to be of interest to the audience the films would reach, too.[14] Burton's Tutankhamun films were shown to Metropolitan Museum trustees, along with films of the Egyptian Expedition's own work, and in 1925, the Museum

[10] For example, Petrie, *Methods and Aims* and Droop, *Archaeological Excavation*.

[11] Der Manuelian and Reisner, 'George Andrew Reisner on archaeological photography', 17.

[12] I have in mind here the work of scholars such as Victor Burgin, Allan Sekula (in some respects) and John Tagg.

[13] See E. Edwards, 'Tracing photography', and relevant discussion in Poole, *Vision, Race, and Modernity*.

[14] For example, Wilfong and Ferrara, *Karanis Revealed,* 25–34: film taken on this Fayum site in the late 1920s mixed working events (survey, digging, crating up a statue for transport) with scenes of camp life and a wedding procession from the nearby village.

dig-house staged a show of films for its Egyptian workmen before they broke camp for the summer.[15]

What most still photographs of work in the field had in common was a certain informality, like the photos that tourists might have taken at the same time. The archaeologists were, after all, tourists of a kind themselves. The photographs' informality was a function not only of their subject matter, but of how they were taken – with handheld devices like Reisner had recommended, which took roll or sheet film or, at most, small glass plates. There were good technical reasons for this, since film negatives were more portable, and handheld cameras were easier to carry, reposition and operate. But there was also a regime of value at work, just as there was in the way such photographs were included or excluded from excavation archives. It would have been a hassle, not to mention a waste of larger-format glass plates, to dignify archaeological labour with the use of a tripod-mounted view camera.

Yet Burton himself did just that in Seasons 1, 2 and 4 of the Tutankhamun excavation. Using his 18×24 cm plate camera required certain physical conditions (adequate light and space) as well as a degree of advance planning. More than anything it required the motivation and will to take photographs that were more formal and staged in their set-up and in their finished look, not to mention more time-consuming to take and develop. In the first season, Burton took just three large-plate photographs showing work in progress – at the ceremonial breaking-through into the Burial Chamber, attended by Lord Carnarvon and his family on 16 February 1923, as well as Pierre Lacau; the undersecretary of the Ministry of Public Works, Abd el-Halim Suleman *Pasha*; and the Antiquities Service inspectors for Luxor and Upper Egypt. Such was the public interest in this event that all three of these negatives were published in the London *Times*.[16] Each shows Howard Carter with either Carnarvon or, in one shot, Arthur Mace. In two, including the photo with Mace, Burton's camera faces straight on to the wooden step and ramparts made to protect the guardian statues during the demolition of the wall – and to conceal the access hole at the bottom of it. In these shots, someone off to one side holds something up to shield glare from the electric lamp (Figure 5.2). Burton had little room to manoeuvre, since there were rows of observers behind him in the Antechamber, but for the third shot – in which Carnarvon peers into the Burial Chamber beyond, and Carter looks steadily at the camera – he managed to move the camera to one side. Carter kept all three negatives in his personal collection.

The prompt to photograph this event may have come from *The Times* itself, or may have been a general and favourable idea among the archaeologists involved. Besides which, *The Times* contract precluded any other photography. Perhaps encouraged by the success – in publishing terms – of those three photographs, Burton took many more 'men

[15] For the films being shown to museum trustees: '1,036,703 visited museum in year: Increase in attendance attributed to interest in the Tut-ankh-amen discoveries', *New York Times,* 22 January 1924: 16; the same article points out that 'in deference to' Carter, the Tutankhamun films would not be shown again until his anticipated lecture in New York that spring. Burton reported in a letter to Lythgoe that films including work at Deir el-Bahri and one of Winlock's mummy unwrappings had been shown to the Expedition's Egyptian staff: 'One thing I think I forgot to mention + that was, that we gave the men a cinema show before the camp broke up. We had it on the *mandera* outside your room + it was a great success + was much appreciated as many of them had never seen a "movie" before' (letter dated 10 May 1925; MMA/HB: 1924–9).
[16] GI negs. P0289, P0290 and P0291.

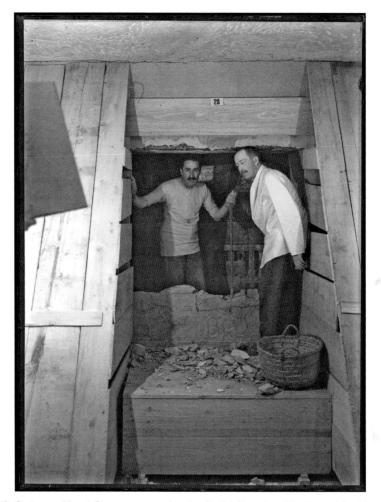

Figure 5.2 Carter and Lord Carnarvon opening the Burial Chamber. Photograph by Harry Burton, 16 February 1923; GI neg. P0291.

at work' photographs in the second season, experimenting with the effects he could obtain. In late November 1923, he photographed Carter and Arthur Callender, with one of the Egyptian foremen, packing the two guardian statues in the Antechamber; this and the statues' subsequent removal from the tomb was covered by *The Times* and picked up by other newspapers (see Figures 6.4 and 6.5).[17] Around the same time, he also photographed Arthur Mace and Alfred Lucas at work on one of the guardian statues just inside KV15 and in the bay outside the 'laboratory', tending to chariot 120 (Figure 5.3).[18]

[17] See Riggs, *Tutankhamun: The Original Photographs,* 13–16. The removal of the statues earned a small front-page notice in the London *Daily Express,* 30 November 1923, while the Manchester *Guardian* ran *Times*-copyright copy the same day ('Tutankhamen's statue guardian: delicate removal feat', p. 9). The relevant Burton photographs are GI negs. P0491, P0492, P0497, P0498, and P0499; MMA neg. TAA 715.

[18] Working on chariot: GI neg. P0517, MMA neg. TAA 315. Working on statue 22: GI neg. P0493, plus negs. P0494 and P0495 of the statue on its own.

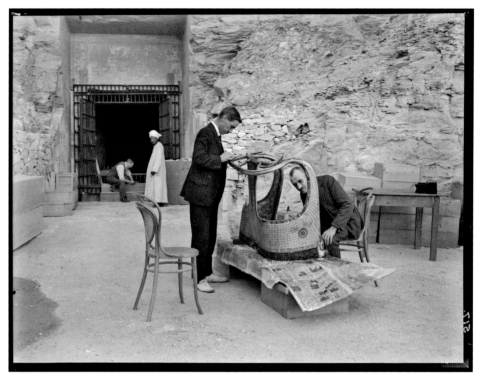

Figure 5.3 In the bay outside KV15, Arthur Mace and Alfred Lucas work on a chariot body. Photograph by Harry Burton, November 1923; GI neg. P0517.

Although these photographs were not published at the time, similar photographs, perhaps taken by reporter Arthur Merton, were used instead, creating a picture spread in the *Illustrated London News* that emphasized the delicate and scientific nature of the work being carried out on the objects – work that only Europeans, not Egyptians, could perform.[19]

The bulk of the 'working' photographs that Burton took inside the tomb date from December 1923 and document progress into the Burial Chamber and towards the burial itself: demolishing the rest of the wall between the Antechamber and Burial Chamber, opening and removing the shrine doors (see Figure 1.1), lifting and rolling-up the linen pall that hung on a frame between the first and second shrines, and the arduous dismantling of the shrines – in particular, the first and largest one. In all, Burton devoted around twenty-nine negatives to this process, if one counts those photographs that include human actors or in which the apparatus of the scaffolding, hoist ropes and electric lights dominate. Carter kept all but one of these negatives for himself, passing to the Metropolitan

[19] See Riggs, 'Shouldering the past'. The double-page spread was 'Preserving and removing: The delicate task of taking Tutankhamen's furniture from his tomb', *Illustrated London News,* 17 February 1923: 238–9.

a duplicate negative of the photograph that showed him kneeling before the open shrine doors.[20]

The choice to photograph these events, and some features of the resulting photographs, suggests a wish to document irreversible actions, in keeping with the archaeological doctrine (however inconsistently applied) of recording something before excavation removed or altered it for good. However, I suggest that the most consistent features in this sequence of photographs are the relationships they reveal between different participants and the camera, as well as a concern with technology and apparatus at this key stage of the work.[21] I approach both of these through the concept of photographic affect, and within the context of colonial labour relations.

Elizabeth Edwards has recently argued that the affective qualities of photographs, which have heretofore been configured as a polarity to photography's evidential, knowledge-producing character, should instead be repositioned in tandem with the evidence base that photographs created and the meanings they accrued.[22] 'Photography has always been a social act,' she notes, 'bounded to a greater or lesser extent by power relations', especially in colonial contexts.[23] Taking photographs, being photographed, looking at, sharing, exchanging and copying photographs were such common activities in the field (whether on site, in the dig house or travelling to and from them) that they will have been banal, as were the differences in status – and attributions of agency – both between and among the foreign archaeologists and their indigenous employees. For anthropology, Edwards uses 'affect' to encompass the subjective, embodied and emotional experiences of all parties in the fieldwork encounter, to which we can also add subsequent viewers and users of the photographs. For archaeological photography in a colonial or semi-colonial context – and Egypt in the 1920s was arguably somewhere between the two – what photographic images represent is often a form of presence glossed over, forgotten or suppressed in written modes of discourse at the time, and often into the present day.

Photographs also give us glimpses of personal interactions, physical contacts and haptic details that could not or would not be attested in any other medium: the grip of hands on tools or equipment; the texture of clothing, scuffed shoes or (for the Egyptian workers) bare feet; the pressure of bodies pressing against each other; and indeed, the gleam of perspiration on skin or sticking under the arms of a sweat-stained shirt. In the photographs Burton took during Season 2, these affective qualities exist alongside the more hagiographic character inscribed in the composition of the photographs, and in the way some were published. A Burton photograph printed in *The Times* on 28 December 1923 shows the demolition of the plastered stone wall separating the first chamber of the tomb from the Burial Chamber

[20] GI negs. P0501–P0510, P0605, P0606, P0608–0610, P0618–P0620, P0626, P0627, P0629, P0630 and P0634–P0637. In addition, Burton took two photographs, with the large-format camera, of Percy and Essie Newberry working on the linen pall on 30 January 1924: GI negs. P0622 and P0623. In the Metropolitan Museum, neg. TAA 678 is a 'duplicate' of GI neg. P0626, passed on during Carter's lifetime; another negative, TAA 1132, is from the group sent to New York from Carter's Luxor house in 1948.

[21] Çelik, *About Antiquities,* 155–7 also notes the interest in tools and technology that accompanied descriptions and visualizations of archaeological labour, in nineteenth and early twentieth century Ottoman lands.

[22] E. Edwards, 'Anthropology and photography'.

[23] Ibid., 240.

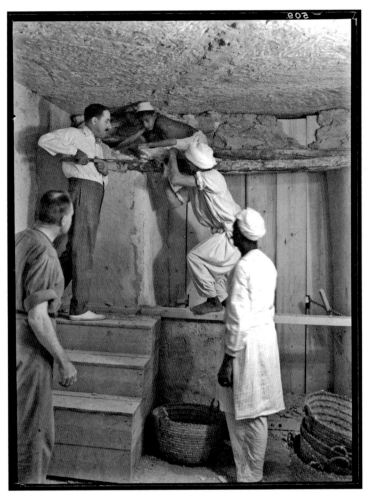

Figure 5.4 Demolishing the wall between the Burial Chamber and Antechamber. Photograph by Harry Burton, 1 or 2 December 1923; GI neg. P0509.

beyond (Figure 5.4). Wooden planks (courtesy of the site's carpentry workshop, run by local Copts) protect the burial shrines on the other side. *The Times* caption – 'Mr Carter and Mr Callender at work' – was not unusual in ignoring the presence of the two foremen and a small boy, perched atop the ancient wooden lintel. For all the brute force the demolition required, it also needed care and close collaboration between the British and Egyptian staff. Other photographs in the sequence depict only Carter, at the start of the demolition, or only the Egyptian workers. This photograph is one of two that bring their British and Egyptian subjects together to rather awkward effect, although this did not preclude their publication. In fact, *The Times* would re-use the other, in which Carter turns to the camera, in 1939 to illustrate Carter's obituary, cropping it to his upper body and that of the workman or *ra'is* next to him – Carter, the heroic archaeologist, in action.[24]

[24] 'Obituary: Mr. Howard Carter', *The Times,* 3 March 1939: 16.

Or was he? In both of the photographs that show him with the Egyptian men and boy, only Carter seems self-consciously aware of the camera's presence: his pose may look active, but there is no tension in his muscles, unlike the straining forearms of the Egyptian workman balancing on the wooden beam. The second Egyptian man stands in the foreground with his back towards the camera, in a still posture that embodies a sense of expectancy, although it conveys little evident muscular tension. For that, we have to look to the balancing workman and Arthur Callender who waits, back to camera, to receive the chunks of stone the Egyptian man is working free. Despite the valorizing efforts of the tripod-mounted view camera and Carter's positioning of himself in front of it, these and other photographs taken by Burton to show work inside the tomb are not his most successful in technical terms. Figures – usually the Egyptian workmen – are often out of focus, or where the focus is sharp, it is all too clear which of the subjects, like Carter, is intentionally holding still for the exposure. With difficult work to be done, those being photographed engaged with the photographic process in different ways, or not at all.

For a photograph in which all the actors are in sharp focus, Burton took advantage of a natural pause in the Burial Chamber work, as Carter, Callender and two foremen start to slide the first roof section of the outermost shrine forward from its walls – a tense stage in the task of dismantling these unique objects (Figure 5.5). A *New York Times* news report about the dismantling of the shrines conveyed the atmosphere and emphasized a silence that was punctuated only by Carter's occasional commands, although it does not specify in which language they were made. The descriptive account is worth quoting at length:

Three white men, divested of all superfluous clothing, move warily across the eastern end of the mortuary chapel. There is but little air penetrating down in these sepulchral regions, and the strong electric lights provide an unwelcome central heating system. The atmosphere inside the tomb is both tense and oppressive. The faces of the three men at work and those of the native staff standing in solemn silence close by are glisteningly white in the hard glare from these huge globes on either side. Perspiration streams from their faces. One can sense the tense nervous strain.

Suddenly Mr. Carter gives the word. He moves to the corner of the outer shrine and almost fearfully puts his hand on it. The moment has come to continue the task of taking to pieces this great gleaming canopy. [. . .] Mr. Carter stops and surveys his assistants. He gives another word and as gently as a hospital nurse these men exert pressure to bring the woodwork apart. There is no need for Mr. Carter to speak again.[25]

The account, by an unnamed author, may overplay the silence of the work and underplay the role of the 'native staff', but it conveys the tension and the cooperation involved. In the confined space of the Burial Chamber, grappling with fragile and heavy gilded wood, both physical and intellectual coordination were essential. Carter credited Callender, the ex-engineer, with devising the scaffolding, ramps and hoists needed to dismantle the shrines around the royal coffins. But it was the Egyptian carpenters who made these structures, and the Egyptian *ru'asa* and other workers who undertook the fraught project with

[25] 'Nerves are taut in pharaoh's tomb', *New York Times,* 9 December 1923: 3.

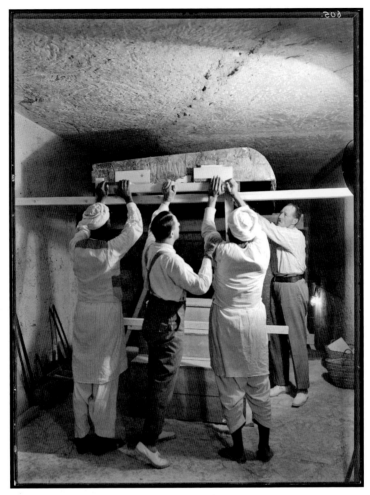

Figure 5.5 Removing the first roof section of the outermost shrine. Photograph by Harry Burton, 16 December 1923; GI neg. P0605.

Callender and Carter. In the stillness that worked to the camera's advantage, we glimpse the constant verbal or non-verbal communication such delicate work required, as Carter lays a hand on the arm of the *ra'is,* perhaps to offer a suggestion as they coordinate their movements. The lamp light Burton has bounced off the ceiling traces the texture of the clothing both men wear and the weight of Carter's hand resting near his colleague's shoulder. For all that the gesture may speak of guidance and direction from a superior to his subordinate, it is a physical contact that speaks to close and long acquaintance, too. The London *Times* published this particular photograph on 18 January 1924, captioned 'Mr Carter and Mr Callender are seen with native workmen'.

Carter is, quite literally, the focus of many of Burton's photographs, whether taking the lead in acts of demolition, gazing into the open shrine doors or captured in lone contemplation, as he was in the 1925 coffin-tending shots (like Figure 5.1) or in photographs that show him seated in the Burial Chamber that winter of 1923–4, taking notes at a point when the

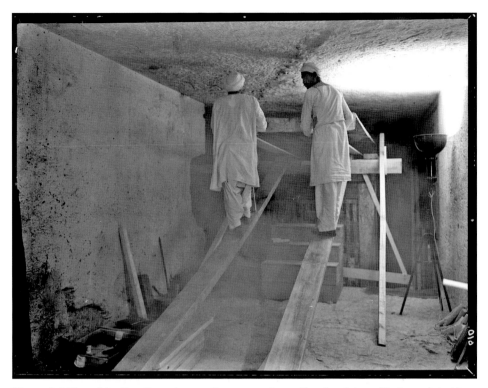

Figure 5.6 Two of the Egyptian *ru'asa* on the ramps, dismantling the shrines. Photograph by Harry Burton, 22 or 23 December 1923; GI neg. P0610.

shrines had been reduced to their constituent parts.[26] The heroic mode of such photographs is indisputable, and even where photographs show him accompanied by Mace and Callender, it is Carter positioned at the front of a group or facing the camera. But the presence of colleagues – British or Egyptian – who ignore the camera, or misjudge its timing, works against the effect Burton may have hoped to achieve at the same time that it betrays the physical intimacy, and at times the tedium, of the work. Notably, Burton also took a few photographs at this stage of Season 2 that show the Egyptian foremen apparently on their own – or that show no one at all, only the carpentry contraption of ramps, steps and scaffold and the ever-present electric lamp, bouncing light off the ceiling. In Figure 5.6, for instance, one of the foremen looks over his shoulder, aware of the presence of Burton (and his own Egyptian assistants), while the other *ra'is* keeps his back to the camera as if focused on something or someone out of sight at the other side of the Burial Chamber.

This particular photograph is at a different angle and has a tighter, closer framing than two or three others taken around the same time, probably on the same day.[27] Burton seems to have been seeking the best view, but the best view of what, we could ask? On

[26] GI negs. P0636 and P0637.

[27] The group comprises GI negs. P0608, P0609, P0610 and TAA 1132, most likely taken on 22 or 23 December 1923 judging by Carter's journal entries on the removal of the shrine roof (see http://www.griffith.ox.ac.uk/discoveringTut/journals-and-diaries/season–2/journal.html).

the Griffith Institute database, the photographs have been associated with the outer shrine itself, as object number 238, yet it is obscured by the men's bodies and the wooden framework. Considered as a composition, the primary interest of the photograph is the equipment that dominates the picture, placing the simple but effective technology – ramps, levers, the photographer's lamp, the reflector in the far corner – at its heart.

With no white archaeologist visible in Figure 5.6, the two foremen should be rendered especially present in the photograph, yet there is something in the structure of both the act and the image that keeps the Egyptian men in the background, in every sense. Lacking the strained effect of photographs in which Carter looked directly to the camera, or Mace and Callender tried to hold still, this photograph lacks a clear visual priority. Burton has not encouraged the men to pose for the camera; he has not invited their gaze, nor suggested they turn towards him – or if he did, the invitation was not accepted. It is a curious photograph in some ways, more like a disappointing snapshot than the carefully framed and timed large-format exposure it is. The two Egyptians appear almost incidental to the image, but since they are securely perched on the two ramps, their inclusion must be intentional; other exposures in the sequence always include at least one *ra'is*.[28] Perhaps they are as essential as the apparatus that the rest of the photograph represents – the scaffolding and lighting that were, with manpower and strength, the main tools the archaeologists needed at this stage of the work. From the foremen to the basket boys and girls, Egyptians who worked at the tomb of Tutankhamun were tools of production, contracting their labour to archaeologists who viewed indigenous bodies as capable of performing work that the European body could not.[29] Because Burton photographed in the more intimate setting of the tomb, among British and Egyptian men who had long-standing relationships with each other, his more formal images often convey something of that closeness, even when they also gesture to the fundamental inequities of the multivalent relationship between archaeologist and subaltern. It is an uncomfortable paradox of colonial archaeology and similar endeavours: the people with whom archaeologists worked most closely remained most distant, and the people photographed most often have been the most often overlooked.

The weight of antiquity

The most numerous and visible Egyptian participants in the Tutankhamun excavation were the adolescent and adult men who worked as porters or bearers, to use two words associated with them in English sources at the time. In the absence of records like pay books in the excavation archive, it is impossible to identify any of them by name or say exactly where they were from, although most were probably drawn from villages on the west bank of the Nile, the largest of which was Gurna.[30] These communities had been supplying and supporting archaeological labour for a century. Most likely, Carter's head

[28] GI negs. P0608–P0610; MMA neg. TAA 1132.
[29] On which see Natale, 'Photography and communication media'.
[30] See Van der Spek, *The Modern Neighbours of Tutankhamun*.

ra'is, Ahmed Gerigar, was responsible for hiring and coordinating labour each season – one of the tasks that made this a powerful role in communities like Gurna.[31] Unlike Gerigar and the other three named *ru'asa* on the site, the porters worked outside the tomb, doing the less specialist, but still delicate, work of carrying objects to KV15. Apart from larger numbers – upwards of fifty men – hired at the end of a season to haul crated antiquities to Luxor, bound for Cairo, no more than half a dozen or so workmen operated on site itself. This was a small and select band.

But who were they? A photograph published in *The Sphere* – a rival to the *Illustrated London News,* with which it merged in 1928 – is the only image known to me in which some of the porters and *ru'asa* are posed for a group portrait, presumably taken by a journalist (Figure 5.7). It is one of five photographs on a single page in the paper's 3 February 1923 issue, headlined 'Visitors flock to the Tutankhamen tomb' with the credit

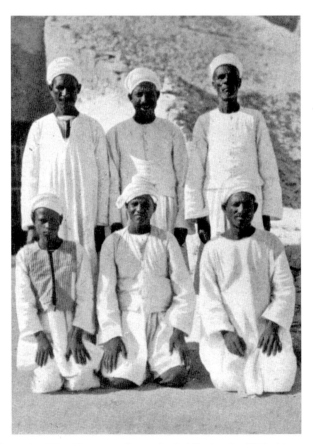

Figure 5.7 Photograph of Egyptian men who worked at the tomb of Tutankhamun, published with the caption 'The men who are assisting Mr. Howard Carter' and identifying the three men at the back as 'head men'. *The Sphere*, 3 February 1923: 111.

[31] For the role of the *ra'is,* see Doyon, 'On archaeological labour'.

'Special *Sphere* Pictures'.[32] Alan Gardiner, in a sun helmet, features in another photograph on the page, while a photograph of the Egyptian soldiers assigned to guard the tomb, lined up at attention with their rifles, describes their attitude as 'an amusing one' and characterizes them as 'bristl[ing] with the lust to kill someone'. The photograph of the Egyptian workmen bears a more respectful, if still anonymous, caption: 'The men who are assisting Mr Howard Carter'. It specifies that the three men at the back of the photograph are 'head men', perhaps meant as an equivalent to foremen or *ru'asa*. All three can be identified in other press photographs. The two men standing at left and centre are the same men respectively carrying and accompanying the so-called 'mannequin' (object 116, Figure 5.8), while the younger man kneeling in the centre appears in several photographs taken for *The Times,* in which he waits outside KV15 or assists Callender.[33]

The tall, slim man at the back right of *The Sphere* photograph may be Gerigar himself, a suggestion I make on the basis that in photographs from several stages of the work, a

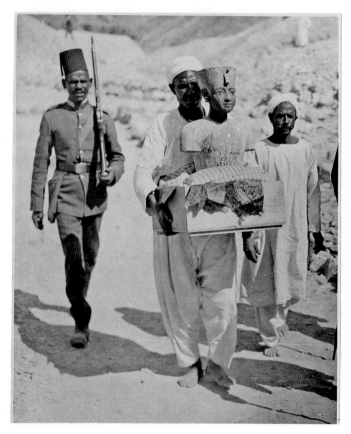

Figure 5.8 An Egyptian workman, possibly a *ra'is,* carrying the 'mannequin' (object 116) to the 'laboratory' tomb of Seti II (KV15). Press photograph, possibly by Arthur Merton, January 1923.

[32] 'Visitors flock to the Tutankhamen tomb', *The Sphere,* 3 February 1923: 111.
[33] See Riggs, *Tutankhamun: The Original Photographs,* 57 (figs. 68, 69, at right), 81 (fig. 107, 2nd right).

similar figure appears in postures of authority, instructing fellow Egyptians (see Figure 5.10, far right).[34] Gerigar was probably most senior in age as well as rank, which seems to fit the features of the tall man in *The Sphere* photograph. Moreover, if the men arranged themselves for the photograph, it is possible, if speculative, that this man is intentionally in the most authoritative position, if we read the resulting photograph from right to left, top to bottom, as one reads Arabic script. As Edwards has argued, the space of a photograph is a social one, and social relations may be performed for the camera in ways that defy reductive or polarizing explanations.[35] There is an inherent ambiguity here about who was looking at whom, regardless of which faces confront the camera.

How little we can say about the Egyptian staff on this most famous of excavations, or even in *The Sphere* photograph, is in sharp contrast to the coherent and comprehensive narrative that Carter's journals appear to provide for his part of the work. Photographs offer a corrective, not only on their evidentiary basis – demonstrating the presence, number and at least some of the roles Egyptians performed – but also for what they convey about less formal uses of the camera than the Burton images considered above. The technical differences in the types of handheld, snap-shot cameras used to photograph porterage had a bearing on the kinds of photographs produced, which were not in such sharp focus as Burton's (especially when enlarged) but could be taken in quicker succession, with shorter exposures and from rapidly changed vantage points. The frequency with which such porterage photographs were taken and reproduced, and the extent to which they still circulate, suggests that there is more at stake in these photographic acts than simply tourist and media interest in the tomb: the Tutankhamun find was exceptional, but it was not an exception in terms of the kinds of activities involved on site. Rather, I argue, these photographs of porterage should be seen as part of an established visual repertoire of empire, in which the representation of non-Europeans as servants and labourers was a commonplace of consumer culture. Advertisements and product packaging in the late nineteenth and early twentieth centuries, for example, associated images of indigenous people with products – tea, cocoa, cotton – that originated in corresponding outposts of the British Empire, depicting Africans or Indians as producers or porters of the raw materials. Any Europeans included in such illustrations were in positions of command and supervision, perpetuating the idea of a benign imperialism that had brought its improving and 'civilizing' mission to the very people such imagery 'dehumanized, diminished, and naturalized as servants and inferior beings', as Anandi Ramamurthy has written.[36] The photographic archive is in constant conversation with a wider 'archive' of visual tropes and acculturated ways of seeing – perhaps especially when photographs appear at their most diffuse, repetitive, or banal.

Photographing manual labour, like porterage, on archaeological sites meant photographing what were in effect the raw materials of archaeology: the artefacts or

[34] Ibid., 84 (fig. 112, at right); 86 (fig. 115, seen from back).
[35] E. Edwards, 'Negotiating spaces'.
[36] Ramamurthy, *Imperial Persuaders,* 8. See also Jackson and Tomkins, 'Ephemera and the British Empire', 155–64, and McClintock, *Imperial Leather* for a wider discussion of how race and imperialism were mutually supportive constructs.

structures out of which the archaeologist would manufacture the ancient past. Asymmetries, inequalities and anonymity suffuse photographs of labour at the tomb, not only between foreign and indigenous staff members, but among the British or Egyptian participants themselves; social relations were not binary, but multifaceted. Some of the individuals involved in the Tutankhamun excavation had known each other and worked together for decades, however different their individual experiences were or how difficult the interpersonal relationships enabled (or disabled) by the colonial encounter. Others, like the porters used to transport crates to the river or train station, may have been hired only for specific tasks. Either way, there were a number of social factors in play around, and through, the photographic encounter we see in print.

Photographs of work taking place outside the tomb of Tutankhamun are abundant in two senses, first in terms of the numbers that were taken (and by multiple photographers), and secondly, for the 'plentifulness, plenitude and potential' implied in the medium itself.[37] Photographs record unexpected details and random information, an 'excess' that frustrated earlier photographers but offers a boon to researchers now. The area immediately outside the tomb of Tutankhamun was a photographic free-for-all, however; the cameras of tourists and other news outlets were ever-present, putting many photographs beyond the control of Carter, Carnarvon or *The Times* during the first two seasons. As an established winter resort, the town of Luxor on the opposite side of the Nile was well-equipped with photographic suppliers, where negatives could be printed on photo paper or postcards. In a February 1923 edition, the *Illustrated London News* observed that work on site was accompanied by the 'click of the ubiquitous Kodak', which the paper juxtaposed with the 'constant creaking of the crude water-wheels which abound in the locality', contrasting the modern Western technology of photography with an ageless Oriental primitivism.[38] Such photographs were not formally incorporated into the Arabic number sequence Carter assigned to images he associated directly with the tomb, including Burton's large-format 'work-in-progress' photographs. Instead, Carter's archive in Oxford includes some of these less formal photographs, as both copy and original negatives, in the Roman-numeral sequence he assigned to images he considered more tangential to the tomb, from Burton's photographs of the Valley of the Kings to his own photographs of work in the Valley pre-dating the 1922 discovery.[39] Since the 1970s, the Griffith Institute in Oxford has accepted separate donations of tourist or press images, too, some issued as postcards or at least printed on postcard paper (an inexpensive option at the time), and several that were mounted in a simple, anonymous album.[40] In New York, the Egyptian department at the Metropolitan Museum

[37] E. Edwards, 'Anthropology and photography', 237.

[38] 'The suggested pharaoh of the Exodus causes an influx into Egypt: Tutankhamen attracts tourists', *Illustrated London News,* 10 February 1923: 196–7.

[39] Discussed in Riggs, 'Photography and antiquity in the archive'.

[40] Currently catalogued in the Griffith Institute as follows: TAA ii.6.1–20, a small private album of photographs made between 27 December 1922 and 3 February 1923; TAA ii.6.21–4, postcards (or prints on postcard paper) of porterage; TAA ii.6.25–8, four photographs of porterage; TAA ii.6.50, 'Sport and General press agency copyright' photograph dated 5 December 1922; TAA ii.6.51–4, four photographs of porterage; TAA ii.6.64, postcard captioned 'Exploitation of Tout-ankh-amon's tomb', apparently from the 1920s.

of Art has also over time accrued some postcard-printed shots of work outside the tomb, as well as photographic prints thought to have been donated by Egyptian Expedition member Lindsley Hall, who helped draw the plan of the Antechamber in the first season. Beyond these two institutions, photographs depicting the Egyptian porters at work circulate widely, often in the form of vintage postcards and news agency prints.

The quantity of snap-shot photographs taken, and their frequent reproduction at the time and subsequently, gives the impression that they document the entire excavation. In fact, however, almost all of them date to Season 1, when objects from the Antechamber were transported on stretcher-like wooden trays and could be glimpsed between their steadying or protective bandages. Photographs of the objects being brought out of the tomb focus (or at least purport to) on archaeological objects. But human activity, whether by the Egyptian workers or the 'team', was crucial for the visual interest of reportage from the site. The most common photographs show trays of objects being manoeuvred up the tomb steps or carried towards KV15, but *The Times* also published photographs taken by Carnarvon himself of work areas that were off the tourist track, such as the carpentry workshop.[41] Several photographs circulated in *The Times* and elsewhere of the moment in late January 1923 when the so-called mannequin (object 116) was carried by one of the foremen or site porters, shadowed by his colleague and one of the Egyptian military guards in some views (Figure 5.8), and by Arthur Weigall, Howard Carter or background tourists in others.[42] The clear view of the object itself, and the way its head and torso echoed, or in some views almost covered, the body of the man carrying it, provided particular visual interest – helped too by the bright, open-air conditions under which such photographs were taken. Needless to say, the presence of the porters themselves rarely earned even a mention when such photographs were published, nor that of the uniformed military personnel specially detailed to guard the tomb – the 'amusing' soldiers deemed by *The Sphere*'s snide correspondent to be a trigger-happy bunch.[43]

Given the nature of the portering and transport work, photographs often show the Egyptian and British staff working together to move objects out of the tomb and to KV15. Sometimes, Carter, Callender or Mace adopt a supervisory position, striding along beside a tray carried by Egyptian porters. Other photographs show them pitching in together,

[41] Riggs, *Tutankhamun: The Original Photographs,* 49 (fig. 57).

[42] Ibid., 77 (figs. 97, 98); other examples taken on the same occasion include one of the photographs donated to the Griffith Institute (see http://www.griffith.ox.ac.uk/gri/4acc0003.html, now part of the TAA.ii.6 group) and Alamy picture library images BR6ABD, BR6A58, BRfAP3 and DDT02T (see www.alamy.com). Arthur Weigall was the Egyptologist and former chief inspector for the Antiquities Service who reported on the find for the *Daily Mail;* he was scorned and rebuffed by Carter, especially after he tried to warn Carter to behave differently with the Antiquities Service: see Hankey, *A Passion for Egypt,* 259–74.

[43] 'Visitors flock to the Tutankhamen tomb', *The Sphere,* 3 February 1923: 111. The caption to the photograph of the Egyptian soldiers reads in full: 'The attitude of these guardians of the tomb is an amusing one. "Never in their lives have they held such positions of rank in the public eye," declares *The Morning Post*'s Special Representative. "When Mr Carter emerges to the air or when an object is brought out, the soldiers fairly bristle with the lust to kill someone. Nothing would give the section any pleasure comparable to the unutterable joy of sweeping the front of the tomb with a volley of lead. And if Mr Carter himself interferes . . ."'. Read against recent Egyptian independence and the 1919 revolution, white fears of indigenous violence clearly run through this alarmist, and alarming, account in a newspaper that circulated widely in the British colonies.

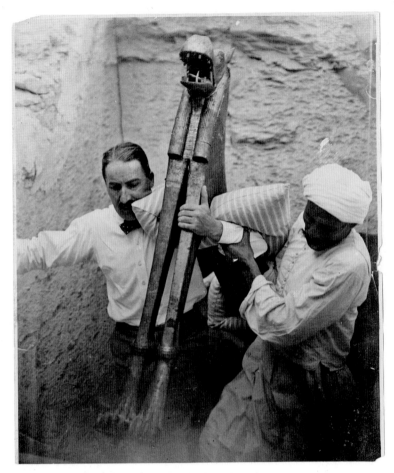

Figure 5.9 Carter and a *ra'is* struggle with the weight of the hippo couch (object 137). Photographer unknown, January 1923.

however. One of the photographs possibly taken by the Metropolitan Museum's Lindsley Hall depicts up close the level of coordination and physical contact that the portering work also involved (Figure 5.9). Its intimate vantage point – from near the tomb entrance, rather than the road level above – indicates that it was made by someone on or closely involved with the team, while other photographers snapped away above.[44] Divested of his usual waistcoat, Carter and the same Egyptian man seen in many photographs of work inside the tomb struggle together at the top of the stairs with the side of a gilded, hippo-headed wooden couch. The effort of the work is obvious: a ticking-covered pillow cushions the weight of the couch on Carter's shoulder, and the Egyptian man – one of the foremen,

[44] An unpublished *The Times* photograph I have seen online (since taken down) may show Hall or someone else – a slender man in a boater hat – in the act of taking the image. Compare Alamy library image BR6ACR (www.alamy.com), for another vantage point of the hippo couch removal.

judging by his frequent appearance in these photos – helps lift Carter's flagging arm. Their intimate contact, hand to arm, knees almost touching, did not preclude publication of this photograph, whose close-up view lent it an immediacy lacking in the photographs taken from ground level. That the Egyptian man adopts, literally, a supporting role to Carter may have matched expectations, and in any case, it is Carter's face, left hand, and the carved front of the ancient couch that are in sharpest focus. When the weekly *Illustrated London News* published this photograph in a double-page spread on 17 February 1923, its caption simply identified 'Mr Carter and an Egyptian' as the men at work, acknowledging the presence of the second human being while declining to name him. A few months later, Carter and Arthur Mace used the same photograph in their first book about the tomb, this time without either naming the Egyptian man or referring to his presence.[45] Both Carter and Mace will have known this man well and worked alongside him on an almost daily basis for months. They certainly knew his name, but they must have assumed either that their readers were disinterested in such a detail, or that it was inappropriate to the task of archaeological record-keeping and publication.

Another example of porterage, again probably photographed by someone closely involved, took place in May 1923 when the first load of crated objects was transported by light railway more than five miles to the Nile and loaded on a government barge bound for the museum in Cairo (Figure 5.10). It was a crucial moment: the archaeologists and antiquities officials, including Rex Engelbach, the chief inspector for Upper Egypt, were anxious about the condition and security of the objects along the journey, while the question of whether Cairo would be their permanent home also hung in the background. The London *Times* – presumably via reporter Arthur Merton – described it as

> throughout a fascinating spectacle. The gang which did the manual work consisted of 50 Saidis, or labourers, of Upper Egypt, who are renowned for their industry and endurance. These qualities they fully demonstrated yesterday, and, in addition, most of them displayed marked intelligence in handling and guiding the cars, to each of which three men were attached, the remainder being occupied in raising and relaying the lines.[46]

Carter and Mace (writing in Carter's voice) also detailed the transport in their book, but they did not include any of the photographs representing it. As the press report noted, fifty men were involved in the process, which took fifteen hours over two days. They laid and re-laid sections of light railway track as they progressed, an action Carter described as

> a fine testimonial to the zeal of our workmen. I may add that the work was carried out under a scorching sun, with a shade temperature of considerably over a hundred [38C], the metal rails under these conditions being almost too hot to touch.[47]

[45] Carter and Mace, *Tomb of Tut.Ankh.Amen,* vol. I, pl. xxxii.
[46] 'Treasures of Luxor', *The Times,* 16 May 1923: 15+.
[47] Carter and Mace, *Tomb of Tut.Ankh.Amen,* vol. I, 177.

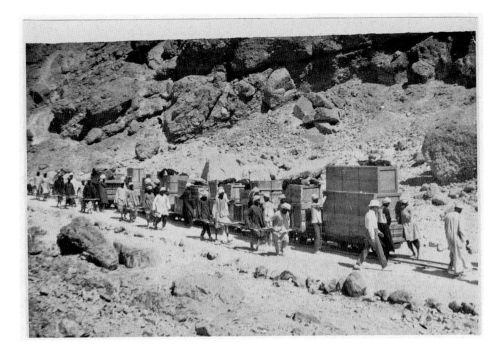

Figure 5.10 Egyptian porters taking the tomb objects to the Nile at the end of the first season. Photographer unknown, 15 May 1923.

Reading Merton's and Carter's words while viewing these images makes both the reading and the viewing more uncomfortable. In Figure 5.10 (negative XV, by his own numbering) a topee-wearing Carter strides towards the front of the train, perhaps to confer with the long-robed figure at the far right of the picture – possibly senior *ra'is* Ahmed Gerigar, though it is impossible to confirm this. Alongside the crates of royal treasure are the Egyptian labourers carrying the tracks, their short shadows signalling the time of day. In the midday heat, we see where physical collaboration among the collective had its limits, as if only the body of the 'native' were impervious to the biology of burns.

At the river, the porters waded into the water to lift the crates onto the boat – and someone was still taking photographs. In one view, two *effendiya* – perhaps inspectors with the Antiquities Service, like Tewfiq Boulos – adopt the position of command usually reserved for whites in such images: sharp if slightly dusty shoes, crisp suit, *tarbush* in place, and hands clasped behind back or akimbo at the waist (Figure 5.11). Children watch in the background and donkeys mill about at water's edge. Egyptians supervising their countrymen welcome the treasures of Tutankhamun to the next stage of their journey, besuited modernity confronting its traditional 'other' over the tops of the crates. Wilson Chacko Jacob has argued that *effendi* masculinity in the interwar era required realigning the self with a new national ideal, in a process that replaced colonial objectification with a

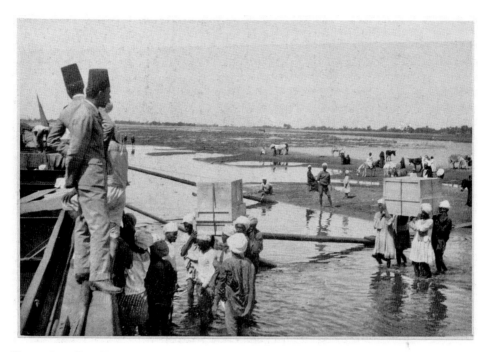

Figure 5.11 Two Egyptian officials observe as porters load crates onto the government barge. Press photograph, possibly by Arthur Merton, 16 May 1923.

new sense of subjectivation, via practices of the self.[48] In part, the Egyptian performance of modernity relied on the symbolic value assigned to the *fellahin,* the peasant farmers coopted in nationalist discourse as Egypt's indefatigable workforce and essential, pre-modern spirit.[49] Whoever took this sequence of barge-loading photographs – *The Times* reporter Merton, perhaps – may not consciously have had in mind the contrast between *effendiya* bureaucrats and menial labourers, or between their forms of dress, or yet between the relaxed confidence of the alert inspectors (if that is who they are) and the monotonous strain of the porters' physical slog. As with Burton's photographs of the ramps and scaffolding involved in dismantling the shrine, the photographic act here is a function of the noteworthy moment and of the interest arising from the crates and the mode of their conveyance. There is no print or negative of this photograph in the New York and Oxford excavation archives, only in the newspaper archives in which it first circulated, or from which it was recirculated more widely. But read against its archival traces, and in the light of contemporaneous social history, the image speaks to the weight of a past that was carried on the shoulders of many Egyptians – but that was also a platform on which other Egyptians could rise.

[48] Jacob, *Working out Egypt,* 1–18, 44–64.

[49] On the peasant as a representational trope in nineteenth- and early twentieth-century Egypt, see Abul-Magd, *Imagined Empires,* esp. 122–46; Baron, 'Nationalist iconography'; El Shakry, *The Great Social Laboratory,* Gasper, *The Power of Representation;* and Grigsby, 'Out of the earth'.

Resurrections in the archive

Absence is in the nature of the archive. Even in what I characterize as the expanded archive of the Tutankhamun excavation, encompassing press and tourist photographs, the most significant absence constitutes the shadow archive of photographs taken by Egyptians, in particular the Egyptian student groups, tourists and officials who came to see the tomb. After 1924, Egyptians working for the Antiquities Service or Ministry of Public Works may have photographed visits made by dignitaries like the Italian prince Umberto of Savoy and his wife, who were shown around Luxor and its west bank by Pierre Lacau.[50] However, photographs taken by Egyptians, in any capacity, for private viewing remain outside the institutional archives of archaeology. Indeed, surviving photographs are more likely to be in private hands. Even if some have entered state-owned archives in Egypt, the 'gatekeeper' approach and bureaucratic ethos of these institutions today presents certain difficulties of access, for instance determining where a collection of photographs might be, or what photographs a specific archive might contain.[51] These are issues that affect research in other decolonizing and postcolonial contexts as well, where archival practices may cut across the expectations of researchers in complex ways.[52]

The archives of Egyptian archaeology tend to occupy more privileged spaces, whether in metropoles like New York and Oxford for the Tutankhamun photographs or in foreign-owned institutes in Egypt such as the Institut français d'archéologie orientale, which traces its founding to 1880.[53] As we have seen throughout this book, photographic material in such archives has been archived and used primarily as a record of antiquities, inscriptions and site features, and after that as a way to illustrate and commemorate white European or American archaeologists – with Harry Burton's heroic framings of Howard Carter at one extreme, and less formal portraits of individual archaeologists, or camp life, at the other. Among the archive photographs that depict the indigenous Egyptians involved in archaeology, those that show processes of manual labour outnumber themed subjects such as payday or meal breaks (which in any case implicitly refer to manual labour), or portraits like those Flinders Petrie and his colleagues took of Egyptian field and domestic staff.[54]

[50] See Orsenigo, 'Una guida d'eccezione', for photographs from Lacau's personal archive; no photographer is credited, but the prints were made at the studio of Peter Zachary in Cairo. At Luxor, Attiya Gaddis, owner of the Gaddis and Seif studio in the Winter Palace Hotel, photographed important visitors and events, selling his images to the press: see Golia, *Photography and Egypt*, 57–9. Luxor studios like Gaddis and Seif also did a brisk trade in copies of photographs – for instance, Burton photographs from the tomb of Tutankhamun.

[51] As discussed, within a range of related issues, in Ryzova's insightful essay, 'Mourning the archive'.

[52] Thus Buckley, 'Objects of love and decay', who argues that 'rather than being something aberrant and a stereotypical sign of the neglect and inefficiency of the postcolonial state, decay – as well as the right to allow for decay – is central to the cultural practice of archiving. The desire to preserve the national heritage in these material remains signals the transformation of the former colony into a modern nation and the national attainment of a specific sign of being modern' (at 250). See also Hayes, Silvester and Hartmann, '"Picturing the past" in Namibia'; Hayes, Silvester and Hartmann, 'Photography, history, and memory'.

[53] For the photographic archive of the Institut français, see Driaux and Arnette, *Instantanés d'Égypte*.

[54] See Quirke, *Hidden Hands*, 271–93.

But archaeological archives also include photographs that represent middle- or upper-class Egyptian men interacting with Western Egyptologists or paying visits to archaeological sites, for instance in official capacities – especially from the 1920s onwards, in keeping with the changed power relations that Egyptian independence brought with it. An interest in the pharaonic past, and making visits to pharaonic sites, was a hallmark of self-fashioning at the time, central to the cultural and political movement known as Pharaonism and avidly incorporated in new school curricula.[55] The Egyptian men who worked for the government, or were attached to visiting delegations in other ways, belonged to the broad social category of the *effendiya*, which emerged in the nineteenth century as a middle-class, modern elite, distinguished by Western dress and education as well as the forms of cultural expression that its members embraced in literature, the arts and politics, to distinguish themselves both from colonial authorities and from the Egyptian lower classes. It was from the *effendiya* that the anti-colonial movements leading to Egypt's independence and early nationhood emerged, although in the interwar period, the title *effendi* began to lose some of its glamour as other modes of subjectivation supplanted it, broadening the category to include minor bureaucrats and clerks.[56] The *tarbush* and tailored suits were by then ubiquitous for the holders of such posts – including the antiquities inspectors or Ministry employees who appear regularly, but anonymously, in photographs of work associated with Tutankhamun's tomb, like the two men observing the loading of the crates in Figure 5.11.

In this chapter, we have seen that although the Tutankhamun photographs taken by Burton and others frame the work of archaeology as the preserve of white, male protagonists, it is possible to refigure our approach to these photographs and thus foreground the collective nature of archaeological labour and knowledge production. In this final section, however, I test the possibilities and limitations of this approach by juxtaposing two examples in the Tutankhamun-related archives of the Metropolitan Museum of Art. Both examples help broaden the conceptualization of how many Egyptians, in many different ways, contributed to or identified themselves with the resurrection of Tutankhamun – but both also offer cautions about what the colonial archive allows, or disallows, where Egyptian subjectivity is at stake. Recent years have seen a growing awareness in histories of archaeology and Egyptology that more can and should be done to credit those excluded from the disciplines' hegemonic narratives, an exclusion taken to comprise Euro-American women on the one hand, and indigenous subalterns on the other.[57] In the former case, the danger is that women are simply incorporated into an existing hagiographic paradigm of male scholar-adventurers. In the latter, the difficulty lies in well-meaning scholarship that directs its energy to identifying Egyptians by name where possible, or pointing out their presence in photographs, as if this change in descriptive practice – in essence, a filling in of gaps – were an end in itself, another stage in the

[55] See Colla, *Conflicted Antiquities*, 121–65.

[56] Ryzova, *The Age of the Effendiyya;* Ryzova, 'Egyptianizing modernity'.

[57] For example, regarding women in archaeology, see Carr, *Tessa Verney Wheeler;* Cohen and Joukowsky (eds), *Breaking Ground;* Diaz-Andreu and Sørenson, *Excavating Women.* On indigenous labour, see for instance Quirke, *Hidden Hands;* Shepherd, *The Mirror in the Ground.*

purification of Egyptological science.[58] Admirable and important as a change in descriptive practice may be, it skims over the depths of the historiographic issues at stake. In her analysis of the social sciences in Egypt during the colonial era, Omnia El Shakry has discussed the challenge of writing a postcolonial history that does more than replicate colonial categories, nationalist narratives, or linear temporalities.[59] One of El Shakry's points is that differing modernities are constitutive and characteristic of modernity. Therefore, it is misguided to assume that gap-filling or 'recovering' indigenous subjectivities (I borrow her inverted commas) will magically ameliorate the inequities of past and present.[60]

Yet archives have an important role to play, and photographs within them can reveal more than they intended, whether read against the grain or read – as my first example shows – at face value. On at least three occasions in the late 1920s, Burton photographed groups of Egyptian officials and politicians visiting the tomb of Tutankhamun and KV15 with Howard Carter. The visits may have happened to fall on days when Burton was working on site, or else he was asked specifically to be there in order to take these group photographs, as he had photographed the gathered archaeologists, doctors and officials ahead of the mummy unwrapping (see Figure 1.6). Whereas Carter numbered photographs of the gathering for the mummy unwrapping in his standard Arabic-numeral sequence, he instead assigned Roman numerals to Burton's photographs of the Egyptian political visitors, placing these in the more mixed group of images concerned with subjects other than work proper on the tomb.[61] In the Metropolitan Museum of Art's Tutankhamun albums, the group photographs of politicians are sequenced towards the beginning of the album set, where they must have been added at a later date. They are mounted alongside other photographs from Carter's Roman-numeral sequence, as well as prints from Burton negatives that reached the Museum posthumously in 1948 and were numbered by Nora Scott. Many of these album pages have no captions, or else have captions inked directly on the page. But others, including all the Burton group shots, have captions typed on paper and pasted onto the page. It is uncertain exactly when this was done, but since some of the typed captions refer to 'Griff' (that is, Griffith Institute) numbers, in all likelihood they date from the early-to-mid 1950s, after Scott and Penelope Fox undertook the collation and print exchange between their respective photograph collections.

Typed labels in the Metropolitan Museum albums identify the November 1925 group photographs from the unwrapping as 'The Committee' – a word that does not appear in Carter's notes or in the second *Tut.Ankh.Amen* volume, in which he described the unwrapping at length.[62] It is a word that suggests scientific or managerial work, so perhaps

[58] See Carruthers, 'Introduction: Thinking About Histories of Egyptology'.

[59] El Shakry, *The Great Social Laboratory*, 219–22.

[60] Ibid., 219.

[61] Burton seems to have taken four group photographs at the start of the unwrapping, although only two of his original negatives exist. The photographs are as follows: GI negs. P0939 (a half-plate glass copy negative, probably mid-twentieth century, as well as a film copy negative, c. 1980s); P1559 (a film copy negative, c. 1980s); and as 18 × 24 cm glass plates, MMA negs. TAA 391 and TAA 1103.

[62] MMA/Albums, 84 ('Committee', for neg. TAA 1103); 984 ('Committee unwrapping mummy', for TAA 391); and 985 ('Mummy committee', for GI neg. P0939).

it was intended as an appropriate and respectful designation of the gathering. Conceivably, it survived in oral recollections of the occasion, only being inscribed in the archive at this later date. However, the typed captions affixed beneath prints of the Egyptian political visits are difficult to characterize as either respectful or serious in their intent: each reads, simply, 'The Boys' (Figure 5.12).[63]

The photograph illustrated here, taken outside KV15, includes members of the Liberal Constitutionalist party, which was elected after Britain forced Sa'ad Zaghloul's Wafd party from power in 1924. Among the group are no fewer than three past, present and future prime ministers, including Zaghloul's long-time rival Adli Yakan *Pasha,* who stands front and centre, facing the camera with his hands resting on his walking stick.[64] The second image captioned 'The Boys' in the Museum albums was taken on the occasion of one of King Fuad's visits to the tomb and positions him at the front, with Yakan and Carter next to him at the road above the entrance to Tutankhamun's tomb.[65] To date, I have not seen a photograph depicting only white archaeologists captioned in this way, and the captions appear essentially derogatory, specifically with respect to race. In America in the 1950s, 'boy' was widely used by whites to address African-Americans, echoing its use in colonial contexts: recall that 'boys' was also how Harry Burton referred to the Egyptian youths and men who assisted him with photographic work.[66] The album captions may be jocular, certainly – Carter's presence perhaps lends an element of the tongue-in-cheek here. But jokes are only another way of masking (and revealing) the tensions at play in asymmetrical relationships, as Homi Bhabha and others have argued.[67] On the album page, the mimicry of the caption undermines the coevality and equality that the photograph, with its foregrounding of Egyptian masculinity, asserts. Self-assertively modern Egyptian men fill the photographic frame, but the archive denies them any identity other than an insult.

My second example looks to the archive for traces of Egyptian agency behind the camera, where Burton's 'boys' worked. These assistants appear in some of the photographs that show Burton at work in Egypt, doing tasks such as holding a ladder for him, or standing by as he films or photographs (Figure 5.13). In Burton's own correspondence, he does not refer to any of these men or youths by name, only as a collective, for instance in a letter he wrote to Winlock in 1934:

[63] MMA/Albums, pp. 85 (neg. TAA 1130) and 86 (neg. TAA 1127). Album page 87 is captioned 'The Boys and Girls', under a photo depicting the visit of an unknown woman in an elegant dress and fur-trimmed coat, posing outside KV15 with Carter, Lacau and several men in *effendiya* attire, including the Minister of Public Works with whom Carter clashed, Murqus Hanna, as well as finance minister Ali Shamsi (GI neg. LXXXVII; MMA neg. TAA 1129). Colla, *Conflicted Antiquities,* 194 fig. 11 also identifies undersecretary of public works Abdel Hamid Soliman in the photograph, but is incorrect in his suggestions about the date (16 February 1923: the photograph is more likely to have been taken after 1925) and the identity of the woman (who is definitely not Carnarvon's daughter, Evelyn).

[64] GI neg. LXXXVI; MMA neg. TAA 1127. See Colla, *Conflicted Antiquities,* 207 fig. 12, identifying prime ministers Muhammad Tawfiq Nasim and Muhammad Mahmud in the photograph as well.

[65] MMA neg. TAA 1127. A film copy negative exists in the Griffith Institute (P1761), made in the 1980s or 1990s, but it is not included in the Institute's online database.

[66] See Chapter 1, n. 5; Chapter 3, n. 20.

[67] Bhabha, 'Of mimicry and men'. See also Dunphy and Emig's 'Introduction' to their edited volume *Hybrid Humour: Comedy in Transcultural Perspectives.* Stuart Hall's work on the stereotype as a form of representation is also relevant here: Hall, 'The spectacle of the other'.

Figure 5.12 Howard Carter, Adli Yakan and members of the Liberal Constitutionalist party pose outside KV15 – as mounted in the Metropolitan Museum of Art's Tutankhamun Albums, page 81. The print corresponds to GI neg. Pkv86 (LXXXVI). Photograph by Harry Burton, date unknown, probably 1926.

> Today is the first of the last week of Ramadan. I am always pretty glad when it's over. My boys are not particularly bright during the Fast + one hasn't the heart to drive them. I'm also a fellow sufferer as I don't smoke during Ramadan.[68]

Burton distances and dismisses the men at the same time as revealing an adjustment he made to his own habits for the Muslim holy month. It is a glimpse of how the relationships that operated in and through colonial archaeology affected the subjective experiences of everyone involved.

[68] Burton to Winlock, 9 January 1934 (MMA/HB: 1930–5).

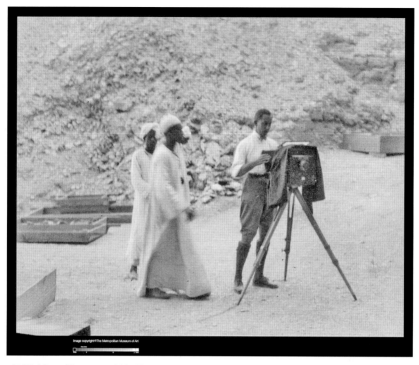

Figure 5.13 Harry Burton and his Egyptian assistants, photographing near the tomb of Tutankhamun in the 1920s. MMA neg. MM80950 (film copy negative of a print taken with a hand-held camera).

Like other archaeological tasks, photography was a collaborative endeavour. Burton's assistants likely had responsibilities that included help with set-up, backdrops and reflectors, but may also have encompassed darkroom tasks, equipment maintenance and supervision of supplies. They are among the unnamed subjects in photographs, and in Burton's correspondence, but a more personal glimpse of their relationship with Burton emerges in a letter that Burton's widow Minnie wrote from Cairo to his former employer, Ambrose Lansing, at the Metropolitan Museum, a few months after Burton's death. It is a revealing letter for what it says about life, and labour, in the contact zone:

The only other person I have heard from of the Luxor staff (except their joint letters of sympathy) was Harry's Hussein who wrote + asked me to try + help him to find work. But I didn't know what he was fit for – having, as far as I knew, done nothing but camera work for 20 years or so. He came here to see me the other day + said he was on his way to Suez as he had heard there was work to be found there. Poor fellow – he wept when he spoke of Harry. He told me not to cry. He said "Mr Burton is dead. I too will be dead soon, + so will you + everyone else. Mr Burton was a good man + he is with god, + you will find him there. He knows where you are + what you are doing." Don't you think that was extraordinary? It was just about Kurban Bayrami [the Eid el-Adha], so I gave him a pound (Harry always did) + my blessing. He told me the others

were all well, except Mr Winlock's Salama (I don't remember him) who had died suddenly recently, but I didn't understand what he died of.[69]

Like other wives of the Museum's Egyptian Expedition staff, Minnie Burton had accompanied her husband in Egypt for more than twenty years, living in the dig house and encountering – albeit in more restricted contexts – many of the same Egyptian workmen. A relationship of exchange and responsibility clearly existed between Burton and 'his' Hussein, which Minnie as Burton's widow felt obliged to continue, despite her evident confusion over other Egyptian staff whom Hussein assumes she will remember, and over Hussein's own fitness for any form of employment other than an archaeological dig. Her letter reports a conversation at the heart of the colonial encounter, where the asymmetries, inequalities and differences inherent to collective effort can be seen behind the camera, as well as in front of it. The click of the Kodak and the shunt of the dark-slide have left us with photographic archives rich with potential to re-enter the contact zone and retrieve something of the embodied and emotional experiences it shaped, in all their confusion, discomfort, or tedious banality. But this is possible only if we look more closely and more critically at our archival sources, which were not designed to enable the resurrection of modern Egypt – only the reinvention of its ancient, idealized past.

Authentication, authority, scientific rigour and security: photographing the work of archaeology enabled archaeology to do many kinds of work, far beyond its purported remit of discovering, recovering and preserving the ancient past. Since the first use of daguerreotypy in Egypt in the 1840s, photographs had documented – and created – a Western presence in exotic lands, a presence concomitant with mastery, control and technical prowess. Even where they show Egyptians and foreigners working closely together, photographs of archaeology thus tap into a seam of enduring visual tropes, which work against reading them as collective effort and instead encourage a reading based solely on inequalities. Those inequalities were real, without a doubt, but so too was a persistent interest in representing archaeology in action. The fame of the Tutankhamun discovery – and, until the 1924 breakdown, the impact of *The Times* contract – meant that both the British and American team members and the Egyptian workforce were photographed more often, and in a wider array of working contexts, than on most excavations.

 What photographs and other archival sources allow us to do is to re-present indigenous participation within the science of archaeology, but also, importantly, to re-examine the discursively produced subjectivity of colonizer and colonized during the early formation of

[69] Minnie Burton to Lansing, 16 January 1941 (MMA/HB: 1936–42). Burton had died in the American Mission Hospital at Asyut the previous June, suffering from a fever and complications of diabetes. Lansing's condolences at the time spoke of his esteem for Burton and their long association: 'I never knew a man whose perennial cheerfulness in the face of difficulties was more marked than his. Ever since I first met him in 1912, I think it was, when he was working for Theodore Davis, and in the long years of our association on our own expedition, which you also shared, I knew that he could be depended upon – indeed, latterly my greatest worry about him was to try to prevent his taking too large a view of what was expected of him' (letter to Minnie Burton, 11 July 1940, in the same correspondence file).

an independent Egyptian state. Histories of archaeology belong to wider histories of labour relations, something Nathan Schlanger has discussed in relation to fieldwork in western Europe.[70] In Europe, or Ottoman Turkey, the organization of labour reflected the social stratification that had emerged in industrial societies, anonymizing fieldworkers under collective nouns such as 'gangs'.[71] In colonial contexts like Egypt, where those credited as archaeologists were invariably white men, such stratification was further complicated by race relations and the concessionary privileges that foreign residents of Egypt enjoyed. The participation of Egyptians from a range of social strata has thus been downgraded or ignored, even where they are the sole or primary subjects of photographs taken at the site. Being 'in the field' was an embodied reality, not an abstraction. The men – and some boys – who worked at the tomb of Tutankhamun brushed against each other's clothing and bodies, smelt each other's sweat, waited, conferred, adjusted, manoeuvred, balanced, day in and day out for months and years. The split seconds caught by a camera may be flattened to shades of grey in the photographic image, but there is a depth and fine-grained texture to the encounters these photographs represent, well beyond the printed surface. The reasons why archaeological labour was photographed are thus inextricable from how it was photographed, as well as how these photographs did, or did not, become incorporated into the excavation archive.

Archaeological archives provide a starting point for interrogating the production of difference and the legacy of colonialism within archaeological labour. Although archives reflect the concerns of the practitioners, almost exclusively Western, who created and shaped them, they nonetheless hold the possibility of historical and disciplinary critique. By studying photographs of work at the tomb, their publication in the press and their various archival trajectories, we can dismantle the narrative of the hero-discoverer and scientific objectivity and try to build in its place a counter-narrative that restores texture, nuance, and complexity to the collective effort of archaeology in Egypt – and that challenges both disciplinary and popular assumptions about Egypt and Egyptology today. Egyptians in their hundreds, and from across the social spectrum, played fundamental roles in the most famous archaeological discovery ever made in their country. They shouldered their past both literally and figuratively, from rough labourers to experienced foremen, and from cooks, cleaners, guards and soldiers to the *tarbush*-wearing *effendiya* of the new nation-state's officialdom, whose Ministry of Public Works oversaw it all. Newspaper and excavation archives show this collective effort quite clearly, for all that it has been underrepresented, if not invisible, in the multitude of books, exhibitions and media Tutankhamun continues to generate. Colonial-era archaeology helped create, reify and reinforce inequalities and injustices that cast long shadows – even if the media-friendly face that Egyptology found in Tutankhamun seemed, and still seems, quite unperturbed.

[70] Schlanger, 'Manual and intellectual labour in archaeology'.
[71] See Çelik, *About Antiquities,* 146, for a similar point.

6

WORLDS EXCLUSIVE: MEDIATING TUTANKHAMUN

Photographs that were never taken haunt the archive. What no one thought to photograph, and why, has much to tell us about what everyone did photograph, often in such predictable patterns – Egyptian men carrying crates of swaddled artefacts, or Western archaeologists looking busy with antiquities. Some photographic possibilities were forgotten or overlooked, or else deemed unnecessary or inappropriate – all the objects or angles that never made it in front of Burton's lens, for instance, or identifiable portraits of the *ru'asa* Carter named in his books. There were other photographs that simply could not be, because there was no camera present, or conditions were inadequate, or the significance of the event was realized only after it took place. The unique and localized acts of discovery feted by conventional narratives of archaeology, and heralded in the media, present a photographic problem if no one thought to capture them at the time.

In the absence of the photographs that might have been, imaginative art helped fill the gap and feed the feverish interest the popular press took in the Tutankhamun excavation. The French weekly *Le Petit Journal Illustré* featured the tomb on the back page of its 11 February issue in 1923 (Figure 6.1). At the time, the magazine's colourful covers were always illustrations; it restricted photographic prints to its half-tone interior pages. Photographs did provide source material for the publication's artists, however. For the Tutankhamun cover, the illustrator R. Moritz (a *Petit Journal* regular in the 1920s) combined views of objects clearly inspired by four Burton photographs of the Antechamber, which had been published for the first time in the London *Times* on 30 January and appeared the following day on the front page of the daily *Le Petit Parisien*.[1] These four photographs showed the right-hand guardian statue with a tattered textile still draped over its arm; the elaborately carved alabaster vases, in a close-up that isolates them from their setting; the chariots and couches at one end of the Antechamber; and the guardian statues, lion couch and painted box in front of the plastered doorway at the other (see Figure 1.2). For the illustration, the artist narrowed the space and added or removed objects to suit his

[1] The photographs in question are GI negs. P0007, P0010, P0012 and P0321; associated MMA negs. are TAA 4, TAA 6 and TAA 10. 'Interior of Tutankhamen's tomb: first photographs', *The Times,* 30 January 1923: 14; 'Lord Carnarvon décrit quelques-une des richesses de Tut-ank-amen', *Le Petit Parisien,* 31 January 1923, front page (http://gallica.bnf.fr/ark:/12148/bpt6k605280z.item). For the British market, better-quality, larger-scale versions of the same photographs appeared in the *Illustrated London News* on 3 February 1923 (cover, 166–7, 169, 172–4).

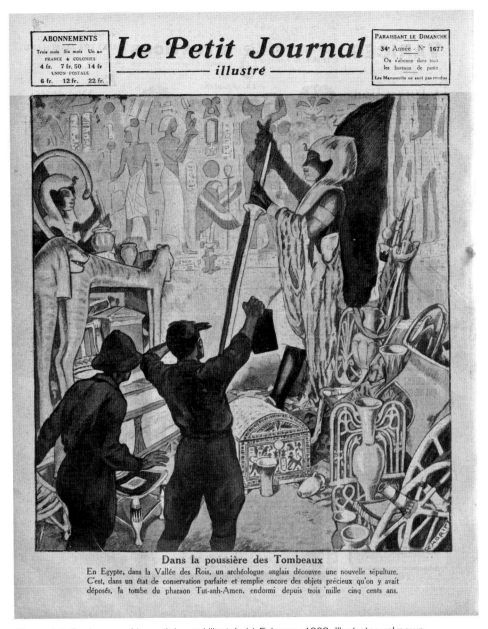

Figure 6.1 Back page of *Le petit journal illustré,* 11 February 1923. Illustrator unknown.

composition. Along the right side of the image, he placed the elaborate alabaster vases, which were in fact on the other side of the Antechamber, as well as the chariot wheels from the opposite end of the room. The most striking artistic license – so effective in the red, green and yellow tints of the illustration – are the paintings added to the plain tomb walls, offset by the almost silhouetted figures of two men immediately identifiable as Western adventurers, thanks to a pith helmet and jodhpur-style trousers. The caption,

written in the present tense, conveys the immediacy of the scene: 'In Egypt, in the Valley of the Kings, an English archaeologist finds (*découvre*) a new sepulchre', in a 'state of perfect preservation' and 'still filled with precious objects' deposited thousands of years ago. The men are as frozen in space as the 'precious objects' are in time. They rear back from the spectacular scene before them, even as readers of *Le Petit Journal Illustré* must have leaned in to absorb its details.

In the colourful illustration, the dazzling light from the archaeologist's lantern casts a dark shadow on the tomb wall behind the guardian statue, making it appear even larger in scale. The shadow was not, or not only, the work of the artist's imagination, however, but a striking visual effect in Burton's close-up of the statue – one of the four photographs first published at the end of January, which was also the cover image of the *Illustrated London News* on 3 February 1923 (Figure 6.2). In this photograph, a beam of light from the mobile electric lamp created a sharp outline of the statue against the tomb wall, in a profile view that conformed to the conventions of ancient Egyptian two-dimensional representation, even as the photograph itself showed the statue in a more Western- or portrait-style angle – a three-quarter view just possible for Burton within the confined space of the Antechamber. Hand-drawn pictures were not the only images that offered dramatic possibilities. In book and periodical publishing during the early decades of the twentieth century, the difference between photography and pictorial illustration was not necessarily perceived by viewers as a choice between the 'real' and the 'imagined', and both kinds of images depended for their meanings on the text and framing of the printed page as well.[2] Drawing and engraving techniques had been used to reproduce photographs long before lithography and halftone printing made direct reproduction of the photograph possible, in the stippled dots of newspaper and magazine pages. As a result, audiences were well accustomed to viewing both illustrations and photographs with varying degrees of trust in their fidelity, not dissimilar to the way that archaeology itself continued to value drawings alongside photography, one technique reinforcing the other. The past could be represented in a range of modes and media, texts and images: the lurid scene of archaeological *découverte* complemented, rather than competed with, the stark stillness of the photographs that were its source.

In this chapter, I examine how photographs shaped the public presentation of the tomb of Tutankhamun by their presence, their absence and their inevitable entanglement with the very things – commerce, politics, self-promotion – that archaeology claimed to rise above. I focus primarily on the media coverage the excavators sanctioned in the London *Times* and the *Illustrated London News,* since this is where the 'official'

[2] See Collier, 'Imperial/modernist forms in the *Illustrated London News*'; Gretton, 'The pragmatics of page design'; and Mussell, 'Cohering knowledge'. Both focus on nineteenth-century periodicals, but Gretton considers the early twentieth-century as well. On the use of images in the illustrated press, see also Beegan, *The Mass Image;* Hockings, 'Disasters drawn'; and Sinnema, *Dynamics of the Picture Page,* as well as Belknap, 'Through the looking glass', for the role of photographs in presenting science as an imperial project in the nineteenth-century press. Other examples of imaginative illustrations inspired by the work at Tutankhamun's tomb include a cover of *L'Illustrazione del Popolo,* 2 March 1924, depicting coffins being lifted out of a setting that bore little relationship to the Burial Chamber. In contrast, *La Domenica del Corriere,* 24 February 1924, used a cover illustration clearly inspired by Burton's photographs of Carter, Callender, Mace and the *ru'asa* peering into the shrine doors.

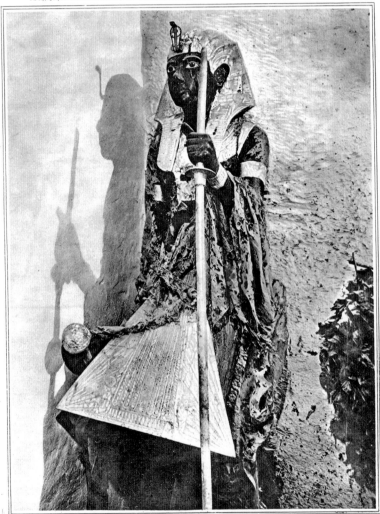

THE ILLUSTRATED
LONDON NEWS

REGISTERED AS A NEWSPAPER FOR TRANSMISSION IN THE UNITED KINGDOM AND TO CANADA AND NEWFOUNDLAND BY MAGAZINE POST.

SATURDAY, FEBRUARY 3, 1923.

The Copyright of all the Editorial Matter, both Engravings and Letterpress, is Strictly Reserved in Great Britain, the Colonies, Europe, and the United States of America.

ON GUARD AT HIS SEPULCHRE FOR 3000 YEARS: A STATUE OF KING TUTANKHAMEN.

Above is seen one of the two life-size statues of Tutankhamen found standing on either side of the sealed door, which Lord Carnarvon arranged to open soon after his recent return to Luxor. Here we get a full-face view of the right-hand statue, showing very clearly the wonderful detail of the face and costume. Both the statues are shown in profile in a double-page photograph in this number, and, as there mentioned, they are magnificently carved in wood covered with a black pitch-like substance. The head-dress, armlets and wrist-bands, mace and staff, are heavily gilt, and over the left arm hangs a fabric of fine linen. On the forehead is the uræus, or cobra, the emblem of royalty, of inlaid gold and bronze. The eye-sockets and eyebrows are of gold, and the eyeballs of arragonite, with pupils of obsidian. On the right is part of the funeral bouquet, also illustrated on other pages.

"THE TIMES" WORLD COPYRIGHT, BY ARRANGEMENT WITH THE EARL OF CARNARVON. (SEE OTHER PAGES.)

Figure 6.2 Cover of the *Illustrated London News,* 3 February 1923, with Burton's striking photograph of one of the guardian statues (object 22; corresponds either to GI neg. P0321 or MMA neg. TAA 6).

photographs first appeared. Where possible, I weigh this against the coverage and visualization of the tomb in other print outlets, especially in Great Britain and the United States, but also in some of the Arabic-language press in Egypt. The fact that I do not read Arabic has limited how much I can say about the visual sources available to an Egyptian readership in the 1920s, but interest in the discovery was extremely high, attracting middle-class Egyptian tourists to the site and inspiring Egyptian cartoons, songs, poems, novels and plays. In any language, how images worked with – or against – the written presentation of the excavation depended in part on the availability of photographs, but also reflects contemporary discourse about both ancient and modern Egypt. The tomb, its treasures and its political ramifications often made for interesting bedfellows with other news stories of the day.

Given the bitter issues of access and copyright that dominated the two field seasons preceding Carter's so-called strike, the first section of the chapter revisits the question of *The Times* contract, considering its impact on other news outlets and on Burton's own photography. A discourse of art and science dominated the sanctioned presentation of the tomb in *The Times* and, especially, the *Illustrated London News,* with the excavators keen to assert scientific rigour and disinterest.[3] Burton's photographs and the words – often Carter's – that accompanied them were integral to this, but once published, photographs and other images (like rival papers' drawings) were less easy to control; likewise the photographs that people took outside the tomb. The second section of the chapter considers how British press coverage in particular asserted the 'modernity' of the tomb equipment even as it drew on a bewildering range of cultural comparisons in its efforts to make ancient Egypt accessible to newspaper readers. More than mere journalistic style, these comparisons – from St George, to Charlie Chaplin, to Aboriginal Australians – speak to the by-then commonplace, even banal, worldview fostered under British imperialism, which persisted long after the empire itself began to wane. Modernity was an ambiguous phenomenon, however, and a yearning for imagined pasts already tinged interpretations of the tomb.[4] Nostalgia also contributed to the narrative of domesticity that Carter, through the press, wove around photographs of objects from the tomb, even those with an overtly religious significance. In the interwar era, apprehensions of ancient Egypt made the ancient culture seem ever more familiar, even comforting, to Western audiences, just as the modern Egyptian state became ever more independent. The domestication of Tutankhamun included, and facilitated, its commodification. Photographs of the tomb and its treasures circulated as commercial products in the 1920s and 1930s, for instance through postcard packs and collectable cigarette cards. Whether at home or as tourists to Egypt (before the Second World War intervened), such

[3] Cox Hall, *Framing a Lost City,* 20–2, 86–102, also discusses the role of scientific discourse in *National Geographic Magazine*'s presentation of American exploration at Machu Picchu, pre-World War I. The National Geographic Society sponsored the Yale Peruvian Expeditions, and each issue of the magazine was estimated to reach a million readers at the time, who were invited through text and photographs 'to travel with the scientific expedition on its journey' (96).

[4] See Fryxhell, 'Tutankhamun, Egyptomania, and temporal enchantment', for a similar argument about Tutankhamun's escapist appeal, based largely – as she points out – on replicas, visual and written representations and commodities.

products invited European and North American audiences to participate in the archaeological discovery by purchasing, viewing and sharing some part of it – in the process reinforcing a communal memory of Tutankhamun that would prove to be a deep and lasting one.

Copyright and control

In a memorandum of agreement dated 9 January 1923, the Earl of Carnarvon appointed the Times Publishing Company Limited

> as sole agents for sale throughout the world to newspapers magazines and other publications of all news articles interviews and photographs (other than cinematograph and coloured photographs both of which are excluded from this agreement) relating to the present and future exploration work conducted by the Earl and his agents in the Valley of the Tombs of the Kings Luxor Egypt so far as they relate to the excavation of the several chambers already opened and yet to be opened of the tomb of Tutankhamen.[5]

The sentence continued in the same unpunctuated legal language, abjuring anyone connected with the excavation from divulging any news or photographs to any person or company other than *The Times,* and requiring them to take 'all such steps such as shall be reasonably possible' to prevent news or photographs leaking out. The next section of the contract specified the mechanics by which photographs would be supplied to *The Times*:

> The whole of the photographs other than cinematograph or coloured photographs which may be taken by or on behalf of the Earl Mr Howard Carter his agent Dr Allen Gardner [*sic*] or by any other member of the staff of the Earl or anyone duly authorised by him or them shall be supplied to the Times representative [. . .] as soon as possible after any exploration or discoveries [. . .] being forthwith transmitted by the Times representative to the Times in London either by telegraph or by mail.[6]

The Times would endeavour to place both news articles and photographs in the world's press, listed – in revealing order – as the London newspapers, British provincial newspapers, the newspapers of the US and Canada, newspapers of Continental Europe, newspapers of Egypt and newspapers published anywhere else in the world. Subject to Carnarvon's approval, the paper also promised to 'act with the utmost fairness' towards all the British and Egyptian press, supplying articles free of charge to 'such Egyptian

[5] For the contract and its implications, see James, *Howard Carter,* 277–82, 290, 303, with a transcription at 480–5 (quoted passage at 480). A portion of the contract is illustrated (but not transcribed) in Carter and Reeves, *Tut-Ankh-Amen,* xxii, and see pp. xviii–xxiii for discussion.

[6] James, *Howard Carter,* 481.

native newspapers' who were interested. Everything published in this way would bear the acknowledgement 'The Times World Copyright by arrangement with the Earl of Carnarvon', and the Earl retained the right to all the news articles and photographs 'for the purpose of any lecture film caption or any book or books which he may hereafter deliver write publish produce or cause or authorise to be delivered written published or produced'.[7] In return for this exclusive agreement, Carnarvon received £5,000 up front, and 75 per cent of all net profits accruing above that sum from the sale of rights.

Money was the nub of the matter: by the time of the Tutankhamun discovery in 1922, Carnarvon had been funding excavations in Egypt for over fifteen years. It was more than an expensive hobby. It was an investment he hoped would pay off, or at least pay for itself. Hence the purchase and selling-on of antiquities – to the Metropolitan Museum of Art, among others – that he had long engaged in with the help of Carter's keen eye and contacts in the trade. With money matters on his mind, Carnarvon was open to a direct approach from the editor of *The Times*, Geoffrey Dawson, who (according to Alan Gardiner's eyewitness account) called on Carnarvon at his London residence to propose an arrangement similar to that the newspaper had had with the British Mount Everest reconnaissance expedition the preceding year. At Christmas 1922, Carnarvon wrote to Carter that he was considering *The Times* option, as well as weighing up the possibility of a film contract with Pathé. *The Times*, Carnarvon wrote, was 'the first Newspaper in the world', and he thought the eventual agreement that he signed was focused enough not to appear 'too common and commercial'.[8] Carnarvon had already given the *Illustrated London News* a scoop as well, meeting with their illustrator Amédée Forestier – specially despatched for the purpose – at Marseilles on his way back to England from Egypt in December 1922. Forestier had worked for the *News* since 1882, and he too created an impressionistic drawing of the moment of discovery – based not on photographs (at least not Burton's, which hadn't yet been taken), but on 'material supplied by Lord Carnarvon' (Figure 6.3).[9] There was no question of the find's newsworthiness.

Both Carter and Carnarvon underestimated the damage *The Times* contract would do to their relations with the Service des Antiquités and with other press outlets – especially the Egyptian press and a handful of rival British and American papers. For his own part, Carter expressed concern about how to satisfy the overwhelming press interest, not only because of the demands this placed on his time and energies, but also because communicating to the press was properly the responsibility of the antiquities service. Nonetheless, he adhered strictly to the terms of the agreement once it was in force, even appointing *The Times* correspondent Arthur Merton to the official register of excavation staff, in a duplicitous move that angered Lacau. Carter also shrugged off warnings from the Egyptologist Arthur Weigall, a one-time colleague in Egypt who had since moved back to England and become an author and journalist. Weigall represented one of *The Times'*

[7] Ibid., 482–3.

[8] Ibid., 278.

[9] 'The first glimpse of the great Egyptian treasure', *Illustrated London News*, 23 December 1922: p. 1022–3. For Forestier's work and the *News'* interest in archaeology under Bruce Ingram's editorship, see Phillips, '"To make the dry bones live"'.

Figure 6.3 Amédée Forestier's drawing of the moment of discovery, based on his interview with Lord Carnarvon and published across two pages in the *Illustrated London News,* 22 December 1923.

rivals, the *Daily Mail* (though both were owned by Alfred Harmsworth, Viscount Northcliffe), but he was also more sensitive to the political situation in Egypt than Carter seems to have been. As Weigall cautioned Carter already in January 1923, it was a mistake to think 'that the old British prestige in this country is still maintained'.[10] From within the team itself, Arthur Mace held his tongue in public but committed his own thoughts on the matter to his journal: *The Times* contract 'is much more drastic, now we have seen it, than we ever imagined', he wrote that January, and in February, that the arrangement 'has landed us in all sorts of trouble'.[11] Other British papers, American journalists and several editors from the Egyptian press had appealed in the meantime to the Ministry of Public Works to halt the Carnarvon contract, but the move was successfully blocked, allegedly by Carnarvon's threat to shut down work at the tomb.[12] The government had more pressing concerns both at the national level, as it developed its own governmental apparatus, and locally at Luxor, where, in early February, an Egyptian employee at a sugar factory had been shot and killed by the firm's European manager, while dragomen – the lifeblood of the tourist industry – had gone on strike in protest at their treatment in the separate investigation of a Canadian tourist's murder. According to the *New York Times,* the dragomen blamed (unnamed) foreign archaeologists for high-handed tactics.[13] At the moment of Egypt's

[10] James, *Howard Carter,* 280, but see the fuller account in Hankey, *A Passion for Egypt,* 262–8, which draws on Weigall family archives unavailable to T.G.H. James.

[11] James, *Howard Carter,* 282–3.

[12] 'Protests fail against Carnarvon', *New York Times,* 12 February 1923: 15.

[13] 'Americans indignant at treatment', *New York Times,* 10 February 1923: 15.

nominal independence, the violence of the colonial encounter remained all too real – and archaeology was omnipresent in the creation and reinforcing of its inequities.

Carnarvon's agreement with *The Times* inevitably changed the excavators' interactions with the press. Before the contract was signed, Carter – who was hardly as loathe to publicity as he sometimes claimed – seems to have enjoyed bantering with the assembled tourists and journalists outside the tomb. In early January 1923, the *New York Times* reported that he slowed the pace when walking with the Egyptian 'bearers' carrying a tray of alabaster vases towards KV15, the better to allow the crowd to see them.[14] In contrast, a month later, with the contract in place, the same newspaper reported that the excavators threw a sheet over one of the chariots when it was carried from the tomb, to stop an American cameraman from taking moving picture film – even though movie film was excluded from *The Times* arrangement.[15] Burton was making his own films for the Metropolitan Museum, and the idea of exclusivity had clearly taken hold. Visiting the tomb that first winter to report for *National Geographic Magazine,* Maynard Owen Williams described the air of waiting among the hampered press pack that gathered around

> the new wall of irregular stones which hid the entrance to Tutankhamen's mausoleum. Two correspondents sat there and another roamed about waiting for news. For weeks they had waited under the glare of the sun, compelled by the force of circumstance to be detectives rather than scribes. Suddenly and without warning some wondrous treasure would be brought forth in its rough but easy-riding ambulance, to be rushed to another tomb which was used as storehouse and preserving laboratory. Now and then some rumour would escape the portals, to be weighed and considered before it was put upon the telegraph wire or in the discard.[16]

One press photographer, Williams observed, had taken to wearing a *tarbush* 'to render himself less conspicuous among Moslem crowds'. To illustrate his *National Geographic* article, Williams took his own photographs to use alongside other sources, and its photo credits include Edgar Aldrich, the Ledger Photo Service, the Luxor photographic studio of Gaddis & Seif, and the *New York Times,* given copyright credit for the Burton photographs that the magazine reprinted, which the paper itself had licensed from London.

Cameras were everywhere, which presented a difficulty from the start for *The Times* contract and its demand that the excavators take every precaution against news and images reaching other sources first. Luxor was not the Himalayas of the British Mount Everest reconnaisance expedition. The town had ample photographic facilities in and around the hotels, making it simple for tourists to have their negatives developed and made up as either plain prints or postcards to send home. The tomb's location on the tourist trail, together with the intense media scrutiny that accompanied the find, meant that more photographs were taken of work on the site than for any other excavation in

[14] 'Pharaoh's vases give off old scent', *New York Times,* 5 January 1923: 3 ('Mr. Carter courteously instructed the bearers to walk slowly in order to allow the visitors to examine the vases without touching them. Mr. Carter laughingly informed the ladies that the vases contained perfumes of the King'.)

[15] 'Protests fail against Carnarvon', *New York Times,* 12 February 1923: 15.

[16] Williams, 'At the tomb of Tutankhamen', 469.

Egypt, especially during the first two fever-pitch seasons. From the parapet wall erected to separate the tomb from the Valley road, tourists and press correspondents aimed their cameras at the entrance some fifteen feet below, especially when objects were being carried out on open trays in the early months of 1923 – as the previous chapter discussed. This practice was abandoned in favour of closed crates (where possible) from the second season onwards, perhaps as much for the secure transport of the objects as to dissuade the crowds and their photographic interference.

The photography *The Times* and the excavators could control was what Burton carried out in the tomb itself and in the laboratory of KV15. This consideration influenced some of the photographic choices Burton made, such as many of the work-in-progress photographs considered in the previous chapter that appear to have had journalistic interest in mind – opening the burial chamber (Figure 5.2), demolishing the partition wall (Figure 5.4) or tending to the coffins (Figure 5.1). Even more obviously in the style of publicity shots is a series of photographs Burton made at the start of the second season, in late November 1923. In the best-known image from the series, Howard Carter, Arthur Callender and one of the Egyptian foremen frequently pictured in the tomb appear in sharp focus in the Antechamber (Figure 6.4).[17]

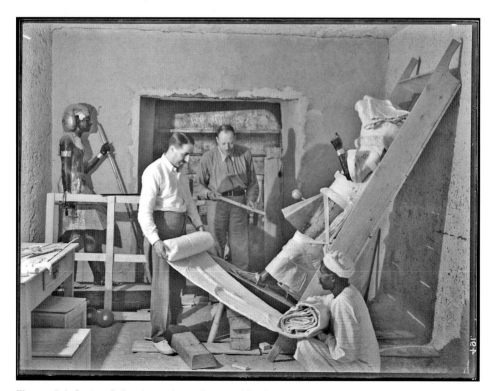

Figure 6.4 Carter, Callender and a *ra'is* posed in the process of packing the guardian statues. Photograph by Harry Burton, 29 November 1923; GI neg. P0491.

[17] GI neg. P0491; on a similar negative in the Metropolitan Museum, TAA 715, Callender is obscured by shadow.

All three men must have been holding still for the exposure of the plate. Shadows cast by an electric light, positioned out of shot to the left, outline the guardian figure (object 29) still standing next to the opened burial chamber, where the gilded outer shrine is also illuminated. The deepest shadows fall to the right side of the scene, picking out the slats of the tray that holds the second statue of the pair, its walking stick removed from one hand and its number card (22) pinned to one of the bandages that wrap its body like a 'war casualty' or 'a severely wounded man', as the papers put it.[18] Carter and his Egyptian co-worker are caught – we are meant to think – in the act of further wrapping or padding the statue, stretching a length of thickly folded cloth between them with one rolled end in each man's arms. Behind, Callender holds a folding ruler, and around the tomb chamber, we see the tools of work that have replaced the antiquities it once held: a simple desk, a pair of long-bladed scissors, a couple of wheels propped against a wooden frame. The positioning of human figures and objects within the photograph sets up pleasing lines of arrangement: the rough side walls contrast with the plastered rear wall; the opening of the burial chamber frames Callender and, in the beam of the lamp, Carter; the slant of the statue's carrying tray meets the slant of the part-rolled bolt of cloth at a right angle; and at the bottom end of the roll, the Egyptian *ra'is* crouches. It was a pose that Orientalist painters had long used to depict the passivity of indigenous Egyptians in the face of their ancient forebears, strangely similar to a grand 1890s oil painting of a mummy unwrapping in the old antiquities museum at Giza, in which an Egyptian man in turban and *galabiya* winds up discarded mummy bandages.[19] Here wrapping, rather than unwrapping, takes centre stage to show the scientific care that Carter and his team are taking towards the treasures of Tutankhamun. Squatting at Carter's feet, his Egyptian colleague occupies the least important role in this depiction of the work, even as the lamplight on his cheekbone echoes the sheen of the resin-painted skin on the guardian statues.

The clear focus and careful composition of the scene helped make this the most successful photograph of the sequence in terms of publication. It appeared in the London *Times* on 28 December 1923 and the *Illustrated London News* the following day.[20] Bruce Ingram, the *News'* publisher (who, with Burton, would be executor of Carter's estate), partnered *The Times* in presenting the official coverage of the excavation, since the *News'* weekly format, printing technology and healthy circulation figures were best suited to photographic reproduction. *The Times* often featured on a Thursday or Friday morning one of the photographs that the *Illustrated London News* would publish on Saturday, and the *News* borrowed some of the wording of its texts from features first trailed in *The Times*. From Luxor, Merton telegraphed stories to London on an almost daily basis in 1923 and early 1924, but photographs had to be printed and posted, with the result that two weeks might separate one of Merton's articles and the publication of photographs

[18] Respectively 'Tutankhamen's statue guardian: Delicate removal feat', *Manchester Guardian,* 30 November 1923: 9 (subhead: 'Borne like a war casualty from the tomb'; the article itself is *Times* copyright), and 'Tutankhamen's statue: Removal from the tomb', *The Times,* 30 November 1923: 12.

[19] See Riggs, 'Colonial visions'.

[20] 'In Tutankhamen's shrine: The first work of the season', *The Times,* 28 December 1923: 12; 'Tutankhamun trove: A gold chariot panel; packing a statue', *Illustrated London News,* 29 December 1923: 1198.

depicting the events he described.[21] This had the effect – surely familiar to readers at the time – of repeating similar information but by different means; it also increased the frequency and duration of publicity about a major story like the Tutankhamun discovery. The wrapping and removal of statue 22, for instance, was the subject of a Merton article in *The Times* on 30 November 1923 – published the day after the events it described.[22] 'A difficult task', read the subhead over Merton's description of the work involved in packing the first of the heavy statues, which Carter is credited with accomplishing in an 'ingenious manner' over two hours, by propping a tray behind the statue, using wedges to raise the statue beneath its plinth and lean it back into the tray, and finally swathing the statue in cotton wool and bandages until it 'looked like a severely wounded man after treatment in a casualty ward'.

A *Times* article published the following day reported the successful removal of the second guardian statue (object 29).[23] But only two weeks later, on 14 December, could *The Times* publish a photograph – probably taken by Merton – that showed it being manoeuvred up the tomb steps by Callender and three Egyptian workers (Figure 6.5).[24] The image may show the destination of the bolt of cloth Carter and his *ra'is* had held

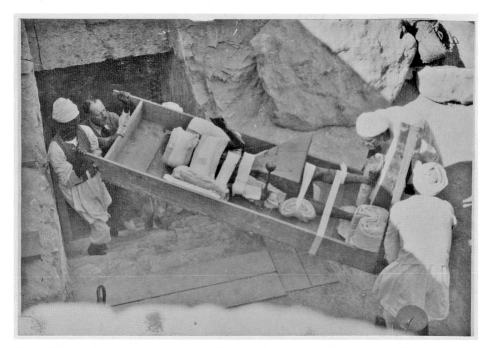

Figure 6.5 Egyptian workmen carry one of the guardian statues (object 29) out of the tomb. Press photograph, possibly by Arthur Merton, 30 November 1927.

[21] See Riggs, *Tutankhamun: The Original Photographs,* 3–5, 7–9.
[22] 'Tutankhamun's statue', *The Times,* 30 November 1923: 12.
[23] 'Tutankhamun's tomb', *The Times,* 1 December 1923: 10.
[24] 'Removing Tutankhamen statues. Royal theatre party', *The Times,* 14 December 1923: 18.

rather ambiguously between them, which here seems to have been used to pad the space between the base of the statue and the side of the tray. A further two weeks would then pass before Burton's staged photograph of the 'wrapping' appeared in late December, a delay perhaps caused by the timing of Burton's own developing and printing work, or by internal decisions at *The Times* and the *News*. Whatever the reason, the fate of the two guardian statues, whose location in the Antechamber meant that they had featured so prominently in the press during the first season, thus occupied a full month of media coverage at the busy start of the second season at the tomb.

Circulating images

True to its side of the agreement, *The Times* sought to sell on rights to news articles and photographs about the tomb, with enough success to pay Carnarvon's estate beyond the £5,000 advance. This was the mechanism by which the *Manchester Guardian* published a story about the statue removal on the same day as *The Times,* clearly marked 'The "Times" World Copyright' beneath the headlines.[25] The *Guardian* should also have credited *The Times* on 14 December, when it too published the photograph of a guardian statue being carried over the top of the tomb steps.[26] The copyright information would have been clearly stamped on the back of the print, just like another surviving print of this same photograph that originated with *The Times* (Figure 6.6).

Purple-inked stamp impressions identify 'The Times photograph copyright in all countries' and give the instruction 'Not to be published before', with room for a date stamp – in this instance, 14 December. A typewritten caption affixed to each print sometimes underscored *The Times'* control by heading the text, in uppercase lettering, 'The Luxor Tomb: "The Times" Official Photographs' and cross-referencing other *Times* coverage, though few newspapers included more than a brief description. For prints of Harry Burton photographs, such as the posed wrapping of statue 22, an additional stamp made explicit the requirement for copyright acknowledgement. It read in full:

> THIS PHOTOGRAPH Must be Acknowledged as follows: "The Times" World copyright Photograph by Mr. Harry Burton, of the Metropolitan Museum of Art, New York Expedition, lent by courtesy of the trustees and the Director of the Egyptian Department.[27]

Crediting both Burton and the Metropolitan Museum was a mark of how important Burton's work was to the excavation, but this was not unique to Burton's Tutankhamun work: the Museum already credited him this way in press coverage of its own Egyptian

[25] See n. 15.

[26] 'A statue of Tutankhamun', *Manchester Guardian,* 14 December 1923: 7.

[27] Further examples in Riggs, *Tutankhamun: The Complete Photographs,* 6 (fig. 2), 109 (fig. 145).

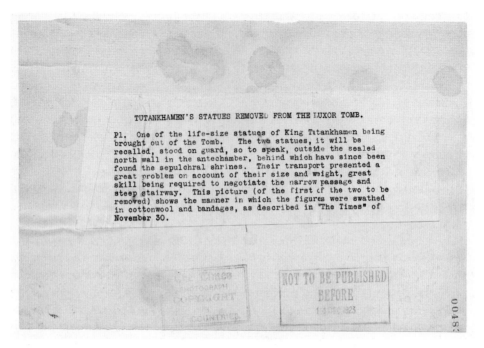

TUTANKHAMEN'S STATUES REMOVED FROM THE LUXOR TOMB.

Pl. One of the life-size statues of King Tutankhamen being
brought out of the Tomb. The two statues, it will be
recalled, stood on guard, so to speak, outside the sealed
north wall in the antechamber, behind which have since been
found the sepulchral shrines. Their transport presented a
great problem on account of their size and weight, great
skill being required to negotiate the narrow passage and
steep stairway. This picture (of the first of the two to be
removed) shows the manner in which the figures were swathed
in cottonwool and bandages, as described in "The Times" of
November 30.

NOT TO BE PUBLISHED
BEFORE

Figure 6.6 The reverse of the press photograph in Figure 6.5, showing date and copyright stamps from *The Times* newspaper distribution service.

Expedition.[28] Nonetheless, Carter will have been minded of the benefit of displaying his gratitude to the Museum, which was also rewarded by press coverage on its home turf. The *New York Times* followed the Metropolitan Museum's involvement in the tomb with interest, both on its own and by purchasing stories and photographs from the London *Times.* The Museum had posted a deficit of more than $300,000 in 1922, so positive news – a letter of thanks from Carnarvon, a marked increase in visitors to the Egyptian galleries, and a display of Burton's Tutankhamun photographs in the spring of 1923 – was welcome.[29] The gilded lustre of Tutankhamun covered many cracks.

But not all, and the fissure between competing newspapers only grew larger as the work continued. Reporting that Carter had downed tools in February 1924, the *Daily Express* could hardly keep a sense of *Schadenfreude* out of its front page coverage ('Evil of monopoly', read the subhead), deigning to name the 'London paper' with which Lord Carnarvon had made his 'unfortunate contract'.[30] The same paper had been among the first to denounce Carnarvon's memorandum with *The Times,* labelling it 'Tutankhamun

[28] E.g. 'In 2000 B.C.: A slaughter-house, brewery, and bakery in Egypt', *Illustrated London News,* 2 April 1921: 449, credited 'By courtesy of the Metropolitan Museum of Art, New York. Photographs by Mr. Harry Burton, of the Expedition staff'.

[29] 'Crowds at Museum see Egyptian tombs', *New York Times*, 5 February 1923: 3; 'Tut-ankh-amen views in Museum', *New York Times,* 5 May 1923.

[30] 'Women barred from the tomb', *Daily Express,* 14 February 1924: 1.

Ltd.' already in February 1923 and deploring the Egyptian government's apparent surrender to a 'private venture'.[31] Like other newspapers unable or unwilling to purchase images from *The Times,* the *Daily Express* made do by taking its own photographs from vantage points outside the tomb or by using artists' illustrations.[32] Carter protected his relationship with *The Times* after Carnarvon's death, during the stoppage of 1924, and after work resumed in 1925, when the contract was no longer valid. In 1924, for instance, Carter threatened Arthur Weigall and the organizers of the British Empire Exhibition with litigation, until Weigall demonstrated that his personal drawings and photographs were the source of the popular reconstruction of the tomb that featured in the Exhibition. Even more people will have seen the reconstruction of the tomb than saw it in newspaper photographs: the Empire Exhibition was held at the new, purpose-built Wembley Stadium throughout 1924 and 1925, and attracted 27 million visitors – including Harry and Minnie Burton.[33]

Understandably, it was the Egyptian press who felt the slight of 'Tutankhamun, Ltd.' most keenly, banned from reporting on an archaeological discovery in their own country. The monthly magazine *Al-Hilal,* which covered arts, history, news and science from around the world, published a handful of features on the Tutankhamun excavation, accompanied by Burton photographs that may have been supplied by Carter, or else were re-photographed from other publications – such as the close-up of statue 22 still in its ancient wrapping, which had been a cover image for the *Illustrated London News* (Figure 6.7; compare Figure 6.2).[34] *Al-Hilal's* coverage over the course of the first two seasons included stories about the initial discovery, a notice of Carnarvon's death, and a feature on the early Egyptian pioneers of Egyptology, and for all of these (as for its other stories) it drew on a range of visual sources. In addition to Burton's published photographs, for example, it republished a drawing from a January 1924 issue of *The Sphere,* signed 'D. MacPherson Luxor', which was one of several MacPherson executed especially for this rival to the *Illustrated London News* (Figure 6.8).[35] The MacPherson drawing depicts the structure of the shrines in isometric view, their constituent parts sliding apart like a three-dimensional puzzle and the imagined space around them peopled by multiples of the two Egyptian workmen seen in photographs. The interplay of graphic and photographic

[31] 'Tutankhamun, Ltd.', *Daily Express,* 10 February 1923: 1.

[32] For example, 'With the explorers at Luxor. In special "Daily Express" photographs', *The Daily Express,* 17 Febraury 1923: 8 – a column of images headed by an artists' reconstruction of the discovery used courtesy of the *Illustrated London News.*

[33] See Hankey, *A Passion for Egypt,* 286–7; Collins and McNamara, *Discovering Tutankhamun,* 76–9; and Fryxhell, 'Tutankhamun, Egyptomania, and temporal enchantment', 530–2. The Burtons visited the Exhibition while in London, before their trip to the United States: 'After lunch to Wembley by Paddington. Round in Radiotoc. Saw Burmah, Canada, & to performance of conjuring in Indian Pavilion, etc.' (GI/MBdiary, entry for 27 May 1924, at http://www.griffith.ox.ac.uk/minnieburton-project/1924.html).

[34] *Al-Hilal* 31 (1923), 562; see also coverage in *Al-Hilal* 32 (1924). I am grateful to Mahmoud Hassaan Al Hashash for reading the relevant articles on my behalf and translating the image captions.

[35] 'The sections composing the great outer shrine in the burial chamber,' *The Sphere,* 26 January 1924: 20–1. MacPherson contributed to a range of coverage in *The Sphere,* but for drawings specifically related to the Tutankhamun discovery, see the following: 24 February 1923: 6–7; 12 January 1924: 7; 19 January 1924: 66–7; 3 February 1923: 12; 10 February 1923: 22; 24 February 1923: 184–5; 8 March 1924: 15; 22 March 1924: 24–5; 24 May 1924: 19; 28 November 1925: 22–3.

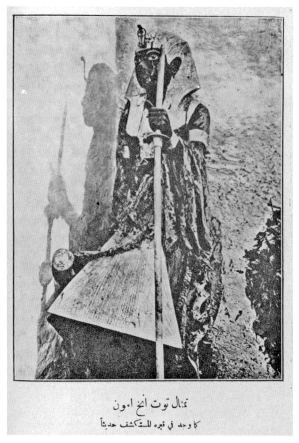

تمثال توت انخ امون

كما وجد في قبره المستكشف حديثاً

Figure 6.7 Burton's photograph of statue 22, reproduced in *Al-Hilal* magazine's feature on the discovery in 1923.

رسم تحليلي يبين الاجزاء (وعددها ٢٣) التي كان يتألف منها ناووس توت عنخ أمون (عن « سفير »)

Figure 6.8 A drawing by D. MacPherson, from *The Sphere* (January 1924), reproduced in *Al-Hilal* magazine later that year.

illustration was typical of many media publications at the time, not only because of the printing constraints some faced, but also because drawings allowed certain things to be visualized that a camera could not.[36] Moreover, both kinds of images could be copied almost indefinitely, thanks to re-photography. This is one of several factors *The Times* contract miscalculated. Whether photographic images circulated as officially stamped prints or as published newspaper images, they were more difficult to control than Carnarvon – himself a keen photographer – seems to have realized. Perhaps they would prove more tractable in telling the stories that helped create an ancient Egypt fit for the modern world.

The ambivalence of being modern

'When Modernity Fails': this was the strap line on an advertisement for Craven tobacco, placed in the London *Times* on 14 February 1923, just as controversy over journalists' access to the tomb of Tutankhamun raged in Luxor. It ran beneath a photograph of the site, labelled to show the tomb, the 'dark room' (KV55), the power station and adjacent sites, and photographs showing Carter and Mace packing a couch, and Burton filming with the Akeley.[37] Crowded on the page with other photographs – the opening of parliament, pancake day, the Tibetan army 'being built up on the British model' – the Craven advertisement assured readers that the timeless taste of Craven tobacco would transport smokers back to the 'deep, old-fashioned flavours of years gone by', for the duration of a pipe. Modernity might have failed in some respects, and flavours, but it succeeded in commanding the past – or at least those parts of the past worth preserving or revisiting.

The distinct horizons of time that newspapers marshalled on behalf of the modern age were horizons of space as well, from the tobacco plantations of Virginia, to the Valley of the Kings, to Pall Mall, and thence to the suburban living rooms of 1920s England. Modernity itself had emerged in the shared geographies of colonialism, as Wilson Chacko Jacob and Timothy Mitchell have argued with specific reference to Egypt.[38] To recognize the colonial embeddedness of the most banal media imagery is to recognize modernity's debt to colonialism – and to the image economy in which both 'Western' and 'foreign' press shared, as the examples from *Al-Hilal* suggest. Further, reading the news stories and advertisements that flank and surround the Tutankhamun coverage highlights the wider concerns of the day, and the distinctly imperial character of the British press in

[36] Another example is the exclusive use of line drawings by Hamza Abdallah Carr in an English-Arabic booklet rushed into print in Cairo, by Saleh Lutfi, in January 1923. See Raph Cormack, 'Pictures of Tutankhamun', *On Paper*, 15 December 2017: https://wordpress.com/read/blogs/123996015/posts/2501. As Cormack points out, images such as these might have been the inspiration for the stage props seen in a photograph in the same blogpost, showing a production of the play *Tutankhamun* at a school in the Delta town of Mansoura.

[37] 'At the pharaoh's tomb. The King opens parliament', *The Times,* 14 February 1923: 16.

[38] Jacob, *Working out Egypt;* Mitchell, *Rule of Experts.*

particular.[39] Weeklies like the *Illustrated London News* or *The Sphere* combined society and political coverage, science and theatre news, a bit of sports and motoring, and regular features on art, history and archaeology – just as they combined photography and drawings in their efforts to bring the 'modern' world, with all its paradoxes, to readers. The rarity of the Tutankhamun discovery lent it particular prominence, but the tone of discourse surrounding it did not develop in isolation. Seeing news photos, reading headlines, following Carter's progress in the press: all of these brought ancient Egypt and Tutankhamun into an ambit of the everyday, and in 1920s Britain – where the tomb was reported on most intensively, as a point of national pride – the everyday was, like the Craven tobacco ad, of two minds about the value of the modern. For every sign interpreted in a positive light, as modern by virtue of novelty, discovery or progress, there were reminders of 'the primitive' at Europe's own edges, of earlier life-ways that were disappearing (for good or ill), and of the destruction wrought by modern warfare.[40] Readers of the illustrated press encountered these contrasts in rapid succession, never viewing ancient Egypt on its own: in 1923, the *Illustrated London News* featured one of Howard Carter's delicate paintings of an Egyptian tomb scene, made earlier in his career, and on the next page, 'the great silence on Armistice Day' in Trafalgar Square and Whitehall.[41] Time was not chronological, in the modernist age, but collapsible – and the particular fascination with ancient Egypt articulated in interwar Britain offered an enchanting escape from the disillusions of the post-war present.[42]

Accordingly, in British, and to some extent American, press coverage of the tomb, references to other times and other places pepper the headlines, stories and captions for Burton's photographs. These varied cultural references worked in tandem with page layouts and the content of the photographs themselves to guide readers in how they should 'see' and think about ancient Egypt. Familiarizing the ancient, exotic and strange seems to have been a common tactic: one article promised to tell readers 'how the ancient Egyptians did the things we do'.[43] The resulting melange of cultural comparisons could be attributed to the jaunty, conversational style of middlebrow journalism in the interwar era. But in light of the geopolitical context of the find, the controversies and legal actions that shadowed its early seasons, and the assertions of scientific probity made in part through Burton's photographs, it is worth looking more closely at the comparisons used in presenting news and images of the tomb. In words and pictures, the discourse of science allowed the excavators and their supporters in the British press to argue that contemporary Egyptians were unable to appreciate, care for, and be entrusted with antiquities, or for that matter with anything deemed to require expertise. It followed that

[39] Compare the observations made by Robson, 'Old habits die hard', for press coverage of the excavation of Nimrud in Iraq in the 1940s–1950s.

[40] Two examples among many that juxtapose primitive/modern and ancient/modern, both from the *Illustrated London News:* 'Primitive nomads in modern Europe: Sarakatchans and Albano-Vlachs', 18 July 1931: 101; 'China – backward, yet progressing. Ancient ways and a modern road-to-be', 26 July 1930: 155.

[41] *Illustrated London News,* 17 November 1923: 893, 894.

[42] Fryxhell, 'Tutankhamun, Egyptomania, and temporal enchantment'.

[43] 'How the Egyptians did the things we do today', *Illustrated London News,* 29 March 1930: 524.

contemporary Egyptians could not be 'modern', a word that, at the turn of the twentieth century, began to encapsulate what it was to be current and in charge of one's own self-fashioning.

When the Egyptian government – including Pierre Lacau and Rex Engelbach from the antiquities service – reopened the tomb in early March 1924, after Carter's abrupt departure, the largest English-language newspaper in Egypt, *The Egyptian Gazette,* dripped its scorn on Sa'ad Zaghloul, other Egyptian politicians, and Egyptians in general. Sa'ad's youthful supporters, cheering the overnight government train when it departed Cairo, were smashers of street-lamps and shop windows; 'leathern Saidi throats' disturbed travellers en route with their shouts of greeting and calls for Egyptian control of the Sudan; and 'dusky faces pressed against the carriage windows' confirmed the writer's view that Zaghloul had done nothing but '[teach] them the power of the mob'. The unnamed correspondent continued:

> The essentially political character dominating the earlier proceedings remained equally marked throughout, while, on the other hand the absence of archaeological interest was indicated equally pointedly by the absence from yesterday's ceremony of a single Egyptologist of note, excepting M. Foucart, the head of the French Egyptological Mission [Georges Foucart, director of the Institut français d'archéologie orientale].

The sprinkling of distinguished British and European guests – Lord and Lady Allenby, Major-General Sir Lee Stack, a Prussian prince, and the Duke and Duchess of Aostan – could not make up for the presence of so many *effendiya* and their families, even 'Moslem ladies' as well as Copts. After visiting the tomb and taking tea in a special tent nearby, hosted by minister of public works Murqus Hanna and his wife, the Egyptian government hosted a banquet at the Winter Palace Hotel, followed by a fireworks display and a procession of illuminated boats on the Nile, which 'made an extremely effective finale to the day's outing, and incidentally provided a conclusion entirely in keeping with the character of the whole proceedings, which from first to last were quite unrelated to scientific effort, being entirely in the nature of a fête'.[44]

What sounds like an exuberant (and hastily put-together) official occasion, punctuated by predictable tea tents and banquet speeches, had a fatal flaw in the eyes of the *Gazette's* reporter and other Britons: it was an Egyptian event, organized by Egyptians, and attended for the most part by Egyptians. That was the 'political' element, in British eyes, and that

[44] 'At the tomb of Tutankhamen: The government's hospitality', by a 'special correspondent', *The Egyptian Gazette,* 8 March 1924. The article's subtitle is deeply sarcastic, when read in light of the content and tone of the article. For a sense of the grand occasion, see the Agence Rol photographs in the archives of the Bibliothèque nationale de France, online at ark:/12148/btv1b53127370j and ark:/12148/btv1b531273710.

Such sarcasm was not a factor of press authorship alone. In his own journals, Carter continued to be scornful of the Egyptian press and Egyptian visitors, for instance in this entry from 10 February 1925, shortly after the Service re-opened KV15 for him: 'No work today on account of the Government visitors. They were about forty in number, none of which had any real interest in seeing the tomb further than curiosity. Up to the present no [Egyptian] newspaper correspondents have shown any interest nor demanded any news. The absence of Egyptians among the visitors today was also significant of the pretended interest last year'. (GI/HCjournals)

was the rub. Egyptians – and other populations subject to colonialism – insisted on their modernity, and on the autonomous statehood that went with it. Tutankhamun entered the news when the aftershocks of the First World War were still being felt: in the first weeks after the discovery, it shared headlines with France's occupation of the Rhineland, after Germany defaulted on war reparations; with the Lausanne Conference necessitated by Mustafa Kemal Atatürk's victory in Turkey; and with troubled efforts to draft a constitution for Egypt, following Britain's unilateral granting of limited Egyptian independence in February 1922.[45] On the same February 1923 *Daily Express* front page that lamented 'Tutankhamen Ltd.', the paper ran a 'stop press' reporting that the most recent Egyptian prime minister to resign (Nasim *Pasha*, a loyal Fuad courtier) had blamed British interference for the problems facing the fledgling government. In other words, Egypt modern as well as ancient regularly made the news – but coverage of the Tutankhamun discovery was one area that brought the two together. For *The Times*, Arthur Merton fawningly documented visits to the tomb by English aristocrats, minor royals and significant colonial officials like High Commissioner Allenby, the *Sirdar* Major-General Lee Stack, or Sir John Marshall, head of the antiquities service in India.[46] A single newspaper column could report approvingly visits by George V's equerry Sir Charles Cust and Sir William Garstin, a director of the Suez Canal company and former undersecretary of public works for the British administration in Egypt – yet deride the 'considerable delay' caused by the visits of Hafez Hassan *Pasha*, Under-Secretary in the Ministry of the Interior; Abdel Rahman Rida *Pasha*, procurer general of the Native Courts; and a party of students from the Giza Polytechnic Institute, some of whom carried their own cameras.[47] Some visitors were clearly more welcome at the site than others.

Press coverage rarely related the tomb and its objects to modern Egypt in any historical or cultural terms, excepting occasional references in the mode of Orientalizing or primitive 'survivals' from the distant past. One of Burton's photographs of baskets found in the Antechamber drew comparisons to baskets in use 'today' in Egypt, and the Egyptian workmen's chanting as they backfilled the entrance drew comparison to an unspecified past – reminiscent of the records of workmen's songs that several archaeologists in Egypt had kept.[48] A press photograph of the men and basket-boys carrying out the work

[45] One example: in the prominent top half of the front page of the *Daily Express*, 5 February 1923, headlines included 'Turks refuse to sign', 'Was it pharaoh's protest? Tempest rises as the excavators dig', and 'New French march into Germany'. The initial invasion of the Ruhr valley had taken place on 11 January.

[46] For photographs of these visits, see Riggs, *Tutankhamun: The Original Photographs*, 89–95. On Marshall, see Guha, *The Marshall Albums*.

[47] 'Pharaoh's chariot', *Manchester Guardian*, 5 February 1923: 7, with copy credited courtesy of *The Times*. Some of the Giza students were pictured with other tourists, and a pile of cameras, in *National Geographic Magazine*'s May 1923 issue, which featured a long story on the tomb by Maynard Owen Williams and used Williams' own photography.

[48] Basket: '3,500-year-old treasures after treatment at Luxor', *The Times*, 25 May 1923: 16 ('The basket is similar to those made and used in present-day Egypt'); 'Now at Cairo: Tutankhamen treasures', *Illustrated London News*, 26 May 1923: 914 ('similar in make to those of modern Egypt'). Chanting: 'The closing of Luxor tomb', *The Times*, 28 February 1923: 12 (praising the 'rapidity and industry' of the boys and men who worked 'in a continuous chain for several hours on end to the peculiar sing-song chant without which Eastern labourers seem unable to work'). On the practice of collecting workmen's songs in late nineteenth- and early twentieth-century archaeology in Egypt, see Clément, 'Rethinking "peasant consciousness"'.

described the scene as 'doubtless [. . .] similar to that three thousand years ago when the tomb was excavated'.[49] For the most part, references to modern Egypt and Egyptians were disparaging, especially in the immediate aftermath of Carter's break with the antiquities service in February 1924. *The Egyptian Gazette* report quoted above was not alone in its mockery and scorn: the *New York Times* ran a story sourced from the London *Evening Standard* about an Egyptian official being disappointed to realize that Tutankhamun's outer coffin was gilded wood rather than solid gold. 'Little appreciation of scientific value', ran the sub-head, while the article pointed out that this anecdote illustrated 'the attitude of the average Egyptian toward the archaeological researches' at the tomb.[50]

Instead, other cultures around the world provided comparisons for the ancient Egyptian finds, as journalists sought to characterize the nature and splendour of the objects in Burton's photographs. The painted box (21) so prominent in Burton's first photographs of the Antechamber 'excell[ed] in beauty and minute detail the finest Chinese or Japanese art', according to one picture caption, while the duck heads carved on the legs of a folding stool 'might excite the admiration of the best Japanese craftsmen'.[51] Later in the 1920s, the *Illustrated London News* would compare throw-sticks from the tomb – non-return boomerangs – to 'those of Australian blacks'.[52] But the British press did not need to look to the reaches of empire for apt comparisons. It found plenty at home as well. The first published photographs inside the burial shrines equated them to the Old Testament 'Tabernacle of the Covenant'; the chariots were a state coach such as the King used at openings of Parliament; an alabaster lamp was 'like the three-branched candelabra of the Christian trinity'; Tutankhamen spear-hunting from a skiff was a 'prototype of St George'; and one of the last repaired objects from the Annexe, a folding chair (the 'faldstool', object 351), was compared to an ecclesiastical throne.[53] The goddess Isis became 'the "Madonna" of ancient Egypt' in a *News* headline, under a Burton photograph taken with the goddess's body turned away from the canopic shrine for the purpose (Figure 6.9).[54] This was the exact opposite of how the figure had faced when the shrine was discovered, and to reposition it, the archaeologists had to lift it off the shrine (to which it was fixed by a tenon), turn it around and re-slot the tenon. In the new position, the figure's outstretched

[49] 'Luxor tomb sealed. Dublin outrage. Cambridge at Putney', *The Times*, 9 March 1923: 16. The photograph used is that reproduced in Riggs, *Tutankhamun: The Original Photographs*, 83 (fig. 110).

[50] 'Set fabulous value on pharaoh's tomb', *New York Times*, 2 March 1924: 17.

[51] Box 21: 'Mummified food for the king's "ka": Tutankhamen's "larder"', *Illustrated London News*, 3 February 1923: 169; folding stool (object 83): 'Research at Luxor', *The Times*, 13 February 1923: 12. *The Illustrated London News*, 24 February 1923: 282–3 (a special 'Egypt Number' of the paper), published Burton photographs of these two objects together under the headline 'Tutankhamen treasures: Unsurpassed Egyptian craftsmanship', repeating the comparison to 'Chinese or Japanese decorative art'; GI negs. P0081 and P0353.

[52] 'Tutankhamen's boomerangs – like those of Australian blacks', *Illustrated London News* 12 October 1929: 627.

[53] 'First photographs taken in the shrine of Tutankhamen', *The Times*, 11 January 1924: 14; 'Like the Ark of the Covenant: the pall on Tutankhamen's shrine', *Illustrated London News*, 26 January 1924: 148; 'A pharaoh's "state coach": one of Tutankhamen's chariots', *Illustrated London News*, 12 January 1924: 60; 'Tutankhamen treasures: a sacred goose, lamps, a wine jar', *Illustrated London News*, 27 June 1925: 1292; 'The pharaonic prototype of St. George and the dragon', *Illustrated London News*, 23 April 1927: cover; 'New treasures from Tutankhamen's tomb', *Illustrated London News*, 23 May 1931: 856.

[54] GI neg. P1149, MMA neg. TAA 968.

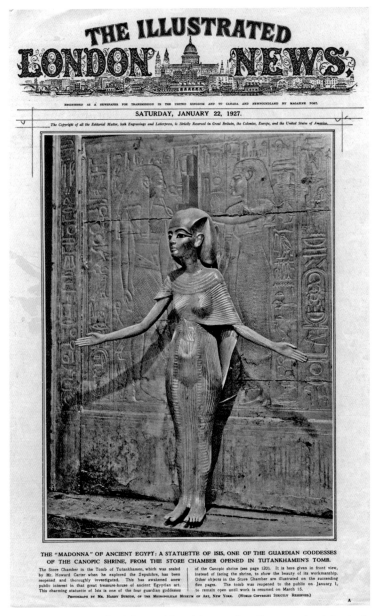

Figure 6.9 Burton's photograph of the goddess Isis guarding the canopic shrine in the Treasury; corresponds either to Griffith Institute Burton neg. 1149 or MMA neg. TAA 968. Cover of *The Illustrated London News,* 22 January 1927, with the subtitle 'The "Madonna" of Ancient Egypt'.

arms did indeed resemble the welcoming embrace of the Virgin Mary, rather than the protecting arms of Isis for the dead. Many of these Christian and contemporary allusions came from Carter himself. In a Royal Institution lecture, he described gold and silver walking sticks as the 'prototype of the Gold-Stick and Silver-Stick in Waiting of our Court of to-day' – but they were entirely in keeping with the tone of contemporaneous journalism, which

revelled in the trappings of imperialism, including militarism.[55] Even the *New York Times* was happy to draw comparisons between General Allenby's First World War campaign 'against the Turks' and the battles of Tutankhamen's own era, 'past and present joined'.[56]

Situated within a familiar cultural landscape of Christian symbols, Venetian gondolas and Queen Anne style, some of the objects found in Tutankhamun's tomb could also be 'modern' – or nearly so, and in a praiseworthy way. Furniture and clothing in particular inspired comparisons to the 'modern', which was in turn borne out by 1920s fashions in clothing and home decor that drew on some ancient Egyptian designs. The *Illustrated London News* again felt compelled to speak of 'prototypes' of modern furniture when publishing one of Burton's photos of a chair from the Antechamber.[57] The same paper described beaded jewellery from the Treasury as modern, too, when it reproduced tinted colour versions of Burton photographs of bracelets and a stole in 1927.[58] By then, however, the argument from a design point of view was circular – ancient Egypt looked 'modern' because to some extent, it had influenced modernist taste. Besides, since 'modern' and 'Western' had been conflated with each other in Euro-American discourse, there was something cozy and comforting in this version of modernity, as even the advertisers of Craven tobacco might concede. Tutankhamun – boy-king, warrior-king, pharaoh – had been made to feel at home.

Just like us

Tutankhamun was tamed by cultural references that located him within an imperial imaginary, with the support of photographs that rendered the tomb paraphernalia legible within an artistic canon indebted to Western traditions, at least for the most materially and visually arresting objects. But another striking aspect of the tomb's public presentation was its emphasis on the imagined personality of its hitherto unknown occupant, in a way that combined tropes of domesticity and masculinity, even as it emphasized the young age at which he died (around eighteen) and even younger age at which he became king (around ten). Nothing in the tomb inspired serious discussion of religious practices in ancient Egypt beyond standard, and rather banal, observations about the god Osiris, mummification, or kingship – despite the rare evidence offered by objects like the shrines with linen-wrapped statuettes, or the clearly purposeful positioning of tomb goods, shrines, statues and model boats, for instance. In fact, Carter – speaking through Merton – likened the tomb and its shrines to a house, a 'domicile' in which the king could live on after death with everything close to hand that 'he possibly might require on emerging from his abode'.[59]

[55] 'Tutankhamen's "Gold-Stick-in-Waiting": evidence of his youth', *Illustrated London News,* 27 June 1925: 1291.
[56] 'Allenby's Egyptian campaign fought on same lines before Tut-ankh-amen', *New York Times,* 25 March 1923: 4.
[57] '"Seats of the mighty" in ancient Egypt: A Tutankhamen chair', *Illustrated London News,* 29 September 1923: 563.
[58] 'Suggesting the modern stole: Tutankhamen's ceremonial scarf', *Illustrated London News,* 16 July 1927: 109; 'Tutankhamen's "modern" wrist-bands', ibid.: 110.
[59] 'The Luxor tomb', *The Times,* 7 January 1924: 12.

Domesticity explained away death, and as many of the tomb goods as possible were presented, in pictures and in words, to conjure vignettes of hearth and home – from a burial site. Ahead of the start of the second season, in September 1923, *The Times* presented a full page of Burton photographs with the headline 'Domestic life in Egypt: a royal wishing-cup'.[60] The coverage followed on from Carter's sell-out lectures in London the same month. Many of the photos of 'domestic life' appeared in the following day's edition of the *Illustrated London News,* including the cedar chair described as 'modern' and a walking stick compared to Charlie Chaplin's, right down to the 'bowler hat' and facial features of the 'Asiatic' prisoner carved into it. Even a wooden snake emblem clothed in linen, which had been found in a shrine in the Antechamber, could be pictured among these 'domestic' items, although no attempt was made to characterize it as droll or quotidian. However, a more elaborate shrine – of wood covered by embossed gold sheets – did fit easily into the domestic narrative, thanks to its scenes of Tutankhamun and his wife, queen Ankhesenamun. Understood today in terms of its visual and verbal plays on sexual intercourse and fertility, at the time of its discovery, the shrine was described as 'an example of naive art', and the depiction of a wife tending to her husband – seen in Burton's side-on photographs of the object – was read as a straightforward depiction of conjugal devotion.[61] This overtly religious artefact, in which several enigmatic objects had been found (including an empty statue plinth), was instead described as follows:

> Delightful little scenes represent homely incidents in the life of the King and Queen, and the atmosphere of affection is apparent. Especial value is attached to these discoveries as illustrating the domestic life of the ancient Egyptians rather than religious beliefs, of which much has already been learned from other Royal tombs.[62]

Nor was the trope of young love, and young widowhood, confined to the first two years of the tomb's discovery: in June 1925, the *Illustrated London News* tinted some monochrome Burton photographs for colour printing, to stunning effect. These were photographs he had taken during the short third season, after Carter had negotiated a return to the site. Time spent at KV15, instead of the tomb itself, allowed Carter to catch up on cataloguing and Burton to play with photographic effects, such as lighting one of the alabaster lamps to recreate how it would have looked when lit in antiquity. This revealed painted decoration sandwiched inside the lamp's double-walled oil well, depicting the queen offering hieroglyphic signs for 'years', hence a long life and reign, to the enthroned king. The caption reduced this to a 'charming picture of the boy-King Tutankhamen and his young bride', while a double-page spread of the outer coffin, also tinted in colour, drew attention to the 'pathetic little wreath' looped around the protective vulture and cobra on its forehead, 'believed to have been placed there by the widowed girl-Queen as a farewell offering'.[63]

[60] *The Times,* 28 September 1923: 14.
[61] See Eaton-Krauss and Graefe, *The Small Golden Shrine.*
[62] 'Domestic life in Egypt: a royal wishing-cup', *The Times,* 28 September 1923: 14.
[63] 'Tutankhamen's palace lamp: Colour brought out by light', *Illustrated London News,* 27 June 1925: 1293; 'The golden coffin of the boy-king Tutankhamen', ibid.: 1294–5.

The familial connections of Tutankhamun extended back in time beyond his consort, who was known to be the daughter of the previous king, Akhenaten, and queen Nefertiti. Tutankhamun's own parentage was a mystery, but objects in the tomb that evoked his childhood or family heritage were also presented, with photographs, to fill out the bare bones of his biographic details. A scarf found in the painted box (object 21) in the Antechamber was dubbed a 'hood and tippet', the latter word in use at the time for women's fur stoles or the stoles worn by clergymen (Figure 6.10). Its small dimensions were, by some logic, 'evidence of a pharaoh's age', and the press speculated that the garment had been used to swaddle Tutankhamun in infancy.[64] The photographs spoke – almost literally, thanks to the captions sent with them through the post – and what they told was a plangent story of the king's youth, followed so closely by his death. A linen glove found in the same box as the 'tippet' caused excitement both for its small size and

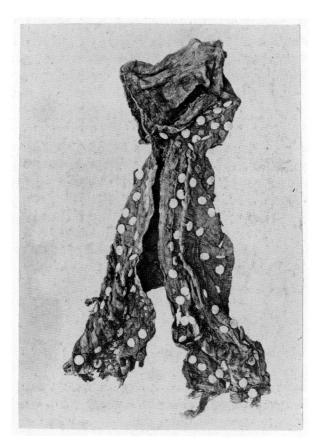

Figure 6.10 The 'hood and tippet' (linen textile with spangles, object 21cc), found in box 21 in the Antechamber. Print corresponds either to Griffith Institute Burton neg. P0394 or MMA neg. TAA 808.

[64] Object 21cc, illustrated by GI neg. P0394: 'Egyptian craftsmanship: The pharaoh's golden sandal', *The Times*, 23 February 1923: 16; likewise, 'Tutankhamen treasures: The earliest glove; children's clothes', *Illustrated London News*, 24 February 1923: 281.

because it was the first glove archaeologists had ever found from ancient Egypt. As the *Illustrated London News* put it:

> A note supplied with the photograph says: 'This glove is made of the finest linen fabric, and is unique, not only as a memento of the king's youth, but as the first ancient Egyptian glove ever discovered. Thus it is the oldest specimen known of its kind, and opens up quite new ideas as to the civilisation of the period. From this interesting relic, together with other unique clothing found bundled into the casket, it is evident that royal children cannot have been nude, as they are commonly shown in the mural decorations of ancient monuments'.[65]

To the *New York Times,* the 'child's glove suggests a mother's care for youngster', and the paper also fancied that a slipper found in the casket 'belonged to some Cinderella of the long ago'.[66] Fairytales were woven, like fine linen, between what were often quite detailed explanations of the materials, workmanship and significance of the finds. Anyone who followed the story in print, and especially in photographs, became familiar with the biographies and personalities not only of the scientists involved, but of the long-dead adolescent at the centre of it all.

The objects, too, took on personal traits, their forms rendered familiar thanks to Burton's photographs or, in the first season, the impressions that viewers gained from snapshots of the porters carrying artefacts out of the tomb on trays. Media coverage was less intensive and frequent in later seasons, to be sure, but the illustrated press maintained an interest in the find – and an interest in the domestic angle on Tutankhamun's life. Newspapers cropped Burton's photographs close in to objects like boxes, tables and head-rests, and described their materials and workmanship in detail, as well as their presumed functions in a home, rather than the tomb.[67] Where something personal or biographical could be ascribed to the objects, that became the focus. Speaking to his preferred outlet the *Illustrated London News* in 1929, Carter described boxes from the Annex as 'interesting mementoes of the King's youth', comparing them to panniers. Perhaps it was their small size – both fit side-by-side in front of Burton's curved paper backdrop – that suggested childhood to Carter. Certainly, the small dimensions of a white-painted wooden chair and footstool, also from the Annex, indicated that they had been designed and made for a child. But which child, and why they were deposited in a burial, was of less concern than the headline that they were from the 'Royal Nursery'.[68] The childlike appeal of the boy-king, and of ancient Egypt more generally, made it a popular subject in children's newspapers, too. In 1925, the American magazine *The Companion for All the Family* ran a story by Egyptologist Caroline Ransom Williams, using photographs of boxes and furniture from the same era as Tutankhamun's to illustrate an account that made ancient Egyptians sound like characters from a Sinclair Lewis novel:

[65] As above (n. 59), from the *Illustrated London News.*

[66] 'Tomb has given up rarest of old art', *New York Times,* 18 March 1923: 4.

[67] 'New Tutankhamen relics: head-rests; "shirt box"; linen-chests', *Illustrated London News,* 6 July 1929: 14.

[68] 'From Tutankhamen's nursery: A high-backed chair and stool', *Illustrated London News,* 20 July 1929: 119.

they ate three meals a day and 'had commodious armchairs with backs into which the body fitted comfortably' – though alas, no rocking chairs.[69]

Domestic or not in their ancient context, the objects from the tomb, its chambers, the coffins and mummy, in a word, Tutankhamun himself, all became domestic in a modern context by virtue of the way images of them circulated outside of the press. Burton's and others' photographs were not limited to the printed pages of newspapers and magazines. Newsreels and lantern slide lectures brought them to audiences around the world, and as we have seen, the Metropolitan Museum of Art displayed Burton images in its galleries, taking advantage of increased interest in ancient Egypt. But the photographs could also be purchased as postcards or collectors' cards, which were the same format and dimensions. The *Illustrated London News* sold collectable packs in the early 1930s, all based on Burton photographs (Figure 6.11). Printed on good quality, coated paper stock,

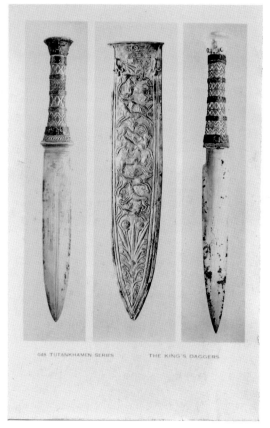

048 TUTANKHAMEN SERIES THE KING'S DAGGERS

Figure 6.11 A Bruce Company postcard from the 1930s, based on photographs by Harry Burton of the daggers found on the mummy of Tutankhamun. The corresponding negatives may be GI neg. P0872, P0873 and P0870; Burton took several exposures of these objects.

[69] Ransom Williams (Mrs. Grant Williams), 'Egyptian life in the time of Tutenkhamon', *The Companion for All the Family,* 8 January 1925: 22–3.

and numbered so as to encourage the acquisition of multiple sets, each packet of these 'real photographic postcards' contained twelve cards, at three shillings plus postage in the UK; shipping to 'British possessions', the US and overseas was also available. The full set of sixty could also be bought outright, for ten or fifteen shillings – a small price for items that were marketed as 'essentially works of art' in themselves, the images having been chosen 'under expert supervision'.[70]

In the 1920s and 1930s, tourism to Egypt – boosted immediately after the 1922 discovery – continued to thrive, with Tutankhamun-themed postcards available through a number of outlets, often adapted from Burton photographs without any credit or licensing arrangement. At Luxor, firms like Gaddis & Seif sold such cards, while in Cairo, the established firm of Lehnert & Landrock dominated the market.[71] The photographs that tourists, journalists and enterprising photographers had taken of porterage during the excavation also found a market as postcards. One series, apparently sold during the 1920s, had printed on the front of the postcard image a series title, 'The Exploitation of Tutankhamen's Tomb' – a telling linguistic slip for 'exploration', perhaps (Figure 6.12).

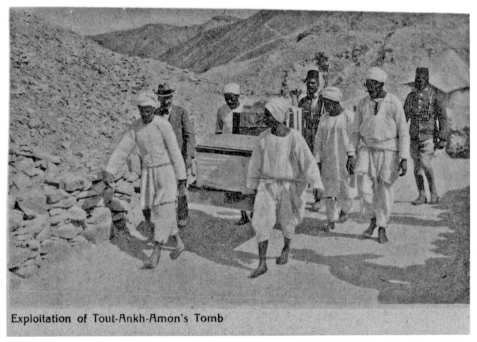

Exploitation of Tout-Ankh-Amon's Tomb

Figure 6.12 Postcard from a series entitled 'Exploitation of Tout-ankh-amon's tomb', based on press or tourist snapshots taken in early 1923. From the archive of Alexandre Varille, copyright Biblioteca e Archivi di Egittologia, Università degli Studi, Milan.

[70] An advertisement appeared to this effect, with sets at ten shillings, in the *Illustrated London News,* 29 March 1930: 540. The following year, the same paper advertised complete sets of 'real photographic postcards' at the higher price of fifteen shillings almost every week between 30 May 1931: 938 and 29 August 1931: 3.

[71] For the firm's history, see Geraci, 'Lehnert & Landrock of North African'. The company still trades today, through its Cairo bookshop.

From stereoscope views to children's newspapers to cigarette cards, protean images of king Tut filtered into the most commonplace areas of interwar life, turning photographs of iconic objects and 'discovery' into consumable commodities. A popular form of advertising for tobacco companies since the late nineteenth century, cigarette cards were issued in collectable packs, in multiples of ten or a dozen; the stiffened board was integral to the packaging, with an image on one side and a descriptive caption, plus company identification, on the other.[72] Some subjects were suitable for children, for instance illustrating the letters of the alphabet, and some, like garden flowers, might be construed as female-oriented, but many were targeted to male consumers, with sporting heroes or 'famous beauties' as a theme. Collecting many themed series of cards – 'Flags of the Empire' or 'Celebrated Bridges' – inevitably meant collecting those parts of the world envisioned as areas under the dominion of empire. Although cigarette cards often relied on illustrations, these were based closely on photographs, and cards could also be printed directly with photographs, too. A Sarony Cigarettes series from the late 1920s, called 'National Types of Beauty', used 'thirty-six actual photographs' of attractive and youthful women: Egypt was no. 17, depicting 'the beautiful Egyptian of the better classes'.

In 1926, British firm Wills' Cigarettes issued a fifty-strong set called 'Wonders of the Past', two of which used coloured drawings based on well-known Burton photographs: the right-hand guardian statue (object 22) and the hippo-headed couch (object 137), from the first season's work (Figure 6.13). Into the 1930s, the tomb of Tutankhamun was still memorable enough to warrant inclusion in sets of cigarette cards.[73] Churchman's Cigarettes issued at least three Tutankhamun-themed cards, as part of its 1935 'Treasure Trove' series and perhaps a subsequent series as well (Figure 6.14). All are illustrations based on press images from more than a decade earlier. There was Amédée Forestier's imagined view of the discovery, 'The First Inspection' that no camera ever caught. There were the guardian statues, forever standing either side of the sealed-up burial chamber – just as they had been in one of the first of the 3,000-odd photographs Burton would take. And there were Carter and his unnamed Egyptian colleague, holding still for the camera in 1925 with their tools poised over the solid gold inner coffin, its gleam still part-obscured by resin. When Tutankhamun could fit so neatly into a pocketbook or cigarette case, it mattered less where the artefacts had wound up, or who owned the copyright to Burton's photographs. Thanks to photography, Tutankhamun was everywhere, and everyone's.

Resin and ritual had not given Tutankhamun his long afterlife: he owed it instead to the artist's pencil, the camera lens and the printing press that made images like the ones we have seen in this chapter so cheap, memorable and portable. The visual impact of the print media, together with the narratives woven around the discovery, meant that European and American audiences formed a particular communal memory of the boy-king – one which

[72] The New York Public Library has a useful resource based on its holdings of the genre: https://digitalcollections.nypl.org/collections/cigarette-cards.

[73] See Collins and McNamara, *Discovering Tutankhamun,* 76.

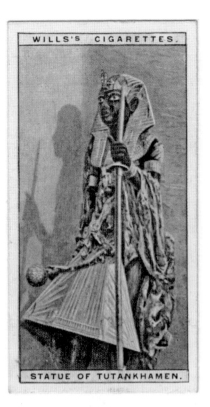
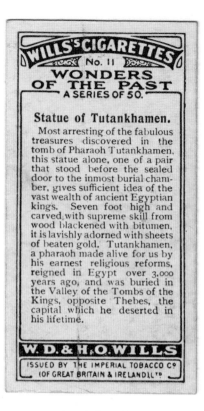
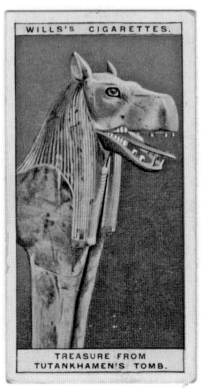
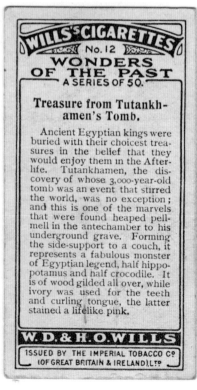

Figure 6.13 Wills' cigarette cards from the 'Wonders of the Past' series, 1920s date. The illustrations are based on Burton photographs of statue 22 and the hippo-headed couch (object 137).

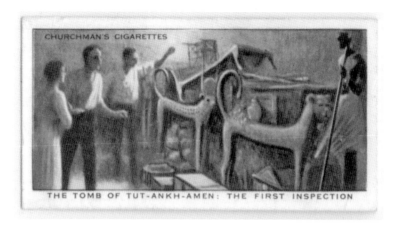

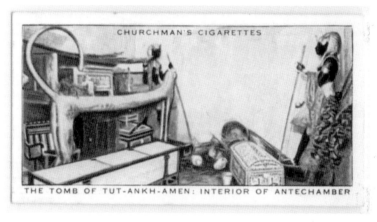

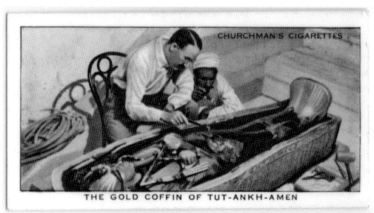

Figure 6.14 Churchman's cigarette cards from the 1930s, based (top to bottom) on Forestier's 1923 drawing of the discovery, a Burton photograph of the Antechamber (such as GI neg. P0007), and Burton's 1925 photograph of Carter and a *ra'is* working on the innermost coffin (GI neg. P0770).

created a personality for him alongside that of his credited discoverer, Howard Carter. Carter's books on the tomb continued to sell well, into the 1930s. The third volume, which appeared in 1933, 'apparently had quite a good sale', according to Burton – who added, 'but I've seen none of the proceeds', well aware by then of the impact his photographs had had on public consumption of the tomb.[74] International press, but particularly the British press, followed Carter's progress at the tomb to the very end. The re-erection of the shrines in the antiquities museum in Cairo took up several pages of the *Illustrated London News* in January 1933, using the photographs Burton had taken a few weeks before (see Figure 1.7).[75] Even with the excavation complete, Tutankhamun remained newsworthy. For example, for the silver jubilee of King George V in 1935, the *News* commemorated the discovery of the tomb as one of the highlights of his reign, in a colour supplement based on a profile photograph Burton had taken of the mask in December 1925.[76] Perhaps the mask in left-facing profile recalled the royal profile used on British postage stamps. Either way, in Great Britain, Tutankhamun represented two kinds of royalty: his own, and the British monarchy, in which the entire identity of empire was vested.

The press closely followed details of craftsmanship, materials and function as the tomb objects emerged from restoration – and appeared in Burton's photographs. They also followed debates about their ownership, with regular, if brief, news bulletins throughout the 1920s revisiting the question of whether any 'duplicate' objects would find homes in England or New York.[77] In the end, however, the destination of the physical objects hardly mattered, for the steady flow of photographs and news stories meant that British and American audiences already 'owned' Tutankhamun in their imaginations. Egyptian views did not enter into this picture, for only ancient, not contemporary, Egyptians mattered. Antiquity was not the opposite of modernity in this discourse but a crucial part of it, because being 'modern' meant being able to control, understand and appreciate the remains of the distant past. This was an illusion, but an endemic and persuasive one, as Sigmund Kracauer observed of the illustrated press of the time:

> In the illustrated publications, the public sees the world, the perception of which is hindered by these very publications. [. . .] There has never been a time that has known so little about itself. In the hands of ruling society, the institution of the illustrated magazines is one of the most powerful weapons in the struggle against knowledge.[78]

[74] Letter from Burton to Winlock, 27 March 1934 (MMA/HB: 1930–5).

[75] 'The wonders of the Tutankhamen shrines revealed', *Illustrated London News,* 7 January 1933: front page and pp. 3–5.

[76] *Illustrated London News,* 17 April 1935, supplement colour pl. XIII ('The most complete archaeological discovery of the reign').

[77] For example, 'Carter sets out tomorrow to reopen tomb', *New York Times,* 14 January 1925: 1, reporting that his new arrangement with the antiquities service still allowed the possibility of duplicates (a similar report ran in the London *Times* the same day). As late as 1931, the British Museum made a request through the British High Commissioner to Egypt, asking the Egyptian government to give it first refusal of any duplicates from the tomb that it decided to release and send abroad: 'Tutankhamen: New exhibits in Cairo Museum', *The Times,* 27 May 1931: 11.

[78] Kracauer, *The Past's Threshold,* 39 ('Photography', originally published in the *Frankfurter Zeitung,* 28 October 1927).

The quantity of photographs taken, the way they were juxtaposed and disseminated in multiples on the printed page, and the disruption caused by this quality of easy, endless reproduction to a sense of human time: these, Kracauer thought, were neutralizing history and creating a popular culture detached from deeper forms of memory, knowledge and critique. What looked like appreciation for the past, or art and science, or other people and places, was in fact shallow and inward-looking.

By tapping into an array of cultural, royal and Judeo-Christian comparisons to present the finds to readers, the print media mapped the tomb onto an imperial worldview in which Britain and Europe were modern and the rest of the world was not. Through the mouthpiece of the *Illustrated London News* and *The Times,* in particular, Carter's own presentation of the tomb created twin narratives, one emphasizing Western scientific rigour, the other the boyishness, domestic life and regal pageantry of Tutankhamun – the now-familiar 'boy-king' or, in popular culture (never in Carter's own words), 'King Tut'. Seeing a newsreel, reading a news magazine, writing or receiving a postcard, and buying or trading cigarette cards: these acts helped cement a visual memory of Tutankhamun and create a collective one, perhaps all the more potent for being tinged with a certain nostalgia for the fading glories of expansionism and discovery. Discovered as Europe and the Middle East emerged from one world war, Tutankhamun would sink back into a certain obscurity in the course of a second war, but the memories – and Burton's photographs – were only dormant, awaiting rediscovery. Sounded live from Cairo for the BBC in April 1939, a month after Carter's death, Tutankhamun's military trumpets fell silent until they were needed once again.[79]

[79] 'To be heard on the wireless: Tutankhamen's 3000-year-old trumpets in a unique musical broadcast', *Illustrated London News,* 15 April 1939: 633. Alfred Lucas gave a brief talk preceding the trumpet blows. The moment was recalled twice in the pages of the weekly BBC magazine *The Listener,* first in 1946 ('Did You Hear That?', 19 December 1946: 875+) and again during the British Museum *Treasures of Tutankhamun* exhibition, by the trumpeter: Rex Keating, 'Blowing Tutankhamun's Trumpet', 13 April 1972: 479.

7

THE LOOKING-GLASS: EGYPTOLOGY'S ARCHIVAL AFTERLIVES

The Churchman's cigarette card of Howard Carter and a *ra'is* posed 'at work' on Tutankhamun's coffin turned into bright colour one of the photographs Harry Burton had taken in advance of the mummy unwrapping in 1925 (Figure 7.1).

Published in an issue of the *Illustrated London News,* with other coverage of the coffins, mask and mummy, there was something about the contrast, clear focus and composition of this image that made it memorable – but only with time, and through modes of circulation other than the various popular or academic books produced about the tomb for most of the twentieth century.[1] The photograph was not among those Carter included in his own books in the 1920s and 1930s, although he had kept the large-format negative at his Luxor home, with a copy negative among his London files.[2] Nor did Jean Capart or Penelope Fox use it in their books in the 1940s and 1950s, both of which included object photographs rather than 'working' shots.[3] When French Egyptologist Christiane Desroches-Noblecourt published a best-selling book about Tutankhamun, preparatory to the exhibition *Toutankhamon et son temps* that she organized in Paris in 1967, she used several Burton photographs as illustrations, as did the popular archaeology writer Leonard Cottrell in his Tutankhamun book, published the same decade – but none of these included the shot of Carter and the *ra'is* at the coffin.[4] The 1972 British Museum exhibition *Treasures of Tutankhamun* did not include the photograph in its catalogue, written by curator I.E.S. Edwards; neither did contributors to the American version of the catalogue, when the 'blockbuster' toured the United States between 1976 and 1979.[5]

Yet the photograph did find its way into a collective visual memory of the tomb of Tutankhamun – and of the act of archaeological discovery that has been coded so

[1] 'Tutankhamen's third coffin – of solid gold: The uncovering', *Illustrated London News,* 6 February 1926: 232.

[2] The 18 × 24 cm negative (now TAA 1354) was among those sent to New York in 1948 when Charles Wilkinson cleared Carter's house. Carter's half-plate glass copy, GI neg. P0770 (here, Figure 7.1), was already in the Griffith Institute when Fox compiled her guide in 1951; hence it must have been in London before his death.

[3] E.g. Carter, *The Tomb of Tut.Ankh.Amen,* vol. II, which includes other photographs of him, Callender and the *ru'asa* in the tomb, and compare Capart, *Tout-ankh-amon;* Fox, *Tutankhamun's Treasures.*

[4] Desroches-Noblecourt, *Tutankhamen;* Desroches-Noblecourt, *Toutankhamon et son temps;* and Cottrell, *The Secrets of Tutankhamen.*

[5] See I.E.S. Edwards, *Treasures of Tutankhamun;* Gilbert (ed.), *Treasures of Tutankhamun.*

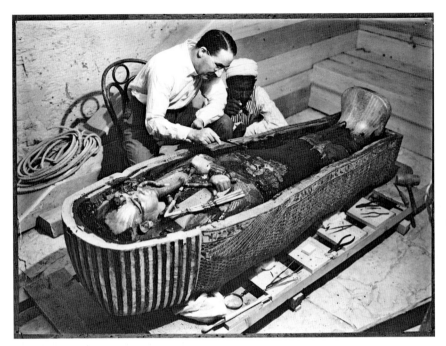

Figure 7.1 Carter and an unnamed *ra'is* posed at work on the innermost coffin. Original photograph by Harry Burton, 25 October 1925; GI neg. P0770, glass 12 × 16 cm copy negative, perhaps dating to the 1920s or 1930s.

relentlessly and thoroughly as a prerogative of Western masculinity. Other means of circulation, like the cigarette card, may help explain the photograph's current popularity. Certainly, since the 1990s, it has been included as routine in books, journalism or online features about Carter and Tutankhamun.[6] During the writing of this book between 2015 and 2017, it was consistently one of the top two or three returns in Google image searches for 'Carter Tutankhamun', and the first in a sub-category of 'Tomb' that the search engine automatically generated for that search or for the single search term 'Tutankhamun'. The neat triangle made by the coffin and the mirrored bodies of the two men may be part of the image's appeal, but so too are its apparent immediacy and its adaptability: I have spotted at least three mock-ups of the photograph in museum and archive 'back rooms', each of which imposed an image of another person's face (a volunteer or staff member, a visiting media personality) over the face of the Egyptian man. Carter's own face is never covered. In 2016, the drama serial 'Tutankhamun', made for ITV television in the UK, took this trope even further: it eliminated the *ra'is* altogether from publicity photographs directly

[6] E.g. Allen, *Tutankhamen's Tomb,* 56 (fig. 44; caption: 'Carter examines the innermost gold coffin'); Collins and McNamara, 101 (digital colourization; caption 'Howard Carter and an Egyptian assistant inspect Tutankhamun's innermost coffin'); Reeves, *Complete Tutankhamun,* 109 (caption: 'Carter patiently chips away at the hardened black unguents poured liberally over the innermost, gold coffin').

inspired by Burton's 1925 original.[7] In these photos, and the corresponding scene in the production, actor Max Irons portrays Howard Carter working in solitude at the coffin, the angle of his body and the frozen action of his hand copied almost exactly from the historic image – apart from the missing Egyptian. The erasure was in keeping with the arc of the drama, which presented Carter as a hot-blooded heterosexual hero, and anyone wearing a *tarbush* as an enemy of science. Instead of the white-bearded French gentleman that he was, 'Pierre Lacau' appeared with dark hair and moustache, his appearance and accented English (he was played by French actor Nicolas Beaucaire) doing little to distinguish him from *tarbush*-wearing 'Orientals' in the background.

This concluding chapter considers the history and legacy of the Tutankhamun photographic archive from the late twentieth century to the present day. Formed under late colonialism in Egypt, the archive and its images had a public face crafted amid the ideals and idylls of imperialism. But even when the photographs slipped from public view and academic interest, the archive itself – and its colonial categorizations of knowledge and values – continued to work within and upon the field of Egyptology. It was tended by the successors of Penelope Fox and Nora Scott, worked on by photography technicians and museum conservators, and preserved as a memory of a 'golden age' in Egyptology.[8] Any risk of obscurity for Tutankhamun disappeared forever in the 1960s and 1970s, when first Desroches-Noblecourt and then Edwards negotiated at the highest levels of their own and successive Egyptian governments to organize loans of Tutankhamun objects from Cairo to Europe. The boy-king's second resurrection tellingly coincided with global capitalism's encroachment on the pan-Arab socialism of Nasser's Egypt, shortly before and after his death – and meant that Burton's photographs were resuscitated for new publicity purposes and political ends. How the photographs were used in the Tutankhamun exhibitions is the focus of the first section of this chapter, considering in particular the British and American *Treasures of Tutankhamun* shows of the 1970s, which saturated public discourse with the gold and glory of Egyptology. The chapter then examines the impact the exhibitions had on the archives themselves, continuing the micro-history of the Griffith Institute archive in order to trace larger trends in academic Egyptology, as it became aware of the public appeal its own past held. Finally, I weigh up some of the multiple versions and alternative archives in which historic photographs of the Tutankhamun excavation now circulate. From digital reconstructions of the tomb, to the Ramesseum rest house on the road to the Valley of the Kings, the photographs offer a looking-glass into which many people peer, as if from habit – but absent a history of the photographs themselves, all these images can reflect are shadows of a colonial past.

[7] See the last page of the press pack, available for download at http://www.itv.com/presscentre/press-packs/tutankhamun. The publicity photo was used in several major UK print and online publications when the series aired, including the *Radio Times* (http://www.radiotimes.com/news/2016-11-23/the-real-story-behind-the-curse-of-tutankhamun), *The Spectator* (https://www.spectator.co.uk/2016/10/distinctly-corny-itvs-tutankhamun-reviewed/) and *The Times* (https://www.thetimes.co.uk/article/lost-in-lust-itv-misses-the-real-pharaohs-curse–0qqqnm2dp).

[8] Reid, 'Remembering and forgetting Tutankhamun'; Reid, *Contesting Antiquity,* 51–79.

Touring Tutankhamun

An entire book (or more) deserves to be written about the series of loan exhibitions that saw objects from the tomb of Tutankhamun leave Egypt to tour Europe, North America, the Soviet Union and Japan in the 1960s and 1970s. Here, I limit myself primarily to observations about the role that the excavation archives and, in particular, the photographs played in staging these events and repackaging Tutankhamun for late twentieth century consumption. I focus on the 1972 British Museum exhibition and the multi-venue version that toured the United States between 1976 and 1979, since these made use of the respective Oxford and New York archives and in many ways continued the 'official' narrative that Howard Carter had presented half a century before. The background to these two related, but distinct, *Treasures* exhibitions is important to consider as well, in order to understand the political context in which objects from the tomb continued to move – and the ways in which photographs, old and new, accompanied them.

Befitting its dominance in the post-war era, the United States was the first country to which objects from the tomb travelled, as part of an exhibition called *Tutankhamun Treasures* that premiered at the Smithsonian Institution in Washington, D.C. in 1961 and criss-crossed the country, visiting regional museums.[9] Only a small number of small-scale antiquities were included in the show, which then formed part of the United Arab Republic of Egypt's pavilion at the World's Fair in New York in 1964 – a pavilion dominated by news of the Aswan High Dam construction and the UNESCO campaign to relocate the temples of Abu Simbel.[10] The tour represented a tentative Egyptian effort to foster ties with the United States, balancing American interests with the Soviet cooperation that President Nasser also pursued. After it left the US, the show stopped at the Royal Ontario Museum in Toronto, while an enlarged version travelled to Japan in 1965–6.

The UNESCO salvage campaign for the Nubian temples, including Abu Simbel, had been spearheaded by the Egyptian Minister of Culture Sarkat Okasha (a close ally of Nasser), with the assistance and advocacy of Christiane Desroches-Noblecourt. A rare, and often sidelined, woman in French Egyptology, Desroches-Noblecourt had been working in Cairo for a project sponsored by France's foreign ministry – a photographic survey of the temples, carried out under the rubric of an institution called the Centre for Documentation of Scientific Research. She thus enjoyed good relations with the Egyptian authorities as well as an entrée with the French government; UNESCO itself was headquartered in Paris. The reward for France's efforts on behalf of the UNESCO campaign was a much larger loan of Tutankhamun objects, approved by Okasha and Nasser himself – and including the famed mummy mask, which left Egypt for the first time.

[9] See http://www.nywf64.com/uar01.shtml, for an excerpt from the World's Fair Official Guidebook entry on the U.A.R. of Egypt pavilion; *Tutankhamun Treasures* was a guide to the 1961 Smithsonian exhibition. Reeves, *The Complete Tutankhamun,* 212–3, lists dates and tour venues from 1961 to 1981. I thank Will Carruthers for discussing the 1960s context of these loans with me.

[10] On the Nubian temple campaign, see Carruthers, 'Grounding ideologies'; Allais, 'Integrities'.

It was a prominent part of Desroches-Noblecourt's exhibition *Toutankhamun et son temps,* which enjoyed a run of almost seven months at the Petit Palais, from February to September 1967, and attracted more than 1.2 million visitors. The triumphant show was a fitting peak for Desroches-Noblecourt's long career: she credited the discovery of the tomb in the 1920s – and its coverage in the French press – with sparking her girlhood interest in ancient Egypt.[11]

In preparing the Paris exhibition, Desroches-Noblecourt made use of the excavation archives in Oxford, where she was also able to consult Alan Gardiner before his death in 1963 – the end of the living memory of the British and American team.[12] Her own book on Tutankhamun, translated into English, appeared before the Petit Palais show and was reprinted several times. Apart from one press photograph from *The Times,* the book drew on the Griffith Institute's holdings for the rest of its monochrome photographs of the tomb and its objects. These were often edited to help them fit into the book's small format, both by cropping closely to the image and by erasing the background, so that objects like chest 32 or the folding bed 586 'floated' against the white of the page.[13] Close cropping was also used to print one of Burton's previously unpublished photographs of the mummy's head, reducing how much of the wooden plinth was in shot – while retouching erased the brush handle propping up the base of the skull (compare Figure 4.14), so that the head also appeared almost to hover in space.[14] On the opposite page from this image, Desroches-Noblecourt used another unpublished photograph of the head, at the stage of unwrapping when a double twist of linen still wreathed the forehead and flakes of crumbled textile were strewn on the supporting pillow.[15] A caption treated the unmasking and unwrapping of the head as if it were the reverse: 'The head of the mummy ready for the funerary mask', read the English caption, encouraging readers to view the photograph through the eyes of ancient embalming priests.[16]

A highlight of Desroches-Noblecourt's book was new photography of the Tutankhamun objects taken specifically for the purpose in the Egyptian Museum in Cairo – the first colour photographs made since Burton's Autochromes more than forty years earlier.[17] They were taken by leading art photographer F.L. (Frederick Leslie) Kenett, a refugee from Nazi Germany who settled in Britain and became known for his photography of sculpture

[11] This and other biographical details were recounted in her obituaries, e.g. Romero, 'La mort de Christiane Desroches-Noblecourt', *Le Figaro,* 24 June 2011; [unsigned], 'Christiane Desroches-Noblecourt, première femme égyptologue, est morte', *Le Monde,* 24 June 2011; and [unsigned], 'Christiane Desroches Noblecourt', *The Daily Telegraph,* 1 July 2011.

[12] See Desroches-Noblecourt, *Tutankhamen,* vi (acknowledgements).

[13] E.g. Desroches-Noblecourt, *Tutankhamen,* 137 (figs. 82–3), 138 (fig. 84).

[14] Ibid., 164 (fig. 101).

[15] MMA neg. TAA 1248, for which a film copy negative (P0792A) exists in the Griffith Institute, perhaps dating to the 1950s and thus available to Desroches-Noblecourt in her Oxford-based research.

[16] Ibid., 165 (fig. 104).

[17] Ibid., vi (acknowledgements). For the Petit Palais catalogue, different colour photographs (uncredited) were reproduced, with new monochrome photographs supplied by Mohammed Fathy Ibrahim, chief photographer for the Centre for Documentation. They are a mixture of whole-object and close-up photographs, either with a grey or black background, or against textured cloth: see Desroches-Noblecourt, ed., *Toutankhamon et son temps,* e.g. 94–7 (cat. 19, dagger 256k), 124–7 (cat. 26, chest 32).

in particular. Desroches-Noblecourt's British publisher, George Rainbird, commissioned Kenett for the task.[18] A temporary photographic studio was set up in the museum's Tutankhamun galleries for the purpose, and thirty-two of Kenett's new photographs appeared in colour plate sections. The subjects chosen for colour photography, the angle to the camera at which they were photographed, and the level of the camera lens in relation to the object, often create striking echoes of the photographic choices Burton himself had made – no doubt because of certain features of the objects, as they suggested themselves to both Burton and Kennet, but also at least in part because of the influence of the Burton images. Not only had the Burton photographs been published in news media and books, as we have seen, but they had been circulating in the Egyptian tourist industry and the museum itself for decades, as postcards that reproduced monochrome or colour-tinted versions of uncredited Burton prints. Conscious or otherwise, the influence of these earlier photographs on Kenett's own images seems clear in the colour close-ups of the 'Asiatic' figure on a walking stick (object 50uu), the angle and framing of the alabaster perfume container in the form of a boat (object 578) and the isolation of the lion and hippo heads from two of the funerary couches, so memorably captured by Burton in the first season (compare the hippo-head cigarette card, Figure 6.13).[19]

Burton's photographs would feature more prominently in Britain's riposte to the Paris show: the *Treasures of Tutankhamun* exhibition held at the British Museum in 1972, marking the fiftieth anniversary of the discovery of the tomb and signalling the repair of Egyptian and British relations, which had been severely damaged by the 1956 Suez crisis. According to the British Museum curator responsible for *Treasures,* I.E.S. Edwards, he first made contact with Sarwat Okasha in London in 1966 and tried, but failed, to arrange for the Petit Palais exhibition to travel to England. Another opportunity to bring the Tutankhamun objects to London almost materialized in 1967, through the efforts of *The Times* editor-in-chief, Denis Hamilton. Hamilton had met Nasser in Egypt during commemorations for the Battle of Alamein. He claimed that although Nasser admitted having rejected Edwards' initial request, he was willing to reconsider it if *The Times* sent its best-known photographer, Lord Snowdon (then married to Princess Margaret), to Cairo to take publicity photographs. The Six-Day War of 1967 made this politically unfeasible. Finally, in 1969, Edwards and Okasha met again in London and agreed on the 1972 anniversary as an occasion for a major exhibition. Egypt hoped to receive proceeds from the exhibition to support the UNESCO-backed salvage projects, which may have helped Okasha gain the approval of Gamal ed-Din Mukhtar, the head of the Egyptian Antiquities Organization, and President Nasser. President Anwar Sadat continued this support after Nasser's death in 1970. On the British side, the Foreign Office lent a hand to the British Museum at every stage, while the office of the Prime Minister was kept informed

[18] I.E.S. Edwards, *From the Pyramids to Tutankhamun,* 282 describes Rainbird's role in Kenett's commissioning. For Kenett (né Cohen), see the brief biography at http://londonphotographicassociation.blogspot.co.uk/2012/10/photographer-sculptor-frederick-leslie.html, with a bibliography of this works. The Griffith Institute in Oxford holds prints of his Cairo Museum photographs.

[19] Respectively, Desroches-Noblecourt, *Tutankhamen,* colour plate x (compare Gi neg. P0340); xv (printed in reverse; compare GI neg. P1258); and xxvi–xxvii (compare GI negs. P0512, P0512A; GI neg. P0166).

of developments and progress.[20] It helped that the then-chair of the British Museum trustees was Lord Trevelyan, a former British ambassador to Egypt. *The Times* played its part too, sponsoring the exhibition, providing advertising and lending staff to relevant committees at the British Museum. Denis Hamilton was made a Trustee of the Museum (and later knighted) in recognition of his contribution – an arrangement Edwards found dubious but had to accept.[21]

The *Treasures of Tutankhamun* exhibition was a diplomatic exercise as much as a public celebration of ancient Egyptian art and British Egyptology. But British Egyptology did figure prominently, and in a flattering light: Edwards retold the tale of the tomb's discovery and clearance without making any mention of the 1920s political controversy or Carter's dispute with the Egyptian authorities. This sanitized version may have suited both British and Egyptian sensitivities at the time. Edwards also had to respect the opinions of the Egyptian authorities about which objects could travel, not only for conservation reasons but for concerns about how Egypt – and Nubia – were being represented abroad. A walking stick carved with a bound African prisoner (one of four objects 48a–d) was withdrawn from the loan at Egypt's request, Edwards wrote, because it 'offended the susceptibilities of some present-day Egyptians'.[22] Those 'susceptibilities' may have been about representations of race in general – or representations of Nubia in particular, given the internal discord caused by the forced removal of Nubian populations as a result of the Aswan dam project. Edwards does not mention any other restrictions placed on the loans, apart from concerns about conservation and packing. Fortunately for the British Museum, conservation approval involved another British connection to the 1920s excavation: H.J. Prenderleith, who had briefly advised Carter on material at the tomb, had gone on to head the conservation department at the British Museum, and during the negotiation of the *Treasures* loan was director of UNESCO's centre for conservation (ICCROM).[23] Unlike the Petit Palais show, which incorporated other objects from Cairo related to Tutankhamun's reign, the British Museum exhibition featured only objects from the tomb itself. This was an exhibition more strictly focused on the king's burial goods – and on the British role in finding them.

Treasures in the archive

To present the story of the tomb's discovery, Edwards arranged for the British Museum to borrow documents from the archives of the Griffith Institute and the Metropolitan Museum

[20] Edwards' autobiographical account (*From the Pyramids to Tutankhamun*, esp. 247–65) obviously represents his own views and recollections, but is valuable for the perspective it gives on such organizational matters – and is supported by extensive records kept in the archives of the British Museum's Department of Ancient Egypt and Sudan. See also his introductory remarks and expressions of thanks, in I.E.S. Edwards, *Treasures of Tutankhamun*, 10–11.

[21] Edwards, I.E.S. *From the Pyramids to Tutankhamun*, 266, 297. Philip Taverner, *The Times'* marketing director, was also pressed into service on British Museum organizing committees: see his obituary [unsigned], *The Times*, 4 March 2016, and Edwards' exhibition catalogue acknowledgements, cited above.

[22] Ibid., 264.

[23] Ibid., 263–4, 269.

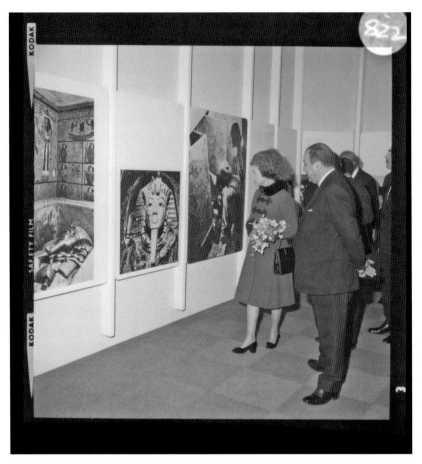

Figure 7.2 Queen Elizabeth II visits the *Treasures of Tutankhamun* exhibition at the British Museum in 1972. The entrance to the exhibition was lined with enlarged prints of Burton photographs.

of Art – and to use 1920s photographs in the catalogue, publicity and exhibition itself. The exhibition team, led by designer Margaret Hall, used sepia-tinted enlargements of Burton photographs in the forecourt of the museum, where the queues of visitors would take in this fabled history before viewing the objects themselves (Figure 7.2).

As *The Times'* Norman Hammond described the effect:

> One of the most engrossing rooms lacks objects altogether, being hung with enlargements of superb photographs of the excavation in progress and its protagonists, but this prepares the visitor for the glories to come.[24]

[24] 'Power, majesty and detail in a memorable exhibition', *The Times,* 29 March 1972, in a special supplement devoted to the exhibition.

Queue the visitors certainly did: *Treasures* surpassed all expectations. Its original six-month run, from March to September 1972, was extended until the end of December, with the museum opening seven days a week, including six days of continuous 10 am to 9 pm visiting hours. Visitors queued from early in the morning, with wait times up to eight hours, and the line snaked from the first-floor exhibition galleries (a space freed up by the ethnographic collection's move to Burlington House), around the forecourt, and onto the surrounding pavements. An estimated 1.65 million visitors saw the show, and it remains the most popular exhibition ever held at the museum.[25] One result of its success was a donation of more than £650,000 to UNESCO's campaign to move the temples of Philae Island, which was to be flooded by the Aswan dam construction. But another was a widespread revival of interest in Tutankhamun, ancient Egypt and Egyptology – a revival whose ramifications continue to be felt today, and a revival that owed much to the purged, heroic narrative of discovery that the show, and its deployment of Burton's photographs, foregrounded.

The British Museum catalogue made use of Kenett's colour photographs, several *Times* photographs from the 1920s, and monochrome photographs of the objects taken by photographers Mohammed Fathy Ibrahim and Sami Mitry in Cairo.[26] But just as important were Burton photographs supplied by the Griffith Institute, including images of the 'untouched' Antechamber and Treasury, the opening of the shrine doors, and a number of the objects, whether exhibited in the show or used for illustrative purposes in the publication. In the catalogue, these Burton photographs almost always had the background around the object removed so that objects floated on the page, or else the background details were reduced to a solid grey within the rectangular image frame.[27] Both treatments helped the older photographs blend in with the new black-and-white photography, even where the resulting grey areas made for awkward blank blocks (around the *in situ* sarcophagus, for instance).[28] The use of Burton's photographs alongside new ones arguably helped establish the reputation his work had in Egyptology for its sharpness of detail, and confirm the idea that 'objective' – and therefore 'good' – object photography was timeless. On the one hand, the contemporary look and feel that Burton's images of the tomb objects had in the 1970s depended on manipulations like those described above, to help them blend in with newer photography. On the other, photographs that were clearly of 1920s date – Carter at work in the tomb, or stages of the mummy unwrapping – benefitted from the rediscovery and re-activation of old photographs taking place in Britain (and elsewhere) at the same time, as local history societies, picture researchers, museums and the media began to turn to overlooked photography collections.[29]

[25] See https://www.britishmuseum.org/system_pages/holding_area/archive_tutankhamun.aspx.

[26] Edwards, *From the Pyramids to Tutankhamun,* 11.

[27] The list of photographic credits in I.E.S. Edwards, Treasures of Tutankhamun, 54, does not easily convey which photographs originate with Burton photography from the 1920s; some are not Burton or Griffith Institute images (as in cat. 13), others are but are credited to a Cairo source (e.g. cat. 6). Of those photographs correctly credited to the Griffith Institute, using Burton photographs, cats. 15, 16, and 18 (among others) are examples that have the background removed, and cats. 27 and 37 are examples with the background 'greyed out' or simplified.

[28] Ibid., 45, based on GI neg. P0705.

[29] Samuels, *Theatres of Memory,* 321–4, 337–47.

Besides which, the very existence of the images authenticated Britain's role in the discovery in the first place – and America's, which came to the fore when a revised version of *Treasures of Tutankhamun* toured the United States in the late 1970s. The objects had, in the meantime, visited museums in the Soviet Union, reflecting ongoing diplomatic relations between Egypt and the USSR. In 1974, however, President Nixon visited Egypt to meet with Anwar Sadat, marking a new strategy on both sides in the wake of the 1973 oil crisis and Arab-Israeli war.[30] Sadat agreed to lend Tutankhamun objects to the United States – supposedly, at Nixon's request, ensuring that America had more 'treasures' and more venues than the Soviet Union version. The Metropolitan Museum of Art was asked to organize the exhibition, with Henry Kissinger emphasizing to museum director Thomas Hoving that it was 'a vital part of the Middle East peace process and all future relationships with Egypt'.[31] It was also a further stage in the creation of the 'king Tut' phenomenon – a phenomenon that, as Melani McAlister has pointed out, did not arise out of the 'intrinsically fascinating character' of ancient Egypt, archaeology, or Tutankhamun.[32] Rather, it arose through multiple and multi-directional representations of Tutankhamun, which cut across class lines and genres (news media, clothing and trinkets, catalogue sales, Steve Martin's comedy), and which allowed Americans to reframe a national identity battered by the civil rights movements and anti-war protests of the 1960s. The show opened in Washington, D.C. in 1976, during the bicentennial celebrations for America's declaration of independence from Britain. It closed three years later in New York, having been seen by 8 million visitors – and having demonstrated that 'ancient Egypt' was more American than anyone had realized. In the meantime, Sadat, President Jimmy Carter and Israeli Prime Minister Menachem Begin had signed the Camp David Accords.

For the American tour and the associated catalogue, produced by the Metropolitan Museum, a different approach was taken to photography. Hoving insisted on new colour photography, to take place at the Cairo Museum. His autobiography recounts in picaresque style the alleged lengths he went to in order to secure enough electricity for the photographic equipment, by splicing into the city's electricity grid.[33] Hoving used a photographer who had worked regularly for the Metropolitan Museum, Lee Boltin, assisted by Ken Kay. Boltin and Kay photographed the antiquities against backdrops in jewel-tone colours or jet black, while a sound system played Boltin's favourite Beethoven, Mozart and Bach. The monochrome images in the catalogue were once again Burton's. This time, however, they were printed from negatives held at the Metropolitan Museum, supplemented for a few of the catalogue entries by photographs from the Griffith Institute.[34] Mimicking the fiftieth-anniversary exhibition at the British Museum in 1972, which displayed

[30] My discussion here draws on the insights of McAlister, 'The common heritage of mankind' and McAlister, *Epic Encounters,* 125–54. For the US version of the exhibition, from the perspectives of two people involved, see also I.E.S. Edwards, *From the Pyramids to Tutankhamun,* 314–18, and Hoving, *Making the Mummies Dance,* 401–14 (a self-aggrandizing account, but no less telling for that).

[31] Hoving, *Making the Mummies Dance,* 402.

[32] McAlister, *Epic Encounters,* 125–6.

[33] Hoving, *Making the Mummies Dance,* 406–10.

[34] Gilbert (ed.), *Treasures of Tutankhamun,* 2.

fifty objects from the tomb, the American tour was linked to the fifty-fifth anniversary of the discovery (that is, 1977) and displayed fifty-five artefacts. The catalogue Foreword, signed by the directors of all the participating museums in order of hosting, emphasized this difference between the US and British shows – and a difference in the 'basic theme of their overall presentation':

> Since almost fourteen hundred glass negatives made by the Metropolitan Museum's photographer Harry Burton throughout the course of the six-year excavation are at the Metropolitan, it was agreed by the participating institutions that these irreplaceable photographs and the actual objects would be brought together into a unique and complementary unity in the exhibition and the accompanying publications.[35]

American audiences did not need to know Burton's nationality, or that another archive existed: this was an American tale. *New York Times* reporter Tom Buckley penned a catalogue essay on the discovery of the tomb, emphasizing the contribution of the Metropolitan Museum's Egyptian Expedition – and, like I.E.S. Edwards in the London catalogue, avoiding entirely the political fall-out of the find by passing quickly from the first two seasons of work, to a brief mention of the mummy unwrapping, and thence to Carter's death in 1939.[36]

Published in a larger format than the British version, the American catalogue of *Treasures* made more copious use of both colour and monochrome photographs. Notably it reproduced a larger number of Burton's photographs showing objects *in situ* or in stages of removal, including the jumble of the Annexe, the clearing of boxes and the raising of the coffins with pulleys and rope. The effect of 'before' and 'after' photographs can only have contributed to the sense visitors (and readers) had of being part of the excavation: thus one of the king-on-a-leopard statues (object 289b) was illustrated with Burton photographs of it still wrapped in its shrine, and unwrapped in front of Burton's curved-paper backdrop, while a pen holder and papyrus burnisher (objects 271e, g) appeared both as photographed on Burton's ground-glass frame and as found inside box 271.[37] Colour photographs and close-up views, printed at the front of the catalogue, brought these objects into glittering focus, as visitors would have seen them in the show. But in the course of the exhibition, visitors also followed Carter's progress through the tomb. The objects were displayed in the order in which they had been found, and enlargements of Burton photographs flanked the cases.[38] The museum visitor, or

[35] Ibid., 4.

[36] Buckley, 'The discovery of Tutankhamun's tomb', in ibid., 9–18. Hoving himself treated the 1920s dispute, and other controversies about the excavation, in his 1978 bestseller *Tutankhamun: The Untold Story,* but this appeared after Tutankhamun, and Carter's heroism, were well-established in the museum presentations and public imagination of the discovery. Hoving's book relayed Carter and Carnarvon's until-then unacknowledged exploration before the 'official opening' in 1922, when they accessed the Burial Chamber and Treasury through a hole that Burton's photographs afterwards helped hide (see Figure 1.2).

[37] Gilbert (ed.), *Treasures of Tutankhamun,* 149 (cat. 38); 144–5 (cats 33–4), respectively.

[38] Described in McAlister, *Epic Encounters,* 130–1.

catalogue reader, was encouraged to step into the shoes of the white, male archaeologists and witness the spectacular transformation of jumbled artefacts into works of art.

Despite the slightly altered selection of objects, the changed organization of the exhibition, and the different installation of the Burton photographs (preceding the exhibition proper in London, but an integral part of it in the US), both the British and American versions presented the eponymous 'treasures' as works of art, displaying most of them in single, spot-lit cases. This was not an unusual choice in museum exhibition design at the time, but emphasizing their artistic qualities did serve a larger purpose – one that echoes the earlier interpretation of the objects, too. As universal works of art, the artefacts from Tutankhamun's tomb could be held up as 'the common heritage of mankind' – a heritage that was, in *Treasures,* controlled by the United States and supported by oil giant Exxon.[39] Such phrases used a language and an ideology that UNESCO campaigns had begun to articulate increasingly since the 1972 adoption of the Word Heritage Convention, itself inspired by the campaign to 'save' the Nubian temples flooded by Egypt's modernizing dam.[40] They were not dissimilar to the claims made decades earlier for the benefits Western science could uniquely, and disinterestedly, offer to the tomb. However much Egypt, like other 'developing' nations, used the concept of world heritage to its own ends, the universalizing claims of beauty, discovery and salvage always served Western interests more. Who owned the Tutankhamun objects was a question settled in 1929, when the Egyptian government reimbursed Lady Carnarvon for her family's excavation costs. Who owned the history and the idea of Tutankhamun was there for anyone to see, from the British Museum's forecourt to the Seattle Museum of Art. Tutankhamun was also there for anyone to buy: to take Seattle as just one example, visitors exited the exhibition through a museum shop almost as large as the individual galleries, and local businesses offered themed advertising and merchandise. One store promised 'Egypt: The Ultimate Fantasy', but a fantasy was what all the products offered, from Boehm porcelain replicas sanctioned by Egypt (retailing at up to $2,700) to an office supply company that offered 'memories, mementoes, gifts' (including photo albums) enabling shoppers to 'enjoy the beauty' of the Tutankhamun experience for years to come.[41] Tutankhamun's image, and Burton's photographs, had been commodified already in the 1920s and 1930s, but the scale and saturation of the 1970s manifestation was unprecedented – and its impact on Egyptology as well.

Egyptology and the archive

Thanks to the touring exhibitions that proved Tutankhamun's soft power, the period between the 1960s and the 1980s saw the tomb powerfully imprinted in the public

[39] See McAlister, *Epic Encounters,* 129, 133–40.

[40] Carruthers, 'Grounding ideologies'; for Cold War context, see also Carruthers, 'Visualizing a monumental past'.

[41] Advertisements, pp. 37 (The Museum Store, Modern Art Pavilion), 68 (Frederick & Nelson department store), 69 (J.K. Gill office supplies), in the Official Program, *Treasures of Tutankhamun,* published by *The Weekly* ('Seattle's newsmagazine'), summer 1978. The program's centre spread (pp. 40–1) gives a scale layout of the exhibition, including the museum store.

consciousness once again. But the organization of the exhibitions, and the intense publicity they generated, also had an impact on Egyptology itself, especially on the holding institutions in Oxford and New York. At the Griffith Institute, annual reports and correspondence reveal a marked shift from concerns with 'records' and academic publication programmes to a self-conscious identity as 'archives' that house both the historical identity of Egyptology and the contemporary, globalized appeal of Tutankhamun. The popularization of ancient Egypt that Ambrose Lansing, in New York, had envisioned in the 1940s exploded in the 1970s in ways he could not have foreseen – and saw the Griffith Institute, with its flagship Tutankhamun collection, reconfigured as a specifically archival institution in which photographs and photography played a significant role.

In the wake of Penelope Fox's work on the Tutankhamun photographs, the Griffith Institute could confidently state in its annual report for 1952, 'There is now a complete set of all extant negatives of the tomb in both New York and Oxford'.[42] In fact, Nora Scott and Fox's successor as Assistant Secretary, Barbara Sewell, continued to exchange queries about the catalogue of Tutankhamun photographs for years to come. It was Sewell who received Phyllis Walker's final donation in 1959, comprising the ten Carter photograph albums and an oil portrait of Howard by his brother William, which hangs in the Institute's archive room today.[43] Throughout the 1950s, annual reports document the seemingly endless effort that the Institute's clerical staff – Sewell in particular – expended on dealing with the 'records', as the collections were known. Photographic objects were a substantial part of these records, not only the Tutankhamun material but also photographic collections the Institute had purchased or accepted as gifts and loans since the late 1940s. No wonder the reports for this period regularly comment on the need for more space and improved storage and classification systems in the Institute's Records Room. By 1957, some of the records were considered 'in need of a drastic reclassification', and in the annual reports for that year, the word 'archive' makes its first appearance, referring to 'the Griffith Archive photographs'.[44] These would benefit from a card catalogue, the report suggested – and it should be arranged in geographical order, like the *Topographical Bibliography,* research for which these photographs were meant to support. The group clearly did not include the Tutankhamun photographs, which always retained a distinct identity in the Institute's operations.

On the assumption that a 'complete' photographic record of the tomb of Tutankhamun now existed, the Griffith Institute returned to the question of publishing the Tutankhamun material. As a member of the Management Committee, and the only surviving member of the Tutankhamun team, Alan Gardiner took an active interest in publication plans. He had been calling for some time for a publication that would do justice to the records, estimating that £60,000 would be needed for a 'scientific' publication with a description of every object and colour plates.[45] It was Gardiner who had secured the contract for Penelope Fox's 1951

[42] Ashmolean Report (1952), 67.
[43] Letter from Sewell to Walker, 1 July 1959 (GI/Carter 1947–7).
[44] Ashmolean Report (1957), 75, 77.
[45] For instance in a letter to the editor published in *The Listener* magazine, to follow up on an abridged radio interview he had given; reproduced in the issue of 17 March 1949: 450.

'picture-book' with Oxford University Press, and in conjunction with his eightieth birthday celebrations in 1959, the Institute mooted plans for a 'serial publication' of Carter's notes and drawings, as funds and time permitted. Such a series 'would be well worth undertaking if it offered the promise of making generally available material now accessible only to those able to visit Oxford, and of permanently recording documents which must inevitably deteriorate with the passage of time'.[46] A desire for permanence in the face of decay: if this was a position that sat easily within archaeological thought, it was also a position that reflected the uncertainties of the decolonizing era and the anxieties of the nuclear age.

In 1960, the Griffith Institute announced the creation of a sub-committee to develop the Tutankhamun publication series. A dedicated typist set to work creating a duplicate set of Carter's handwritten index cards 'as an insurance against possible deterioration or damage'.[47] Work also began on preparing a hand-list of all the objects in the tomb, checked against the Burton prints and negatives in the Griffith Institute. Barbara Sewell began the project, which was continued by the new Assistant Secretary Mary Nuttall after Sewell resigned in 1961 (to become Secretary of the Oriental Institute which had been built next door). Alongside Nuttall, Helen Murray was hired, dividing her time between the Record Room and the *Topographical Bibliography.* Murray took over the task of typing up the duplicate index cards, while Michael Dudley in the Ashmolean Museum's photographic service 'made a complete photographic record of the numerous sketches and drawings appearing on Carter's cards'.[48] Nuttall and Murray's *Handlist to Howard Carter's Catalogue of Objects in Tutankhamun's Tomb* inaugurated the new Tutankhamun Tomb Series in 1963, shortly before Gardiner died – and just as Desroches-Noblecourt's book on Tutankhamun was published by George Rainbird.[49] Listing each of the objects in Carter's numerical order, the slim *Handlist* was 'received with interest and enthusiasm' among Egyptologists.[50] A Foreword by the Secretary, Near Eastern archaeologist Robert W. Hamilton, blamed history and geography for the long delay:

> Up to the present time historical factors have opposed insuperable obstacles to the publication of any comprehensive catalogue of Tutankhamun's tomb, that almost fabulous treasure being, of course, the property of the Egyptian Republic and preserved in the Egyptian Museum at Cairo.[51]

The *Handlist* gave scholars their first indication of exactly how many tomb objects there were, directed them to photographs in the Carter and Mace volumes, and indicated

[46] Ashmolean Report (1959), 71.

[47] Ashmolean Report (1960), 78.

[48] Ashmolean Report (1961), 77. The relevant photographs appear to be GI negs. P0540C, P0540D, P0540E, P0540F and P0837B, all 12 × 16 cm glass plates in the Griffith Institute. A former RAF photographer, Dudley joined the Ashmolean photographic studio as an assistant in 1956, was promoted to principal technician in 1968, and became its head in 1997, after Olive Godwin retired: see Dudley, 'Chief photographers'. I am indebted to David Gowers in the current Ashmolean photographic studio for this reference and his own recollections.

[49] Murray and Nuttall, *Handlist;* Desroches-Noblecourt, *Tutankhamen.*

[50] Ashmolean Report (1963), 85.

[51] Murray and Nuttall, *Handlist,* vii.

where a drawing existed in the Carter archive; its system of notations also marked all the objects that had not been photographed. Eight further volumes in the new series appeared between 1965 and 1990. Each was illustrated by Burton's photographs as well as new photography, where possible, and each addressed a class of objects – hieratic inscriptions, chariots, model boats – in keeping with the artefact-focused approach Carter had taken.[52]

The British Museum *Treasures of Tutankhamun* exhibition in 1972 jolted the Griffith Institute out of these placid academic endeavours – so much so, that it warranted a separate sub-heading in the Institute's report for the 1971–2 academic year, with a paragraph that merits quoting in full:

> Preparations for the British Museum's exhibition of treasures from Tutankhamun's tomb, celebrating the fiftieth anniversary of their discovery, the lavish publicity that accompanied them, and the popular excitement generated by the occasion, all kept the administrative side of the Institute and its archive more than usually busy throughout the year. It was common knowledge amongst Egyptologists that the Institute possessed not only Howard Carter's manuscript records of the tomb but also the set of Burton's photographic negatives. These contributed in a spectacular and admirable fashion to the exhibition in the British Museum, but could not escape notice also of the press and of innumerable publishers and broadcasting organizations in whom they inspired an insatiable desire for prints and information, stretching the capacity of the staff and photographic studio at times to their limit. To coincide with the opening of the exhibition on 30 March 1972 the Institute itself published the fourth fascicle of its Tutankhamun Tomb Series: F.F. Leek: *Human Remains from the Tomb of Tutankhamun.*[53]

The somewhat exasperated tone of the uncredited paragraph highlights several operational assumptions within the organization, as well as the tension its staff perceived between their academic identity as Egyptologists, and the need to engage with the press and other media – ironically, the kind of public profile Lansing had hoped the Tutankhamun photographs might help generate back in 1946. Notably it was the 'administrative side' of the Griffith Institute, and the Ashmolean photographic studio, that bore the brunt of this interest, because the interest was so specifically driven by Harry Burton's photographs, made famous once again.

Whatever ambiguity or annoyance it had felt at the time, in the wake of the 1972 British Museum exhibition and the intense publicity it generated, the Griffith Institute increasingly identified one sphere of its work as archival and itself as an archive. Having first appeared in an annual report in 1957, to refer to other photographic material, the word 'archive' occurred only sporadically until the paragraph quoted above.[54] Beginning with 1973–4, however, the Institute's annual report included a sub-head called 'Archives', looked after by Assistant Secretary Helen Murray. When Murray retired in 1981, Egyptologist Jaromir

[52] See list at http://www.griffith.ox.ac.uk/gri/5publ.html; individual studies continue to appear outside the series.
[53] Ashmolean Report (1971–2), 58.
[54] Ashmolean Reports (1958), 81; (1963), 5; (1964), 85–6.

Malek, the editor of the *Topographical Bibliography*, 'assumed control of the archives'.[55] Thus two separate roles held throughout the post-war period by women – editing the *Topographical Bibliography* (which had been done, without pay, by Rosalind Moss until 1971), and caring for the archives as part of a clerical appointment – merged into a single post held by a man with a doctorate in Egyptology, who was accordingly on a higher, academic-level pay scale. In the 1990s, the creation of an additional job title for Malek – Keeper of the Archives, in line with curatorial titles at the Ashmolean Museum – helped further define the Griffith Institute holdings and lend them institutional prestige.

These shifts in emphasis signal the increasing importance of archive holdings as materials for both research and public-facing activity. The higher profile, and the particular recognition of the Tutankhamun material, led the Griffith Institute to focus more attention on the condition of its photographic objects. In 1980, the Institute commissioned a report from the Ashmolean Museum's senior conservator, Anna Western, for advice about the care of the Tutankhamun negatives and prints.[56] Western recommended that all the negatives should be copied using Kodak SO–015 film, with both the originals and the copies stored in acid-free folders and metal filing cabinets. From the new negatives, a complete set of 'archive prints' would be made 'by archival standard processing' on non-resin coated paper. These should also be stored in acid-free folders and storage boxes, and never used. As new prints were required, they would be made from the new film negatives 'so that the original glass negatives are not used again but safely stored in their acid free envelopes in their dark cupboard'. Copies, in other words, would serve the purpose – the image content taking primacy over the photographic objects, including the 'new' archive prints. Western also recommended that any Tutankhamun negatives already showing signs of deterioration should be washed to remove silvering deposits and yellow stains; this also appears to have removed some of the masking tape Burton had applied (see Figure 4.7). The Institute acted on Western's advice immediately: the Ashmolean photographic service took care of washing or re-fixing the glass plates, and Jean Dudley (Michael's wife) began a two-year long programme of copying the Tutankhamun photographs, completed in November 1983 (Figure 7.3). In that same month, Elizabeth Miles began to work at the Griffith Institute, in a role described as an assistant to Malek.[57] Miles searched Carter's card index of objects from the tomb for any unattested photographs, from which the Ashmolean photographers created further copy negatives – some 300 in total, to which Miles assigned new 'P' numbers.[58]

Technologies of re-photography – which Scott and Fox had deemed too expensive and unsatisfactory to pursue at large scale a generation earlier – now promised an even more 'complete' archive of Tutankhamun photographs, this time through the efforts of the

[55] Ashmolean Report (1981–2), 50.
[56] 'Conservation of Carter negatives and prints' report by Miss. A.C. Western, Chief Conservator, Department of Antiquities, 23 January 1980 (GI/Carter 1978–80).
[57] Ashmolean Report (1983–4), 48.
[58] Ashmolean Report (1984–5), 51. I warmly thank Elizabeth Fleming (née Miles) for sharing with me her memories and the rationale of the extensive work she did on the Tutankhamun photographs in the 1980s and 1990s.

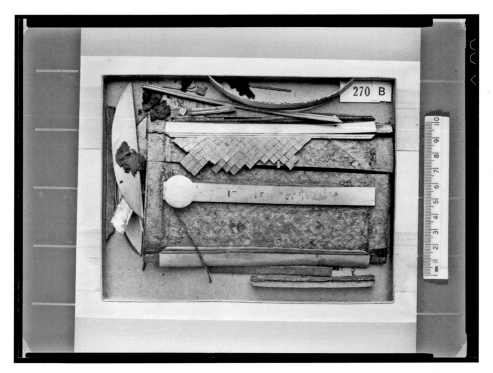

Figure 7.3 A print of box 270b from the tomb (showing it before repair, photograph perhaps by Burton), here re-photographed in the 1980s in the Ashmolean Museum photographic studio, with a 10 cm scale. GI neg. P1825, 12 × 16 cm film copy negative.

Griffith Institute working on its own, with little input from the Metropolitan Museum of Art. As early as 1988, Malek and the Institute staff also explored the technological advantage that a computer database might offer. Guided by the Ashmolean Museum's computer officer, the Institute planned two separate databases: one would replace the Institute's overall card index of its archival holdings, while the other would be specific to the Tutankhamun photographs.[59] In 1995, the Institute secured its own computer network and website, setting the stage for digitally scanning modern prints of all its Tutankhamun negatives – originals and copies alike, with no distinction made between them.

This was the beginning of a website called 'Tutankhamun: Anatomy of an Excavation', which today describes itself as the 'definitive' record of the Tutankhamun archive.[60] The site includes a database of 'Burton photographs', comprising low-resolution files scanned from modern prints of uneven quality, and including photographs taken by Carter and other photographers, such as films and old glass copy negatives of the May 1923 porterage of crated objects by light rail. The quality of the scans is also often poor or

[59] Ashmolean Report (1988–9), 45.
[60] See http://www.griffith.ox.ac.uk/discoveringtut/. Recent changes to the landing page make this resource look more recent than it is. The underlying architecture of the website dates to the late 1990s and early 2000s, although new material is regularly added to reflect ongoing archiving, transcription and scanning.

indifferent (with uncalled-for cropping, for instance), but at an early stage of the internet, limited web storage capacity and transmission speeds could not accommodate higher-resolution files anyway. Apart from cosmetic changes to the website landing page, the underlying database of the photographs is unchanged at this writing. As with the image quality, data fields and search facilities remain limited by the confines of the early internet age. The platform permits searches by negative or object number, or by the object names used in Nuttall and Murray's 1963 *Handlist*. It gives no information about the different formats of negatives or positives held in the Institute archives, the source of the scanned image, or any correlation to the photographic holdings of the Metropolitan Museum, which are not mentioned on the site – presumably based on the persistent assumption that the two collections were identical, and that no more than the 2,000-odd photographs listed in the database exist. For the research and publicity purposes of Egyptology at the turn of the millennium, such details did not matter. The image was the thing, and a complete and total archive of the tomb – not the photographic objects – was the goal.

In and out of the archive

In New York, the Metropolitan Museum of Art did not pursue any specific web-based projects relating to its Tutankhamun photographs or other Burton material, but it did organize two exhibitions around his work. The first, held at the Oriental Institute Museum in Chicago in 2006, and the Metropolitan Museum of Art in 2006–7, focused on Burton's photographs as a way to narrate the 1920s discovery and excavation. It displayed digital images based on prints known or assumed to have been made by Burton in the Metropolitan Museum's archive, supplemented by photographs from the Griffith Institute. The published catalogue singled out the 'Anatomy of an Excavation' website for praise.[61] Five years earlier, another Metropolitan Museum exhibition, 'The Pharaoh's Photographer', had looked at the full spectrum of Burton's work in Egypt.[62] No accompanying catalogue was published, and the show was overshadowed by the destruction of the World Trade Center on its opening day, 11 September 2001. It was co-curated by Egyptologist Catharine H. Roehrig of the Department of Egyptian Art and nineteenth-century photography specialist Malcolm Daniel from the Department of Photographs, each of whom composed a label for the sixty original prints on display. The aim, according to the press release, was to show Burton's photographs 'in a dual role – as important historical documents and as works of art in their own right'.[63]

As we saw earlier in this book, the Museum had displayed Burton's prints in the 1920s as well, helping to generate, and satisfy, public interest in the tomb of Tutankhamun. But they were not created as works of art. Neither Burton nor his colleagues ever spoke of his

[61] Allen, *Tutankhamun's Tomb,* 7. The New York exhibition shared a title with Allen's book, while the Chicago venue used the title 'Wonderful Things! The Discovery of the Tomb of Tutankhamun: The Harry Burton Photographs' (see https://oi.uchicago.edu/museum-exhibits/special-exhibits/two-special-exhibits-oriental-institute).

[62] See http://www.metmuseum.org/exhibitions/listings/2001/harry-burton.

[63] See http://www.metmuseum.org/press/exhibitions/2001/the-pharaohs-photographer.

photography in such terms, even when the display of his photographs was mentioned in correspondence or the press. 'Art' they had become, however, just like the artefacts. 'Purchase art prints' is now an option on the homepage of the Griffith Institute, which leads to a sister site where selected Burton photographs, Carter drawings and other material from the archives are available to order as prints or canvases – with the Tutankhamun excavation records in pride of place.[64] These are the financial challenges facing academic and cultural institutions in the early twenty-first century, as they balance the responsibility of caring for their archives with pressure to generate income. The 1970s blockbusters cemented the commodification of Tutankhamun, the tomb and the images, as have the various Tutankhamun-themed exhibitions held regularly since, whether involving artefacts on loan from Cairo or reproductions based in part on photographic research. The respected Factum Arte team of 'digital mediators' consulted photographs in the Griffith Institute to help create a facsimile of the tomb structure at Luxor, including images of a wall that Carter and his colleagues destroyed in order to extricate the shrines.[65] Photographs, and the 'Anatomy of an Excavation' website itself, have also played a part in more populist exhibitions based on replicas of the tomb and its objects, several of which have toured Europe and North America in recent years. These generate profits not for Egypt (as tours of the antiquities do, and the Factum Arte facsimile) but for the companies behind them, which promise scientific exactitude and hail the tomb's 'invaluable legacy', even if the result is a simulacrum that copies only an imagined or improved-upon reality, as simulacra do.[66] Tutankhamun was made for hyperreality.

In 2015, the Griffith Institute collaborated with German-based SC Exhibitions, commercial exhibition organizers who pride themselves on popular appeal: the SC (from parent company Semmel Concerts Entertainment) is said to stand for 'Showbiz Culture'.[67] In addition to touring the most high-profile reconstruction of the tomb and a thousand of its objects, in three 'units' that travel simultaneously worldwide, SC Exhibitions has digitally colourized a selection of Tutankhamun photographs from the Griffith Institute collection, which it displays either separately or in conjunction with the reconstruction.[68] The North American version of the exhibition is known as *The Discovery of King Tut,* while it is marketed in the rest of the world as *Tutankhamun – His Tomb and His Treasures.* Both are similarly spectacular in their presentation of what the tomb 'looked like' and how the objects inside it were arranged. For displaying the colourized photographs, SC Exhibitions uses an audio

[64] The site is http://www.griffithinstituteprints.com/, in association with art print and frame making firm King and McGaw.

[65] See http://www.factum-arte.com/pag/21/The-Facsimile-of-Tutankhamun-apos-s-tomb. Burton photographed the wall before it was destroyed in December 1923: GI neg. P0589; MMA neg. TAA 51. Press coverage at the time explained that the quality of the wall paintings on the destroyed section was 'exceedingly crude', with no 'artistic value attaching to it', implicit justification for the archaeologists' decision: 'Tutankhamen's tomb', *The Times,* 4 December 1923: 11.

[66] One example: http://www.premierexhibitions.com/exhibitions/13/13/discovery-king-tut/about-exhibition. On the phenomenon of these exhibitions, see also some remarks by Jaromir Malek, at http://www.griffith.ox.ac.uk/gri/4semmel.html. For hyperreality and the simulacrum, see Eco, *Travels in Hyperreality;* Baudrillard, *Simulacra and Simulation.*

[67] See http://www.sc-exhibitions.com/.

[68] See http://www.sc-exhibitions.com/exhibitions/kingtut/.

tour and videos that 'animate' the images – panning over or zooming into them, popping colour out from the black-and-white, and adding framing devices. The videos can also be viewed separately on YouTube, where a voiceover tells the by-now familiar tale of triumph, centred on Carter's heroic perseverance and the 'expert team' of white men.[69] Lingering over a photograph of the 'mannequin' porterage (comparable to Figure 5.8), the narrator tells us that the Egyptian military guard was necessary 'to deter the ubiquitous thieves and tomb-robbers'. Other videos repeatedly use the words 'laboratory' for KV15, 'conservators' for Mace and Lucas, and 'explorer' or 'explorers' for Howard Carter and the rest of the 'team', all without any historical context for these terms. Throughout the spoken narrative, present slips seamlessly into past: the present tense describes whatever actions the photographs are deemed to show, while the past tense recounts the use of the objects in antiquity, replete with words like 'art', 'elegant', 'exquisite', 'gold' and 'craftsmanship'. Among the photographs chosen for colourization, and described in the present tense, are several of Burton's posed work-in-progress shots, including the statue wrapping (Figure 6.4) and Carter rolling back a shroud from the coffins (Figure 5.1). These, and other images, are clearly credited to Burton, while *Times* photos probably taken by Merton are characterized, in contrast, as 'amateur'. The video that introduces the 'expert' team further emphasizes Burton as a specialist: 'The art photographer was spending time in Egypt to photograph wall paintings – a godsend for the excavation,' we are told, as if Burton's presence were divine providence instead of his usual workaday grind.

The criticism that can be levelled at such simulations is not that they are populist and profit-generating in their aims – but that they perpetuate an apolitical, ahistorical version of the excavation, one devoid of the very context such ventures claim to provide. 'Context' in this sense is limited to the archaeological, which is presumed to exist through the reconstructed tomb itself. No other context is needed, and the academic expertise that such commercial firms (unlike museums) lack is compensated for by the participation of professional Egyptologists and institutions like the Griffith Institute. While educational or awareness-raising motives can be claimed for such commercial involvements, generating income is a baseline motivation – like the offer of 'art prints' for sale via the Oxford website. Demands on many academic or cultural institutions today far exceed the reach of their core funding, and more traditional ways of underwriting the care of the photographs, such as reproduction fees, have been eroding in the digital age. The Metropolitan Museum and the Griffith Institute consider themselves to share copyright in all the Tutankhamun photographs, and in keeping with agreements made decades ago, they have not levied charges for non-commercial use beyond the basic cost of image supply. Commercial image licensing used to provide a steady income stream, but many photographs associated with the excavation have since entered picture libraries such as Alamy, Bridgeman and Getty Images. *The Times* asserts copyright in its own images, while copyright in the *Illustrated London News* belongs to the Mary Evans Picture Library, which licenses images for reproduction, for instance in this book. Inevitably, the nature of photographic reproducibility means that Tutankhamun photographs also circulate freely

[69] At https://www.youtube.com/playlist?list=PLhMEs4S5wRFFc9cvClWhD2naYdj5uaSTj.

online or can be purchased, and easily scanned, from vintage postcards or news clippings. As Lord Carnarvon learned long ago, photography is difficult to control.

Egyptology is a field of inquiry boosted at least twice in its history by the boy-king, but it has yet to come to terms with some of Tutankhamun's most enduring legacies – namely the myths of the hero-discoverer, objective data and disinterested science. An exhibition about the Carter archive held at the Ashmolean Museum in 2014, to mark the Griffith Institute's seventy-fifth anniversary, took a markedly more sober approach, with concerted efforts to place the find in some historical context and evaluate its impact in popular culture.[70] However, it stopped short of disrupting the age-old narrative of science, or questioning the record value of photography. Text associated with enlarged photographs that were part of the display often made no reference to Egyptian workers, only the usual 'team' members. Where Ambrose Lansing once hoped the popularization of Egyptology would ensure the discipline's future, it is the popularization of ancient Egypt and 'king Tut' that now seems to mire Egyptology in the past – a past of colonial asymmetries and imperial assumptions. The archival turn that Egyptology began to take in the 1970s, in part amidst the organization and promulgation of the *Treasures* exhibitions, has rarely turned towards historical critique and self-examination – in sharp contrast to the cognate fields of anthropology, art history and several strands of archaeology. Archives and their photographs have variously been overlooked, mined for 'data' on sites or artefacts, or used to promote Egyptology in its most conventional articulations, within and without academia. With its habit of looking only at the artefact, or the famous archaeologist, in a photographic image, Egyptology too often treats its archives as mere surfaces – reflecting back the same mystic mauve or golden glow in which Carter once knelt before Tutankhamun's burial shrines. The field has to date found no need to look closely at itself, when there are such wonderful things to admire instead.

Alternative archives

Some time towards the end of 1926, or early in 1927, Harry Burton took four photographs of an Egyptian boy wearing what was his customary long robe and wound turban – but with the unusual addition of a heavy jewelled necklace and pectoral, found in one of the many boxes in the tomb's Treasury (Figure 7.4).[71] 'Tutankhamun's honorific orders', the *Illustrated London News* called this and other examples of jewellery found in the tomb, aligning them with the British civil and military honours system. Under that heading, the paper published one of the photographs of the boy, captioned, 'A living Egyptian boy wearing the 3000-year-old order of the birth of the sun: a photograph taken to show the method of suspension over the shoulders'.[72]

Who this 'living Egyptian boy' was, neither Carter nor Burton ever mentioned, nor it seems did Burton print the negative reproduced here as Figure 7.4, where a slight movement has

[70] Collins and McNamara, *Discovering Tutankhamun*.
[71] GI negs. 1189, 1190; MMA negs. TAA 1157, 1158. Mounted in MMA/Albums, pp. 880f, g, h, i.
[72] 'Tutankhamen's honorific orders: symbols of sun and moon', *Illustrated London News* 23 April 1927: 726.

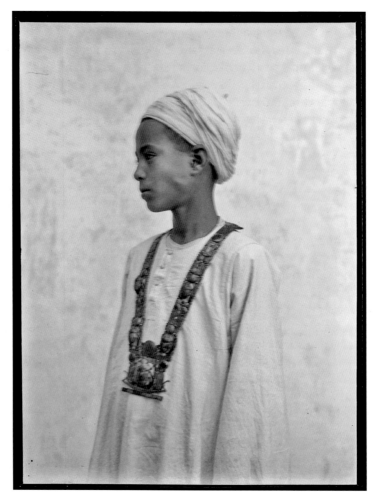

Figure 7.4 An Egyptian boy wearing a necklace and pectoral from Tutankhamun's tomb. Photograph by Harry Burton, November or December 1926; GI neg. P1190.

blurred the boy's features and his jaw is clenched tight as if with nerves, embarrassment, or strain. A later print, with typed 'Griff[ith]' caption, is mounted with the others in the Metropolitan Museum albums, in between photographs of the necklace itself laid on ground-glass to isolate it from both the bodies of living boys and the boxed-up grave goods of dead kings. In the Griffith Institute online database, the photographs are tagged by the object numbers of the pectoral and necklace: 267g and 267h. The boy himself might as well not exist.

So far, so familiar. Except that the preferred photograph – the version printed in the *Illustrated London News* – lives another life, in an alternative archive. Hussein Abd el-Rassul, who bore the honorary title *sheikh,* was a member of the large Abd el-Rassul family on the west bank of Luxor, in and around the village of Gurna. The family gained notoriety in the late nineteenth-century as robbers (never 'explorers') of a cache of royal tombs. Like other Gurna families, they had a symbiotic relationship with the twin trades of archaeology and tourism in the area. Hussein was the proprietor of the tourist rest house – a café and

shady resting place – that has been running for several decades, near the Ramesseum temple. Inside hang several copies of Burton's photograph, either on its own or cradled, in a gilded frame, by the elderly Sheikh Hassan to make a photograph-within-a-photograph. Hussein has been described in recollections by many tourists as a basket-boy or water-boy on the Tutankhamun dig.[73] A Swiss author who was once married to Hussein's grandson Taya also identified Hussein as the boy crouching near the ceiling in photographs of Carter 'demolishing' the wall to the Burial Chamber (such as Figure 5.4), and named the boy's father as the like-named Hussein Abd el-Rassul, said to be one of Carter's foremen.[74] Others have disputed Sheikh Hussein's claims: Carter, who pursued members of the Abd el-Rassul family when he was an antiquities inspector at Luxor, did not name any of them among his four *ru'asa,* and some residents of Gurna have denied any resemblance between the boy in the photograph and the adult Hussein. The skin colour was wrong, some reasoned – skin colour being a physical trait to which many Egyptians are attuned after centuries of Ottoman and European colonialism.

Whether or not young Hussein Abd el-Rassul was the boy in Burton's photograph matters much less here than the point that layers of photographs, and memories, hang on the walls of a building that serves as a meeting place for local people as well as tourists and archaeologists. It is a glimpse of the other stories that photographs can tell – and of the alternative archives that exist outside the institutional archives of the Tutankhamun excavation, or the press archives and photo libraries through which the tomb and its treasures have also been refracted. Writing for *National Geographic Magazine* in 1923, Maynard Owen Williams photographed what he assumed were Egyptian journalists, waiting with their cameras at the tomb. They were, in fact, a group of students from the Giza Polytechnic Institute, whose visit was reported, and photographed, in the *Times* that February.[75] What photographs Egyptian visitors like these took, and what happened to those images over the course of the ensuing century, is what I have characterized as a shadow archive, and trying to locate it has been beyond the scope of my research for this book, likewise any detailed consideration of photographs and other images that circulated in the Arabic-language press. But like the repurposed Burton photograph in the Ramesseum rest house, the students' expectant cameras point to the absences and exclusions inherent to the 'official' photographic archive of the tomb. The photographs that Harry Burton took are not the only photographs of Tutankhamun's resurrection – only the most widely reproduced. To generations steeped in the lore of Carter's discovery, they have offered flattering reflections of an ancient Egypt, and an Egyptology, untouched by time and unmoved by history. We see with compromised eyes.

[73] Including Rohl, *A Test of Time,* 93, and web coverage such as Sonny Stengle, 'The mysteries of Qurna' (http://www.touregypt.net/egypt-info/magazine-mag07012001-magf1.htm); Pascal Pelletier, 'Hussein Abdel Rassoul et le trésor de Toutankhamon (http://www.louxoregypte.fr/pages/un-peu-d-histoire/trouveurs-de-tombes/hussein-abdel-rassoul-et-le-tresor-de-toutankhamon.html); and a blogger known as Lizard Feathers, 'Hangin' with Howard Carter' (http://lizardfeathers.blogspot.co.uk/2011/07/hangin-with-howard-carter.html).

[74] David, *Bei den Grabräubern,* 198–200, 216–18. I thank Caroline Simpson and Kees Van Der Spek for pointing me to this book.

[75] Photograph captioned 'Egyptian students at Luxor', *The Times,* 15 February 1923: 14; see Riggs, *Tutankhamun: The Original Photographs,* 96 (fig. 128).

Archaeology needed photography. Not as a record, as archaeologists are still taught to regard the photograph, but as a way of being, doing, and making visible what archaeology was – or what it wanted to be. This book has argued that acts of archaeological discovery hinged on questions of vision and knowing, in which photographic technologies were deeply enmeshed. Camera work was anxious work, as we have seen throughout this book. It required negotiations, supplies, collaborations, and, not infrequently, serendipities, even for images as controlled as many of Burton's were, in every sense. Control and order shaped the archive, too, and in this book I have argued that archival practices have been essential to photographic practice, both at the time photographs were made and in the decades since. To understand the role photography played in forming communities of knowledge and sustaining them over time, we have to take account of archival practices over time as well. Photographs exist as material objects, layered with the marks of their creation and circulation.[76] Collected and categorized in institutional archives, they take on an evidentiary character that has been, as Stefanie Klamm observes, 'defined by the actors within the archive (or the discipline) and their interests, who through the structuring and preparation of knowledge have control over social and cultural memory'.[77] It is therefore in the care of archives, and the trajectories of photographs in and out of them, that we see disciplinary and institutional histories being made – and boy-kings with them. That much of this work was undertaken after the fact, and by invisible, uncredited workers, makes it no less significant. The significance of archival practices is all the greater, in fact, since it was in these overlooked or dormant-seeming periods that the colonial framework of knowledge production could bed down deep into the archive while the world outside tried, at least, to change.

Every archive has an external face, even if that face is rarely as public or as golden as Tutankhamun's has been. The Tutankhamun photographs were taken with scientific ends in mind, from the way in which Carter folded, cut and filed prints with the object record cards, to the framing and cropping of photographs for different kinds of publication. But what constitutes science, as this book shows, depends on who is speaking for it. In the ten-year span of clearing, documenting and repairing objects from the tomb, the discourse of science and the visual possibilities of photography were often pulled together in accounts that Carter sanctioned or composed. Not to be able to see through such verbal and visual narratives reveals a weakness at the heart of Egyptology, which has primarily used its photographic archives as genealogical charts, rather than sites of self-examination and critique.[78] Alternative archives may yet open other vantage points on the field's own history, privileges and presumptions, and in doing so may encourage alternative forms of practice to arise within the field itself. There is work to do.

Albums, lantern slides, postcards, digitized newspapers, printed books. Negatives in more materials and sizes than I ever expected to encounter. Numbers and alphabetical lists that ran parallel for a while, only to cross each other and skip into other series entirely.

[76] See Klamm, 'Reverse – Cardboard – Print'.
[77] Ibid., 168.
[78] See also Riggs, 'Photographing Tutankhamun'.

I embarked on a study of the Tutankhamun photographic archive thinking that this most famous of finds, and most famous group of archaeological photographs, would make for a straightforward case study of how photography was used in interwar Egyptian archaeology. I thought the doors would be either open or shut, not pivoting back and forth almost a century after the vaunted discovery, as if we could not get enough of the breathless, almost titillating, moment of revelation. The visual memory that endures is thanks in part to the photographs that were taken at the time, but much more to the ways in which have they been deployed, cared for and repurposed ever since. Even in the age of digitization, the photographs are not immaterial but closely tied to the materiality of various photographic objects (negatives or positives), especially in the excavation archives. They exist within an archival ecosystem of catalogues, mounts, correspondence, meeting minutes and files, all of which I have drawn on for this study – and all of which have a very real physical presence demanding some kind of attention or inattention, however unacknowledged those forms of attention, or inattention, may be. Specific archival practices may change over time; apparent revolutions, like the digital, may occur. But if the underlying structures are undisturbed, unquestioned, there is no 'turn' in ways of doing, thinking and seeing that originated in archaeology's colonial context. There is only a deep and well-worn track: an unrippled reflection.

The history of photography is a history of archives – and both are fundamental to history itself. If photography was, to Mace and Carter, 'the most pressing need' on site, it was a need that extended beyond the tomb and into the arenas of emerging Egyptian nationhood, declining imperial power and a Euro-American imaginary in which ancient Egypt was a forebear to the great civilizations of the West. A slightly awkward forebear, in some ways, but one that could not be trusted to the modern Middle East. Every photograph of Carter 'supervising' a porter, of a motor car or telephone line bringing 'modernity' to Luxor, or of a 'refined and cultured' mummified head, had that assumption at its heart, as much a part of photography as the f-stops on Burton's lenses. There are eerie echoes of this salvage and salvation trope both in the 1970s *Treasures of Tutankhamun* tours, developed as they were on the back of UNESCO's Nubian campaigns, and in the digital reproductions and online databases associated with the Tutankhamun archives today, which operate against the backdrop of heritage debates that too often take preservation and protection as a Western remit in which the residents of Egypt and other Middle Eastern countries must be trained.[79]

[79] During the week in which I finished writing this chapter, the Oriental Institute (OI) of the University of Chicago – founded by James Henry Breasted – launched a fundraising video 'highlight[ing] the OI's mission of discovery, preservation and the dissemination of knowledge' in Egypt. The video emphasizes the 'record' created by the Epigraphic Survey's photography and line drawings, the training offered to Egyptian conservation students (so that they can perform future 'maintenance' of OI repairs), and describes the OI's Egyptian archaeological staff as 'specialists' because they use trowels and brushes – the most basic archaeological tools. Training activities are said to anticipate the day that 'they' don't need 'us' anymore, 'because there will be other countries where we need to work anyway'. 'We are trying to teach people to value what they have, teaching them how to explore it', a former director of the OI explains. This is one example of a common narrative refrain in the archaeology of the Middle East, and I single out the Oriental Institute here only because of the coincidence of the video's publication and promotion through social media: see https://youtu.be/b-X0sZwce6E (posted 11 July 2017).

The history of the Tutankhamun archive shows that it is not the photographic image alone that has made the track between Egyptology's colonial past and its present day. Rather, it is the materiality of the photographic objects, their archival lives and the information and ideas with which the archive has filed, labelled, numbered and stamped them. Archival practices carry traces of the knowledge communities, power structures and value systems in which photographs were created and used, as surely as the photographic image carries traces of what was in front of the camera at a given moment in time. New cataloguing, re-photography, scanning, conservation interventions: all such practices serve only to compound or mask the issues at stake if they are used without critical and historical awareness. Throughout its almost one hundred years of existence, the photographic archive of the Tutankhamun excavation has been 'brought up to date' or 'made complete' several times, and each instance has contributed to, even impelled, the normalization and sublimation of colonial knowledge formations and visualities. No matter how iconic an image may be – and many of the Tutankhamun photographs unquestionably are – we must look beyond the image and into the archive in order to confront the fact that photographs, like pharaohs, enjoy long afterlives.

SOURCES

All online resources cited here and in the Notes were live as of 16 March 2018, unless otherwise indicated.

Primary sources

A shortened form after the = sign indicates how a source is cited in the Notes.

Ashmolean Museum, Reports of the Visitors = Ashmolean Report, followed by year of publication.
 1945, Oxford: printed at Oxford University Press by John Johnson
 1946–57, Oxford: printed at Oxford University Press by Charles Batey
 1958–61, Oxford: printed at Oxford University Press by Vivian Ridler
 1962–6, Oxford: printed at Oxford University Press
 1967 to 1971–2, Oxford: printed at Oxford University Press by Vivian Ridler
 1973–4 to 1988, Oxford: printed at Oxford University Press
 1989–98, Oxford: Ashmolean Museum
Biblioteca e Archivi di Egittologia, Università degli Studi, Milan
 Pierre Lacau personal archive (1920s–1930s newspaper clippings, photographs, postcards)
 Alexandre Varille archive (1920s newspapers and magazines)
Cambridge University Library
 Papers of E.J. Dent (for correspondence to Dent from Burton, Harry and Cust, R.H.H.)
 Newspaper clippings file, transferred from the Faculty of Asian and Middle Eastern Studies
 (including *Illustrated London News, The Sphere, The Egyptian Gazette*, and others)
Griffith Institute (GI), Oxford University
 Black Binder, 'List of Burton negatives' characterized by subject (compiled by Elizabeth Miles)
 and 'List of Tutankhamun Duplicate Negatives' ('Burton's List', by Carter's 'red numbers') =
 GI/Black, followed by page numbers
 Burton, Harry, correspondence files
 Burton, Minnie, correspondence files
 Burton, Minnie, diary (http://www.griffith.ox.ac.uk/minnieburton-project/) = GI/MBdiary
 Carter (Howard) Archive
 10 albums of photographs
 Card catalogue of objects from the tomb of Tutankhamun
 'Catalogue of objects sent to Cairo 1922–29' (TAA i.2.14)
 Lantern slides
 'Rough inventory of objects sent to Cairo' (TAA i.2.13) = GI/Carter Notebook 13
 Set of contact prints from *The Times*, donated 1982 (TAA ii.19)
 Carter Deposit files = GI/Carter 1945–6, GI/Carter 1947–77, GI/Carter 1978–80
 Carter, Howard, diaries (http://www.griffith.ox.ac.uk/discoveringTut/journals-and-diaries/)
 = GI/HCdiaries

Carter, Howard, journals (online, as above) = GI/HCjournals

Green Binder, 'Index to Catalogue of Howard Carter Material' and Penelope Fox's comparison
 of the Griffith Institute and Metropolitan Museum holdings of Tutankhamun prints and
 negatives = GI/Green, followed by page numbers

Mace, Arthur, diaries (online, as for Carter journals and diaries) = GI/AMdiaries

NYMMA (New York Metropolitan Museum of Art) Photos files = GI/NYMMA, followed by
 subsection

Metropolitan Museum of Art (MMA), New York

52 albums of photographs, unbound, Department of Egyptian Art = MMA/Albums, followed by
 page number

Annual reports of the Trustees (https://www.jstor.org/journal/annreptrusmetmar) =
 MMA Report, followed by volume number and date

Burton, Harry, correspondence files = MMA/HB, followed by date range subsection

Hartmann, Celia. 2013. Irving MacManus records related to 'Treasures of Tutankhamun'
 exhibition, 1975–9, finding aid, MMA Archives = MMA/MacManus

Newspapers and periodicals. The following online databases were consulted, with individual articles
cited in the Notes by article title, date, page, and author if credited.

Gallica (Bibliothèque nationale de France; sources consulted include *Le Monde*, *Le Petit*
 Parisien, *Le Petit Journal Illustrée*, and photographic archives, e.g. of Agence Rol.)

Illustrated London News Digital Archive

The Listener Historical Archive

ProQuest News (*Chicago Tribune*, *Manchester Guardian*, *New York Times*, *The Sphere*)

The Times Digital Archive

UKPressOnline (*Daily Express*, *Daily Mail*, *Daily Mirror*)

Universitäts Bibliothek, Heidelberg

5 albums of photographs (permalink urn:nbn:de:bsz:16-diglit–11073)

Secondary sources

Abt, Jeffrey. *American Egyptologist: The Life of James Henry Breasted and the Creation of His
 Oriental Institute*. Chicago and London: Chicago University Press, 2011.

Abu el-Haj, Nadia. *Facts on the Ground: Archaeological Practice and Territorial Self-Fashioning in
 Israeli Society*. Chicago and London: Chicago University Press, 2001.

Abul-Magd, Zeinab. *Imagined Empires: A History of Revolt in Egypt*. Berkeley, Los Angeles,
 London: University of California Press, 2013.

Adams, John M. *The Millionaire and the Mummies: Theodore Davis's Gilded Age in the Valley of
 the Kings*. New York: St Martin's Press, 2013.

Ades, Dawn and Simon Baker. *Undercover Surrealism: Georges Bataille and Documents*.
 Cambridge, MA; London: The MIT Press; Hayward Gallery, 2006.

Allais, Lucia. 'Integrities: The Salvage of Abu Simbel', *Grey Room* 50 (2013): 6–45.

Allen, Susan J. *Tutankhamun's Tomb: The Thrill of Discovery*. New York; New Haven and London,
 2006.

Anastasio, Stefano and Barbara Arbeid. 'Archeologia e fotografia negli album di John Alfred
 Spranger', *Quaderni Friulani di Archeologia* 26 (2016): 161–8.

Appadurai, Arjun. 'Archive and Aspiration'. In *Information Is Alive*, edited by Joke Brouwer and
 Arjen Mulder, 8–13. Rotterdam: V2_/NAi Publishers, 2003.

Assmann, Jan. 'Preservation and Presentation of Self in Ancient Egyptian Portraiture.' In *Studies in
 Honor of William Kelly Simpson*, edited by Peter Der Manuelian and Rita F. Freed, 55–81.
 Boston: Museum of Fine Arts, 1995.

Assmann, Jan. *Moses the Egyptian: The Memory of Egypt in Western Monotheism*. Cambridge, MA, 1998.

Atkinson, R.J.C. *Field Archaeology*. London: Methuen, 1946.

Bahrani, Zainab. *The Graven Image: Representation in Babylonia and Assyria*. Philadelphia: University of Pennsylvania Press, 2003.

Bahrani, Zainab. *The Infinite Image: Art, Time, and the Aesthetic Dimension*. London: Reaktion; Chicago: University of Chicago Press, 2014.

Bahrani, Zainab, Zeynep Çelik and Edhem Eldem, eds. *Scramble for the Past: A Story of Archaeology in the Ottoman Empire, 1753–1914*. Istanbul: SALT/Garanti Kültür, 2011.

Baird, J.A. 'Photographing Dura-Europos, 1928–1937: An Archaeology of the Archive.' *American Journal of Archaeology* 115, no. 3 (2011): 427–46.

Baird, J.A. and Lesley McFadyen, 'Towards an Archaeology of Archaeological Archives', *Archaeological Review from Cambridge* 29 (2014): 15–33.

Bangham, Jenny and Judith Kaplan, eds. *Invisibility and Labour in the Human Sciences*. Berlin: Max-Planck Institute for the History of Science (Preprint 484), 2016.

Banks, Marcus and Richard Vokes. 'Introduction: Anthropology, Photography, and the Archive.' *History and Anthropology* 21, no. 4 (2010): 337–49.

Banta, Melissa and Curtis M. Hinsley. *From Site to Sight: Anthropology, Photography, and the Power of Imagery*. Cambridge, MA: Peabody Museum Press, 1986.

Barker, Stephen, ed. 1996. *Excavations and Their Objects: Freud's Collection of Antiquity*. Albany: State University of New York.

Baron, Beth. 'Nationalist Iconography: Egypt as a Woman.' In *Rethinking Nationalism in the Arab Middle East*, edited by James P. Jankowski and Israel Gershoni, 105–24. New York: Columbia University Press, 1997.

Bate, David. 'The Memory of Photography', *Photographies* 3 (2010): 243–57.

Bateman, Jonathan. 'Wearing Juninho's Shirt: Record and Negotiation in Excavation Photographs.' In *Envisioning the Past: Archaeology and the Image*, edited by Sam Smiles and Stephanie Moser, 192–203. Malden, MA and Oxford: Blackwell, 2005.

Baudrillard, Jean. *Simulacra and Simulation*. Ann Arbor: University of Michigan Press, 1994.

Beegan, Gerry. *The Mass Image: A Social History of Photomechanical Reproduction in Victorian London*. Basingstoke: Palgrave Macmillan, 2008.

Belknap, Geoffrey. 'Through the Looking Glass: Photography, Science and Imperial Motivations in John Thomson's Photographic Expeditions.' *History of Science* 52, no. 1 (2014): 73–97.

Bergstein, Mary. *Mirrors of Memory: Freud, Photography, and the History of Art*. Ithaca and London: Cornell University Press, 2010.

Bhabha, Homi. 'Of Mimicry and Man: The Ambivalence of Colonial Discourse,' In Homi Bhobha, *The Location of Culture*, 85–92. London: Routledge, 2004 [1994].

Bierbrier, M.L., ed. *Who Was Who in Egyptology*, 4th edition. London: Egypt Exploration Society, 2012.

Boano, Rosa, Elisa Campanella, Gianluigi Mangiapane and Emma Rabino Massa. 'Giovanni Marro e la ricerca antropologica in Egitto.' In *Missione Egitto 1903–1920: L'Avventura archeologica M.A.I. raccontata*, edited by Paolo Del Vesco and Beppe Moiso, 307–13. Modena: Franco Cosimo Panini, 2017.

Bohrer, Frederick N. *Photography and Archaeology*. London: Reaktion, 2011.

Brilliant, Richard. *Portraiture*. London: Reaktion, 1991.

Braddock, Jeremy. *Collecting as Modernist Practice*. Baltimore: Johns Hopkins University Press, 2012.

Brothman, Brien. 'Orders of Value: Probing the Theoretical Terms of Archival Practice.' *Archivaria* 32 (1991): 78–100.

Brusius, Mirjam. 'From Photographic Science to Scientific Photography: Talbot and Decipherment at the British Museum around 1850.' In *William Henry Fox Talbot: Beyond Photography*, edited

by Mirjam Brusius, Katrina Dean and Chitra Ramalingam, 219–44. New Haven and London: Yale University Press, 2013.

Brusius, Mirjam. *Fotografie und museales Wissen: William Henry Fox Talbot, das Altertum und die Absenz der Fotografie*. Berlin/Boston: De Gruyter 2015.

Brusius, Mirjam. 'Hitting Two Birds with One Stone: An Afterword on Archeology and the History of Science.' *History of Science* 55, no. 3 (2017): 383—91.

Buckley, Liam. 'Objects of Love and Decay: Colonial Photographs in a Postcolonial Archive.' *Cultural Anthropology* 20, no. 2 (2005): 249–70.

Burke, Janine. *The Gods of Freud: Sigmund Freud's Art Collection*. Sydney and New York: Knopf, 2006.

Burton, Antoinette. 'Introduction.' In *Archive Stories: Facts, Fictions, and the Writing of History*, edited by Antoinette Burton, 1–24. Durham, NC and London: Duke University Press, 2005.

Butler, Beverley. 'Egypt: Constructed Exiles of the Imagination'. In *Contested Landscapes: Movement, Exile and Place*, edited by Barbara Bender and Margot Winer, 303–18. Oxford: Berg, 2001.

Butler, Beverley. *Return to Alexandria: An Ethnography of Cultural Heritage Revivalism and Museum Memory*. Walnut Creek, CA: Left Coast Press, 2007.

Capart, Jean. *Tout-ankh-amon*. Brussels: Vromant, 1943.

Carr, Linda. *Tessa Verney Wheeler: Women in Archaeology Before World War 2*. Oxford: Oxford University Press, 2012.

Carruthers, William. 'Introduction: Thinking about Histories of Egyptology.' In *Histories of Egyptology: Interdisciplinary Measures*, edited by William Carruthers, 1–15. Abingdon and New York: Routledge, 2014.

Carruthers, William. 'Grounding Ideologies: Archaeology, Decolonization and the Cold War in Egypt.' In *Decolonization and the Cold War: Negotiating Independence*, edited by Elisabeth Leake and Leslie James, 167–182. London: Bloomsbury, 2015.

Carruthers, William. 'Visualizing a Monumental Past: Archaeology, Nasser's Egypt, and the Early Cold War'. *History of Science* (2017), online first.

Carruthers, William and Stéphane Van Damme. 'Disassembling Archeology, Reassembling the Modern World.' *History of Science* 55, no. 3 (2017): 255–72.

Carter, Howard. *The Tomb of Tut.Ankh.Amen, Volume II*. London: Cassell, 1927.

Carter, Howard. *The Tomb of Tut.Ankh.Amen, Volume III*. London: Cassell, 1933.

Carter, Howard and A.C. Mace. *The Tomb of Tut.Ankh.Amen, Volume I*. London: Cassell, 1923.

Carter, Howard and Nicholas Reeves. *Tut-Ankh-Amen: The Politics of Discovery*. London: Duckworth, 1998.

Çelik, Zeynep. *About Antiquities: Politics of Archaeology in the Ottoman Empire*. Austin: University of Texas Press, 2016.

Challis, Debbie. *The Archaeology of Race: The Eugenic Ideas of Francis Galton and Flinders Petrie*. London: Bloomsbury, 2013.

Clément, Anne. 'Rethinking "Peasant Consciousness" in Colonial Egypt: An Exploration of the Performance of Folksongs by Upper Egyptian Agricultural Workers on the Archaeological Excavation Sites of Karnak and Dendera at the Turn of the Twentieth Century (1885–1914).' *History and Anthropology* 21, no. 2 (2010): 73–100.

Cohen, Getzel M. and Martha Sharp Joukowsky, eds. *Breaking Ground Pioneering Women Archaeologists*. Ann Arbor: University of Michigan Press, 2004.

Colla, Elliott. *Conflicted Antiquities: Egyptology, Egyptomania, Egyptian Modernity*. Durham, NC: Duke University Press, 2007.

Collier, Patrick. 'Imperial/Modernist Forms in the Illustrated London News.' *Modernism/modernity* 19, no. 3 (2012): 487–514.

Collins, Paul and Liam McNamara, *Discovering Tutankhamun*. Oxford: Ashmolean Museum, 2014.

Cone, Polly, ed. *Wonderful Things: The Discovery of Tutankhamun's Tomb*. New York: Metropolitan Museum of Art, 1976.

Cook, Terry and Joan M. Schwartz. 'Archives, Records, and Power: From (Postmodern) Theory to (Archival) Performance.' *Archival Science* 2 (2002): 171–85.

Cookson, M.B. *Photography for Archaeologists*. London: Max Parrish, 1954.

Cottrell, Leonard. *The Secrets of Tutankhamen*. London: Evans Brothers, 1976 [1965].

Cox Hall, Amy. *Framing a Lost City: Science, Photography, and the Making of Machu Picchu*. Austin: University of Texas Press, 2017.

Cross, Karen and Julia Peck. 'Editorial: Special Issue on Photography, Archive and Memory.' *Photographies* 3 (2010): 127–38.

Daston, Lorraine. 'The Immortal Archive: Nineteenth-Century Science Imagines the Future.' In *Science in the Archives: Pasts, Presents, Futures*, edited by Lorraine Daston, 159–83. Chicago: University of Chicago Press, 2017.

Daston, Lorraine and Peter Galison. *Objectivity*. Brooklyn: Zone Books, 2007.

David, Francine Marie. *Bei den Grabräubern: Meine Zeit im Tal der Könige*. Zurich: Unionsverlag, 2011.

Davis, Theodore M. *The Tombs of Harmhabi and Touatânkhamanou*. London: Constable, 1912.

Der Manuelian, Peter, and George Andrew Reisner. 'George Andrew Reisner on Archaeological Photography.' *Journal of the American Research Center in Egypt* 29 (1992): 1–34.

Derrida, Jacques, *Archive Fever: A Freudian Impression*. London and Chicago, 1998.

Desroches-Noblecourt, Christiane. *Tutankhamen*. London: George Rainbird, 1963.

Desroches-Noblecourt, Christiane. *Toutankhamon et son temps*. Paris: Petit Palais, 1967.

Diaz-Andre, Margarita, and Marie Louise Stig Sørenson. *Excavating Women: A History of Women in European Archaeology*. Abingdon and New York: Routledge, 1998.

Dirks, Nicholas. 'Annals of the Archive: Ethnographic Notes on the Sources of History.' In *From the Margins: Historical Anthropology and its Futures*, edited by Brian Axel, 47–65. Durham, NC: Duke University Press, 2002.

Doyon, Wendy. 'On Archaeological Labour in Modern Egypt.' In *Histories of Egyptology: Interdisciplinary Measures*, edited by William Carruthers, 141–56. New York and London: Routledge, 2015.

Driaux, Delphine and Marie-Lys Arnette. *Instantanés d'Égypte: Trésors photographiques de l'Institut français d'archéologie orientale*. Cairo: Institut français d'archéologie orientale, 2016.

Droop, J.P. *Archaeological Excavation*. Cambridge: Cambridge University Press, 1915.

Du Mesnil du Buisson, Comte. *La Technique des Fouilles Archéologiques: Les Principes Généraux*. Paris: Paul Geuthner, 1934.

Dudley, Michael. 'Chief Photographers.' *The Ashmolean* 46 (Spring 2004), 22–3.

Dunphy, R. Graeme and Rainer Emig. 'Introduction'. In Hybrid *Humour: Comedy in Transcultural Perspectives*, edited by R. Graeme Dunphy and Rainer Emig, 7–35. Amsterdam and NY: Rodopi, 2010.

Eaton-Krauss, Marianne. *The Sarcophagus in the Tomb of Tutankhamun*. Oxford: Griffith Institute, Ashmolean Museum, 1993.

Eaton-Krauss, Marianne. *The Unknown Tutankhamun*. London: Bloomsbury, 2016.

Eaton-Krauss, Marianne and Erhart Graefe. *The Small Golden Shrine from the Tomb of Tutankhamun*. Oxford: Griffith Institute, 1985.

Eco, Umberto. *Travels in Hyperreality: Essays*. London: Pan Books, 1987.

Edwards, Elizabeth. 'Photographic "Types": The Pursuit of Method.' *Visual Anthropology* 3 (1990): 235–58.

Edwards, Elizabeth. *Raw Histories: Photography, Anthropology, and Museums*. Oxford: Berg, 2001.

Edwards, Elizabeth. 'Negotiating Spaces: Some Photographic Incidents in the Western Pacific, 1883–84.' In *Picturing Place: Photography and the Geographical Imagination*, edited by Joan M. Schwartz and James R. Ryan, 261–79. London and New York: I.B. Tauris, 2003.

Edwards, Elizabeth. 'Photographs: Material Form and the Dynamic Archive'. In *Photo Archives and the Photographic Memory of Art History*, edited by Costanza Caraffa, 47–56. Berlin: Deutscher Kunstverlag, 2011.

Edwards, Elizabeth. "Tracing Photography." In *Made to Be Seen: Perspectives on the History of Visual Anthropology*, edited by Marcus Banks and Jay Ruby, 159–89. Chicago and London: University of Chicago Press, 2011.

Edwards, Elizabeth. *The Camera as Historian: Amateur Photographers and Historical Imagination, 1885–1918*. Durham, NC and London: Duke University Press, 2012.

Edwards, Elizabeth. 'Anthropology and Photography: A Long History of Knowledge and Affect.' *Photographies* 8, no. 3 (2016): 235–52.

Edwards, Elizabeth. 'Uncertain Knowledge: Photography and the Turn-of-the-century Anthropological Document.' In *Documenting the World: Film, Photography, and the Scientific Record*, edited by Gregg Mitman and Kelley Wilder, 89–123. Chicago: University of Chicago Press, 2016.

Edwards, Elizabeth and Janice Hart, eds. *Photographs, Objects, Histories: On the Materiality of Images*. London and New York: Routledge, 2004.

Edwards, Elizabeth and Sigrid Lien. 'Museums and the Work of Photographs.' In *Museums and the Work of Photographs*, edited by Elizabeth Edwards and Sigrid Lien, 3–17. London: Bloomsbury, 2015.

Edwards, Elizabeth and Christopher Morton. 'Between Art and Information: Towards a Collecting History of Photographs.' In *Photographs, Museums, Collections: Between Art and Information*, edited by Elizabeth Edwards and Christopher Morton, 3–23. London: Bloomsbury, 2015.

Edwards, I.E.S. *Treasures of Tutankhamun*. London: British Museum Press, 1972.

Edwards, I.E.S. *From the Pyramids to Tutankhamun: Memoirs of an Egyptologist*. Oxford: Oxbow, 2000.

El Shakry, Omnia. *The Great Social Laboratory: Subjects of Knowledge in Colonial and Postcolonial Egypt*. Stanford, CA: Stanford University Press, 2007.

Elshakry, Marwa. 'Histories of Egyptology in Egypt: Some Thoughts.' In *Histories of Egyptology: Interdisciplinary Measures*, edited by William Carruthers, 185–97. New York and London: Routledge, 2015.

Evans, Jean. *The Lives of Sumerian Sculpture: An Archaeology of the Early Dynastic Temple*. New York: Cambridge University Press, 2012.

Fox, Penelope. 1951. *Tutankhamun's Treasure*. London, New York, Toronto: Oxford University Press; Geoffrey Cumberlege.

Frayling, Christopher. *The Face of Tutankhamun*. London and Boston: Faber and Faber, 1992.

Fryxell, Allegra. 'Tutankhamen, Egyptomania, and Temporal Enchantment in Interwar Britain', *Twentieth Century British History*, 28, no. 4 (2017), 516–42.

Gamwell, Lynn, and Richard Wells, eds. *Sigmund Freud and Art: His Personal Collection of Antiquities*. Binghamton: State University of New York, 1989.

Gange, David. *Dialogues with the Dead: Egyptology in British Culture and Religion 1822–1922*. Oxford: Oxford University Press, 2013.

Gasper, Michael Ezekiel. *The Power of Representation: Publics, Peasants, and Islam in Egypt*. Stanford: Stanford University Press, 2009.

Geimer, Peter. 'The Colors of Evidence: Picturing the Past in Photography and Film.' In *Documenting the World: Film, Photography, and the Scientific Record*, edited by Gregg Mitman and Kelley Wilder, 45–64. Chicago: University of Chicago Press, 2016.

Geraci, Joseph. 'Lehnert & Landrock of North Africa.' *History of Photography* 27, no. 3 (2003): 294–98.

Gershoni, Israel. 'Rethinking the Formation of Arab Nationalism in the Middle East, 1920–1945: Old and New Narratives.' In *Rethinking Nationalism in the Arab Middle East*, edited by James P. Jankowski and Israel Gershoni, 3–25. New York: Columbia University Press, 1997.

Gershoni, Israel and James P. Jankowski. *Redefining the Egyptian Nation, 1930–1945*. Cambridge and New York: Cambridge University Press, 1995.

Gifford, Jayne. 'Extracting the Best Deal for Britain: The Assassination of Sir Lee Stack in November 1924 and the Revision of Britain's Nile Valley Policy.' *Canadian Journal of History* 48 (2013): 87–114.

Gilberg, Mark. 'Alfred Lucas: Egypt's Sherlock Holmes.' *Journal of the American Institute for Conservation* 36 (1997): 31–48.

Gilbert, Katharine Stoddart, ed. *Treasures of Tutankhamun*. New York: Metropolitan Museum of Art, 1976.

Golia, Maria. *Photography and Egypt*. London: Reaktion; Chicago: University of Chicago Press, 2010.

Goode, James F. *Negotiating for the Past: Archaeology, Nationalism, and Diplomacy in the Middle East, 1919–1941*. Austin: University of Texas Press, 2007.

Gregory, Derek. 'Scripting Egypt: Orientalism and the Cultures of Travel.' In *Writes of Passage: Reading Travel Writing*, edited by James Duncan and *Derek Gregory*, 114–50. London and New York: Routledge, 1999.

Gregory, Derek. 'Colonial Nostalgia and Cultures of Travel: Spaces of Constructed Visibility in Egypt.' In *Consuming Tradition, Manufacturing Heritage: Global Norms and Urban Forms in the Age of Tourism*, edited by Nezar AlSayyad, 212–39. London: Routledge, 2001.

Gretton, Tom. 'The Pragmatics of Page Design in Nineteenth-Century General-Interest Weekly Illustrated News Magazines in London and Paris.' *Art History* 33, no. 4 (2010): 68–79.

Grigsby, Darcy Grimaldo. 'Out of the Earth: Egypt's Statue of Liberty.' In *Edges of Empire: Orientalism and Visual Culture*, edited by Jocelyn Hackforth-Jones and Mary Roberts, 38–69. Malden, MA and Oxford: Blackwell, 2005.

Guha, Sudeshna. 'The Visual in Archaeology: Photographic Representation of Archaeological Practice in British India.' *Antiquity* 76 (2002): 93–100.

Guha, Sudeshna, ed. *The Marshall Albums: Photography and Archaeology*. Ahmedabad: Mapin Publishing; Alkazi Collection of Photography, 2010.

Guha, Sudeshna. 'Beyond Representations: Photographs in Archaeological Knowledge.' *Complutum* 24, no. 2 (2013): 173–88.

Hall, Stuart. 'The Spectacle of the Other.' In *Representation: Cultural Representations and Signifying Practices*, edited by Stuart Hall, 225–90. London: Sage, 1997.

Hankey, Julia. *A Passion for Egypt: Arthur Weigall, Tutankhamun, and the 'Curse of the Pharaohs'*. London: I.B. Tauris, 2001.

Harris, Verne. 'A Shaft of Darkness: Derrida in the Archive.' In *Refiguring the Archive*, edited by Carolyn Hamilton, Verne Harris, Jane Taylor, Michele Pickover, Graeme Reid and Razia Saleh, 61–81. Dordrecht, Boston, London: Kluwer Academic Publishers, 2002.

Hayes, Patricia, Jeremy Silvester and Wolfram Hartmann. 'Photography, History, and Memory.' In *The Colonising Camera: Photographs in the Making of Namibian History*, edited by Wolfram Hartmann, Jeremy Silvester and Patricia Hayes, 2–9. Cape Town: University of Cape Town Press, 1998.

Hayes, Patricia, Jeremy Silvester and Wolfram Hartmann. '"Picturing the Past" in Namibia': The Visual Archive and its Energies. In *Refiguring the Archive*, edited by Carolyn Hamilton, Verne Harris, Jane Taylor, Michele Pickover, Graeme Reid and Razia Saleh, 103–34. Dordrecht, Boston, London: Kluwer Academic Publishers, 2002.

Hevia, James L. 'The Photography Complex: Exposing Boxer-Era China (1900–1901), Making Civilization.' In *Photographies East: The Camera and Its Histories in East and Southeast Asia*, edited by Rosalind Morris, 79–119. London and Durham, NC: Duke University Press, 2009.

Hockings, Paul. 'Disasters Drawn: The Illustrated London News in the Mid–19th Century.' *Visual Anthropology* 28 (2015): 21–50.

Hornung, Erik and Marsha Hill. *The Tomb of Pharaoh Seti I*. Zürich and Munich: Artemis, 1991.

Hoving, Thomas. *Tutankhamun: The Untold Story*. New York: Simon and Schuster, 1978.

Hoving, Thomas. *Making the Mummies Dance*. New York: Simon and Schuster, 1993.

Hurst, John G. 'Donald Benjamin Harden 1901–1994'. *Proceedings of the British Academy* 94 (1997) 513–39.

Jackson, Ashley and David Tomkins. 'Ephemera and the British Empire.' In *Exhibiting the Empire: Cultures of Display and the British Empire*, edited by John McAleer and John M. MacKenzie, 142–67. Manchester: Manchester University Press, 2015.

Jacob, Wilson Chacko. *Working out Egypt: Effendi Masculinity and Subject Formation in Colonial Modernity, 1870–1940*. Durham, NC and London: Duke University Press, 2011.

James, T.G.H. *Howard Carter: The Path to Tutankhamun*. London and New York: I.B. Tauris, 2001 [1992].

James, T.G.H. 'Moss, Rosalind Louisa Beaufort (1890–1990)'. *Oxford Dictionary of National Biography*, Oxford University Press, 2004. http://www.oxforddnb.com/view/article/57479; DOI:10.1093/ref:odnb/57479.

Johnson, George B. 'Painting with Light: The Work of Archaeology Photographer Harry Burton.' *KMT* 8, no. 2 (1997): 58–77.

Johnson, Geraldine A. '"(Un)Richtige Aufnahme": Renaissance Sculpture and the Visual Historiography of Art History.' *Art History* 36, no. 1 (2013): 12–51.

Johnson, W. Raymond. 'The Epigraphic Survey and the "Chicago Method".' In *Picturing the Past: Imaging and Imagining the Ancient Middle East*, edited by Jack Green, Emily Teeter and John A. Larson, 31–8. Chicago: Oriental Institute of the University of Chicago, 2012.

Kennedy, Charles and Beaumont Newhall. *Photographs by Clarence Kennedy*. Northampton, MA: Smith College, 1967.

Kerbouef, Anne-Claire. 2005. 'The Cairo Fire of 26 January 1952 and the interpretations of history.' In *Re-Envisioning Egypt 1919–1952*, edited by Arthur Goldschmidt, Amy J. Johnson and Barak A. Salmoni, 194–216. Cairo and New York: American University in Cairo Press.

Ketelaar, Eric. 'Tacit Narratives: The Meaning of Archives.' *Archival Science* 1 (2001): 131–41.

Kett, Robert J. 'Monuments in Print and Photography: Inscribing the Ancient in Nineteenth-Century Mexico.' *Getty Research Journal* 9 (2017): 201–10.

Khater, Antoine. *Le Régime Juridique des Fouilles et des Antiquités en Egypte*. Cairo: Institut français d'archéologie orientale, 1960.

Klamm, Stefanie. 'Reverse – Cardboard – Print: The Materiality of the Photographic Archive and its Function.' In *Documenting the World: Film, Photography, and the Scientific Record*, edited by Gregg Mitman and Kelley Wilder, 166–99. Chicago: University of Chicago Press, 2016.

Klamm, Stefanie. *Bilder des Vergangenen Visualisierung in der Archäologie im 19. Jahrhundert – Fotografie, Zeichnung und Abguss*. Berlin: Mann, 2017.

Kracauer, Siegfriend. *The Past's Threshold: Essays on Photography*, edited by Philippe Despoix and Maria Zinfert. Chicago: University of Chicago Press for Diaphanes, 2014.

Lansing, Ambrose. 'In Memoriam: Harry Burton.' *Metropolitan Museum of Art Bulletin* 35, no. 8 (1940): 165.

Latour, Bruno. *We Have Never Been Modern*. Cambridge, MA: Harvard University Press, 1993.

Latour, Bruno. *Reassembling the Social: An Introduction to Actor-Network-Theory*. Oxford: Oxford University Press, 2007.

Lee, Christopher C. . . . *The Grand Piano Came by Camel: Arthur C. Mace, the Neglected Egyptologist*. Edinburgh and London: Mainstream, 1992.

Leek, F. Filce. *The Human Remains from the Tomb of Tutankhamun*. Tutankhamun's Tomb Series, V. Oxford: Griffith Institute, 1972.

Lockman, Zachary. *Contending Visions of the Middle East: The History and Politics of Orientalism*. Cambridge and New York: Cambridge University Press, 2010.

Lucas, Gavin. *Critical Approaches to Fieldwork: Contemporary and Historical Archaeological Practice*. London and New York: Routledge, 2001.

McAlister, Melani. '"The Common Heritage of Mankind": Race, Nation, and Masculinity in the King Tut Exhibit.' *Representations* 54 (1996): 80–103.

McAlister, Melani. *Epic Encounters: Culture, Media, and U.S. Interests in the Middle East Since 1945*. Berkeley and Los Angeles: University of California Press, 2001.

McClintock, Anne. *Imperial Leather: Race, Gender and Sexuality in the Colonial Contest*. New York and London: Routledge, 1996.

Mace, Arthur C. 'Work at the Tomb of Tutankhamun.' *Metropolitan Museum of Art Bulletin, Part 2: The Egyptian Expedition 1922–23* 18, no. 12 (1923): 5–11.

Mak, Lanver, *The British in Egypt: Community, Crime and Crises 1822–1922*. London and New York: I.B. Tauris, 2012.

Matthews, Richard J. 'Is the Archivist a "Radical Atheist" Now? Deconstruction, Its New Wave, and Archival Activism.' *Archival Science* 16, no. 3 (2014): 213–60.

Mayer, Andreas. 'Museale Inszenierungen von anthropologiscen Fiktionen: "Rasse" und "Menschheit" im Naturhistorischen Museum nach 1945.' In *Repräsentationsformen in den biologischen Wissenschaften*, edited by Armin Geus, Thomas Junker, Hans-Jörg Rheinberger, Christa Riedl-Dorn and Michael Weingarten, 73–88. Berlin: VWB (Verlag für Wissenschaft und Bildung), 1999.

Mitchell, Timothy. *Rule of Experts: Egypt, Techno-Politics, Modernity*. Berkeley and Los Angeles: University of California Press, 2002.

Mitman, Gregg and Kelley Wilder. 'Introduction.' In *Documenting the World: Film, Photography, and the Scientific Record*, edited by Gregg Mitman and Kelley Wilder, 1–22. Chicago: University of Chicago Press, 2016.

Morris-Reich, Amos. *Race and Photography: Racial Photography as Scientific Evidence, 1876–1980*. Chicago and London: University of Chicago Press, 2016.

Morton, Christopher. 'The Anthropologist as Photographer: Reading the Monograph and Reading the Archive.' *Visual Anthropology* 18, no. 4 (2005): 389–405.

Morton, Christopher. 'Photography and the Comparative Method: The Construction of an Anthropological Archive.' *Journal of the Royal Anthropological Institute* 18, no. 2 (2012): 369–396.

Moshenska, Gabriel. 'Thomas "Mummy" Pettigrew and the Study of Egypt in Early Nineteenth-century Britain.' In *Histories of Egyptology: Interdisciplinary Measures*, edited by William Carruthers, 201–14. Abingdon, UK: Routledge, 2015.

Münch, Hans-Hubertus. 'Categorizing Archaeological Finds: The Funerary Material of Queen Hetepheres I at Giza.' *Antiquity* 74, no. 286 (2000): 898–908.

Murray, Helen and Mary Nuttall. *A Handlist to Howard Carter's Catalogue of Objects in Tutankhamun's Tomb*. Tutankhamun's Tomb Series, I. Oxford: Griffith Institute, 1963.

Mussell, James. 'Cohering Knowledge in the Nineteenth Century: Form, Genre and Periodical Studies.' *Victorian Periodicals Review* 42, no. 1 (2009): 93–103.

Natale, Simone. 'Photography and Communication Media in the Nineteenth Century.' *History of Photography* 36, no. 4 (2012): 451–56.

Newbury, Colin. 'Milner, Alfred, Viscount Milner (1854–1925)', *Oxford Dictionary of National Biography*, Oxford University Press, 2004; online edition, Oct 2008. http://www.oxforddnb.com/view/article/35037; DOI:10.1093/ref:odnb/35037.

Nora, Pierre. 'Between Memory and History: Les Lieux de Mémoire.' *Representations* 26, Special Issue: Memory and Counter-Memory (1989): 7–24.

Nora, Pierre. *Realms of Memory: Rethinking the French Past*. Chicago: University of Chicago Press, 1998. (Translated and abridged from Les Lieux de mémoire, Paris: Gallimard, 1984.)

Olsen, Bjornar, Michael Shanks, Timothy Webmoor and Christopher Witmore. *Archaeology: The Discipline of things*. Berkeley and Los Angles: University of California Press, 2012.

Orsenigo, Christian. 'Una guida d'eccezione per illustri viaggiatori: Pierre Lacau e i Savoia in Egitto.' In *Da Brera alle Piramidi*, edited by Christian Orsenigo, 113–17. Milan: Scalpendi, 2015.

Petrie, W.M.F. *Racial Photographs From Egyptian Monuments*. London: W. Harman for W.M.F. Petrie, 1887.

Petrie, W.M.F. *Methods and Aims in Archaeology*. London: Methuen, 1904.

Phillips, James E. '"To Make the Dry Bones Live": Amédée Forestier's Glastonbury Lake Village.' In *Envisioning the Past: Archaeology and the Image*, edited by Sam Smiles and Stephanie Moser, 72–91. Malden, MA and Oxford: Blackwell, 2005.

Pinney, Christopher. *Camera Indica: The Social Life of Indian Photographs*. London: Reaktion, 1997.

Pinney, Christopher. 'Camerawork as Technical Practice in Colonial India.' In *Material Powers: Cultural Studies, History, and the Material Turn*, edited by Tony Bennett and Patrick Joyce, 145–70. London and New York: Routledge, 2010.

Poole, Deborah. *Vision, Race, and Modernity: A Visual Economy of the Andean Image World*. Princeton: Princeton University Press, 1997.

Poole, Deborah. 'An Excess of Description: Ethnography, Race, and Visual Technologies.' *Annual Review of Anthropology* 34 (2005): 159–79.

Price, Sally. *Primitive Art in Civilized Places*, 2nd ed. Chicago: University of Chicago Press, 2001 [1989].

Quirke, Stephen. *Hidden Hands: Egyptian Workforces in Petrie Excavation Archives, 1880–1924*. London: Duckworth, 2010.

Ramamurthy, Anandi. *Imperial Persuaders: Images of Africa and Asia in British Advertising*. Manchester: Manchester University Press, 2003.

Reid, Donald Malcolm. 'Indigenous Egyptology: The Decolonization of a Profession?' *Journal of the American Oriental Society* 105, no. 2 (1985): 233–46.

Reid, Donald Malcolm. 'Nationalizing the Pharaonic Past: Egyptology, Imperialism, and Egyptian Nationalism, 1922–1952.' In *Rethinking Nationalism in the Arab Middle East*, edited by James P. Jankowski and Israel Gershoni, 127–49. New York: Columbia University Press, 1997.

Reid, Donald Malcolm. *Whose Pharaohs? Archaeology, Museums, and Egyptian National Identity from Napoleon to World War I*. Berkeley and Los Angeles: University of California Press, 2002.

Reid, Donald Malcolm. *Contesting Antiquity in Egypt: Archaeologies, Museums and the Struggle for Identities from World War 1 to Nasser*. Cairo and New York: American University in Cairo Press, 2015.

Reid, Donald Malcolm. 'Remembering and Forgetting Tutankhamun: Imperial and National Rhythms of Archaeology, 1922–1972.' In *Histories of Egyptology: Interdisciplinary Measures*, edited by William Carruthers, 157–73. New York and London: Routledge, 2015.

Reisner, George A. 'Hetep-Heres, Mother of Cheops.' *Bulletin of the Museum of Fine Arts, Boston, Supplement* 25 (1927): 1–36.

Reisner, George A. and William Stevenson Smith. *A History of the Giza Necropolis. Vol. 2, The Tomb of Hetep-Heres the Mother of Cheops: A Study of Egyptian Civilization in the Old Kingdom*. Cambridge, MA: Harvard University Press, 1955.

Reeves, C.N. and John H. Taylor. *Howard Carter before Tutankhamun*. London: British Museum Press, 1992.

Reeves, Nicholas. *The Complete Tutankhamun: The King, the Tomb, the Royal Treasure*. London: Thames and Hudson, 1995.

Richards, Thomas. 'Archive and Utopia.' *Representations* 37 (1992): 104–35.

Richards, Thomas. *The Imperial Archive: Knowledge and the Fantasy of Empire*. London and New York: Verso, 1993.

Ridley, Ronald T. 'The Dean of Archaeological Photographers: Harry Burton.' *Journal of Egyptian Archaeology* 99 (2013): 117–30.

Riggs, Christina. *The Beautiful Burial in Roman Egypt: Art, Identity, and Funerary Religion*. Oxford: Oxford University Press, 2005.

Riggs, Christina. 'Colonial Visions: Egyptian Antiquities and Contested Histories in the Cairo Museum', *Advances in Research – Museum Worlds* 1 (2013): 65–84.

Riggs, Christina. *Unwrapping Ancient Egypt*. London: Bloomsbury, 2014.

Riggs, Christina. 'Discussing Knowledge in the Making.' In *Histories of Egyptology: Interdisciplinary Measures*, edited by William Carruthers, 129–38. New York and London: Routledge, 2015.

Riggs, Christina. 'An Autopsic Art: Drawings of "Dr Granville's Mummy" in the Royal Society Archives'. *Notes and Records* 70, no. 2 (2016): 107–33.

Riggs, Christina. 'Photography and Antiquity in the Archive, or How Howard Carter Moved the Road to the Valley of the Kings.' *History of Photography* 40, no. 3 (2016): 267–82.

Riggs, Christina. 'The Body in the Box: Archiving the Egyptian Mummy.' *Archival Science* 17, no. 2 (2017): 125–50.

Riggs, Christina. 'Objects in the Photographic Archive: Between the Field and the Museum in Egyptian Archaeology'. *Museum History Journal* 10, no. 2 (2017): 140–61.

Riggs, Christina. *Tutankhamun: The Original Photographs*. London: Rupert Wace Ancient Art/ Gower Press, 2017.

Riggs, Christina. 'Photographing Tutankhamun: Photo-objects and the Archival Afterlives of Colonial Archaeology.' In *Photo-Objects: On the Materiality of Photographs and Photo-Archives in the Humanities and Sciences*, edited by Julia Bärnighausen and Franka Schneider, forthcoming. Berlin: Max Planck Research Library for the History and Development of Knowledge.

Roberts, Donna and Patricia Allmer, eds. *'Wonderful Things': Surrealism and Egypt. Dada/ Surrealism* 19, no. 1 (2013). Iowa Research Online.

Robson, Eleanor. 'Old Habits Die Hard: Writing the Excavation and Dispersal History of Nimrud.' *Museum History Journal* 10, no. 2 (2017): 217–32.

Rohl, David M. *A Test of Time: The Bible from Myth to History*. London: Random House, 1995.

Rose, Gillian. 'Practising Photography: An Archive, a Study, Some Photographs and a Researcher.' *Journal of Historical Geography* 26, no. 4 (2000): 555–71.

Ryzova, Lucie. 'Egyptianizing Modernity through the "New Effendiya": Social and Cultural Constructions of the Middle Class in Egypt under the Monarchy.' In *Re-Envisioning Egypt 1919–1952*, edited by Arthur Goldschmidt, Amy J. Johnson and Barak A. Salmoni, 124–63. Cairo and New York: American University in Cairo Press, 2005.

Ryzova, Lucie. *The Age of the Effendiya: Passages to Modernity in National-Colonial Egypt*. Oxford: Oxford University Press, 2014.

Ryzova, Lucie. 'Mourning the Archive: Middle Eastern Photographic Heritage between Neoliberalism and Digital Reproduction.' *Comparative Studies in History and Society* 56, no. 4 (2014): 1027–61.

Samuel, Raphael. *Theatres of Memory: Past and Present in Contemporary Culture*. London and New York: Verso, 1994.

Schiaparelli, Ernesto. *La Tomba intatta dell'architetto Cha nella necropoli di Tebe*. Turin: Reale Museo di Antichità, 1927.

Schlak, Tim. 'Framing Photographs, Denying Archives: The Difficulty of Focusing on Archival Photographs.' *Archival Science* 8 (2008): 85–101.

Schlanger, Nathan. 'Manual and Intellectual Labour in Archaeology: Past and Present in Human Resource Management.' In *Unquiet Pasts: Risk Society, Lived Cultural Heritage, Re-Designing Reflexivity*, edited by Stephanie Koerner and Ian Russell, 161–71. Farnham: Ashgate, 2010.

Schneider, Thomas and Peter Raulwing, eds. *Egyptology from the First World War to the Third Reich: Ideology, Scholarship, and Individual Biographies*. Leiden and Boston: Brill, 2013.

Schwartz, Joan M. '"We Make Our Tools and Our Tools Make Us": Lessons from Photographs for the Practice, Politics, and Poetics of Diplomatics.' *Archivaria* 40 (1995): 40–74.

Schwartz, Joan M. '"Records of Simple Truth and Precision": Photography, Archives, and the Illusion of Control.' *Archivaria* 50 (2000): 1–40.

Schwartz, Joan M. 'Coming to Terms with Photographs: Descriptive Standards, Linguistic "Othering", and the Margins of Archivy.' *Archivaria* 54 (2002): 142–71.

Sekula, Allan. 'The Body and the Archive.' *October* 39 (1986): 3–64.

Sekula, Allan. 'Reading an Archive: Photography between Labour and Capital.' In *Blasted Allegories: An Anthology of Writings by Contemporary Artists*, edited by Brian Wallis, 114–27. Cambridge, MA and London: The MIT Press, 1987.

Shapin, Steven. 'The Invisible Technician.' *American Scientist* 77, no. 6 (1989): 554–63.

Shapin, Steven. *Never Pure: Historical Studies of Science as if It Was Produced by People with Bodies, Situated in Time, Space, Culture, and Society, and Struggling for Credibility and Authority*. Baltimore: Johns Hopkins University Press, 2010.

Shapin, Steven and Simon Schaffer. *Leviathan and the Air-Pump: Hobbes, Boyle, and the Experimental Life*. Princeton: Princeton University Press, 1985.

Shepherd, Nick. '"When the Hand That Holds the Trowel Is Black. . .": Disciplinary Practices of Self-Representation and the Issue of 'Native' Labour in Archaeology.' *Journal of Social Archaeology* 3, no. 3 (2003): 334–52.

Shepherd, Nick. *Mirror in the Ground: Archaeology, Photography, and the Making of an Archive*. Cape Town: Jonathan Ball, 2015.

Shiner, Larry. *The Invention of Art: A Cultural History*. Chicago: University of Chicago Press, 2001.

Siapkas, Johannes. 'Skulls from the Past: Archaeological Negotiations of Scientific Racism.' *Bulletin of the History of Archaeology* 26, no. 1 (2016): 1–9.

Simpson, R.S. 'Griffith, Francis Llewellyn (1862–1934)', *Oxford Dictionary of National Biography*, Oxford University Press, 2004; online edition, May 2008. http://www.oxforddnb.com/view/article/33579; DOI:10.1093/ref:odnb/33579.

Simpson, R.S. 'Gardiner, Sir Alan Henderson (1879–1963).' *Oxford Dictionary of National Biography*, 2009, 10.1093/ref:odnb/33322.

Sinnema, Peter W. *Dynamics of the Picture Page: Representing the Nation in the Illustrated London News*. Aldershot: Ashgate, 1998.

Spanel, Donald. *Through Ancient Eyes: Egyptian Portraiture*. Birmingham, AL: Birmingham Museum of Art, 1988.

Steedman, Carolyn. *Dust: The Archive and Cultural History*. Manchester: Manchester University Press, 2001.

Steedman, Carolyn. 'After the Archive.' *Comparative Critical Studies* 8, no. 2–3 (2011): 321–40.

Stevenson, Alice. 'Artefacts of Excavation: The British Collection and Distribution of Egyptian Finds to Museums, 1880–1915.' *Journal of the History of Collections* 26, no. 1 (2014): 89–102.

Stevenson, Alice, Emma Libonati and John Baines. 'Introduction – Object Habits: Legacies of Fieldwork and the Museum.' *Museum History Journal* 10, no. 2 (2017): 113–26.

Stoler, Ann Laura. 'Colonial Archives and the Arts of Governance.' *Archival Science* 2, no. 1–2 (2002): 87–109.

Stoler, Ann Laura. *Along the Archival Grain: Epistemic Anxieties and Colonial Common Sense*. Princeton: Princeton University Press, 2009.

Swenson, Christine. *The Experience of Sculptural Form: Photographs by Clarence Kennedy*. Detroit: Detroit Institute of Arts, 1987.

Thompson, Jason. *Wonderful Things: A History of Egyptology, 1: From Antiquity to 1881*. Cairo and New York: American University in Cairo Press, 2015.

Thompson, Jason. *Wonderful Things: A History of Egyptology, 2: The Golden Age: 1881–1914*. Cairo and New York: American University in Cairo Press, 2015.

Thompson, Jason. *Wonderful Things: A History of Egyptology, 3: From 1914 to the Twenty-first Century*. Cairo and New York: American University in Cairo Press, 2017.

Tucker, Jennifer. *Nature Exposed: Photography as Eyewitness in Victorian Science*. Baltimore: Johns Hopkins University Press, 2005.

Tucker, Jennifer and Tina Campt. 'Entwined Practices: Engagements with Photography in Historical Inquiry.' *History and Theory* 48, no. 4 (2009): 1–8.

Tutankhamun Treasures: A Loan Exhibition from the Department of Antiquities of the United Arab Republic, 1961–1963. Washington, D.C.: Smithsonian Institution, 1961.

van der Spek, Kees. *The Modern Neighbours of Tutankhamun: History, Life, and Work in the Villages of the Theban West Bank*. Cairo and New York: American University in Cairo Press, 2011.

van Zyl, Susan. 'Psychoanalysis and the Archive: Derrida's Archive Fever.' In *Refiguring the Archive*, edited by Carolyn Hamilton, Verne Harris, Jane Taylor, Michele Pickover, Graeme Reid and Razia Saleh, 39–59. Dordrecht, Boston, London: Kluwer Academic Publishers, 2002.

Wiese, André, ed. *Ägypten, Orient und die Schweizer Moderne: Die Sammlung Rudolf Schmidt (1900–1970)*. Basel: Schwabe, 2011.

Wilder, Kelley. *Photography and Science*. London: Reaktion, 2009.

Wilfong, T. G. and Andrew W.S. Ferrara, eds. *Karanis Revealed: Discovering the Past and Present of a Michigan Excavation in Egypt*. Ann Arbor: Kelsey Museum of Archaeology, 2014.

Williams, Maynard Owen. 'At the Tomb of Tutankhamen.' *The National Geographic Magazine* 53, o. 5 (May 1923).

Winlock, H.E. *Materials Used at the Embalming of King Tut-Ankh-Amun*. New York: Metropolitan Museum of Art Papers, 1941.

Winlock, H.E. and Dorothea Arnold. *Tutankhamun's Funeral*. New York: Metropolitan Museum of Art, 2010.

Yakel, Elizabeth. 'Archival Representation.' *Archival Science* 3 (2003): 1–25.

INDEX